ONE DAY

at Disney

Meet the People
Who Make the Magic
Across the Globe

Foreword by **Bob Iger**

Text by **Bruce C. Steele**

EDITIONS

Los Angeles • New York

Take a magical ride

behind the scenes during

ONE DAY

at Disney

where magic never sleeps.

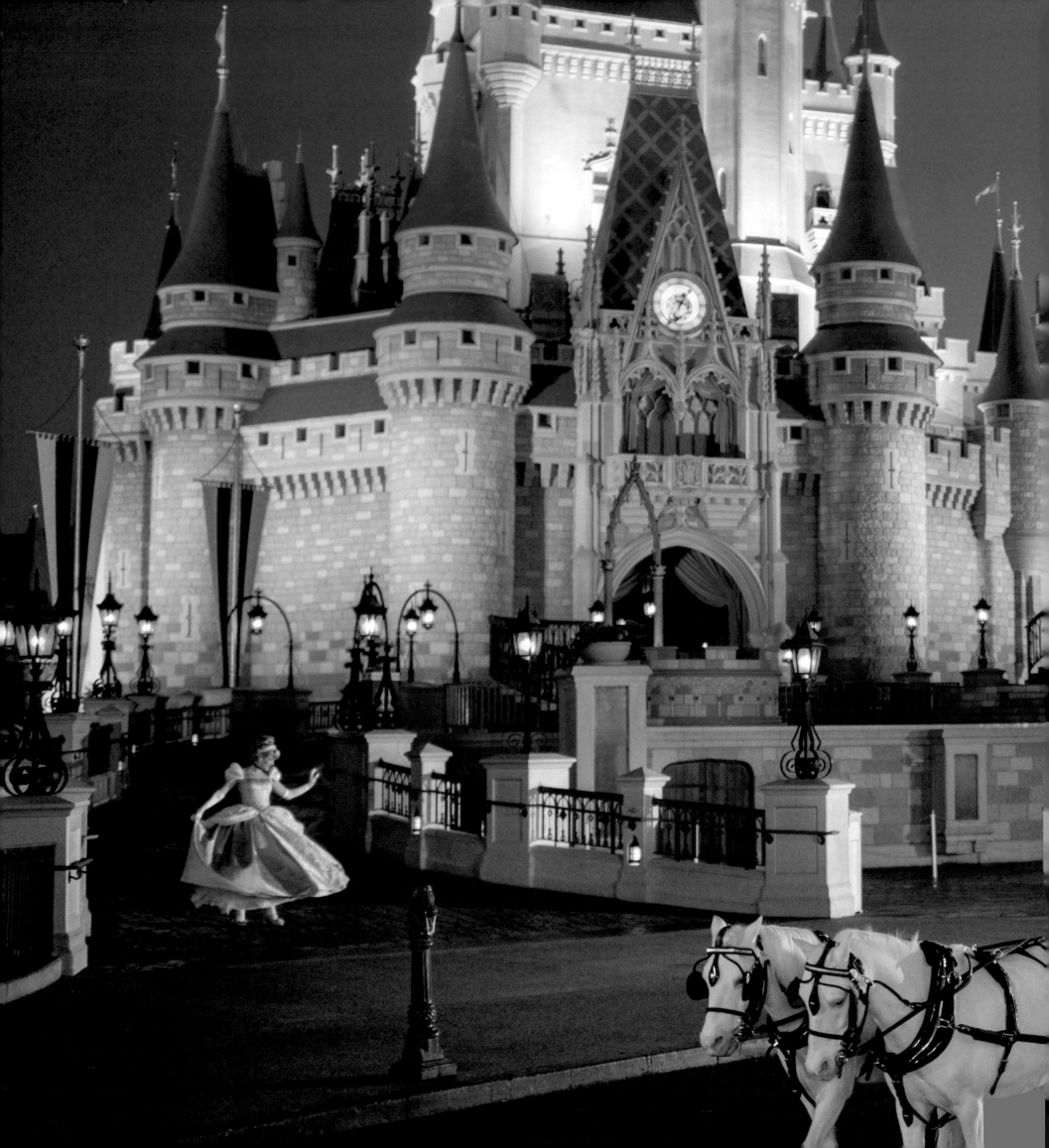

Whether preparing for a Fairy Tale Wedding in Florida . . .

Or getting ready for

The Lion King in Madrid . . .

Or drawing a **true classic** . . .

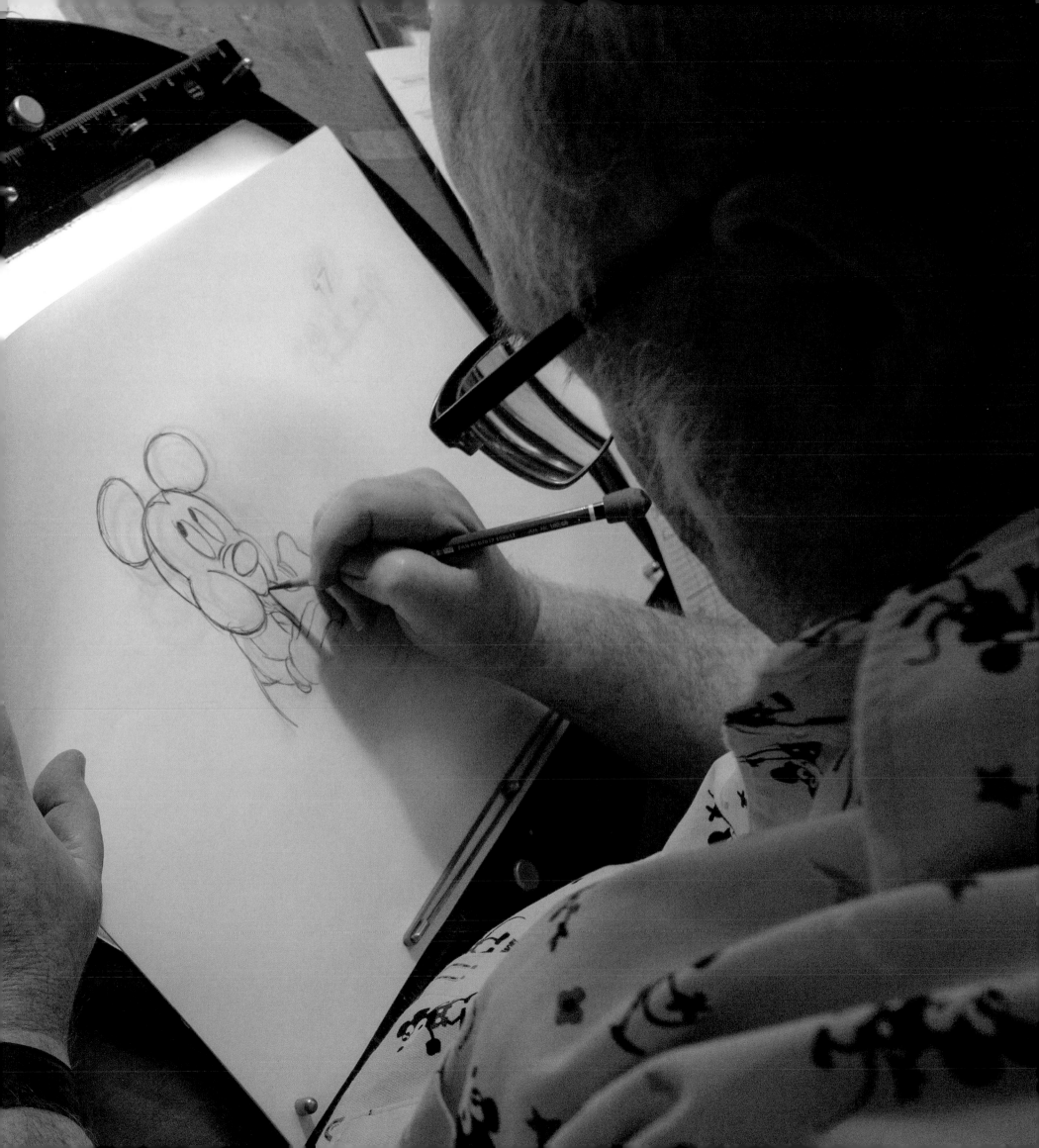

Cast members

across the globe

create magic

every day.

LOS
ANGELES

HOLLYWOOD

HONG KONG

TOKYO

BRISTOL

COSTA RICA

ORLANDO

BURBANK

MADRID

SALT LAKE
CITY

NEWHALL

CASTAWAY CAY

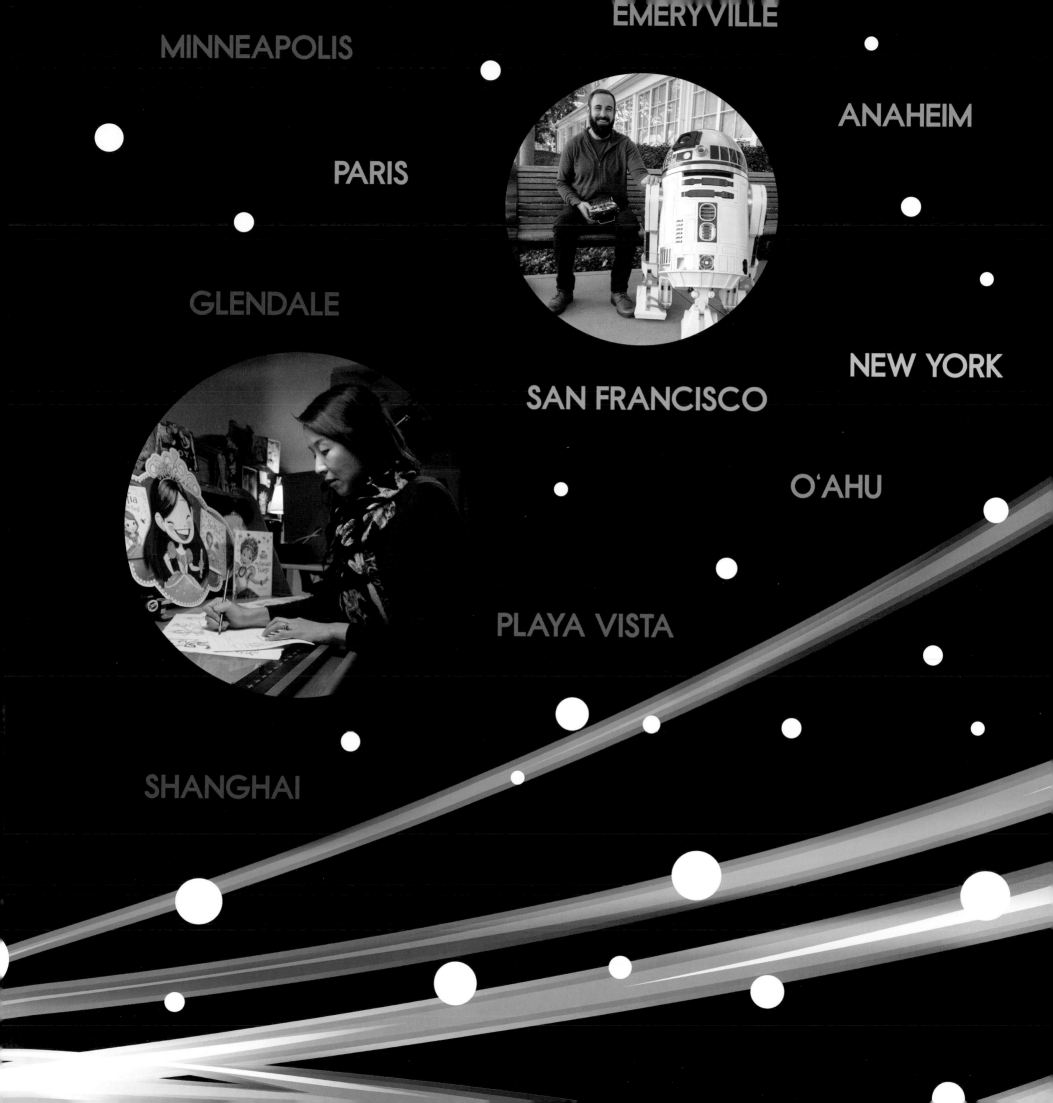

MINNEAPOLIS

EMERYVILLE

ANAHEIM

PARIS

GLENDALE

NEW YORK

SAN FRANCISCO

O'AHU

PLAYA VISTA

SHANGHAI

What's it like to report to work every day for The Walt Disney Company?

For Steve Sligh, it's like being a rancher overseeing a spread regularly "invaded" by movie stars. For Kris Becker, an animal keeper, it's like being a teacher at a tropical school that's attended only by lemurs.

Robin Roberts, a cohost and coanchor at ABC's *Good Morning America*, enjoys some of her best moments with the studio audience after the show wraps. Rob Richards walks from his Hollywood bungalow to his job at a nearby movie palace (though he rarely stays for the feature).

Jackie Ma often spends the day on a mechanical lift, grooming tall palm trees in Hong Kong, while Morgan Pope may be found tossing robots into the air in Los Angeles.

Then there are the thousands of cast members who work day and night at the Disney Parks around the world, the countless Imagineers who dream up what's being added to those parks, and the storytellers (of all sorts) who work on the movies and TV series from Disney, Pixar, Marvel, and Lucasfilm. And they all readily acknowledge none of them could get their jobs done without security guards, tram drivers, and maintenance crews providing vital services.

You'll meet all these people and more inside this book, *One Day at Disney*, as they go about their business on—well, one single day, just an "ordinary" Thursday in 2019. It wasn't a day for movie premieres or the unveiling of any new park

attractions. It was a day for guiding guests, planning and building, testing new technologies, rehearsing, making toffee, and much more.

On that day, a small army of photographers and videographers scattered across the globe to capture what goes on beyond those tantalizing CAST MEMBERS ONLY doors—regardless of whether those being followed turned out to be taking on historic endeavors or typical tasks. All the photos in this book were taken on that single Thursday, beginning early in Tokyo and following the sun around the world through Shanghai, Hong Kong, Paris, Madrid, the Bahamas, Costa Rica, and dozens of places throughout the United States. More than forty hours after it began, the day ended as the sun set on the Aulani resort in Hawai'i.

On that day, some eighty cast members agreed to open up their workshops, dressing rooms, kitchens, cubicles, TV studios, labs, locomotive engines—and some even more surprising and diverse work spaces. They also shared their stories: childhood dreams and capers, career pivots and triumphs, workaday hurdles and joys.

Whether it was soaring over Los Angeles with ABC7 helicopter reporter Chris Cristi or looking into a rhinoceros's mouth with Dr. Natalie Mylniczenko at Disney's Animal Kingdom, this project reveals adventures and perspectives unique to Disney cast members.

On that day, Brie Larson talked about *Captain Marvel*, while the cast of *Modern Family* read through one of the season's final episodes. Korey Amrine swam with his Adventures by Disney guests in a cove in Costa Rica, and Manon Teissier du Cros conjured dessert miracles in Paris.

It was just a day in the life, as extraordinary as any other day at Disney. As any cast member can tell you, a Disney job is less a destination than a limitless journey. And for just *One Day at Disney*, we can all tag along for the ride.

Even in the middle of a busy day, cast members still find the time to think about their families—both at home and families of affinity in television and animation studios, Disney Parks, and . . . jumping together into the North Sea.

As afternoon bends toward evening in Los Angeles, Walt Disney's own shadow may be visible in the active minds of Imagineers, the refurbishment of Disneyland's Sleeping Beauty Castle, and storytelling in all its incarnations.

At a time that's considered "after work" for most folks, the action is just ramping up for live shows that relay news and sports via TV and other media or that entertain theater audiences in person. In Hong Kong, meanwhile, it's morning again.

Whatever the hour, wherever the place, there are jobs to do and stories to tell. The journey of one day comes to an end, but the journey of Disney cast members continues across continents and through the decades.

Foreword by Bob Iger

Chairman and Chief Executive Officer
The Walt Disney Company

Walt Disney once said, "You can dream, create, design and build the most wonderful place in the world, but it requires people to make the dream a reality." With each passing day as CEO of Disney and with every historic milestone we achieve as a company, I gain a deeper understanding of just how right Walt was, along with an even greater appreciation for the men and women who make it possible for us to do the impossible every day.

I am constantly awed and inspired by the creativity and talent, as well as the passion and dedication of our more than two hundred thousand cast members and employees around the world. For every person you see on-screen, onstage, or in our parks and resorts, there are hundreds of others working just as hard behind the scenes, often in extraordinary, unique jobs that only exist at Disney and are essential to the moments, the memories, and the "magic" that have always defined this legendary company.

At any given moment, our employees are creating joy and wonder somewhere in the world. Some are transforming into beloved characters, designing costumes, broadcasting live, or taking Broadway by storm. Others are greeting guests, operating cameras, composing music, drawing comics, elevating the art of animation, or creating TV shows and movies as well as brand new ways to watch them. Many spend their time pushing the limits of imagination and technology to invent new experiences and entertainment that could only come from Disney. Regardless of their role or responsibilities, their region or business unit, every employee of The Walt Disney Company shares a common goal: to deliver the very best . . . in entertainment, news, and experiences. And they do it exceptionally well!

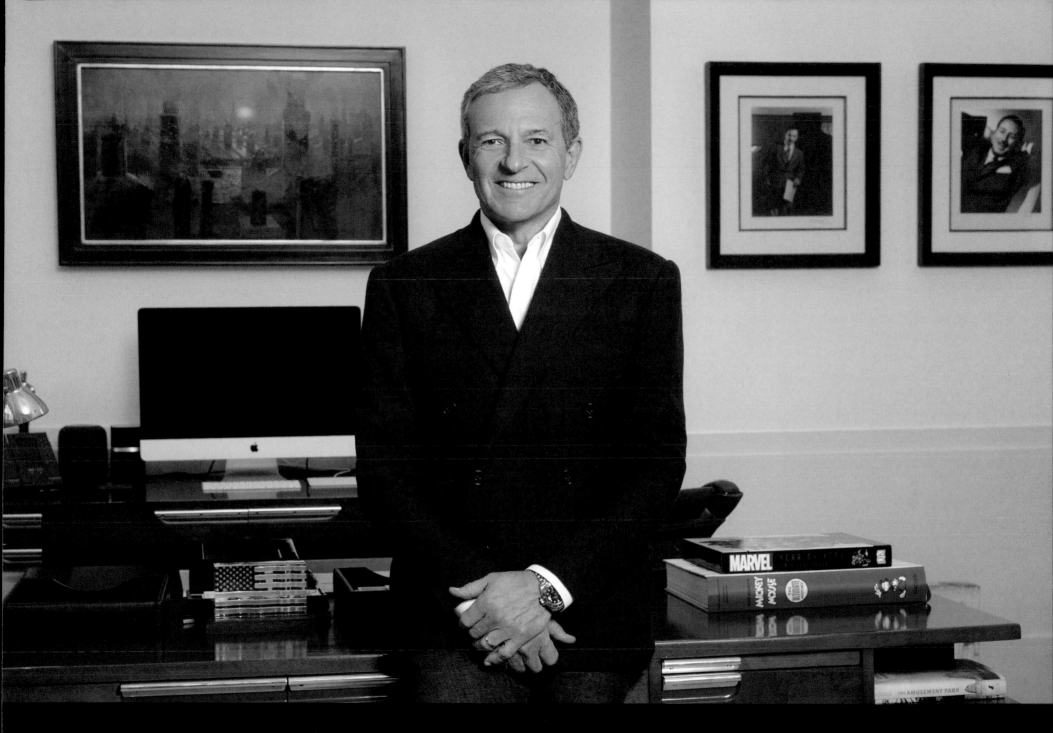

This book is a celebration of the extraordinary people who work at Disney—the famous faces and unsung heroes who "make the dream a reality" every day. We're showcasing a day in the life of Disney, pulling back the curtain to take you behind the scenes and give you a glimpse into what goes on during a single twenty-four-hour period. The people you'll meet in these pages represent the vast array of jobs and experiences across our entire company, as well as the character of the men and women who work here, and I am thrilled and honored to introduce them to you.

Enjoy One Day at Disney!

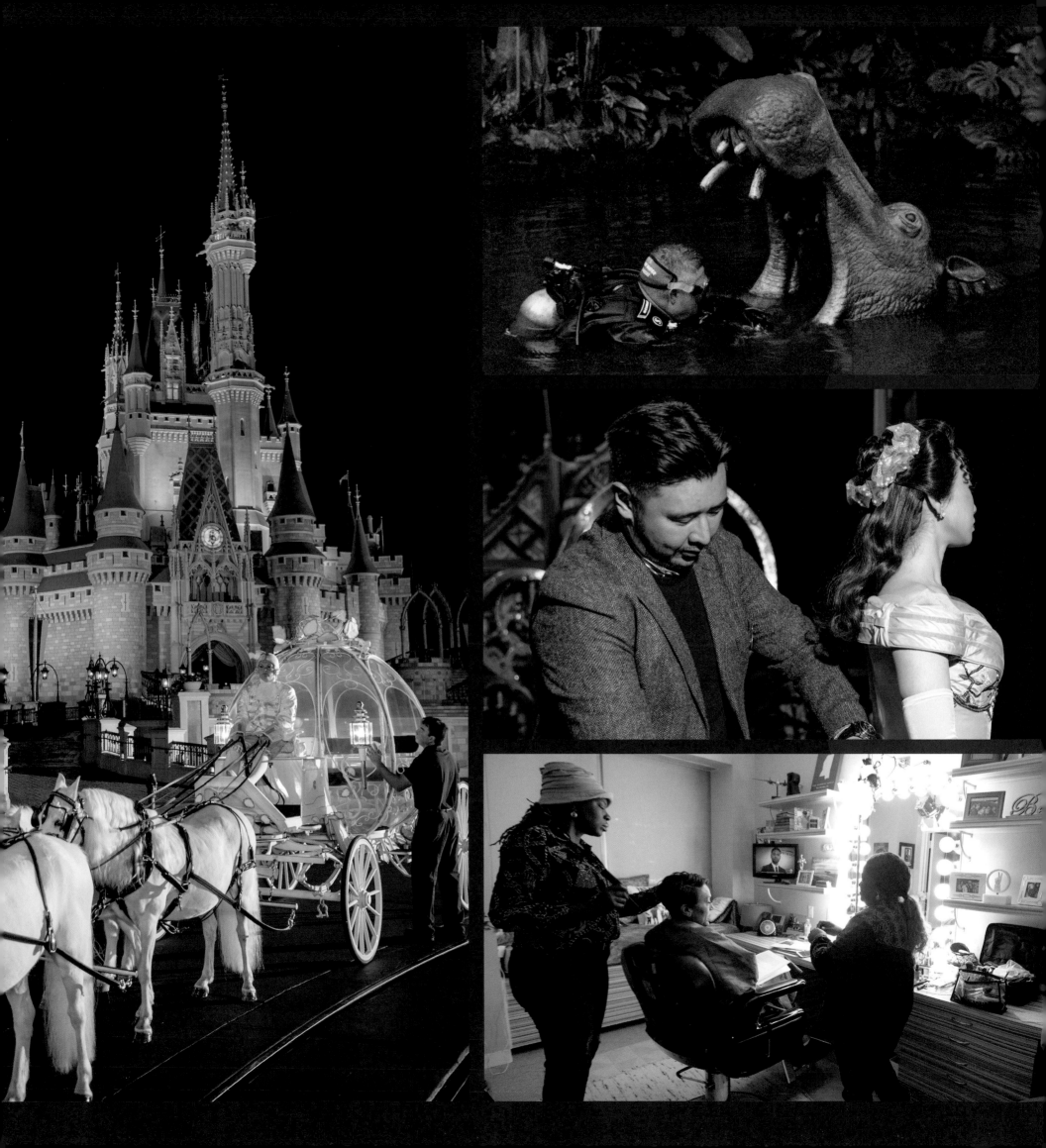

Chapter One

Midnight – 3 am

Cinderella knows the power of midnight. But she may not know that the middle of the night in Los Angeles is the middle of the afternoon in China.

So while Disneyland is quiet except for maintenance cast members like Thom Self, diving through the dark waters of the Jungle Cruise, the Walt Disney Grand Theatre in Shanghai is bustling, prepping for another performance of *Beauty and the Beast*. In New York, it's nearly time for Robin Roberts to get her day started.

Cinderella herself will soon be called upon in Florida, since her carriage and six-horse team have a predawn appointment for Fairy Tale Wedding photos in Walt Disney World.

It's enough to exhaust even a fairy godmother.

STEPHANIE

Part of the Magic

STEPHANIE CARROLL

Hometown
Binghamton, New York, USA

Job
Ranch Hand, Walt Disney World

Favorite Disney movie
The Lion King (1994)

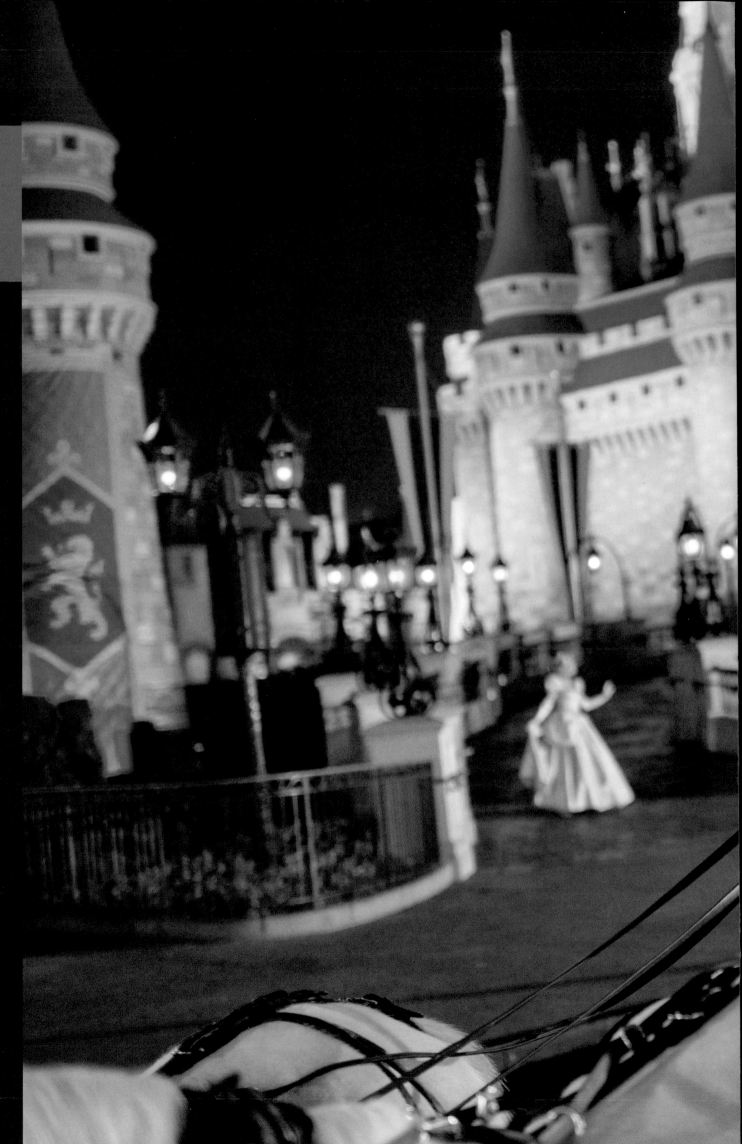

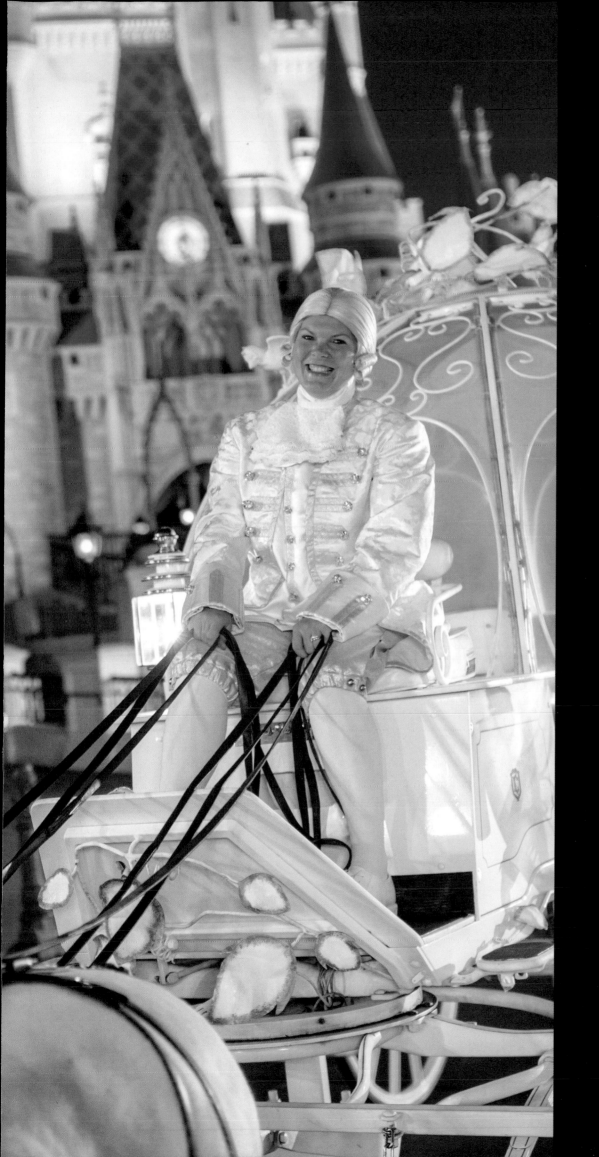

Stephanie Carroll went on her first pony ride at age five. She started cleaning out horse stalls at age eight. That was part of the deal when her mom let her buy her first horse, a colt named Chet. The mucking helped pay the quarter horse's boarding costs.

Now Stephanie is among the ranch hands who train, ride, and look after almost a hundred horses at Walt Disney World. After eight years, she can do all the roles associated with the Tri-Circle-D Ranch stables, from leading guests on trail rides and barn tours to driving the six-pony team that pulls Cinderella's Coach for Disney's Fairy Tale Weddings and for the holiday parades in the Magic Kingdom.

For most Fairy Tale Weddings, the royal coach picks up the bride at the Grand Floridian Resort & Spa, Stephanie says, while a few include wedding photos with the coach in front of Cinderella Castle at dawn, hours before Magic Kingdom opens.

Stephanie takes the elaborate wig and costume required to pilot the royal coach for Disney weddings and parades in stride. "I think it's awesome to be a part of history. It's a tradition that we're carrying on, and kids love it." So does she. "When you come down Main Street, U.S.A., and there are the ponies and Cinderella is there smiling—it's awesome," Stephanie says. "I get goose bumps."

It takes loving training to get horses ready to lead the coach through the crowded park. "To perform at Magic Kingdom they have to trust their driver, it's a bond of trust," she says. "Everything we do at Disney is big and exciting, so it's our job to make the horses comfortable, to keep them safe and to always put them in a fabulous light."

Each horse has a name, a personality, and a story. Stephanie is especially proud of Sherlock, as she played a role in bringing him to Walt Disney World. "He's gorgeous, and he knows he's pretty, but he didn't want anyone to catch him in the beginning." Stephanie won him over, and now he's a regular part of the coach team.

Some horses are born at Walt Disney World, including a foal named Lilly who arrived in spring 2019 and is "the start of a new generation of Cinderella ponies," Stephanie notes. "We're going to see her grow from just a few minutes old to doing her first Disney wedding and being a part of a bride's day."

The horses blossom much as Stephanie herself did, from equestrian school in West Virginia to her current position. As for Chet, her first horse, he's still part of the family. "My kids ride him now," she says with a laugh.

ROBIN ROBERTS

Hometown
Pass Christian, Mississippi, USA

Job
Coanchor, *Good Morning America*

Favorite Disney attraction
The monorail in Walt Disney World

If you roll over in bed some morning at 4:00 a.m. eastern time and glance at the clock before drifting back to sleep, give a quick thought to Robin Roberts. By that time she's been up for forty-five minutes and is halfway through her morning meditation. An hour later she's in her dressing room at *Good Morning America's* Times Square studio in New York. There she huddles with producers to prep that day's show while coworkers she calls the Glam Squad turn her self-proclaimed "hot mess" into the personable coanchor you see on ABC practically every weekday morning.

As former GMA cohost Charlie Gibson once told her, "'As a morning anchor, you're going to be invited to everything, but you're going to be too tired to go to anything.' It's true," Robin acknowledges.

Robin didn't set out to be a news anchor. In high school in Mississippi (where she played tennis) and college at Southeastern Louisiana University (where she played basketball), Robin dreamed of a career in sports. But, she says, "I knew I wasn't going to get paid as an athlete, but I could as a sports journalist." So she got a degree in communications—and a series of sports reporting gigs at television stations in Mississippi, and then in larger markets such as Nashville and Atlanta.

For her jump to ESPN, Robin thanks her late mother, Lucimarian Roberts, who "could work her children into a conversation in an elevator."

Robin's mom met Bob Iger, then a vice president at ABC, at a wedding in the late 1980s. "I don't know how she struck up a conversation with him, but he told her his position and she was like, 'Well, I have a daughter who's in television and she dreams one day of going to the network level,'" Robin recounts. Bob gave her his card, which Mom passed on to Robin. "I was, of course, mortified," Robin says, but the seed was planted. She joined ESPN in February 1990 and started contributing to GMA five years later. In 2005, she became the show's coanchor.

Her public struggle through two health crises—breast cancer in 2007 and a bone marrow cancer called myelodysplastic syndrome in 2012—brought her closer to many viewers, who seek her out after each morning show wraps at 9:00 a.m. "I stay behind to take pictures with our studio audience," Robin says. "Because I've shared so much about my health journey, they feel a bond. I love to spend time with them and hear their stories."

During both battles, her Disney family "rallied around me, from the top executives to the custodians at GMA," she remembers. Her experiences wound up contributing to what she sees as her mission on the show: to enlighten, inform, and entertain.

"Like my mama taught me, 'Make your mess your message.'"

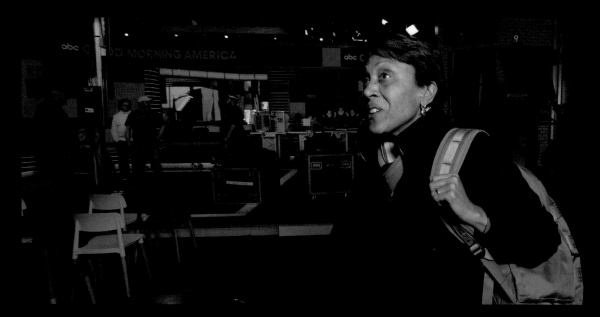

Robin Roberts arrives at ABC's Times Square studio to prepare for *Good Morning America* by 5:00 a.m. every morning she's on the air.

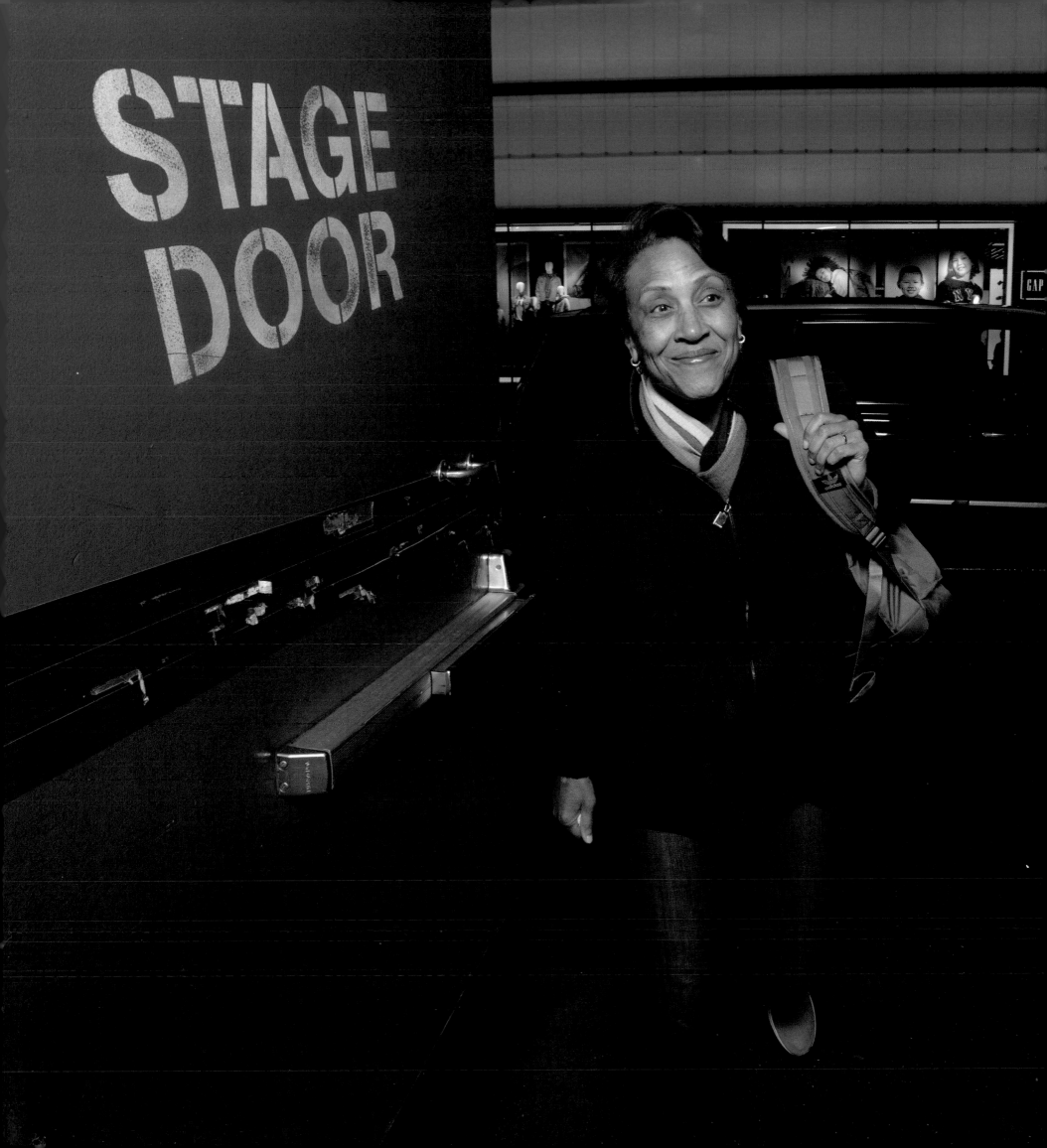

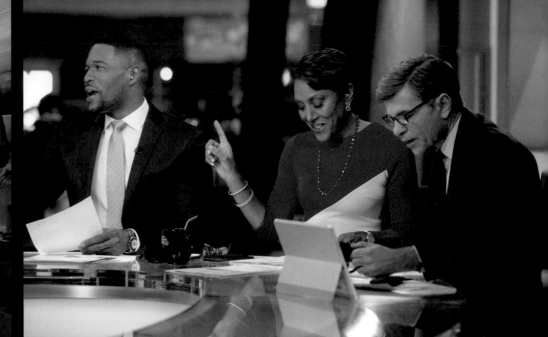

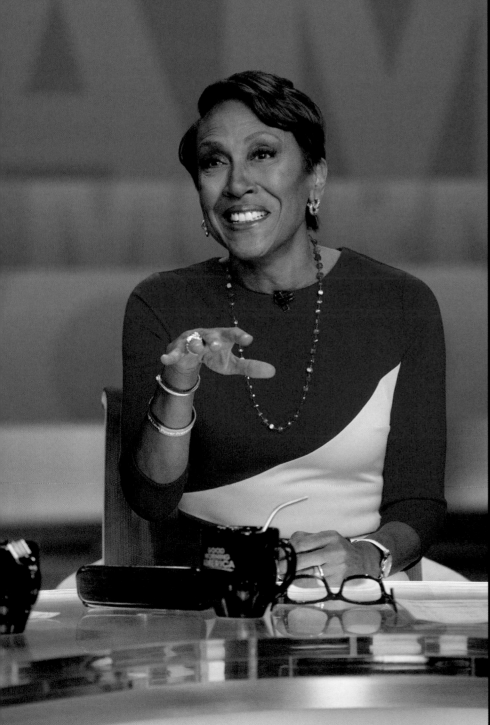

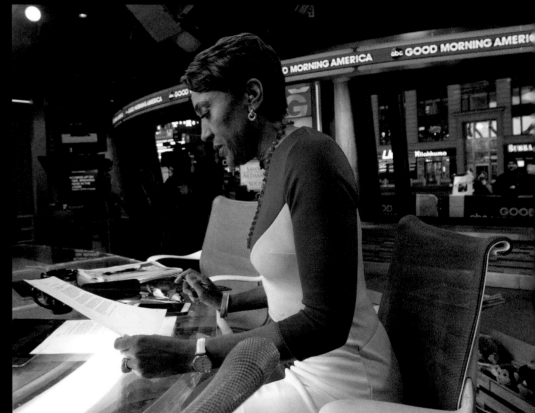

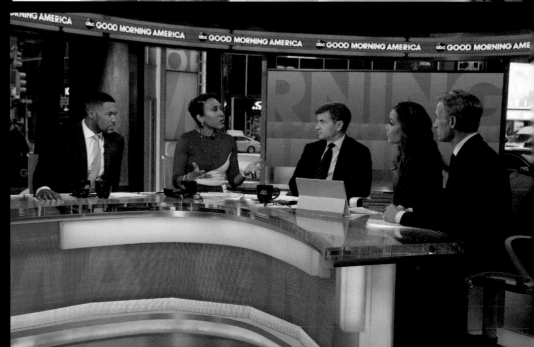

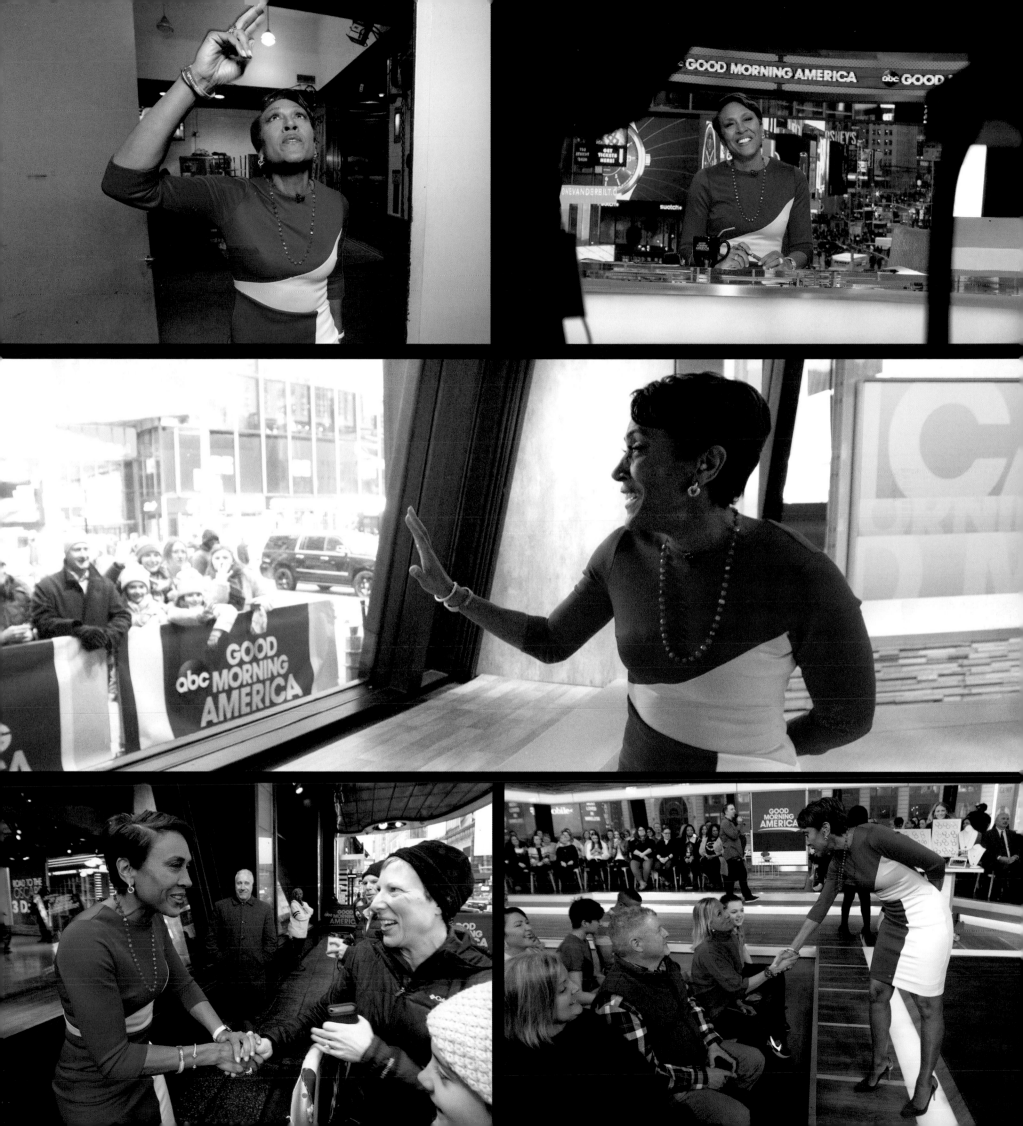

謝政廉
JUSTIN
Part of the Magic

JUSTIN TSE

Hometown
Hong Kong, China

Job
Area Manager,
Costuming and Walt
Disney Grand Theatre
Wardrobe Supervisor,
Shanghai Disney Resort

Favorite Disney movie
Pinocchio

Of all the Broadway-caliber dresses Justin Tse has handled in his career as a wardrobe supervisor, one stands out as the most beautiful: Belle's ball gown from Disney's *Beauty and the Beast*. "In the whole world, it is really quite unique," he says.

The stage musical opened in June 2018 at the Walt Disney Grand Theatre at the Shanghai Disney Resort, where Justin was the costume, hair, and makeup supervisor. The production, which has been staged by several of the original Broadway team, including costume designer Ann Hould-Ward, has just a single copy of the iconic dress, so it's meticulously inspected before and after each performance by Justin's team, who make sure its elaborate embroidery and beading remain pristine.

Tailoring the show's outfits to the Shanghai cast was not easy, he recalls. "The costumes are from New York, so they fit Western-size actors. Asian performers' body proportions are totally different. So we had to refit all the costumes to Asian women and men. That was quite challenging."

Justin was up for the effort, having previously supervised costumes on the Asian tours of Broadway shows including *The Sound of Music*, *The King and I*, and Rodgers and Hammerstein's *Cinderella* featuring Lea Salonga. He joined Disney five months in advance of the 2016 opening of the Shanghai resort.

Justin's first job out of art school was a three-month stint at Disneyland in his native Hong Kong. There he worked at Hong Kong's in-park *Lion King* show, where a supervisor dumped a headdress in his lap. "It was too heavy, so I took it apart and put it back together again to make it lighter." Fittingly, his first show at the Grand Theatre was *The Lion King*.

These days, Justin oversees thousands of outfits, as he was recently promoted to area manager, supervising costume operations for the entire Shanghai resort—all the cast members' uniforms except for the entertainment division. He continues as well as head of wardrobe at the Grand Theatre, where he makes sure to see *Beauty and the Beast* at least once a week.

"It touches my heart every time I hear the laughter and clapping from the audience. When the audience is happy, I am happy, too."

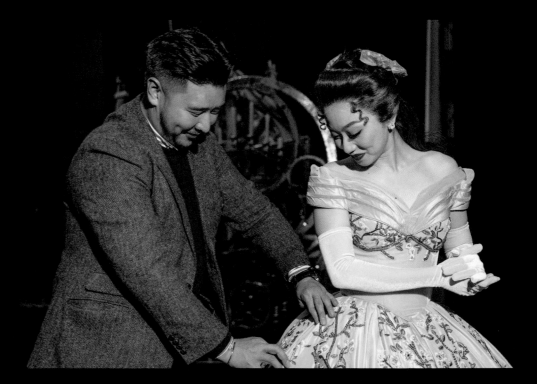

In his role as costume, hair, and makeup supervisor for the Mandarin production of Disney's Broadway musical of *Beauty and the Beast*, Justin Tse regularly inspects the costumes, making sure they're perfectly fitted to the performers, including Gloria Guo, who portrays Belle.

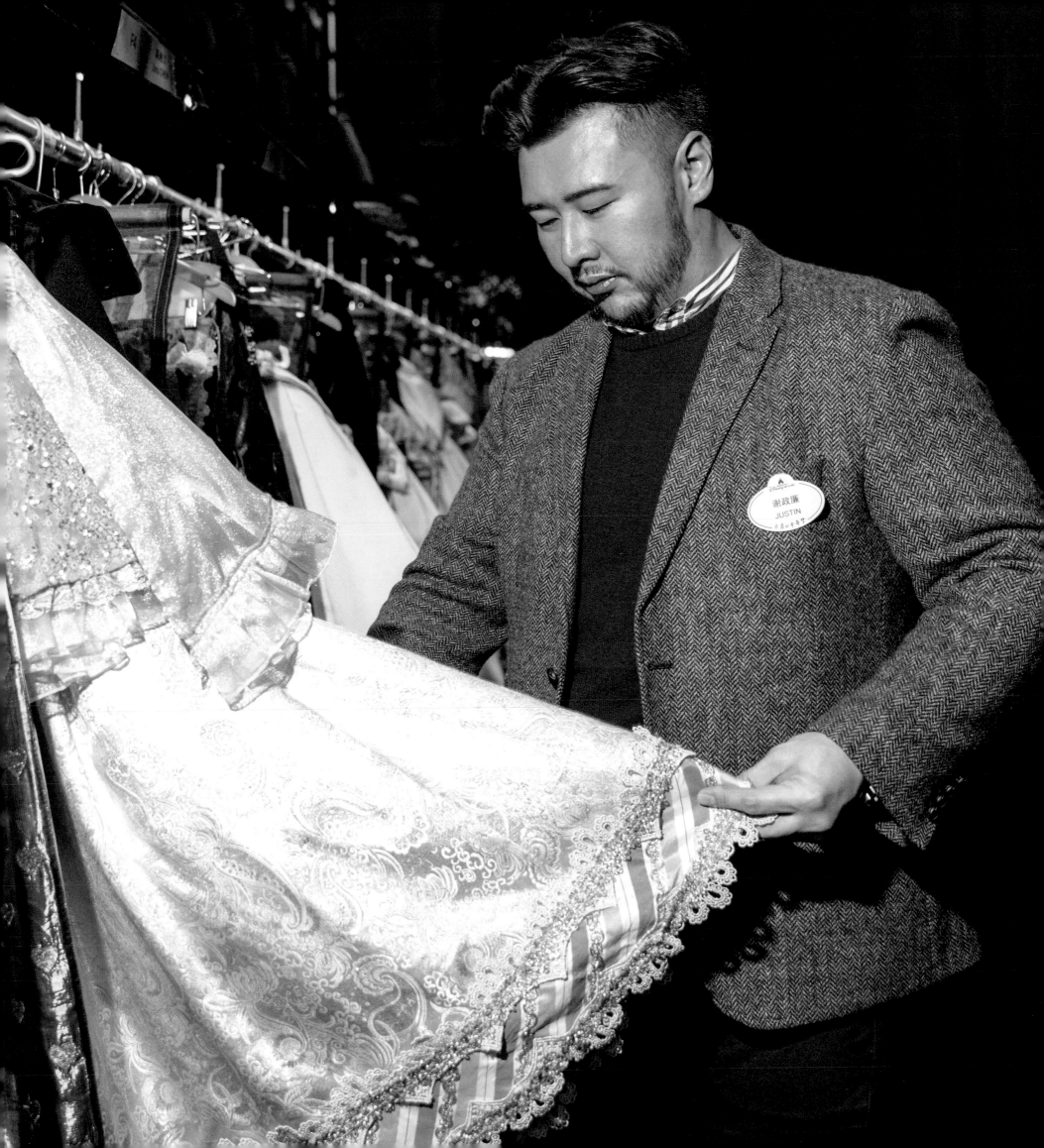

THOM
Part of the Magic

THOMAS SELF

Hometown
Broomfield, Colorado, USA

Job
Attraction Machinist, Disneyland

Favorite Disney movie
The Jungle Book (1967)

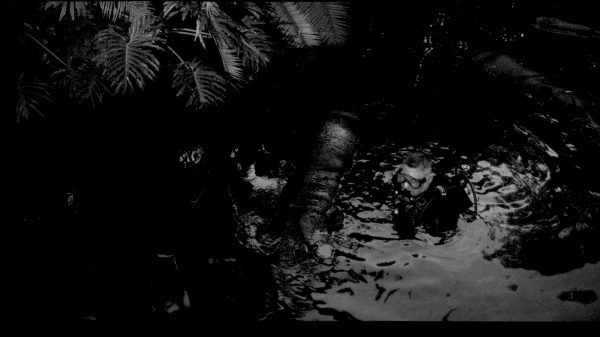

Thom Self is a machinist with a twist: Most of his work is done overnight and underwater on Disneyland attractions including the Jungle Cruise and the Rivers of America.

The average hippopotamus lives about forty to fifty years, but the hippos in the Jungle Cruise attraction at Disneyland are approaching sixty-five and haven't aged a day. That's thanks in part to a scuba-diving maintenance crew that inspects the attraction's boats, tracks, and other underwater mechanics every night after the park closes.

"You never know what might happen from one day to the next," says Thom Self, who has been diving for fourteen of his nineteen years as an attraction machinist. "With all the plant growth out there, palm fronds and branches can fall into the water all the time and can get caught up on the track or even interfere with one of the critters."

In addition to safeguarding hippos and elephants, Thom has worked on everything from the construction of Disney California Adventure in 2000 to the just-opened *Star Wars*: Galaxy's Edge, and he spent six months on a task force sent to China to get Hong Kong Disneyland open in 2005.

That's when he dove into a new adventure. "They needed people to work in the Jungle Cruise and other water attractions over there, and I said, 'Okay, I'll do it,'" he recalls. He had learned to dive recreationally during his ten years in the U.S. Navy, and in short order was certified as a rescue diver, courtesy of Disney. He now spends about half his time in the water during the 11 p.m. to 7 a.m. shift he's been working for nearly twenty years.

It's not Thom's first job at Disneyland. Fresh out of high school in Colorado, he moved to California and got a job cooking at the Plaza Inn on Main Street, U.S.A. He left for the U.S. Navy, where he served as an electromechanical technician on combat systems aboard the USS *Abraham Lincoln* all over the world.

Now he's mostly under the water rather than cruising on top of it, maintaining all Disneyland's water attractions with a crew of about a dozen full-time divers and another fifty or so trained backups, many of them on call during park hours—just in case. The team looks after the Rivers of America, Storybook Land, the Finding Nemo Submarine Voyage—even the moat in front of Sleeping Beauty Castle.

Now and then, a Jungle Cruise hippo will need more help than Thom can provide—a hide replacement, for instance. "Then they'll come out and go to the creature shop, where they are refurbished." Thom says. "Their skins may have changed or been upgraded, but they're still the same figures as when Walt Disney was here."

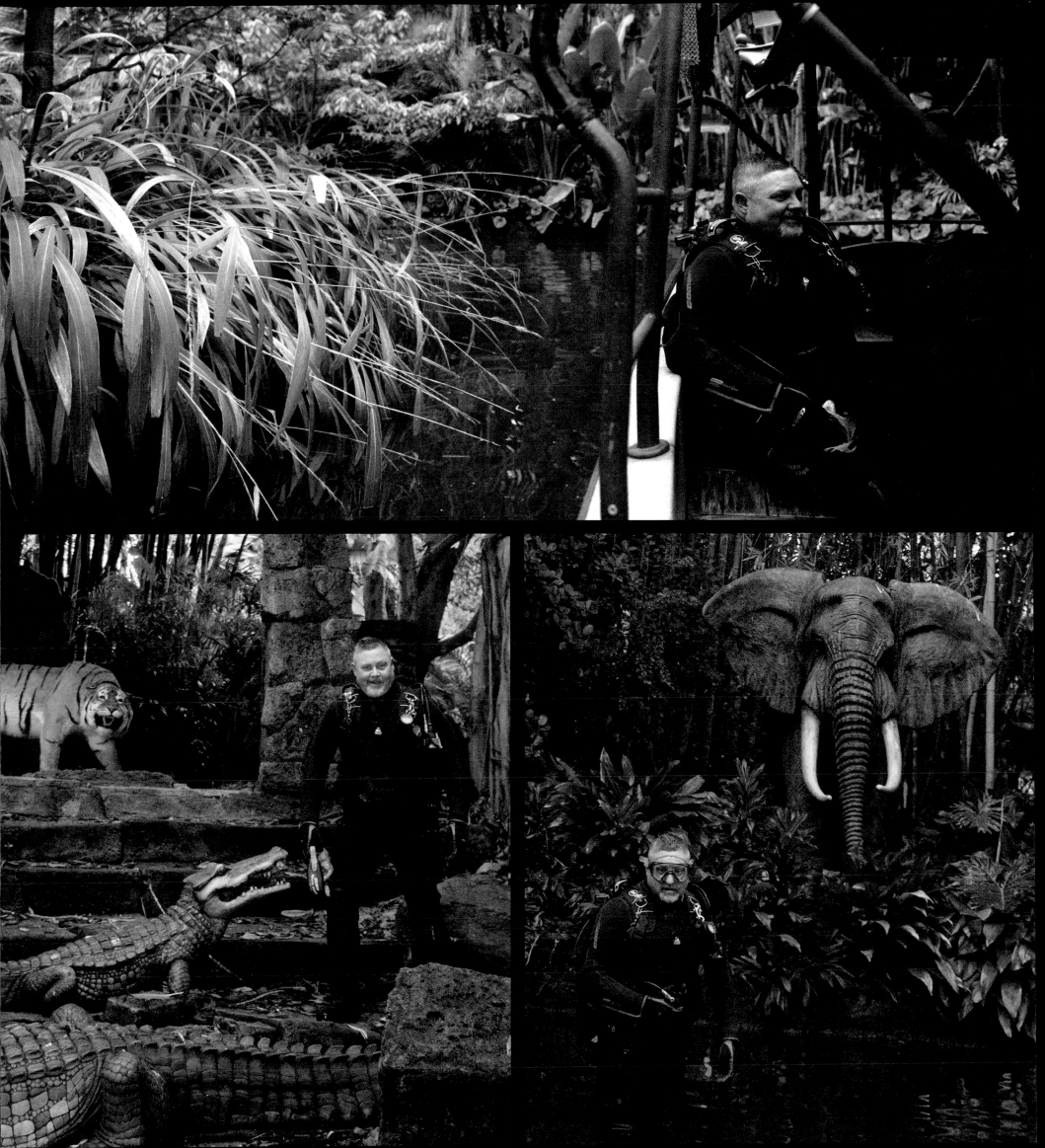

BILLY

Part of the Magic

PAVAN
KOMKAI

Hometown
New York, New York, USA

Job
Manager for Broadcast
Engineering, ESPN+

Favorite Disney movie
The Lion King (1994)

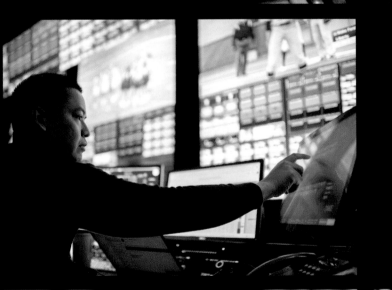

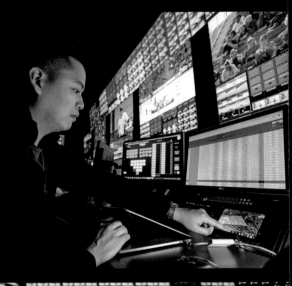

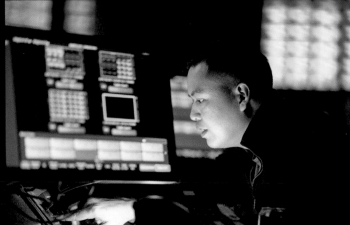

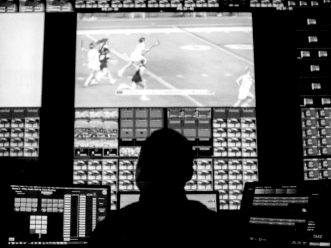

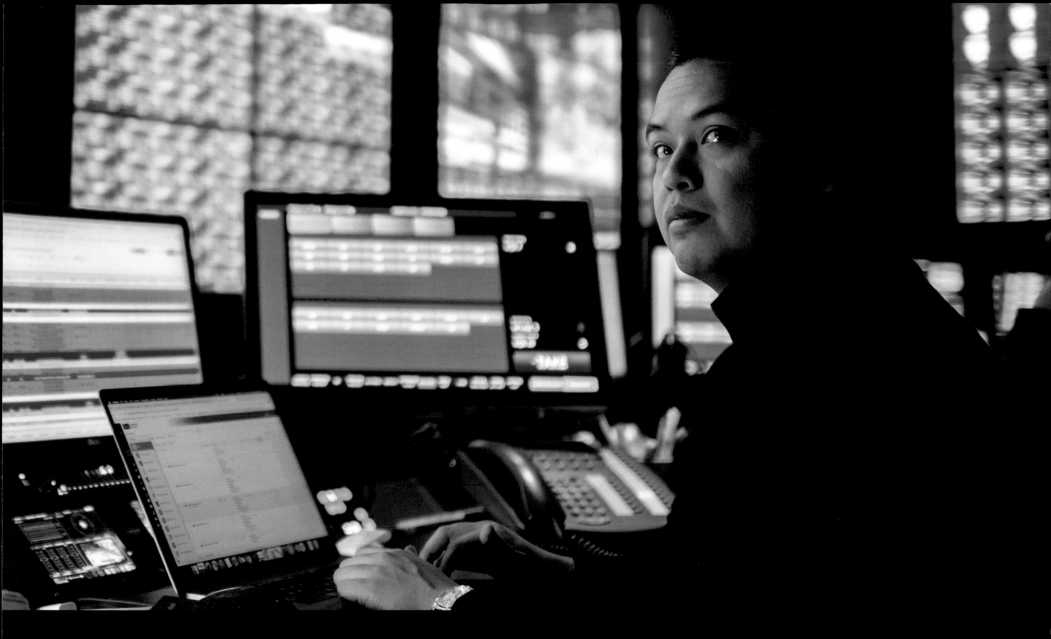

Live television has gone high-tech in the Transmission Operations Center in Manhattan, where Billy Komkai supervises the engineering of broadcast signals for Disney Streaming Services.

It may be opaquely named the Transmission Operations Center, but it's "where all of the magic begins" when it comes to streaming sports content, says Pavan "Billy" Komkai, the manager for broadcast engineering at the TOC (pronounced "tock," as in "ticktock").

Signals from arenas and stadiums and venues all over the world arrive at the TOC for Billy and his engineering team to polish and repackage and—instantly—send on to fans' phones, laptops, tablets, and televisions via ESPN+ and other Disney streaming services. The top priority? "Making sure the video looks clean and audio sounds great," so viewers can enjoy events without a hitch.

That includes team sports—like baseball and basketball, which Billy grew up playing in Manhattan—as well as golf, extreme sports, fights, and more. The audience can be massive: more than half a million new subscribers joined ESPN+ in advance of the Henry Cejudo versus TJ Dillashaw match on UFC Fight Night in early 2019.

Billy began his career with many years on the road, working as an engineer on remote television broadcasts, then jumped at the chance to work for Major League Baseball's MLB Advanced Media, or MLBAM. A subsidiary of that company, called BAMTech, then became part of The Walt Disney Company and is now Disney Streaming Services.

As thrilled as he was to be working for MLB, Billy says the move to Disney made him even more excited.

"What's rewarding about my job is knowing that all the hard work and engineering and planning across different teams comes together to present one single huge event streamed to millions of potential viewers," he adds. Oftentimes, he says, "my own friends tell me that they watched the show."

Billy tries not to take sides in team sports, though he does confess a lingering loyalty to the franchises he grew up with: "I am New York born and raised, so New York is my ticket."

The TOC team is fine with viewers not knowing much about what they do. "Just know we're working hard to make sure the quality of the game you're watching on ESPN+ is streamed to perfection," Billy says. "It takes quite a team effort, but giving fans the joy of watching their favorite team live from any device makes it worth it! Clicking on that app validates all their hard work. It takes quite a team." Just like a good baseball game.

Zhijun "Carlton" Fu

Hometown
Hunan, China

Job
Team Manager,
Attraction Engineering
Services,
Shanghai Disney Resort

Favorite Disney movie
The Lion King (1994)

When Shanghai Disneyland opened on June 16, 2016, it was Carlton Fu's day off. But since he had spent much of the previous year on the engineering team installing and testing attractions, he wasn't about to miss the opening. He headed to the park anyway.

He was in the maintenance room at the TRON Lightcycle Power Run attraction when he heard the sounds he'd been awaiting for months: "Excited screams and yelling from the passengers on the TRON Lightcycles," as he recalls. "It was proof that it was all worth it—all the effort, all the work. It was an important day for me."

Carlton is team manager for Attraction Engineering Services, leading the engineers and technicians who check and recheck the TRON Lightcycles every night after the park closes "to ensure safe, reliable, and smooth operation" the next day. Three team members are on call at all times during park hours in case any glitches arise.

He also leads the park's Attraction Reliability Project, an effort to keep problems from arising in the first place and to keep safety at the highest level. The project has already had several successes, upgrading parts and improving the dependability of the Seven Dwarfs Mine Train, Pirates of the Caribbean Battle for the Sunken Treasure, and other attractions.

Pirates is Carlton's favorite attraction in Shanghai, as its 4-D effects left him awestruck during test runs before the park opened. "It just took my breath away."

Carlton is up front about his "emotional attachment to Disney" from a childhood in Hunan province filled with Disney movies. As a boy, he was also fascinated by how things worked, taking apart and reassembling his toy trains and—under the supportive supervision of his father— the family's television remote control and electric fan.

He earned a degree in industrial engineering from the Civil Aviation University of China and spent eight years working in aircraft maintenance for FedEx before joining Disney. The work was not dissimilar to his job now: "Safety comes first, whether you're dealing with an airplane or a TRON Lightcycle."

What's different is Carlton's level of fulfillment. Every day, he says, "you see the thrill and excitement and happiness" of park guests disembarking from TRON. "A lot of them will do it again. And again. And again. I heard from a colleague that one guest rode TRON eight times in one day. I found that actually incredible."

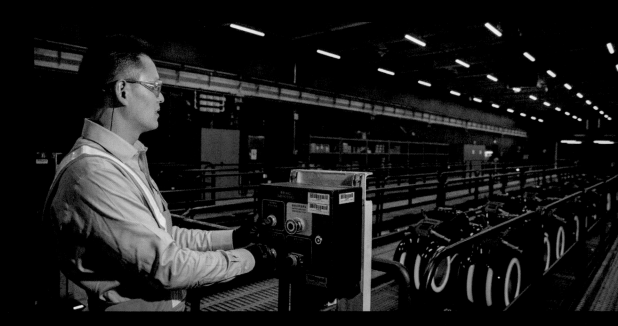

Carlton Fu's background in aviation engineering serves him well as he manages the engineering team that keeps the TRON Lightcycle Power Run zipping along.

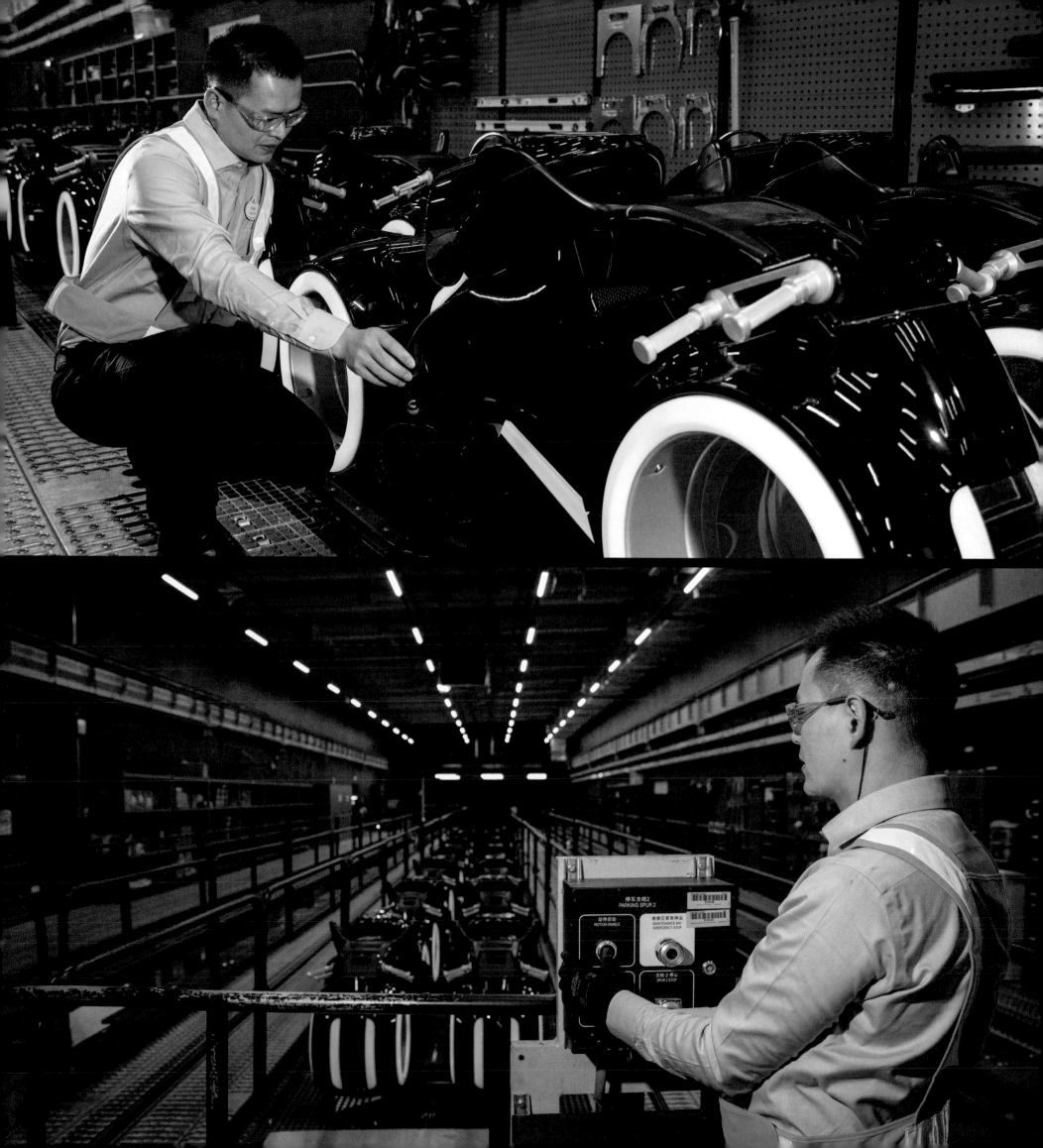

Chapter Two

3 am – 6 am

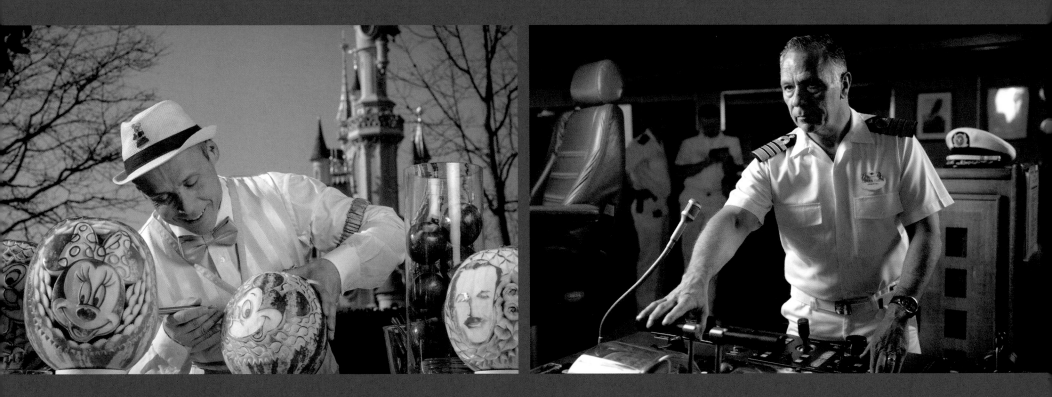

By early afternoon on a sunny day at Disneyland Paris, Cyril Soreau has drawn a rapt crowd for his fruit and vegetable sculpting demonstrations. At other Disney Parks and locales, however, throughout various time zones, some cast members are hoping guests will appreciate their work by *not* noticing it—and are going about their business without great fanfare.

Take Captain Fabian Dib. One of the most rewarding moments for the Disney Cruise Line captain, out sailing the Caribbean, is the smooth dawn docking, often in rough seas, he makes look almost routine. It's a difficult feat that still-sleeping passengers take for granted.

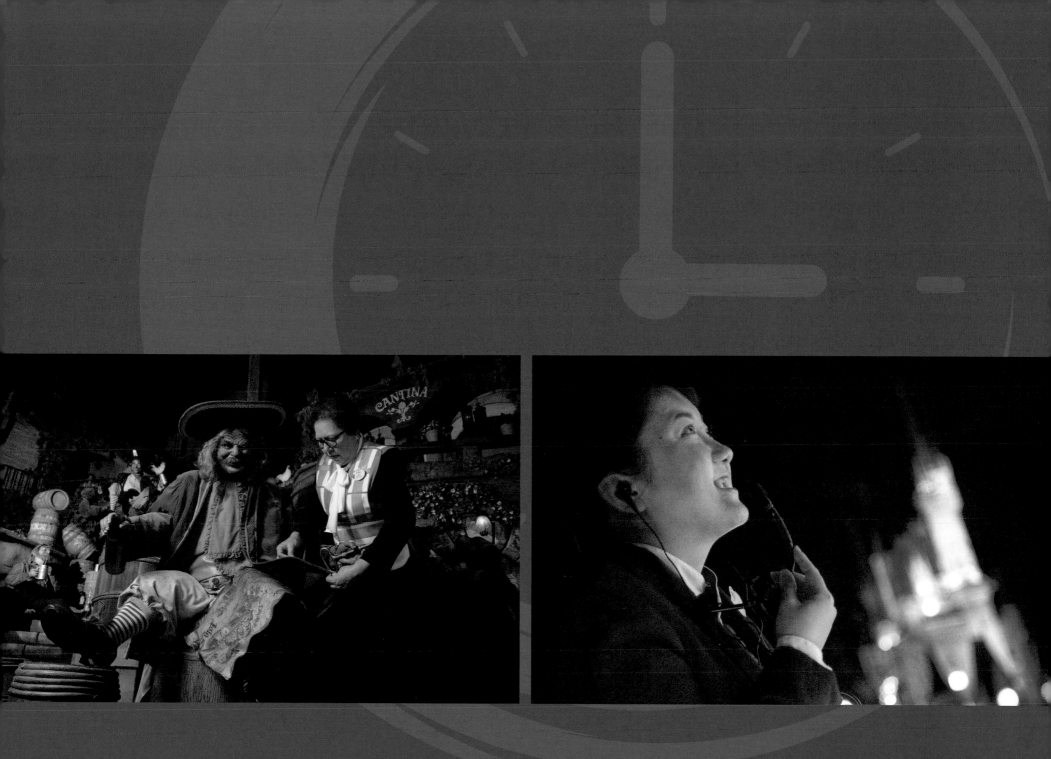

For Lupe de Santiago, working the wee hours at Disneyland in Anaheim to refresh the costumes used in Pirates of the Caribbean, the goal is to have the Audio-Animatronics figures look as if they haven't been touched since the attraction opened fifty-two years ago in 1967.

Like the Cheshire Cat in *Alice in Wonderland*, cast members such as parade stage manager Kae Namiki in Tokyo Disneyland hope to become invisible, with only smiles left behind.

CAPTAIN FABIAN
Part of the Magic

CAPTAIN FABIAN DIB

Hometown
Buenos Aires, Argentina

Job
Captain,
Disney Cruise Line

Favorite Disney movie
Pixar's *Ratatouille*

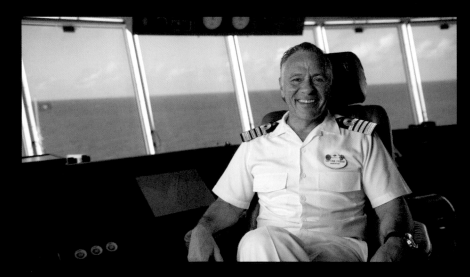

Captain Fabian Dib, seen here with the *Disney Magic*, loves bringing Disney Cruise Line passengers to Castaway Cay, where he gets some shore time.

Captain Fabian Dib has a special connection to the *Disney Magic*. After stints in the Argentine Navy and as an officer in the merchant marine and at smaller cruise companies, Captain Fabian was invited to join the Disney Cruise Line while the *Magic* was being built in Trieste, Italy, twenty-two years ago. At the time, he says, "I was single and twenty-nine. I said, 'Absolutely!' It was a fabulous opportunity."

Captain Fabian, then the safety officer, oversaw the ship's safety systems and evacuation procedures, including protocols for its unprecedented bright yellow lifeboats—the color of Mickey Mouse's shoes—which required special permission from the U.S. Coast Guard. (Orange was the regulation color.)

By 2009, when the *Disney Fantasy* was being planned, he was a ship's captain and once again part of the design team. Actually walking the corridors of a ship he'd seen only in his head for three years was "a unique experience." The only feeling better than watching that ship launch in 2012, he says, was fatherhood.

Each ship is a floating United Nations, with about sixty different nationalities represented in the crew. Captain Fabian speaks English, Spanish, and Italian fluently and can get along okay in Swedish (his wife's language). He spends at least an hour or two every day in the ship's public areas, mingling with the guests. Mostly what he hears, he says, is that "they just absolutely love what we do."

The last day or two of a cruise are Captain Fabian's favorites. One reason is that a visit to Disney's Castaway Cay is often on the itinerary. "It's one of my favorite places," he adds—because it's where he can shed his uniform and go for a run on the beach incognito in shorts and sunglasses. And the last day on board is when "all the guests are in the best mood, and we can feel that everything went fine. That's when I can relax a little."

Other than his brief respite on Castaway Cay, Captain Fabian doesn't get time off when he's working. It's ten weeks on duty, then ten weeks off, when he heads home to Sweden to be with his wife and daughter. "When I'm off, I'm completely off," he says. "Another captain takes over completely. They don't call you and ask, 'Hey, should I go to starboard or port?'"

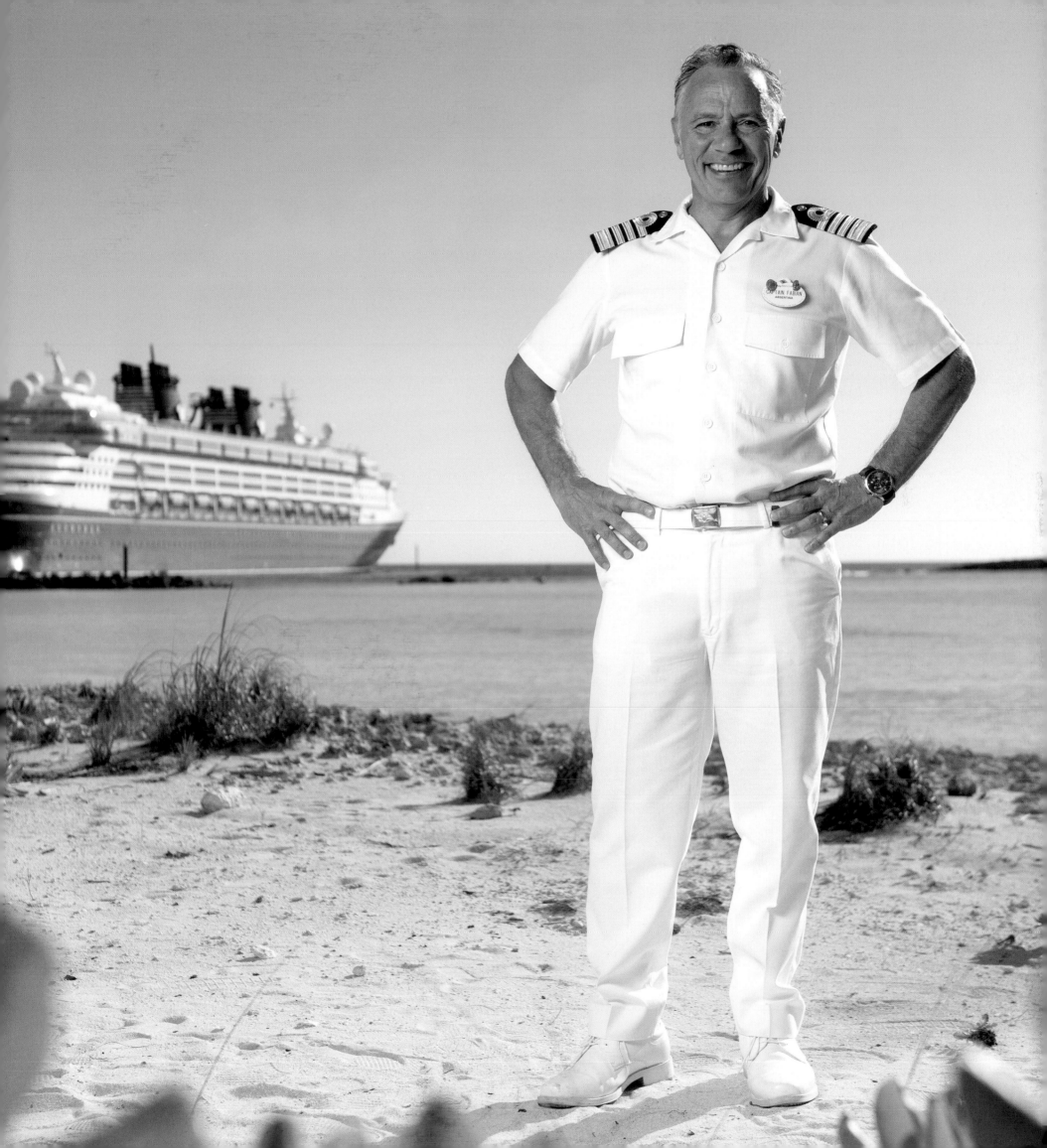

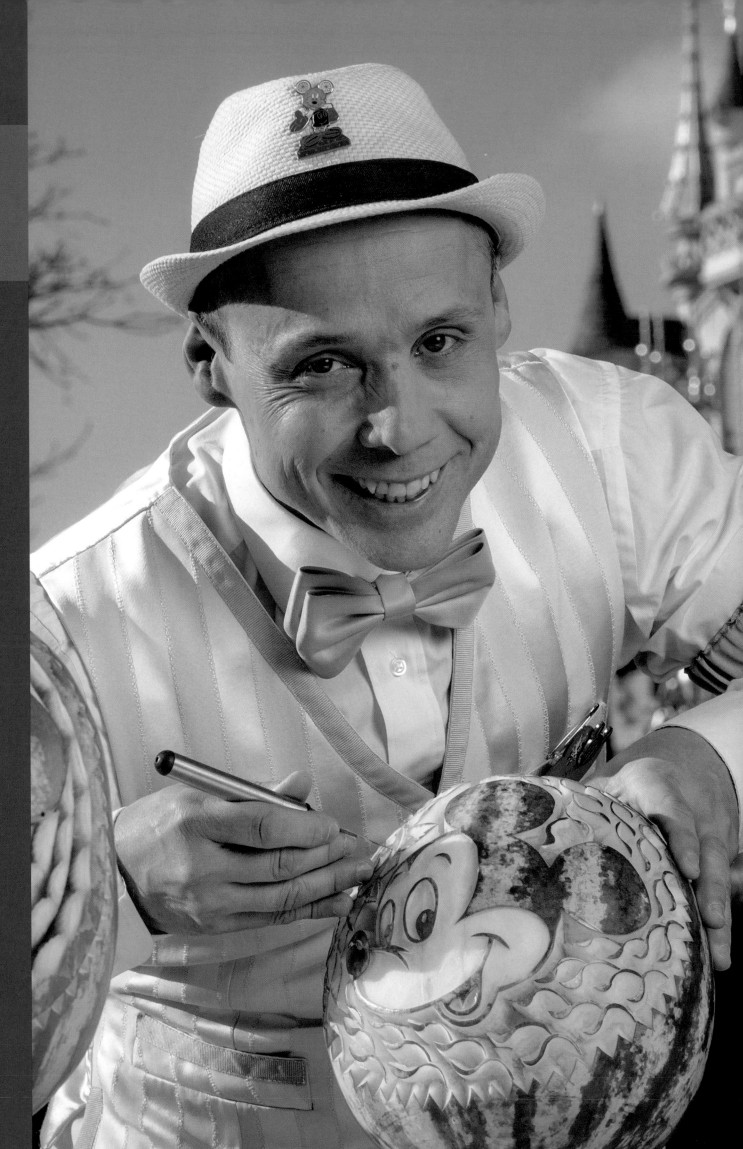

CYRIL
Part of the Magic

CYRIL SOREAU

Hometown
Athis-Mons, France

Job
Fruit and Vegetable
Sculptor, Disneyland Paris

Favorite Disney movie
The Lion King (1994)

Cyril Soreau may be the only Disney cast member in the world who used his artistic skills to carve out a one-of-a-kind job for himself. Literally.

Now a full-time fruit and vegetable sculptor at Disneyland Paris, Cyril started as an apprentice cook on the food and beverage team at age nineteen. He loved food, but he also loved drawing, and he decided to combine his obsessions.

He started by making simple fruit carvings for VIP guests at the Disneyland Hotel, where he was by then on the room service team. That soon grew into more elaborate decorations—Disney characters taking shape on the rind of a melon as Cyril's expert cuts exposed the layers beneath the surface to serve as vivid background colors.

Guests loved it, and Disneyland management took notice. Seven years ago, Cyril became Disney's first full-time sculptor of fruits (mostly watermelons) and vegetables (mostly pumpkins). Now he can usually be found near Sleeping Beauty Castle, carving produce and talking with guests.

"The three questions they ask the most often are: How long does it take to do a sculpture? Can I buy one? And can we take your picture?" he says. The answers are: About two and half hours. No, you can't. And *mais oui!* (But of course!)

The sculptures aren't for sale—many are used as decorations at restaurants and special events—but Cyril keeps a supply of apples on hand and can quickly carve a flower or initial on one side for a child to take along, no charge.

He also uses children's fascination with his work to encourage them to eat five servings of fruits and vegetables a day. He'll take out an unappealing piece of turnip and sculpt it into something fun, "and the kids will eat it right in front of me."

Cyril has been drawing since he was a child himself. "My whole family was artistic," he says. They lived in Torcy, just twelve kilometers west of where Disneyland Paris was being built while Cyril was a boy, wishing he could work there.

Cyril's carving was originally inspired by fruit artists in Thailand whose work he saw online. Now his art is inspiring others, as a young culinary cast member has taken up produce carving at the Disneyland Hotel. Whether she'll follow in Cyril's footsteps, time will tell, hinging on whether she has not just skill but the two qualities Cyril says keep him going: "Passion. And patience."

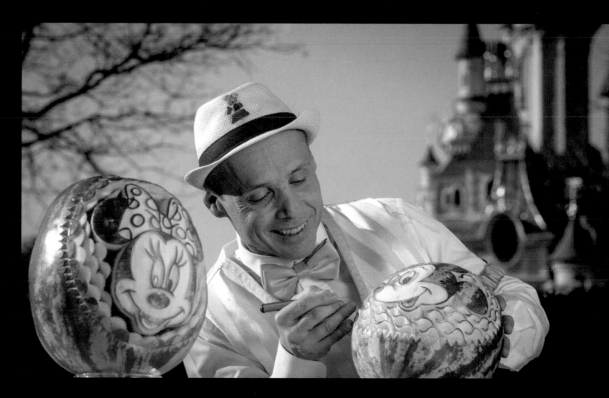

Most days in Disneyland Paris, Cyril Soreau can be found near Sleeping Beauty Castle, turning watermelons into unique works of Disney character art.

LUPE DE SANTIAGO

Hometown
Jalisco, Mexico

Job
Audio-Animatronics
Special Projects Lead

Favorite Disney movie
Pinocchio

It's not easy dressing a pirate. Especially an Audio-Animatronics pirate at the Pirates of the Caribbean attraction at Disneyland. "We cannot say, 'Put your arm this way. Put your leg up,'" notes Lupe de Santiago, the costume lead for the park's Audio-Animatronics figures.

The solution may surprise guests who marvel at the costumes' authenticity. "Everything has to go on with Velcro, and we have to hide it," Lupe says.

The costumes in Pirates of the Caribbean, Splash Mountain, and "it's a small world" may be identical to the ones worn when the attractions opened decades ago, but don't think you're seeing the original outfits—or even the fiftieth outfits. Despite a layer of "body protectors" between the mechanics and the fabrics, costumes on endlessly moving figures wear out quickly and are replaced every four to six months, which keeps a well-staffed sewing room busy year-round.

"The more they move, the more the costumes get damaged," Lupe says.

Growing up in Mexico, Lupe started sewing at age fourteen. She knew she wanted to work at Disneyland from her first visit there with her grandmother. "I told my grandma, 'I want to work here.' She asked me, 'Doing what?'" she recalls. "So I looked and I looked, and I said, 'There's a lot of costumes. At least I can sew buttons.'"

In her thirty years at the park, Lupe has done much, much more. She first worked part-time on outfits for the parades before taking a full-time job with the Audio team, beginning work between 4 and 6 a.m. every day.

She has since worked on the Audio-Animatronics figures in various attractions at Disneyland, including one of Walt Disney's personal favorites, Great Moments with Mr. Lincoln. About her first time meeting the sixteenth president, Lupe says, "I was so scared, because that face is so real. I thought he was going to stand up and ask me, 'What are you doing?'"

She still visits the park on occasion as a guest, as do her now grown children. "I can't just relax and enjoy the rides—I'm always examining everything," she notes. "My kids have inherited that. One day my son came to the park and he went on Indiana Jones. The next day when I woke up, he'd left me a note on top of the table: 'Mom, the last Indy costume is dirty.' And he was right."

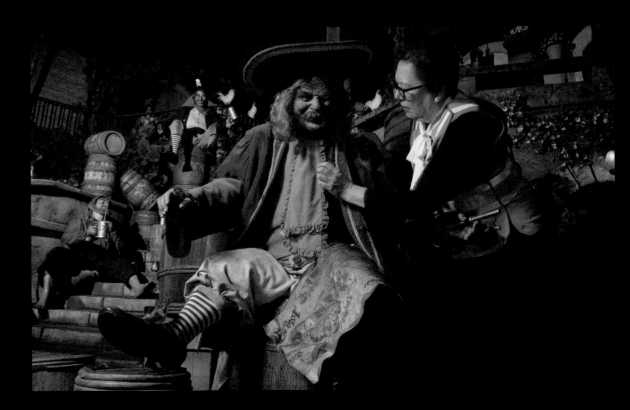

Before Disneyland opens to guests in the morning, Lupe de Santiago mingles with the Pirates of the Caribbean keeping their costumes as fresh as they were when the attraction opened.

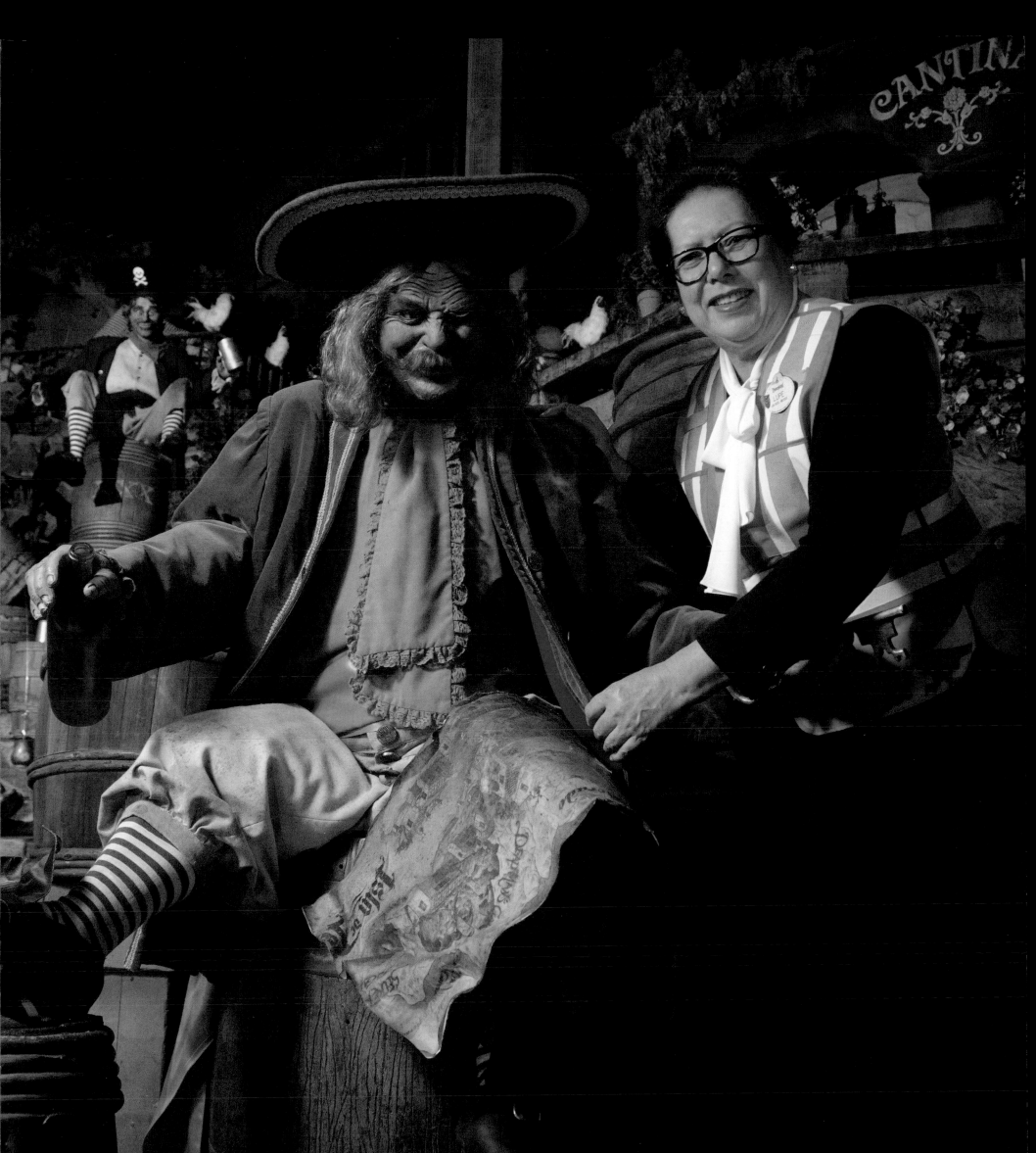

MANON

Part of the Magic

MANON TEISSIER DU CROS

Hometown
Paris, France

Job
Pastry Chef at Walt's—
An American Restaurant,
Disneyland Paris

Favorite Disney movie
Beauty and the Beast
(1991)

The most popular dessert at Walt's–An American Restaurant in Disneyland Paris is American indeed: pineapple upside-down cake.

"It's a recipe based on Walt Disney's favorite dessert," explains pastry chef Manon Teissier du Cros. "This is the only place in France where you can find it."

Manon has been at Walt's since before she even graduated from cooking school in Paris. She worked there on weekends as a student "and they put me right away into the pastry position." She impressed the chef de cuisine enough that she was hired on full time as soon as she graduated.

That was ten years ago. Now she's in charge of all the restaurant's desserts, including such French-inflected American favorites as meringue pie made with yuzu (a close cousin to the lemon) and apple cobbler (featuring Montélimar nougat crumbs suffused with Jim Beam). In development is a cheesecake with honey and black sesame. Head chef Ludovic Mallac, Manon's beloved mentor, "gives me complete freedom when it comes to adding desserts to the menu," she says.

But among the restaurant's current choices, Manon confesses, "My favorite to make is the lemon pie. It takes me back to my childhood. My mother made a beautiful lemon pie."

Mom was a chef de cuisine in Lyon, in southern France, and got her daughter started in the kitchen by the time she was eight. Manon immediately gravitated to desserts and recalls her first solo triumph being a chocolate lava cake. "The outside was very firm and the inside was very soft, so it was perfect. I was very proud of myself." She was nine years old. (Okay, maybe ten.)

The family tradition continues as Manon now bakes at home with her four-year-old daughter. "We are currently making easy desserts—mostly crepes and sponge cakes with yogurt."

At Walt's, the flavors are more complex, such as a sorbet with basil and pineapple that often has guests asking to meet the chef. "The best compliment I get is when guests tell me that they like it so much that they want to make it at home," Manon says. The recipe is a secret, but she's always happy to share tips on sorbet making.

Manon has just begun her culinary career, but she's found her home in the pastry kitchen. "I definitely prefer baking," she says, "because the guests always remember what they had last in a meal, which is the dessert."

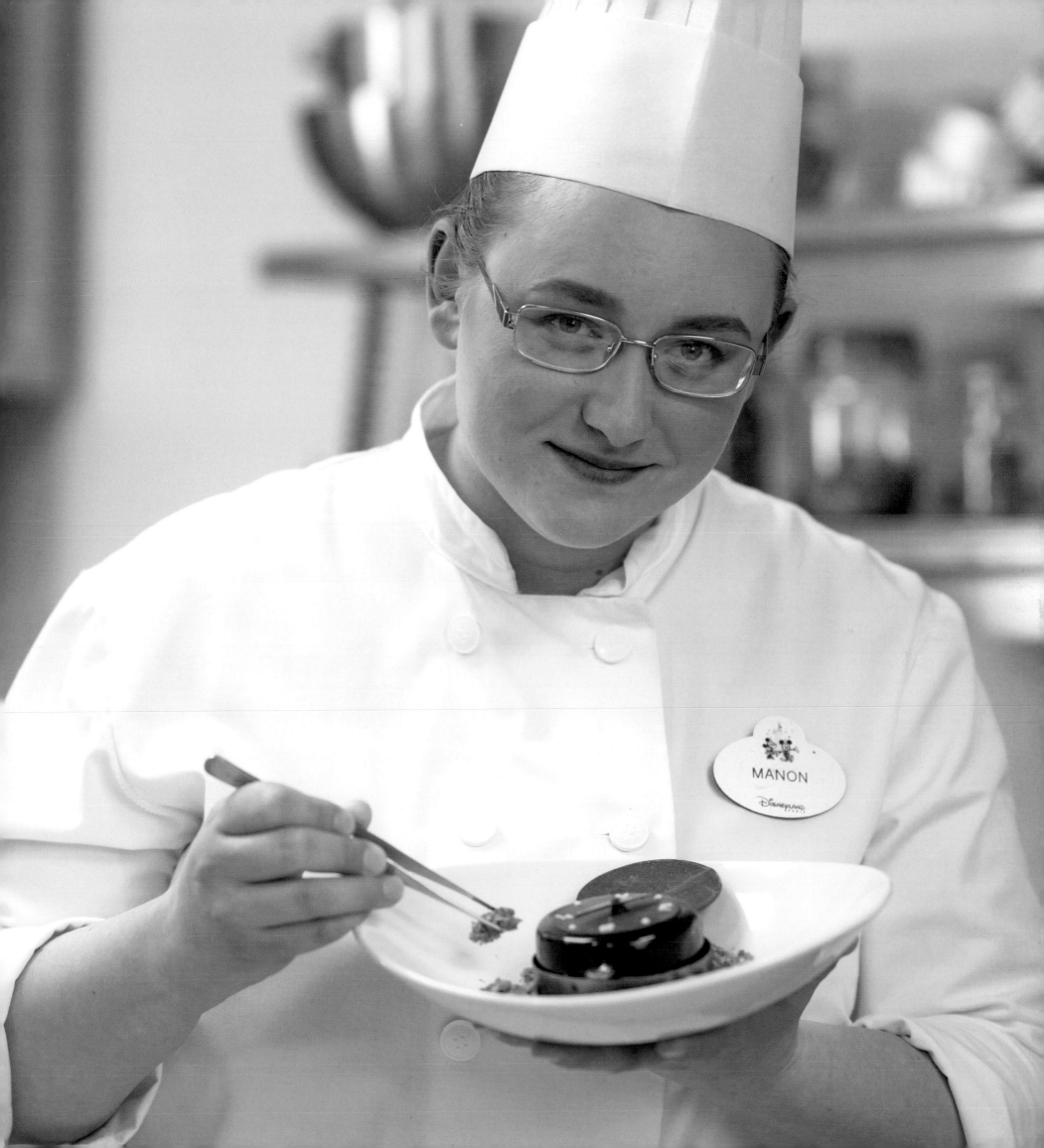

KAE NAMIKI

NAMIKI

Part of the Magic

Hometown
Osaka, Japan

Job
Stage Manager,
Show Operations Group,
Tokyo Disneyland

Favorite Disney attraction
Cars Land at Disney
California Adventure

The costumes weren't ready. The floats weren't finished. It was three months before the Dreaming Up! parade was due to debut at Tokyo Disneyland in the spring of 2018, and there was a lot of work to be done.

That was when Kae Namiki, one of the parade's stage managers, got involved, helping work out the logistics of the parade's route, timing, and crowd control while performers rehearsed in a gymnasium-like facility backstage at Tokyo Disneyland.

Once the choreography and floats were complete, the last step, Kae says, was "a real run-through, early in the morning, before the park opened." That was the first time the event's two hundred performers, float drivers, costume personnel, and guide staff all worked together to test out the show on its actual route.

When the parade debuted on April 15, Kae was among the last to know whether the guests were enjoying the cavalcade. "The float that I'm in charge of is Mary Poppins, Peter Pan, and Wendy, and it's one of the last ones, so I couldn't see how guests were reacting."

Finally, her float entered the "onstage area," as cast members call it, and Kae saw "some of the guests had tears in their eyes, so I could tell the parade moved them emotionally." The months of rehearsal had been well spent.

The same might be said of Kae's twelve years on the parade team at Tokyo Disneyland, starting on a hectic first day not long after she graduated high school. It was trial by fire—working crowd control during spring break, when the park was especially busy. She got through it, but she was so overwhelmed she barely remembers how.

Now she's calm and collected as she walks along beside her assigned float, keeping things on schedule and ready to handle any problem that arises. It's her job, she says, "to ensure a beautiful parade while we are the invisible ones."

Kae usually starts work just before lunch, stage managing two parades a day—or up to four during special celebrations—including the Tokyo Disneyland Electrical Parade in the evening. In between shows are briefings, problem-solving, and careful monitoring of the parade route and the weather.

Her favorite time of day is at the close of each procession. "As the parade ends, we have to go through this large wooden gate at a set time. When we go through on time and can close the gate after a smooth performance, I feel extremely happy."

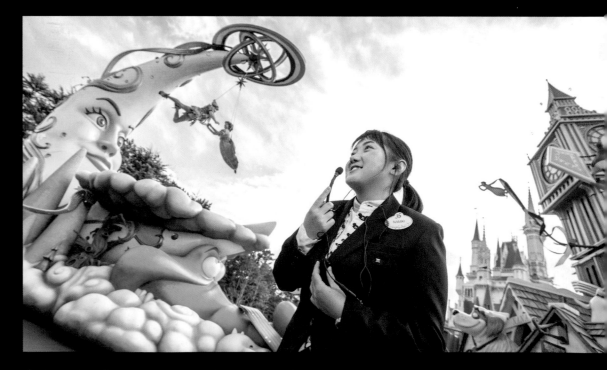

On busy days, Kae Namiki may work as many as four parades, including the daytime Dreaming Up! procession and the evening Tokyo Disneyland Electrical Parade.

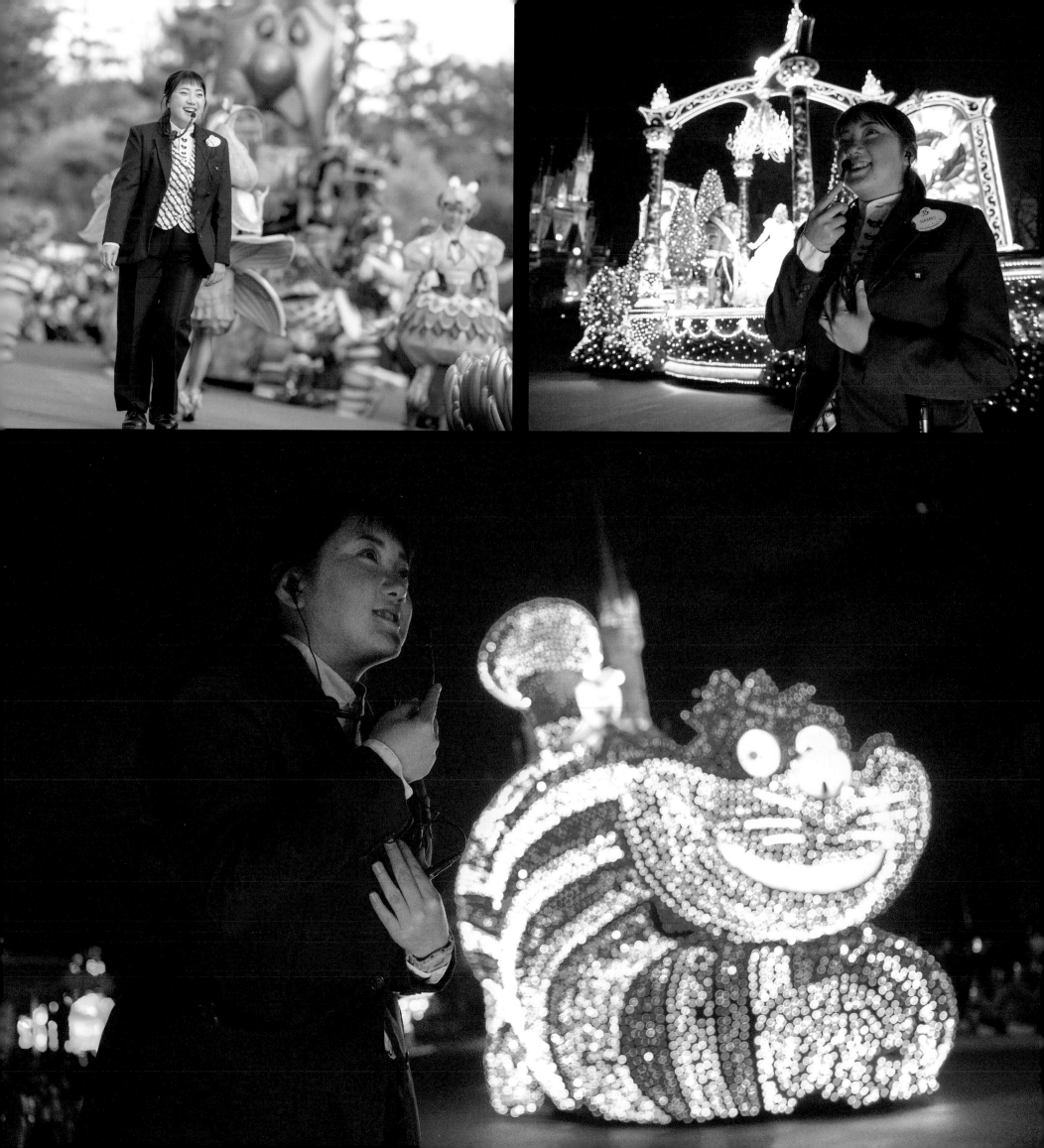

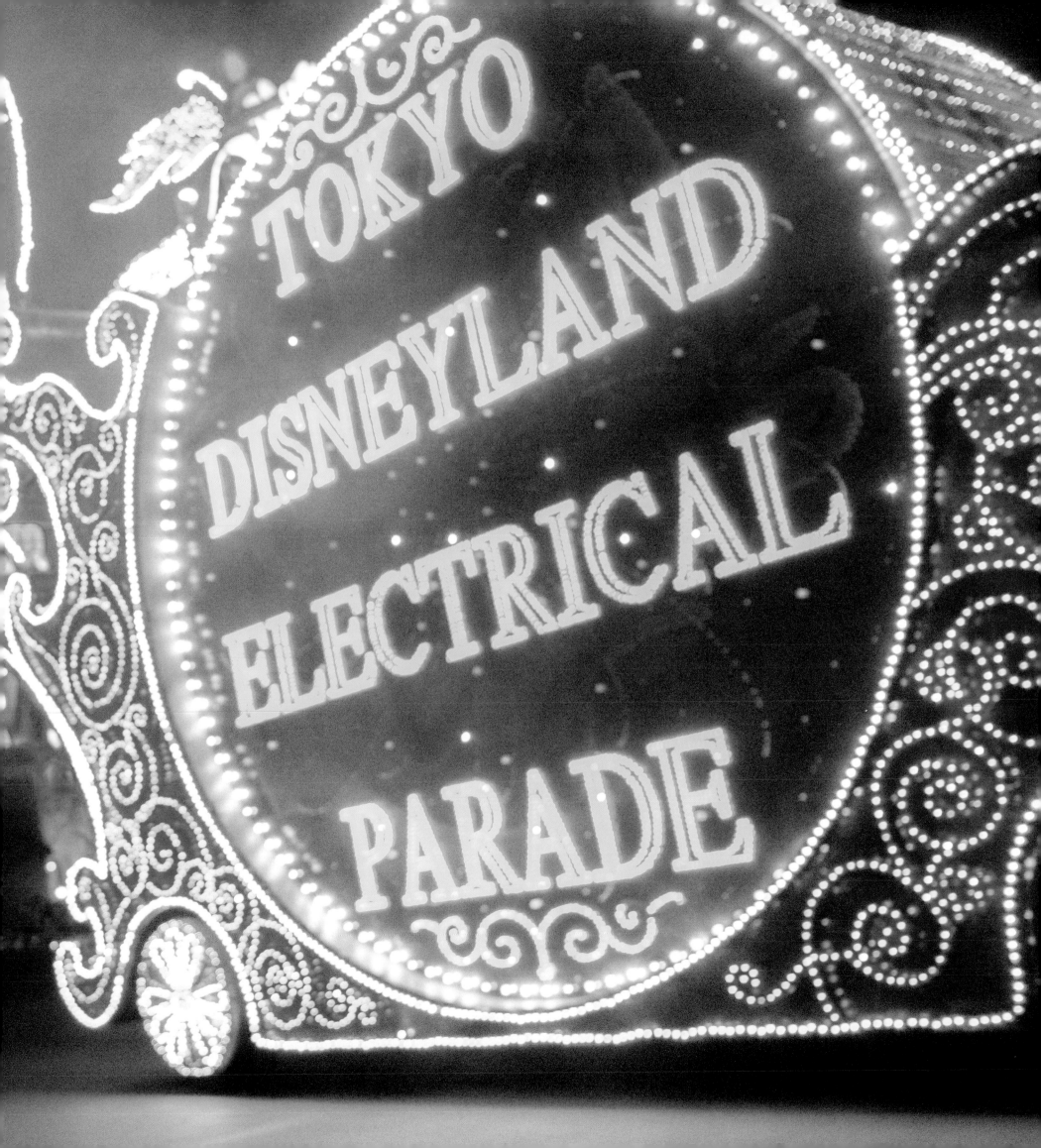

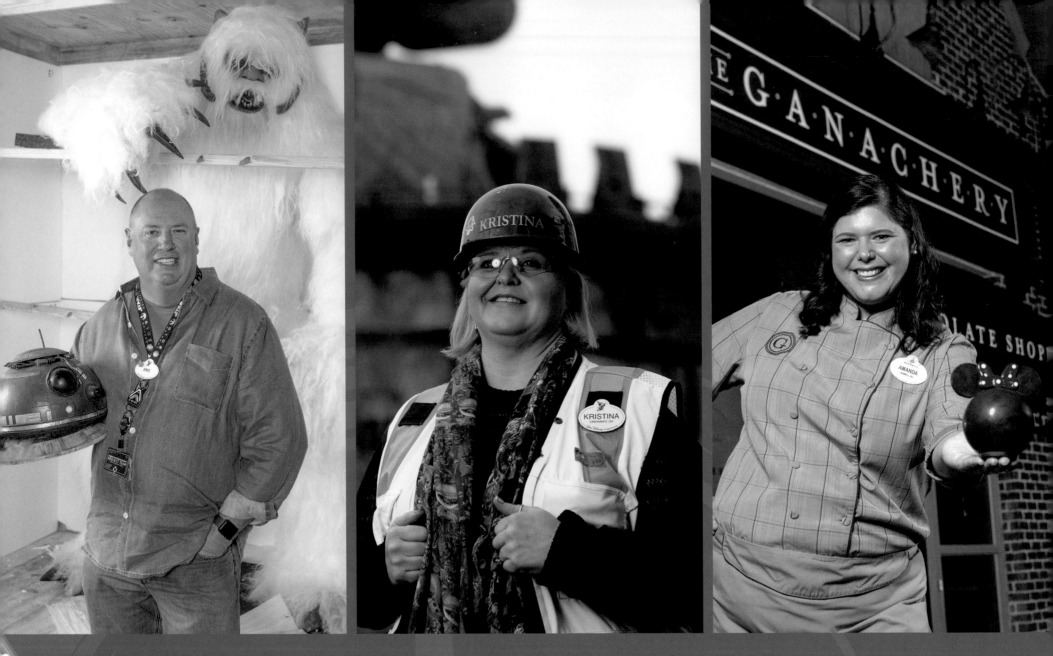

Chapter Three

6 am – 9 am

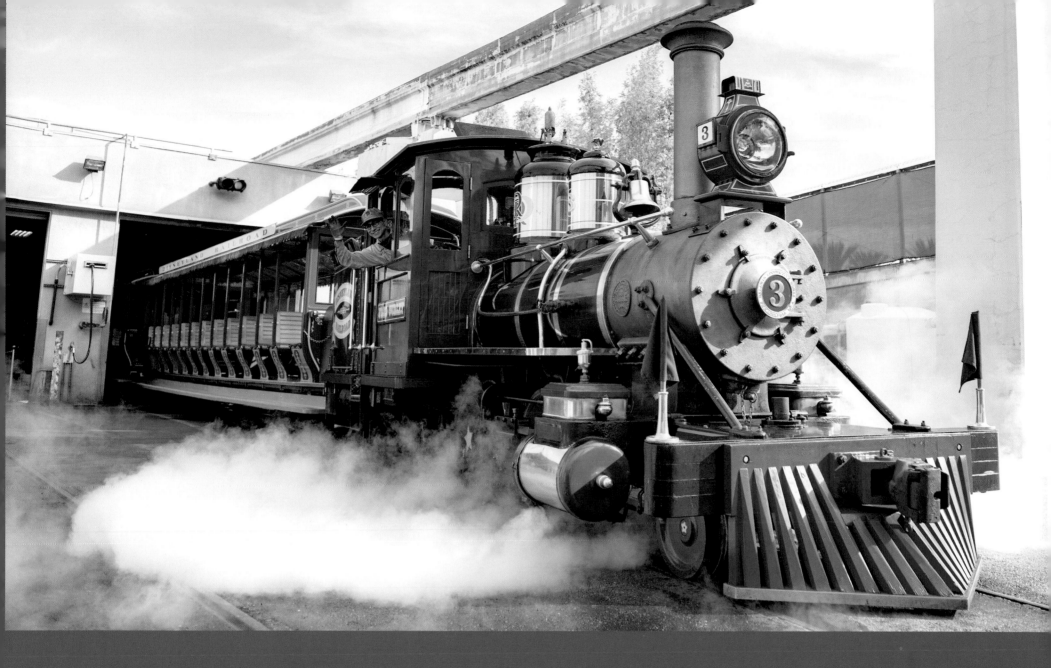

One day at Disney, the planets align. They hang in the sky as dawn slides gradually across the globe: Venus, Jupiter, and Saturn are just above the horizon, forming a virtual arrow pointing to the future.

Beneath their brilliance just before sunrise at Walt Disney World, Amanda Lauder is already busy making chocolate out in Disney Springs. When the glow from the aligned planets reaches California, Mark Gonzales can be found prepping the Disneyland Railroad for another day of grand circle tours around the park.

Another place—one far, far away—is on the minds of props wizard Eric Baker and construction manager Kristina Dewberry: it's Batuu, the remote world that's the setting for Galaxy's Edge in both Disneyland and Walt Disney World.

Disney Parks magic was already global. Now it's interplanetary.

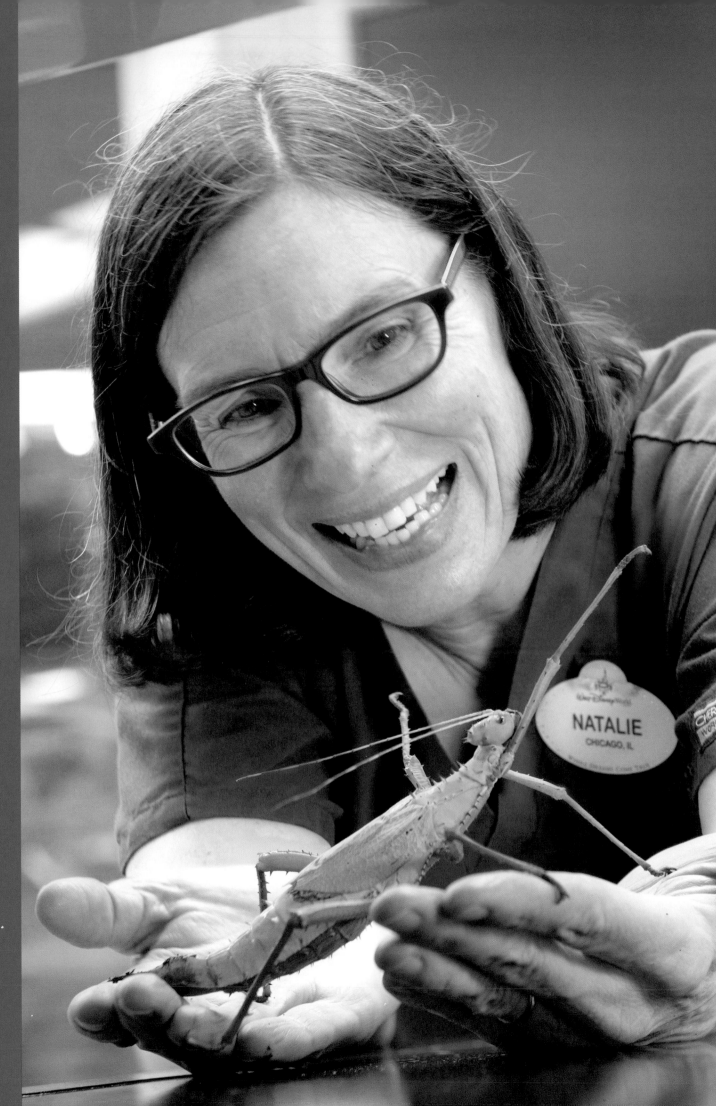

NATALIE
Part of the Magic

NATALIE D. MYLNICZENKO

Hometown
Chicago, Illinois, USA

Job
Veterinarian,
Disney's Animals, Science,
and Environment

Favorite Disney movies
Tangled and *Moana*

In the morning, Dr. Natalie Mylniczenko performed an ultrasound on Jao the rhinoceros. This was a Thursday, and the doctor would be doing her weekly echocardiograms on the gorillas after lunch, when they come in from their habitat for an afternoon break. The gorillas were always easy patients, trained by their keepers to hold the probe to their own chests.

Then there was the cow-nosed ray from The Seas with Nemo & Friends at Epcot, who needed to be brought over to the veterinary facilities at Conservation Station at Disney's Animal Kingdom for a CT scan. Natalie and her team were still working on the logistics for that visit.

The backstage veterinary hospital is a state-of-the-art facility with an impressive array of high-tech medical equipment. Along one wall of the hospital sits a stack of bins on carts filled with everything needed to treat patients in the field: catheters, bandages, medicine, and so on, "so all we have to do is wheel it up to our mobile veterinary unit and go," Natalie explains. "I can do pretty much anything I do in here outside." The medical kits are taken out almost every day for various check-ups throughout the park. Many animals—hippos, giraffes, and "hoofstock," for instance—always get house calls.

The six clinical veterinarians on staff are "specialists at being generalists," as Natalie puts it, schooled in what is called "exotic" animal medicine but is just the everyday agenda at Disney's Animal Kingdom. "One of the things I really love about Disney is that we do zoo work as well as aquarium work,

which is very appealing for somebody who has wide interests," Natalie emphasizes.

Natalie developed her wide-ranging love for animal care growing up in Chicago, "inviting" over local frogs for afternoon stays in her dollhouse and, as a tween, rescuing a tiny snapping turtle. (More than thirty years later, the turtle still lives with her, along with two tortoises, a dog, a cat, and a small school of koi.)

Throughout high school, she volunteered at the city's renowned Shedd Aquarium and later returned there as a full-fledged veterinarian. She was also on staff at the Brookfield Zoo just outside Chicago before joining Disney. Both facilities, like Disney's Animal Kingdom, are accredited by the Association of Zoos and Aquariums, and are committed to pursuing the highest standards of animal care.

She works closely with all the animal keepers, since they're the ones who report any changes in behavior that might indicate something needs more attention. It's the keepers who train the animals to participate in their own care so that a pregnant porcupine, for example, will stand quietly with her front paws on a small railing to allow Natalie to ultrasound her belly. (Conducting an ultrasound on a pregnant scorpion is a little trickier, she adds, involving an extension tool to keep fingers far from the stinger.)

There's no such thing as a typical day, Natalie points out. "We can be doing invertebrates one moment and see an elephant the next and then go see a sand tiger shark the next. It's a fully amazing, eclectic collection."

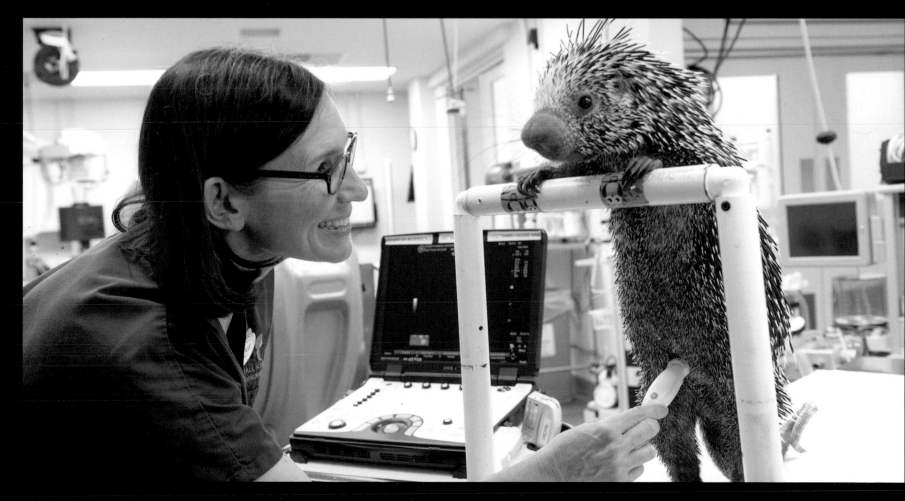

Dr. Natalie Mylniczenko cares for Animal Kingdom residents ranging from insects to elephants. At right, a possibly pregnant porcupine gets an ultrasound.

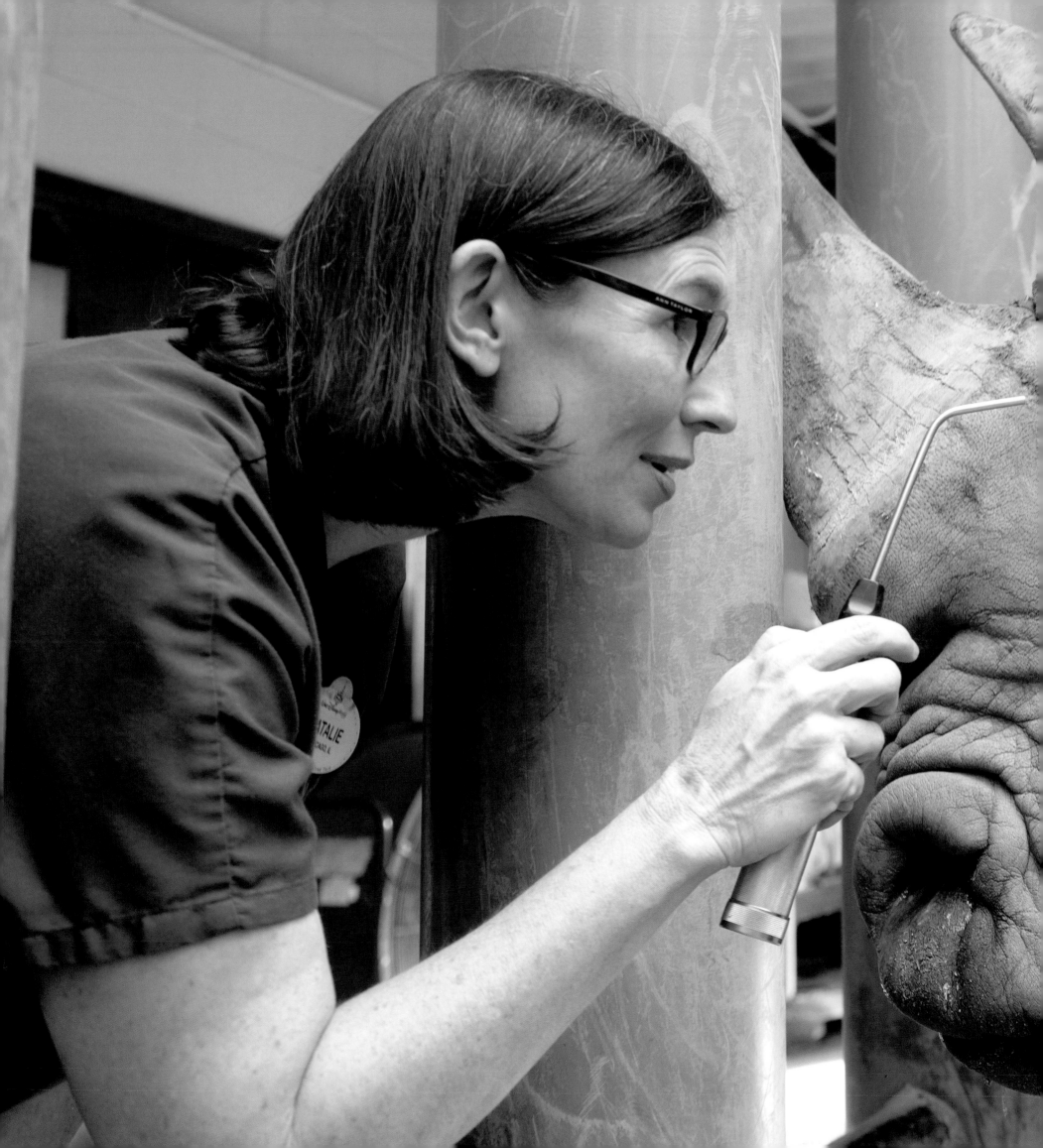

AMANDA
Part of the Magic

AMANDA LAUDER

Hometown
Howell, New Jersey, USA

Job
Chef Chocolatier,
The Ganachery,
Disney Springs

Favorite Disney character
Tinker Bell

After more than a decade as a pastry chef at Walt Disney World, Amanda Lauder had less than two months to prepare to open The Ganachery chocolate shop at Disney Springs. That included hiring and training the staff—without a kitchen, since it was still under construction—as well as finalizing the menu, getting familiar with the brand-new equipment, and traveling to "extra chocolate classes to help me brush up on my chocolate skills," she recalls. As the December 15, 2015, opening approached, she worked some very long days.

Amanda is Disney's only chef chocolatier, headquartered at The Ganachery—an intimate shop that's part show kitchen and part showroom. A tiny room in the back provides storage and space for shipping and administrative tasks, all done standing up, since there's not enough room to sit.

The chocolate itself is made in full view of Disney Springs guests by the fourteen cast members at the establishment, including Amanda—a few at a time, since the kitchen can hold only three or four busy people. The delicate signature treats start with ganache, a creamy chocolate that's blended with flavors such as Italian hazelnut, Egyptian sea salt, Sri Lankan cinnamon, Mexican chipotle, caramel, orange, mint, and, of course, peanut butter. At the heart of every creation is The Ganachery's custom-made chocolate, called Dark 65, which arrives from France one three-and-a-half-ton batch at a time.

"We always say our mission is to educate and elevate," Amanda says. "Educate the guests as to what high-quality chocolate is, and elevate their palates to appreciate that quality."

Amanda's education and acumen in desserts started in elementary school, when she baked brownies to give out at a book fair as part of her book report—on a cookbook, of course. By age fifteen she had honed in on Disney, having been transfixed and laser-focused by a magazine article on the Christmas gingerbread house created for all to crave

annually at the Grand Floridian Resort & Spa at Walt Disney World. She pointed to photos of then executive pastry chef Erich Herbitschek and told her mother, "This is who I want to be when I grow up."

Determination and fate guided her: she earned an internship at Walt Disney World while studying at the elite Culinary Institute of America—and "the stars aligned," as Amanda puts it. She just happened to be randomly assigned to the Grand Floridian. Amanda returned during every school break, and once she got her degree, the resort hired her full time. She stayed ten years, doing "a little bit of everything" on the pastry staff. That included working on the thing that got her into this line of work: the holiday gingerbread house.

The Ganachery has its own seasonal offerings, such as a hot sipping ganache that may be the best hot chocolate you'll ever taste. There's also house-made toffee sold in adorable burlap mini-sacks and, of course, an ever-evolving menu of elegant ganache chocolates. Whatever the season, Disney Springs visitors can be found at the kitchen window, watching the sweet alchemy. "We're not just making chocolate," Amanda says. "We're making a show."

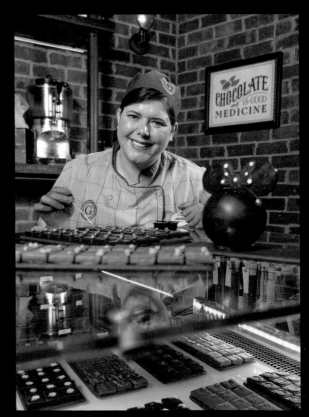

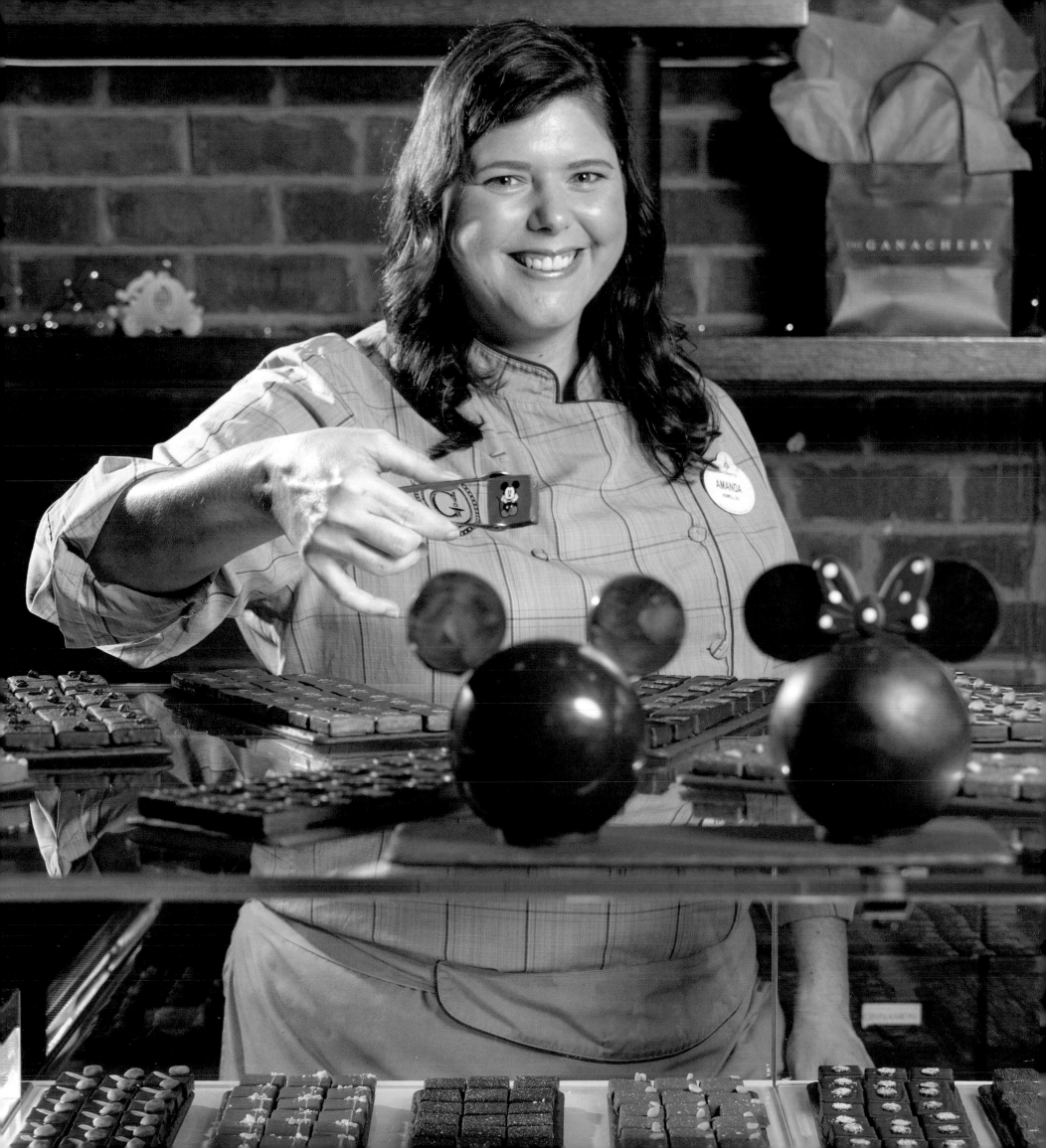

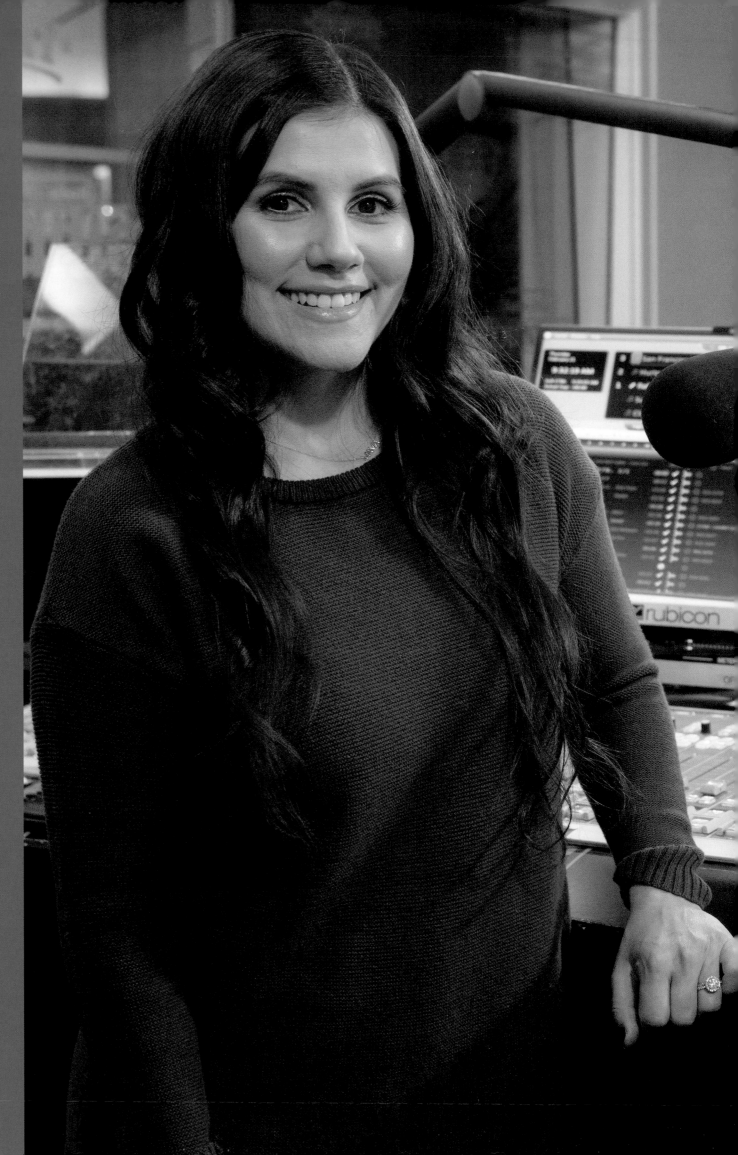

CANDICE
Part of the Magic

CANDICE VALDEZ

Hometown
Dallas, Texas, USA

Job
Talent,
Radio Disney Network

Favorite Disney movie
The Lion King (1994)

As Radio Disney's current longest-running on-air personality, Candice Valdez has interviewed more celebrity musicians than she can count, from Sir Elton John to the Jonas Brothers. Ed Sheeran, who was "real and humble," she says, "probably asked me twenty minutes of questions off the air. He was curious about Disney movies and going to the parks and what it's like working for Disney."

But some of Candice's most memorable moments have been with her listeners. Hosting the Radio Disney Music Awards a few years ago, "I had a fan onstage with me and got to introduce her to her favorite artist, Zendaya," she recalls. "That was really cool, to bring our audience into our world."

Sometimes fans seek her out, like the New Jersey listener who'd been calling in for ten years. He flew to L.A. for the Radio Disney Music Awards and dropped by the broadcasting studio to meet Candice. Or the girl in Florida who called in nearly every day after school and traveled to Walt Disney World with her mom when Candice was there doing a remote broadcast. "They just chatted with us while we broadcasted, like we were old friends," she says with genuine affection.

"What I love most about my job is that I have a unique opportunity to bring kids and their parents together for a fun and entertaining and safe experience." That's especially true, Candice adds, since she became a mom herself in 2018.

Candice's own family was her first audience. She had a short-range microphone that allowed her to do radio shows in her bedroom that her brother could listen to on the radio in his room. She had a "big, funky VHS camera" that she used to produce her own newscasts, with a coffee table as her anchor desk and a cousin playing the weatherman. ("We would go outside to shoot his segment.")

She studied broadcast communications in college in Arlington, Texas, near where Radio Disney was then headquartered, and after a stint on another station, was recruited by the network as weekend and swing shift talent. She left for a short time, but Radio Disney asked her to come back, this time moving her to California to broadcast from the network's new home in Burbank. That was more than ten years ago.

Even off the air, Candice is on duty, "tracking social media, just trying to be up to date on anything that could be relevant to our audience," she says. With nearly sixty thousand Instagram followers and as many as four artists to interview on some days, Candice enjoys being the conduit between listeners and pop stars. "Every day is exciting and different."

In Radio Disney's Burbank studios, Candice Valdez interviews performers such as singer-actress Meg Donnelly, star of the Disney Channel Original Movie *Z-O-M-B-I-E-S* and ABC's *American Housewife.*

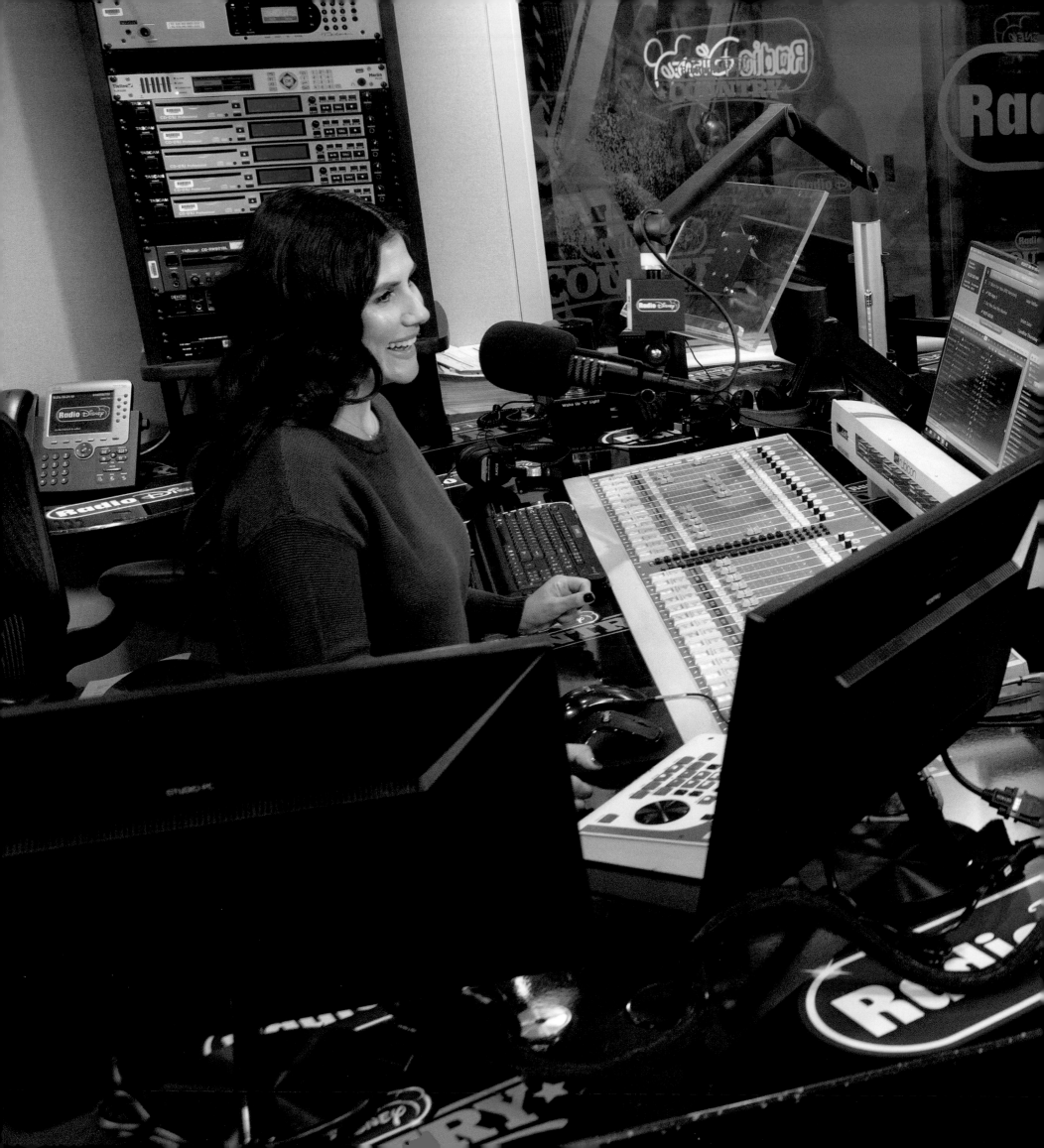

HEATHER
Part of the Magic

HEATHER BARTLESON

Hometown
Pennsville, New Jersey, USA

Job
Senior Facilities Coordinator, Holiday Services, Walt Disney World

Favorite Disney movies
Tangled and *Cinderella* (2015)

In aisle after aisle, boxes and bins are stacked on three tiers, towering nearly thirty feet high, most of them with samples of Christmas décor affixed to one side indicating what's within each container. Halfway through the cavernous building, the shelving gives way to giant Christmas trees, still partially decorated but broken into sections and hanging from the ceiling like wiry green crowns for Willie the Giant.

This is the Holiday Services Warehouse at Walt Disney World and the realm of Heather Bartleson, the team's senior facilities coordinator. She can tell you whatever you might want to know about every little thing—and every humongous thing—in the warehouse, since she's likely the one who ordered it. "It's my job to buy and receive everything that you see in the parks for Christmas and Halloween," she explains.

That includes those forty-to-fifty-five-foot "icon" trees—every park and resort has one—as well as miles and miles of lights and garlands, hundreds of boxes of ornaments and novelties, and "little clips and bolts by the thousand," Heather says.

The Holiday Services team works year-round, spending late winter, spring, and summer preparing for the next holiday season, ordering new treasures and sprucing up existing items. The workshop behind the warehouse is set up like an auto repair shop, with about a dozen parallel bays lined with benches and tool chests. In place of cars on pedestals, Christmas garland is suspended from above as workers in safety goggles check and restore each strand, inch by inch.

Heather honed her purchasing skills by tracking down off-catalog parts for a custom motorcycle shop in her native New Jersey, before she and her husband relocated to central Florida about six years ago. Dedicated fans, "we always planned on retiring to Disney," she says, "so we figured we'd just move our plans up."

Heather started in the PhotoPass department, then saw a job listing in Holiday Services that got her "super excited. I just love holidays in the park," she recalls. That was two years ago. Now nearly all the décor in the Florida parks and resorts—cruise ships, too—comes through her. That includes many items commissioned from local artists and creations from Walt Disney World's own workshops.

As you might imagine, the warehouse gets very busy toward the end of September. For the months leading up to Halloween and then Christmas, it's nearly deserted during the day, as the crews work nights installing the decorations out of view of guests.

"It's an incredible feeling of accomplishment, walking through the parks during the holidays and knowing that everything we did led up to this," Heather says. "The only tricky part about doing something so magical is trying to make it even more magical the next year!"

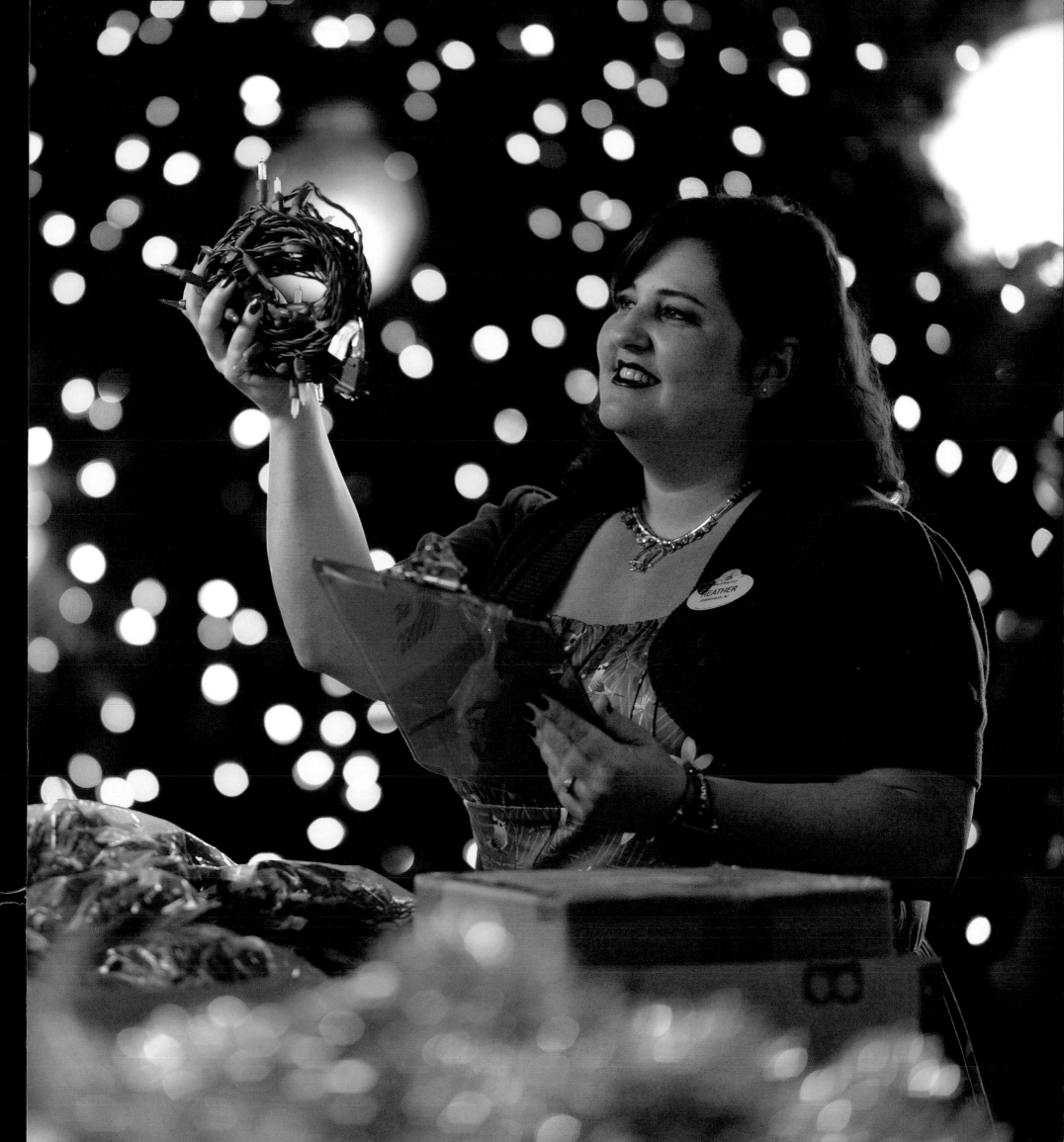

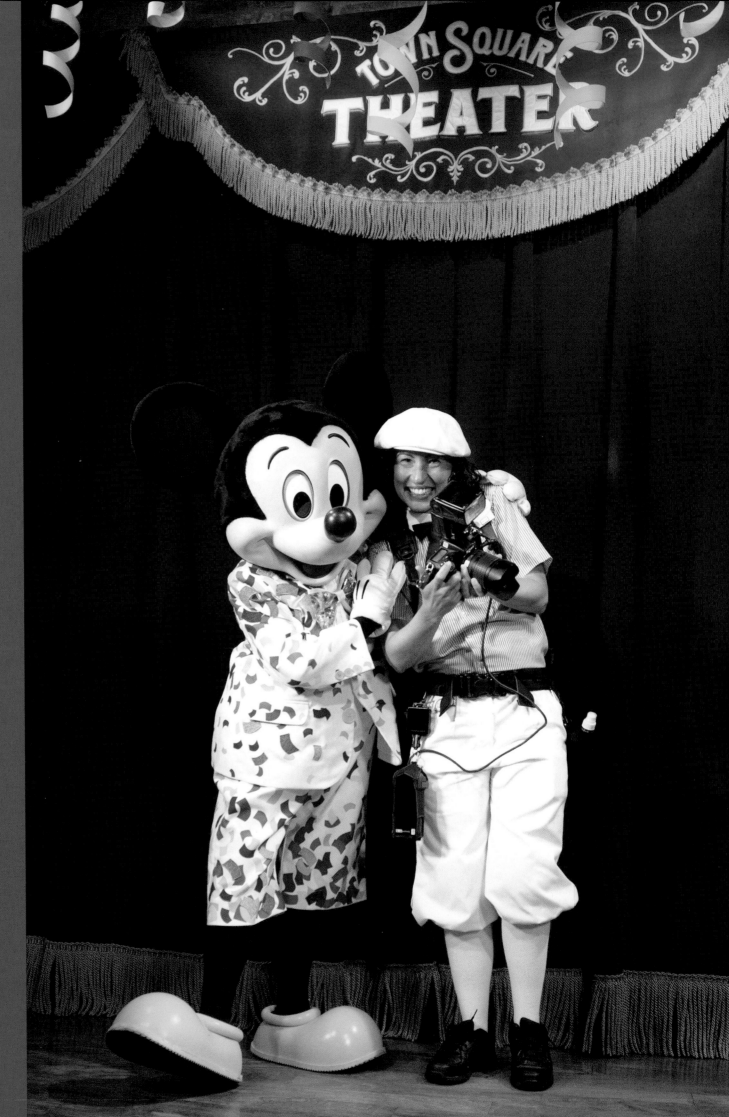

FABIOLA

Part of the Magic

FABIOLA KERSUL DE SALLES

Hometown
Pouso Alegre, Minas Gerais, Brazil

Job
PhotoPass Photographer,
Magic Kingdom,
Walt Disney World

Favorite Disney movie
Mary Poppins

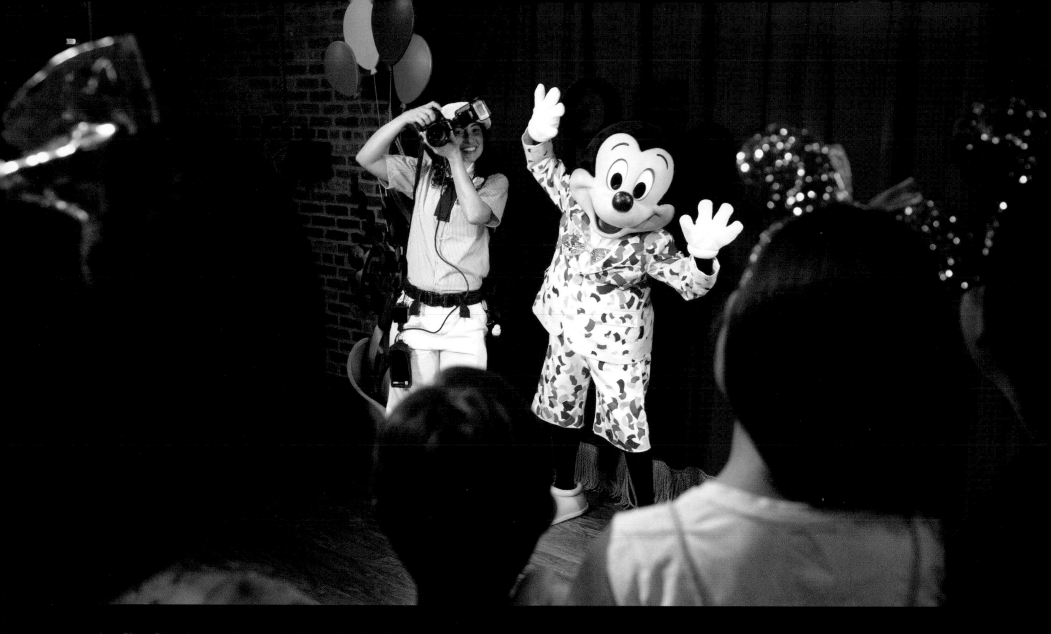

As a PhotoPass photographer at the Magic Kingdom, Fabiola Kersul de Salles works daily with Mickey Mouse, seen here in his Surprise Celebration outfit.

Seeing the enthusiasm Fabiola Kersul de Salles brings to her job as a PhotoPass photographer in the Magic Kingdom, it's hard to imagine she spent more than a decade practicing law in her native Brazil.

"I didn't really like law," she says. "I love to help the guests at Disney. I put myself in their shoes."

The trip took some twenty years from the moment at age fifteen when Fabiola decided working at Walt Disney World was her dream job. "I fell in love with Disney when I came here for the first time," she recalls of that long-ago birthday trip with her mother. "I said, 'Mom, I'm going to be a cast member. I'm going to work here.' I told everybody, and they were like, 'You're crazy. You're gonna change your mind.'"

She did not change her mind. But she bided her time, going to college in São Paulo, practicing law, and spending time with her family. (She was always the one with the camera.) When her beloved grandmother passed away in 2011, she knew it was time to make the move to Florida.

"It has not been easy, because I left my mom, I left my family, my home, my friends, my country, my culture—everything—to move here."

After six years working mostly on Main Street, U.S.A.—in the heat, rain, and cold—she can't imagine doing anything else. She's as much ambassador as photographer, answering questions in English, Portuguese, and Spanish, explaining FastPass and PhotoPass and Disney apps, giving directions, and, of course, coaxing small children into hugging the Beast. Or helping a young couple pose with a onesie in front of the castle for a photo that will announce the coming of their first baby to family back home.

"I love to make memories for people," she says. "It doesn't matter if it is a small kid or a grown-up—their face when they see Mickey Mouse is something priceless. You don't see that anywhere else. This is the place to be."

Her mom comes to visit at least twice a year; her aunt and cousins come as often as they can. That law career, though, will be staying behind in Brazil.

MARK

Part of the Magic

MARK GONZALES

Hometown
Los Angeles, California, USA

Job
Steam Locomotive Engineer, Disneyland

Favorite Disney movie
Pixar's Coco

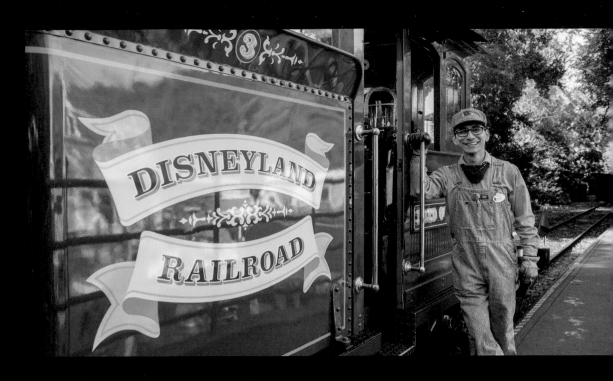

The newest engines on the Disneyland Railroad are at least as old as the park itself, which opened in 1955. The oldest was built in 1894. Engineer Mark Gonzales drives all of them, and after twelve years, "I'm still mastering it," he says.

Mark has some big shoes to fill. "Walt Disney loved these locomotives to death and he actually operated several of them," Mark shares. "He wanted his railroad to be authentic, and these steam engines are the real deal. They have real steam, real heat, real whistles—all of that. And the guys who operate them are doing it the same way they did at the turn of the twentieth century."

It takes two years on the rails to become an engineer. Everyone starts as a fireman, in charge of maintaining pressure inside the boiler. "It's just like a teakettle," Mark explains, with water boiling inside a closed chamber above a firebox, creating the steam pressure that drives the locomotive. A hundred years ago, boilers mostly used coal, but Disneyland switched to biodiesel in 2007. "So we get all of the oil from our restaurants and we recycle it, clean it up, and add about 10 percent regular diesel and burn that."

The engineer, in turn, is the driver—basically "in charge of moving everything." The fireman and engineering team at Disneyland numbers about forty—plus twelve mechanics, a figure that doesn't include the conductors who help guests onto the trains and staff the stations.

Operating engineers who work out of the Roundhouse are at the pinnacle: "These are the guys who are tearing apart the engines and putting them back together again," he notes. It's a role to which Mark still aspires.

Mark started tearing apart engines with his dad in their Los Angeles backyard back in the day. They worked on Chevy engines, and Mark completed his first solo rebuild when he was eleven.

But it was trains that called to him: "We lived down the street from a Union Pacific line, so every day I would hear the trains, and every night, too, so it was in my psyche from the time I was a baby to become a steam train engineer." Mark was the kid whose favorite character in *Dumbo* was the Casey Jr. locomotive and whose favorite live-action Disney film was *The Great Locomotive Chase* with Fess Parker.

He worked weekends in college as a conductor on the Disneyland Railroad and transferred to the Roundhouse as soon as he graduated.

"Well, it's not so much round," Mark says of the famous railroad shop at Disneyland. "It's more of a square house. If you're a train fan, it's a dream come true, with spare axles and cabooses and all kinds of odd tools for laying rails that you would never see anywhere else.

"If you're a fan of anything mechanical, you can sit here and talk to these guys all day long," Mark adds.

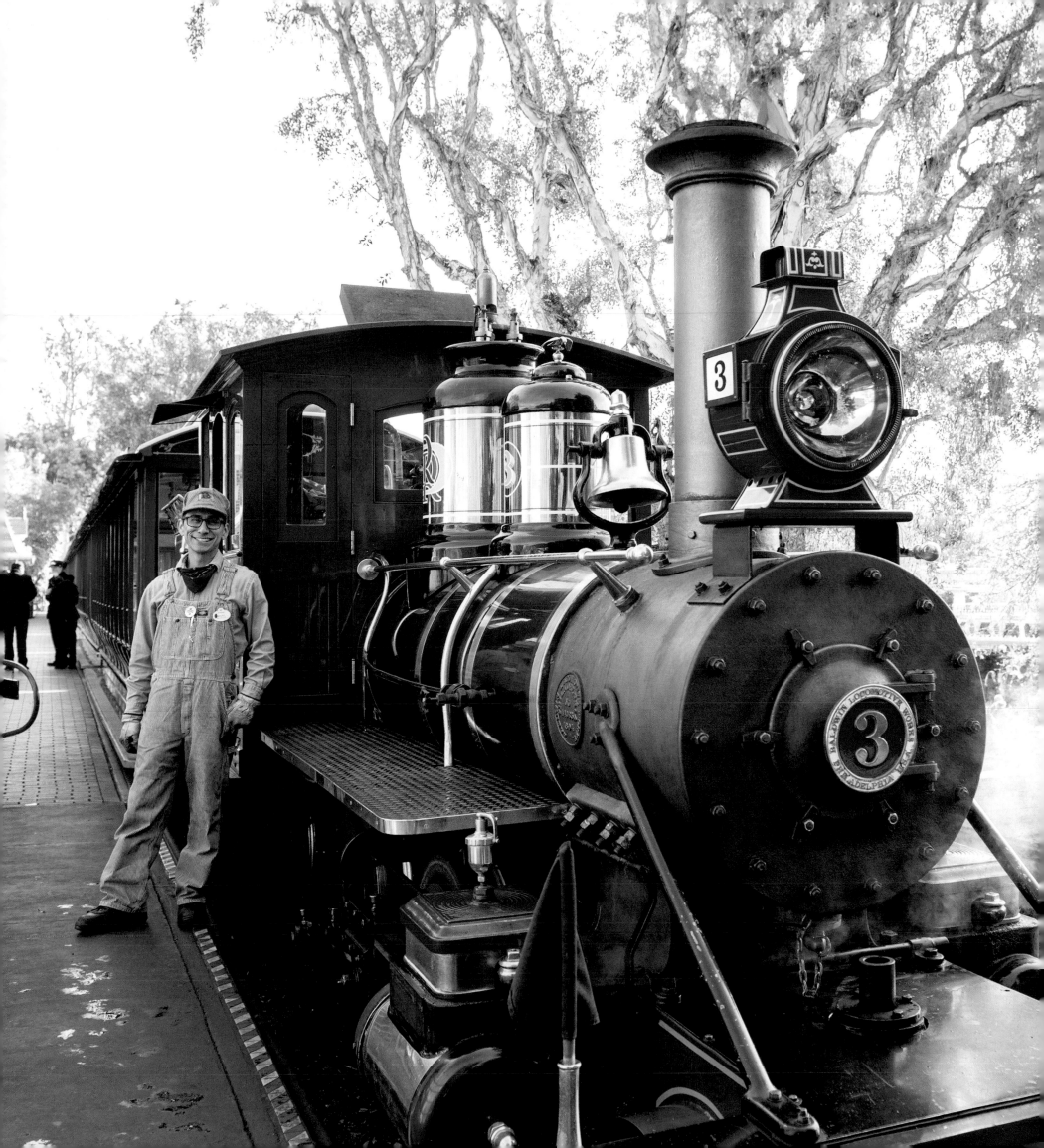

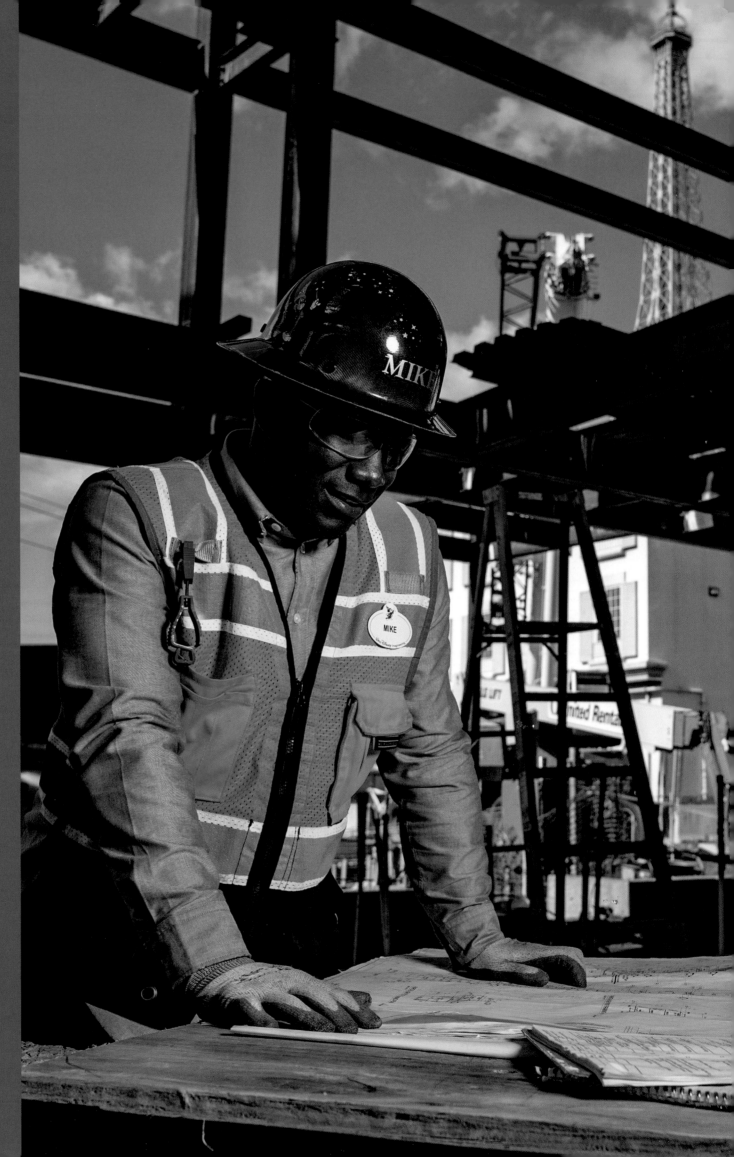

MIKE
Part of the Magic

MICHAEL
DAVIE

Hometown
Chicago, Illinois, USA

Job
Project Manager Principal,
Walt Disney Imagineering

Favorite Disney movies
Pixar's *The Incredibles* and
Monsters, Inc.;
The Princess and the Frog

Mike Davie's first job with Imagineering involved counting doorknobs. Now he's overseeing the creation of the kinetic new *Ratatouille* attraction in the France pavilion at Epcot. In between, Mike helped build a couple of cruise ships.

"What I love most about my job is seeing a project through from inception to completion and working with so many creative and brilliant people every day," he says, citing that cruise ship project as his most memorable. "I was there from the very beginning," from soliciting bids from shipbuilders to joining the *Disney Dream*'s first transatlantic cruise from the North Sea to its christening in Port Canaveral in Florida in 2011. He did the same for the *Disney Fantasy*, which launched in 2012. Along the way, he moved his family to Germany for a few years to be near the Meyer Werft shipyard.

"That's the thing about Imagineering," Mike says. "We're involved with every single detail of a project." The *Dream* build was "one of the coolest things I've done in my career. Even to this day I get goose bumps talking about it. It's just amazing to have seen it when it was just one piece of steel in a shipyard, to now this beautiful ocean liner out at sea."

Mike's current project—set to open in time for Walt Disney World's fiftieth anniversary celebration in 2021—took him to Disneyland Paris, where the 4-D Ratatouille: The Adventure opened in 2014. Talking about the work at Epcot, the Imagineer's conversation is peppered with Walt Disney Imagineering lingo like "ride box"—the structure that houses the core experience—and "crookedology"—the *Ratatouille* attraction's reimagining of the rooftops of Paris, which he says is "a little wonky."

It was another city that first inspired a young Mike to wonder "how things work and how do you build it." Chicago, his hometown, "has one of the greatest, most iconic skylines in the world," which he got to admire every day on the train to school. A degree in civil engineering led to a job with Michigan's Department of Transportation.

Then his wife got a job with Disney, and Mike soon found himself interviewing with Imagineering. "I just sort of fell in love with the company." He started during the building of Disney's All-Star Movies Resort, where handling door hardware inventory soon led to more creative pursuits. "And I've been here ever since."

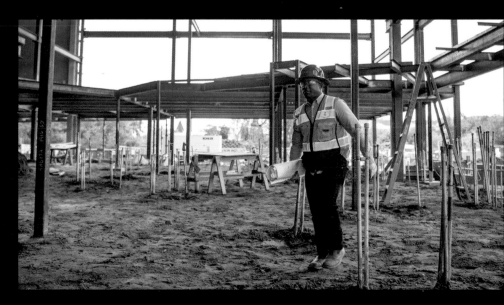

Imagineering's Mike Davie checks out construction work on Remy's Ratatouille Adventure, an attraction set to open in 2021 at the Paris pavilion in Epcot.

ERIC BAKER

Hometown
Rossville, Georgia, USA

Job
Creative Director,
Walt Disney Imagineering

Favorite Disney attraction
Pirates of the Caribbean

A sort of Indiana Jones for Imagineering, Eric Baker has traveled the world for the past three years in search of the artifacts and materials he needed to "take some of the most beloved films in the world and turn them into a real, fully immersive world."

Along with a crew of fifteen artists, Eric's job was to create the *Star Wars*–inspired props and set dressing for the *Star Wars: Galaxy's Edge* lands at Disneyland in California and Disney's Hollywood Studios in Florida. That included everything from tiny Jawas Eric sculpted himself to a twelve-foot-tall stuffed wampa. Thousands and thousands of items were shipped from Florida to Anaheim, and thousands and thousands more were created for the Hollywood Studios location.

When he wasn't supervising the fabrication team at their "top secret location" in Orlando, Eric was often thousands of miles away, combing through overflowing warehouses and mounds of discarded tech for treasures. On one trip to England, "we were driving through farmland and suddenly out in the cow pasture we saw a 747 just sitting there." It was an aircraft graveyard from which Eric harvested miles and miles of wire and cables, as well as other items destined for artistic transformation. "Believe it or not, in the films they use a lot of passenger aircraft seats with the cushions stripped off. And the armrests become arms for a lot of the droids."

Working with the *Star Wars* series artists is part of Eric's job; it's quite a journey for the Georgia boy who had to beg his parents for months to take him to see the original *Star Wars*. Immediately obsessed afterward, he and his brother built their own *Star Wars* play set atop the basement Ping-Pong table. After *The Empire Strikes Back* came out, his mother helped him sculpt, cast, and paint a Yoda mask for Halloween.

Fresh from graduation from the University of Georgia, Eric joined the Disney Career Start program at Walt Disney World. In between entry-level work assignments, he got to take classes in "how to do ink and paint from the ladies who were actually doing it at the time."

Determined to break into film or television, Eric left Disney and spent twenty-five years as a freelance artist, doing everything from puppet wrangling for the Muppets to special effects for the Tom Hanks-produced HBO series *From the Earth to the Moon*. Props and set dressing became his specialty, so when Disney asked him for a recommendation for the Galaxy's Edge job, he nominated himself.

Soon after he started, he visited the set for *The Last Jedi*. "The first thing they did was take us to the cockpit of the *Millennium Falcon*," he recalls. Childhood memories came flooding back: "It was hard to keep it together."

Eric's set visits taught him a lot about how to decorate *Star Wars: Galaxy's Edge*, as well as reminded him of one vital goal: "As a *Star Wars* fan, it's incredibly important to me that we get everything right."

Eric Baker works at a warehouse among props created for *Star Wars: Galaxy's Edge.*

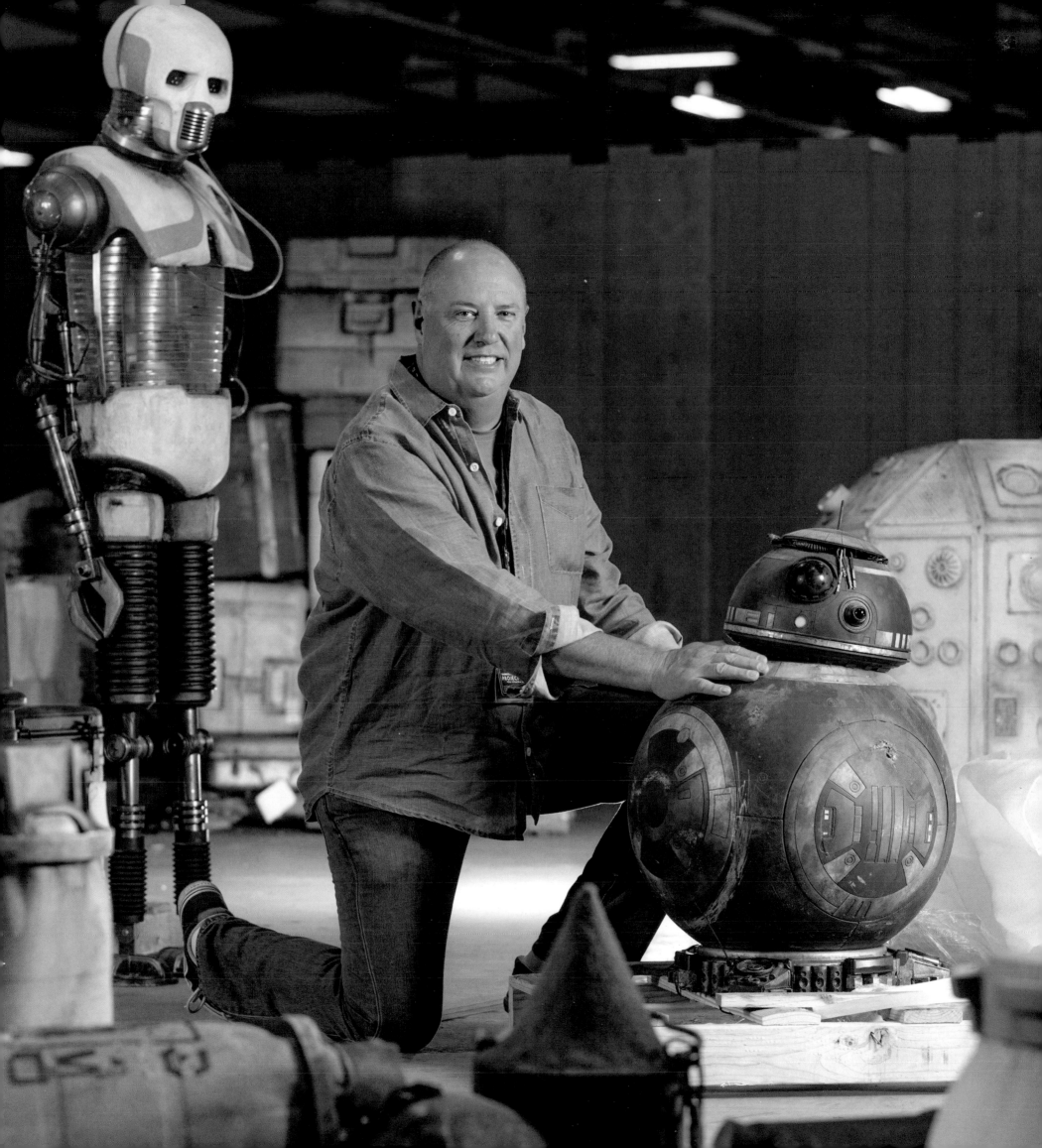

JUAN

Part of the Magic

Juan Estrella

Hometown
Fort Bragg, California, USA

Job
Security Guard, The Walt Disney Studios

Favorite Disney movie
The Lion King (1994)

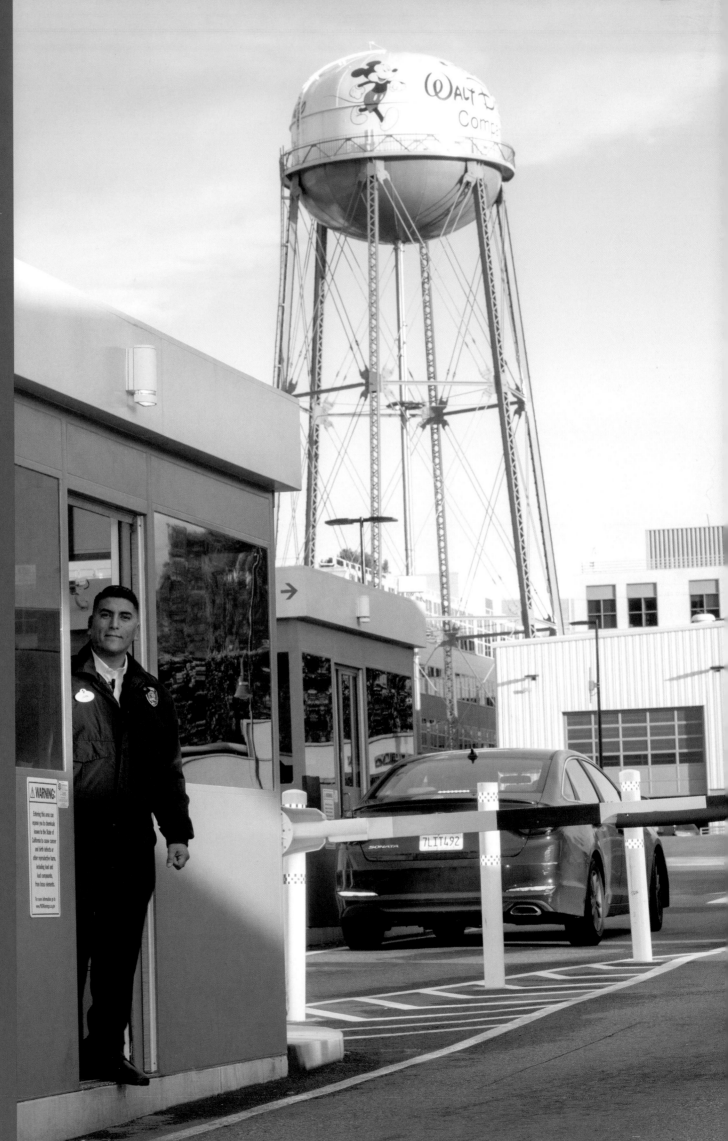

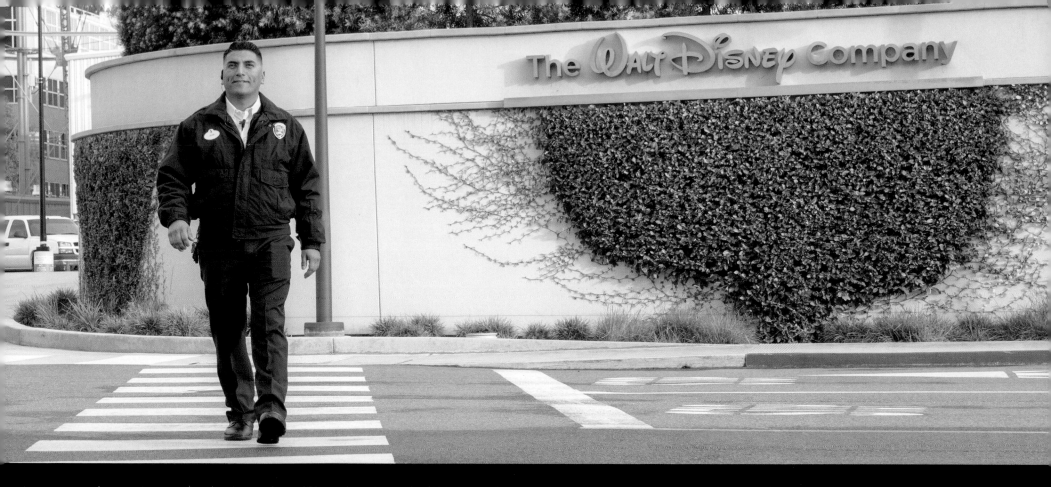

As security guard at the Alameda and Riverside gates to The Walt Disney Studios in Burbank, Juan Estrella meets celebrities almost daily. Keanu Reeves is among his most memorable encounters.

Whether you're a Marvel movie star, a cast member reporting for work, or just a curious tourist, Juan Estrella is likely the first face you'll encounter at The Walt Disney Studios in Burbank. He works at both the Alameda and Riverside gate entrances to the studio's campus, where he's always ready to point you in the right direction. His title may be security guard, he acknowledges, but "customer service is what I do best."

The security team is "definitely a family," Juan adds. "We like to say we protect the magic. Everything that we do throughout the day here—whether it's 114-degree weather or 35 degrees and pouring rain— it all makes sense because we're protecting this magic."

Juan sees that magic in the wide eyes of visitors from around the world who just want to get a glimpse through the gate. "They just stand there with awe," he says. "We forget how mysterious the studio is, and we get accustomed to greeting the celebrities that come in every day."

Many of those celebrities are as personable as *Guardians of the Galaxy* star Chris Pratt, who arrived in his vintage Volkswagen Beetle. Once the vehicle was safely parked, the actor spent so much time

talking with Juan about his car that he was almost late to his meeting.

Juan's first celebrity encounter was with Mickey Mouse, when he was still a young boy growing up in a small town on the Northern California coast. It was just before Christmas, and Juan's dad dressed his sons up in nice clothes to pose for photos with the Disney icon at a local grocery store. He didn't meet Mickey again until his first visit to Disneyland when he was twenty-five. Now he takes his five-year-old son to the park as often as he can—although not nearly as often as the boy would like.

Working at the studio has turned Juan into "a true fan," he says. "Everything that I buy my son is Disney." But he still feels like an amateur Disneyphile, at least when he compares himself with the superfans he meets at the D23 fan club events he works. "They're beyond fans. They know their stuff. That's one thing I like about working here: you never stop learning."

Whether trading bits of Disney history with D23 Members or answering the questions of studio passersby at the Alameda gate, Juan says, "You realize, 'Holy smoke! I'm actually blessed to be working in this amazing company.'"

SIDNEY

Part of the Magic

SIDNEY BAIN

Hometown
Crossing Rocks, Abaco, Bahamas

Job
Tram Coordinator / Trainer / Pest Control Operator, Castaway Cay, Bahamas

Favorite Disney movie
Aladdin (1992)

Sidney Bain has been welcoming Disney Cruise Line guests to Castaway Cay every day for thirteen years—even when he's not on the island. "The minute they board the tram, they hear my voice," says Sidney, who's the coordinator and trainer for all those working on the trams servicing Disney's award-winning private island paradise, "because the spiel on the trams is my voice."

Sidney has been working on Castaway Cay for more than twenty years, starting back when there was little on the thousand-acre isle other than the sun and sand. Back then, he worked as a supervisor on the painting crew with the American Bridge Company, the construction firm charged with building Castaway's facilities, including all the original walkways, roads, and structures, before the first ship ever docked there.

After a year and half on that team, Disney Cruise Line asked Sidney to join their maintenance staff; he soon proved to be so reliable that Disney assigned him a new responsibility: pest control. They even sent a team to train him on how to maintain the company's high standards.

"I've learned that Disney goes above and beyond to create magic for our guests—believable dreams," Sidney says. "All of us on Castaway Cay play a big part in achieving that."

For Sidney, that means making sure the tram staff adheres to Disney's four keys: safety first, courtesy, efficiency, and "show," which encompasses everything from dress and posture to giving directions.

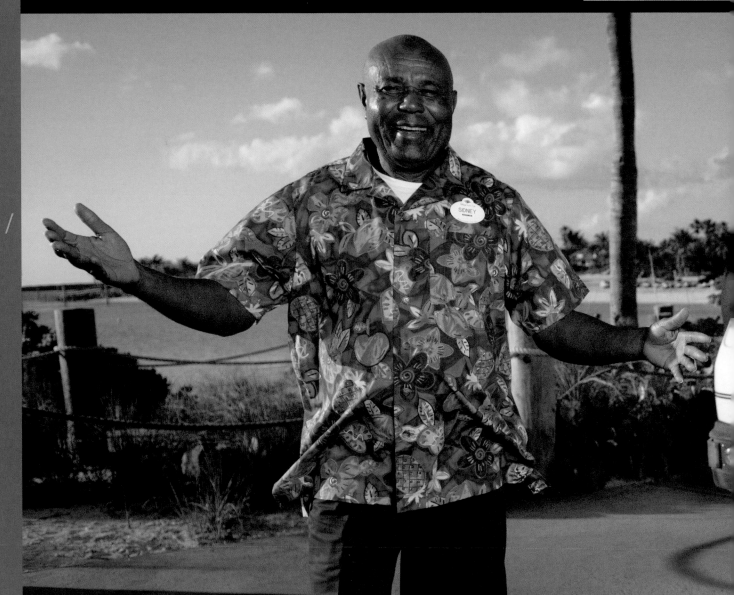

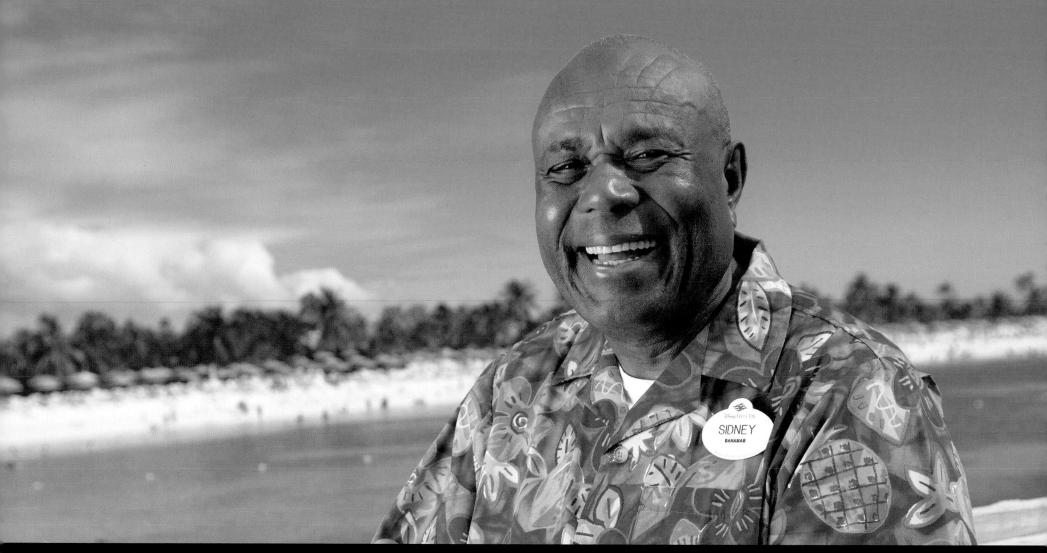

When the guests depart Castaway Cay, Sidney turns his attention to training teams on tram operations and overseeing maintenance work. This means making sure that this all-inclusive island paradise with its sparkling lagoons, water play areas, open-air BBQ dining, and beaches designed for kids, adults, and families remains pristine for guests.

To facilitate his work, Sidney lives on Castaway Cay during the week and heads home to the nearby "mainland" island of Abaco, where his family lives, on his days off.

"I grew up in the hospitality industry," notes Sidney, a native of the Bahamas, who started working as a busboy at fifteen and ascended to restaurant manager before Castaway Cay called.

He knows how much Disney values his work: "They sent a helicopter for me at my house," he recalls about the hectic days after Hurricane Floyd struck the Bahamas in 1999. "It landed on a yard right next to my house." The storm had left a lot of standing water on Castaway Cay where mosquitoes might hatch. Sidney's essential pest control skills couldn't be delayed until the resumption of boat service to the island. "It made me feel special, because it didn't happen for everyone. But it definitely happened for me."

Sidney Bain has worked on Castaway Cay since before the Disney Cruise Line hideaway opened, and it's his voice that greets guests on the island's tram system.

KRISTINA
Part of the Magic

KRISTINA DEWBERRY

Hometown
Cincinnati, Ohio, USA

Job
Construction Manager—
Logistics, Disneyland
Overall, Walt Disney
Imagineering

Favorite Disney movies
Mulan and *Sleeping Beauty*

Shortly after moving to California from Cincinnati in 2008, construction manager Kristina Dewberry took her then eleven-year-old daughter Madison to Disneyland. On Main Street, U.S.A., she pointed to the window that reads ELIAS DISNEY, CONTRACTOR. "See, Madison," she said, "contractors are important at Disneyland."

Within a couple of years, Kristina knew exactly how true that was, having joined the Disney team as construction coordinator for the refurbishment of the Disneyland Hotel. Several major projects later, she's now Walt Disney Imagineering's construction manager for the entire resort area.

Beginning in 2016, Kristina spent most workdays on-site at Disneyland's new *Star Wars* land, Galaxy's Edge, starting "when we were just a gigantic mudhole. It's pretty amazing to see this flat ground and then all of sudden we've got the Cantina. As a huge *Star Wars* fan, it was just really important to me that this be perfect."

Growing up in Cincinnati, Kristina loved reading, riding her bike, and playing with her *Star Wars* action figures with her friends. When she wasn't playing, she might be found pulling nails out of old boards under her father's supervision. By the time she was ten, both she and her eight-year-old brother had tool belts to assist in their dad's workshop as they learned how to do the job safely and efficiently.

"He worked in a factory but had a lot of carpentry skills," Kristina recalls. Her father contributed to both home and charitable construction projects. She helped out through high school and found her calling in building "these lasting things."

After college, she worked in hospital construction for years and became president of the Cincinnati chapter of the National Association of Women in Construction. She has heard her share of "Go away, little girls" from a few jerks on work sites but calls the Galaxy's Edge project "a very positive step in construction history" for the remarkable diversity of the workforce, in both gender and race.

"As the mother of a mixed-race daughter, it's important to me that all people can see themselves as part of the Disney family," she says. The company's efforts at inclusion in images promoting everything from cruises to Disney Stores "just makes me very happy. It's not even a thing anymore."

Seen here in *Star Wars*: Galaxy's Edge, Kristina Dewberry is the construction manager in charge of logistics for the entire Disneyland Resort.

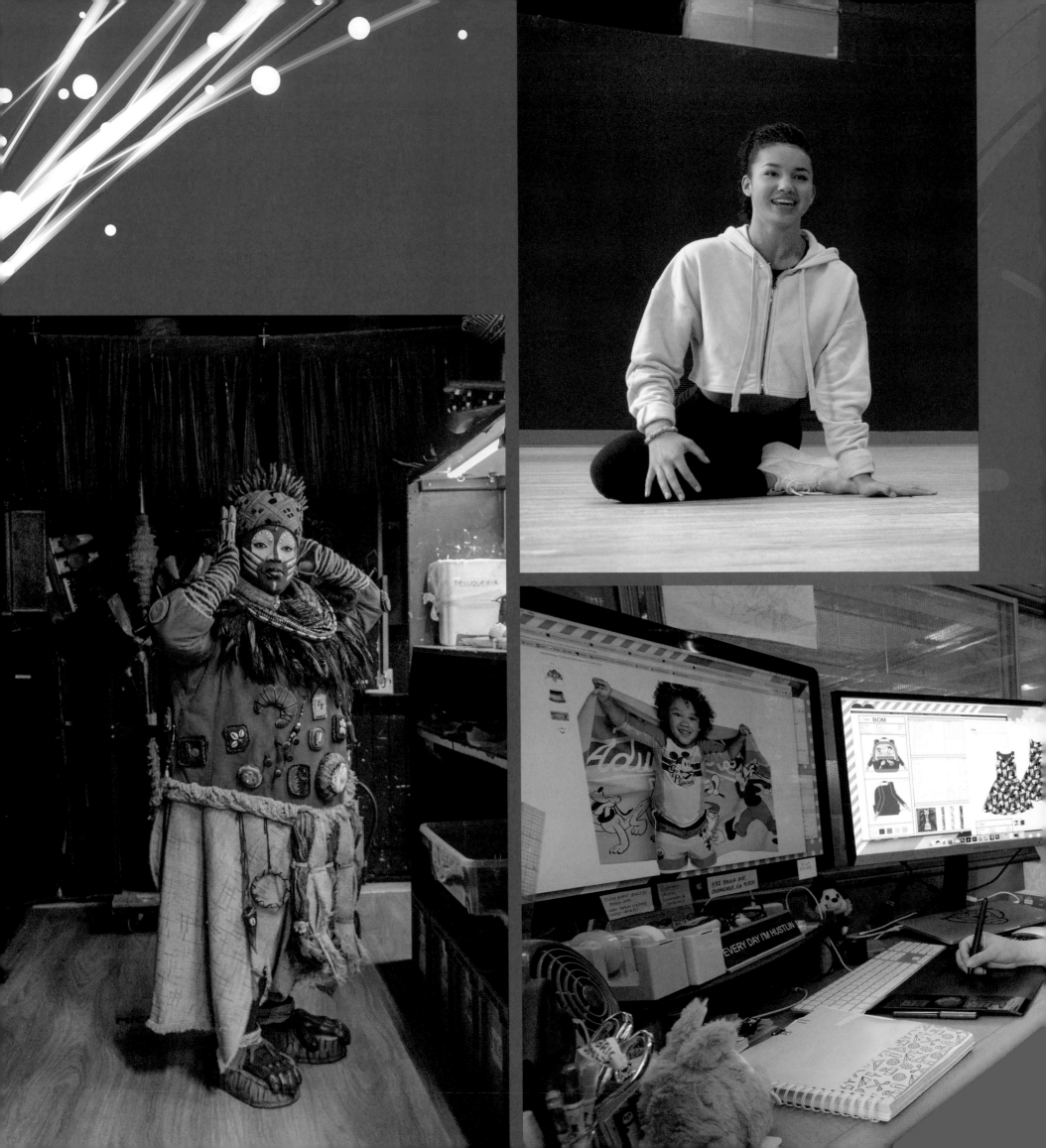

Chapter Four
9 am – Noon

Dreams may come at night, but the realization of a dream knows no time of day. It may be late morning in Glendale, California, where children's clothing designer Nontra Null is living out her childhood hope to be part of the Disney magic.

At the same time in Madrid, Spain, where it's early evening, actor Zama Magudulela is preparing to take the stage, a lifelong dream of hers that is now her livelihood. Zama is Rafiki in *The Lion King*, performed at the Teatro Lope de Vega before nearly 1,500 mesmerized people a night.

But one of the best dreams-come-true stories belongs to teenage actor Sofia Wylie, who has gone from singing *High School Musical* songs for her family at their Arizona home to starring in the Disney+ series inspired by the original movie trilogy.

"Everything has just aligned in such a crazy coincidental way to make everything I've trained for pay off right now," Sofia says. And fellow cast members across the world nod in agreement.

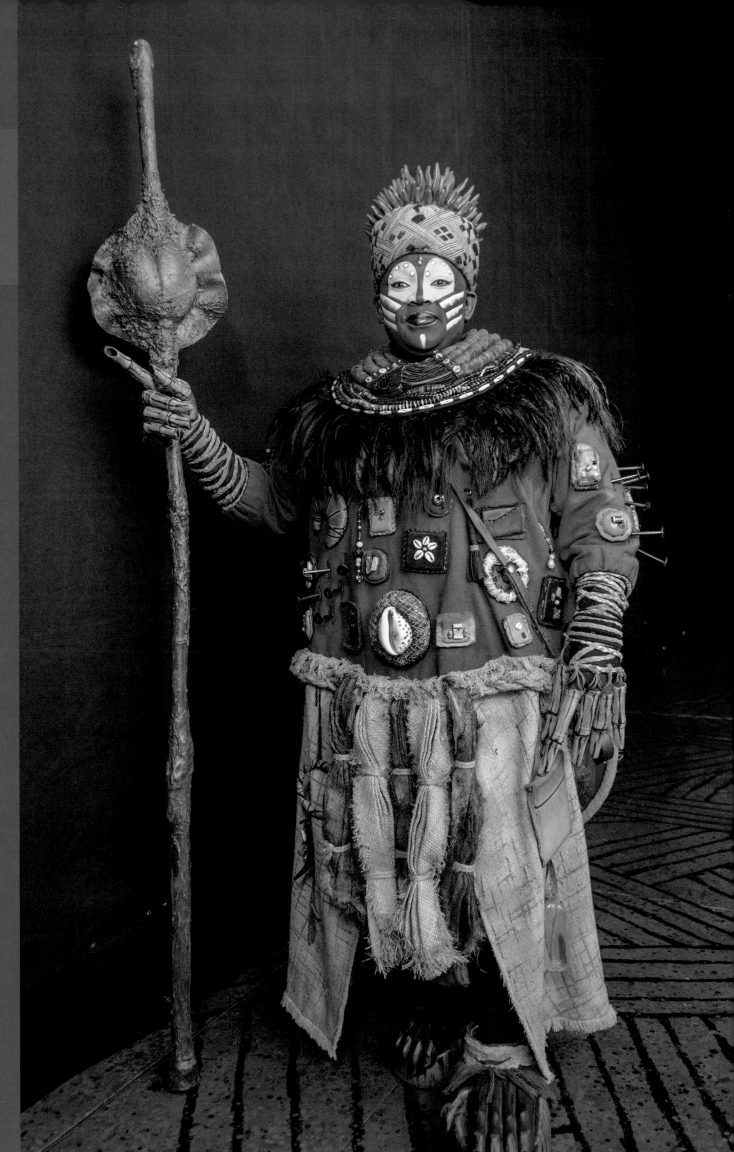

ZAMA

Part of the Magic

ZAMAVUSO MAGUDULELA

Hometown
Durban, South Africa

Job
Rafiki in *The Lion King*,
Madrid

Favorite Disney movie
Moana

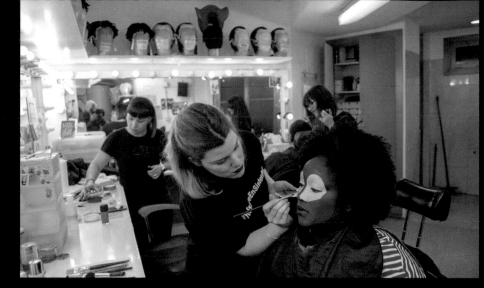

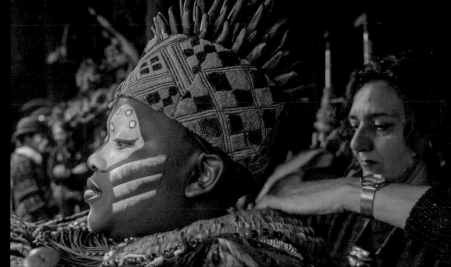

If you talk with Zamavuso Magudulela for more than a few minutes, chances are she'll be laughing and have you laughing, too. "I used to be shy to talk," she says of growing up in South Africa, "but I've never been shy to laugh."

Onstage in *The Lion King* in Madrid, Spain, "Zama"—her nickname—shares her effervescence with the audiences who have packed the grand Teatro Lope de Vega since the Disney production opened there in 2011.

"Do you know how overwhelming it is to see someone crying because of the joy you gave them?" she asks. "You say you work in *The Lion King*, and people just glow. It's like they become candles. They just glow. It's a great feeling."

Zama has been performing in *The Lion King* on and off for more than a dozen years, in Australia, China, Germany, France, and Spain. She was first cast in the role of Rafiki in Paris, and now plays the same part in the Madrid production. "I just can't get enough of it," she says. "It's one of those shows that you can do the rest of your life."

Zama has been singing as long as she can remember, starting in church and school choirs. She earned a degree in marketing but worked in the field only six months before she got a role in a South African stage musical based on Zulu culture. Then she heard about *Lion King* tryouts.

"My first audition went *down*," she confesses with a laugh, recalling her inappropriate renditions of songs sung by Whitney Houston, her childhood idol. She got the job, however, at a third tryout. Since then, over the years, she has sung the show in English, German, French, and Spanish. Whatever the language, "whenever I'm onstage I feel like I'm sharing a little bit of Zama, you know?" Playing the shaman Rafiki, she says, "is joyful. It's mysterious. It's serious."

It's also educational. "This experience made me grow as an artist," she says. "I've met people from different countries and got to understand and appreciate where I come from, which is South Africa. It's made me appreciate life and everything that is happening"—the whole Circle of Life, if you will.

Her South African family may be far away, but the cast and crew in Madrid have their own strong bonds. "We have each other backstage," she says, with a signature Zama laugh. "and if we are happy backstage, we're going to be happy onstage."

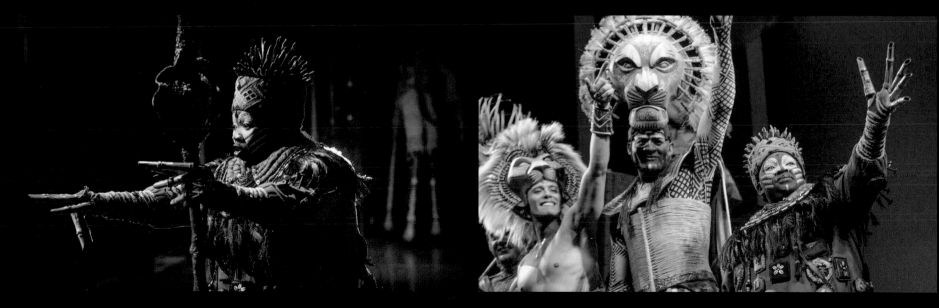

As Rafiki in the Madrid stage production of *The Lion King*, Zama Magudulela does eight shows a week—nine during holidays. She spends forty-five minutes in makeup before every performance.

JOSE

Part of the Magic

JOSE ZELAYA

Hometown
San Salvador, El Salvador

Job
Character Designer,
Disney Television
Animation

Favorite Disney movie
The Lion King (1994)

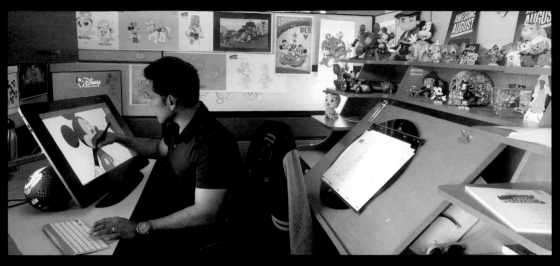

Jose Zelaya designs characters for Disney Television Animation, working with many classic Disney characters.

When Jose Zelaya is at work as a character designer for Disney Television Animation, he uses as many as five high-tech full-color electronic screens. One even serves as his electronic sketch pad. ("We don't use paper anymore," he says.)

But when he was a boy in El Salvador, there was just one screen that mattered: the grainy black-and-white television that brought Mickey Mouse into his family's home.

As helicopters buzzed over his neighborhood raining tracer bullets during El Salvador's long civil war, Disney shows gave him hope. "It made me feel like at the end of the story, after all the chaos, there was going to be a positive outcome."

At age seven, he found an escape in his talent for drawing. Then a TV show rocked his world: it revealed the human hands behind his beloved Disney cartoons. "So I told my mother I was going to work for Mickey Mouse," he says with a smile.

Jose moved to Los Angeles with his mother and his two younger siblings when he was twelve. After getting a degree in animation from Santa Monica College, he spent more than a year searching for his dream job—until a recruiter for Disney Television saw his portfolio. Within days, he had a position on the character design team.

That was twenty-two years ago. Jose has since worked on countless shows, including *Recess* (his first), *Lilo & Stitch: The Series*, and *The Lion Guard*. Designing new characters means a lot of research and collaboration, which has taken him to Mexico, Peru, and Italy. "I found myself designing Minnie's fashion outfit for a short that we were doing," he says of his trip to Milan.

"My job doesn't feel like a job. It feels like something I would do even if I wasn't being paid for it," Jose says.

Now he works to pay back his good fortune by mentoring aspiring artists, "part of keeping the magic alive" for generations to come. Words may sometimes fail him, but he says, "I believe that where words end, art begins."

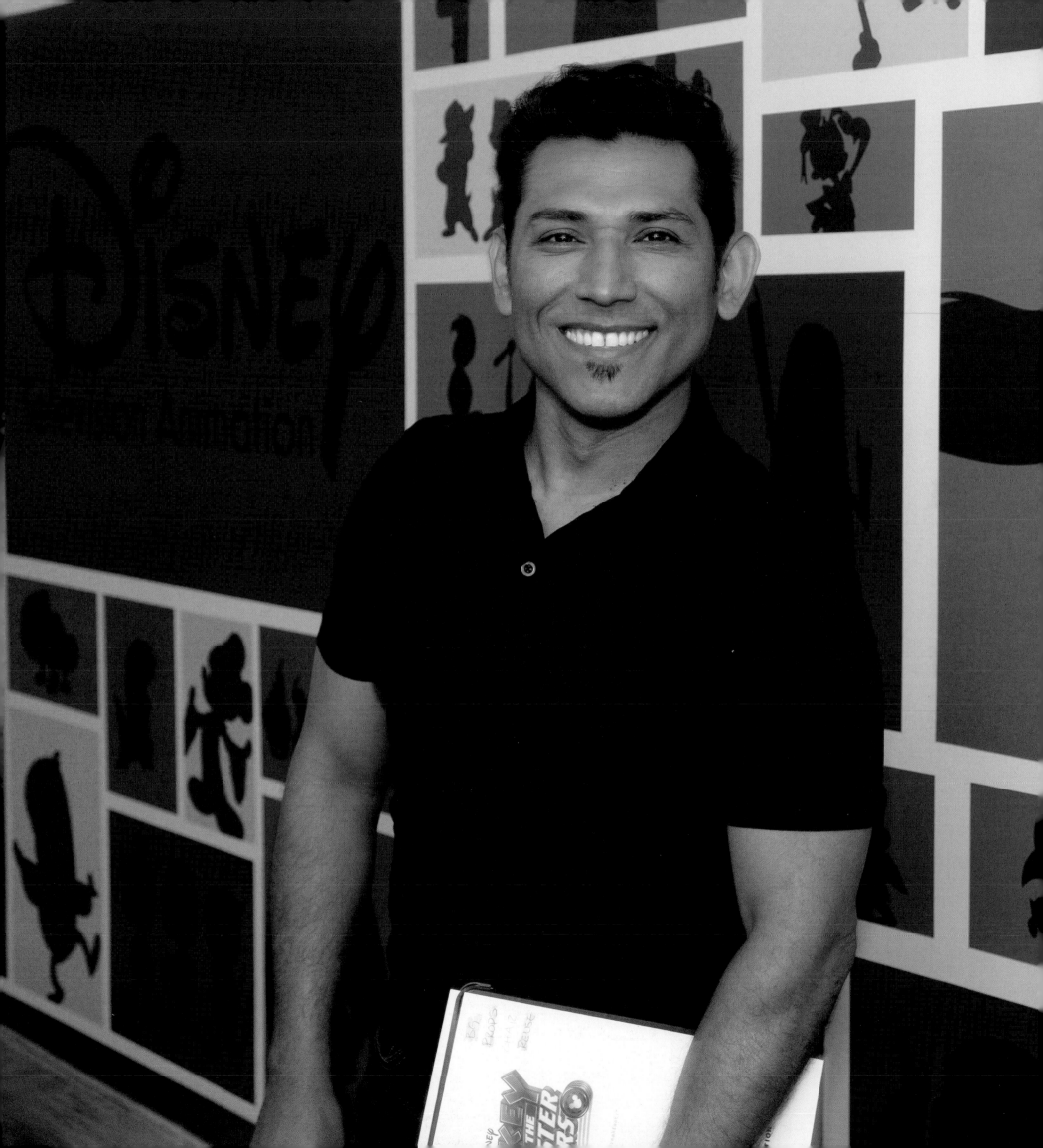

KOREY
Part of the Magic

KOREY AMRINE

Hometown
Lodi, California, USA

Job
Tour Guide with
Adventures by Disney

Favorite Disney attractions
Pirates of the Caribbean
and Indiana Jones
Adventure

That once-in-a-lifetime trip to see the ancient ruins of Machu Picchu in the Peruvian Andes? Korey Amrine has done it forty-five times.

As a guide for Adventures by Disney for the past fourteen years, Korey is quite the globe-trotter, leading guests through the U.S. Southwest, the Amazon, Alaska, Spain, South Africa, Australia, China—the list goes on. Lately he has led the Central Italy itinerary (Rome, Florence, and Venice) the most often: "It's a great tour," he says. "When you go into the Sistine Chapel with just twenty people, after hours, and with one of the best local experts, who's going to explain every painting to you—there's just nothing like it."

There's also nothing like the other adventures Korey leads. The Costa Rican vacation, for example, includes a visit to a volcano and hot springs, an afternoon sailing on a private catamaran, zip-lining, and a rollicking white-water rafting trip.

The great outdoors is in Korey's blood. Growing up on a grape farm in Lodi, California, he and his four older brothers treated Yosemite National Park, a couple hours away, like their backyard.

"My brother Kyle took me up to Vernal Fall when I was just a little kid, and I had never seen anything that pretty in my life. It just made me fall in love with the outdoors." Then Carl, another brother, took Korey white-water rafting in Oregon, "and I knew what I was supposed to do with my life."

He started guiding at age seventeen and never stopped, even during college in Utah—selected for its great snowboarding and rafting—and in pursuit of two master's degrees: one in history, the other in tourism management. In his first year with Adventures by Disney, "I think we did seventeen tours back to back to back, and I just loved it."

New itineraries are tested out on "alpha" and "beta" tours before they're opened to general bookings, and every adventure includes two guides: one from Disney and one local. Guides talk, of course, but they also "listen to what the guests' needs are," Korey notes, as well as monitor conditions at upcoming destinations. "If something doesn't feel right on a trip, it'll be changed."

Other tour companies have tried to lure Korey away from Disney, but he says that would be like turning his back on his family. "I would do anything for them," he says of his fellow Adventures by Disney cast members. Even if that means a forty-sixth visit to Machu Picchu.

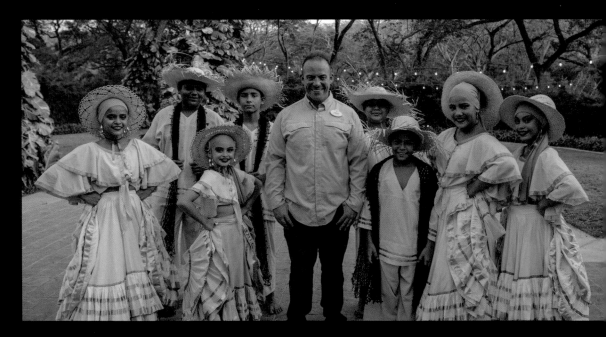

ABOVE: Adventures By Disney guide Korey Amrine stands with a dance troupe in Costa Rica. When they're not performing, the dancers are local farmers.

OPPOSITE: The Costa Rican adventure includes a day on a catamaran on the Pacific Ocean, with paddleboard lessons and time to explore a private beach.

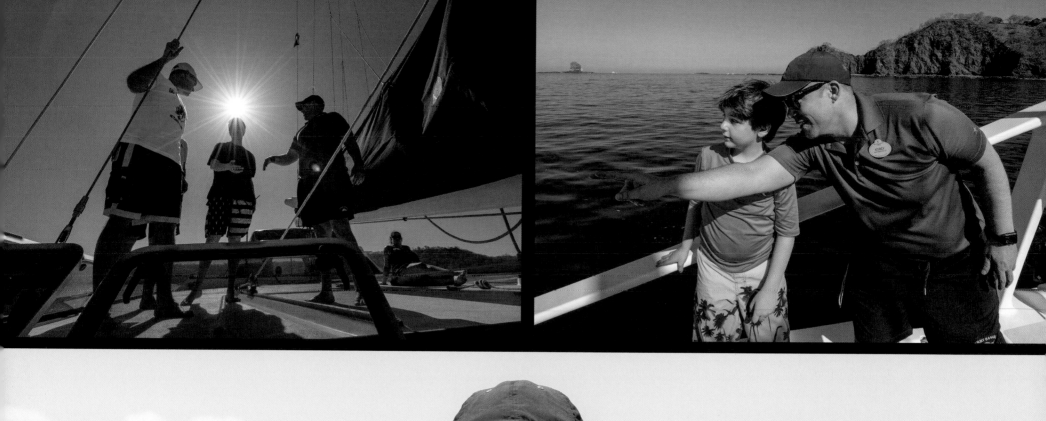

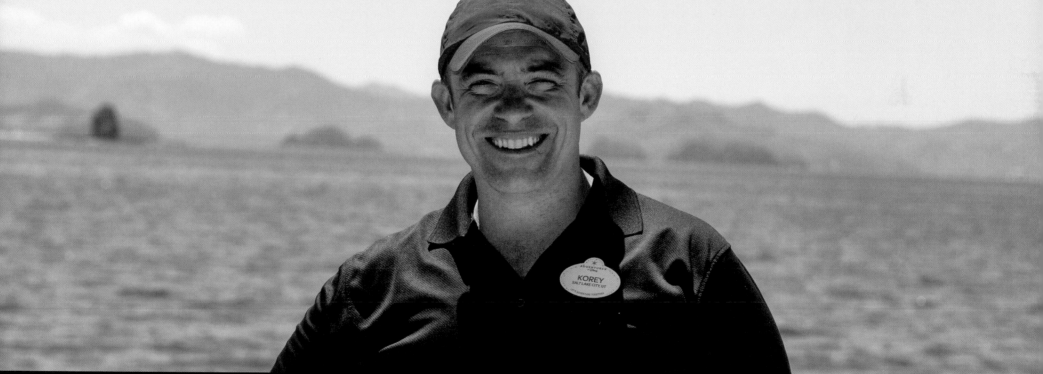

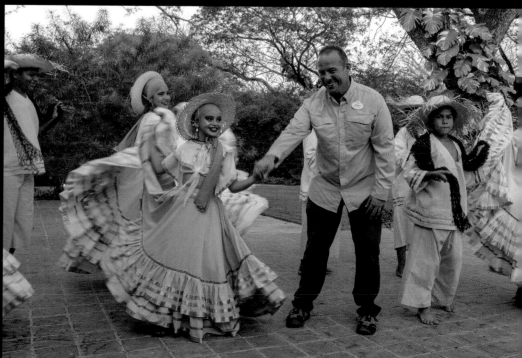

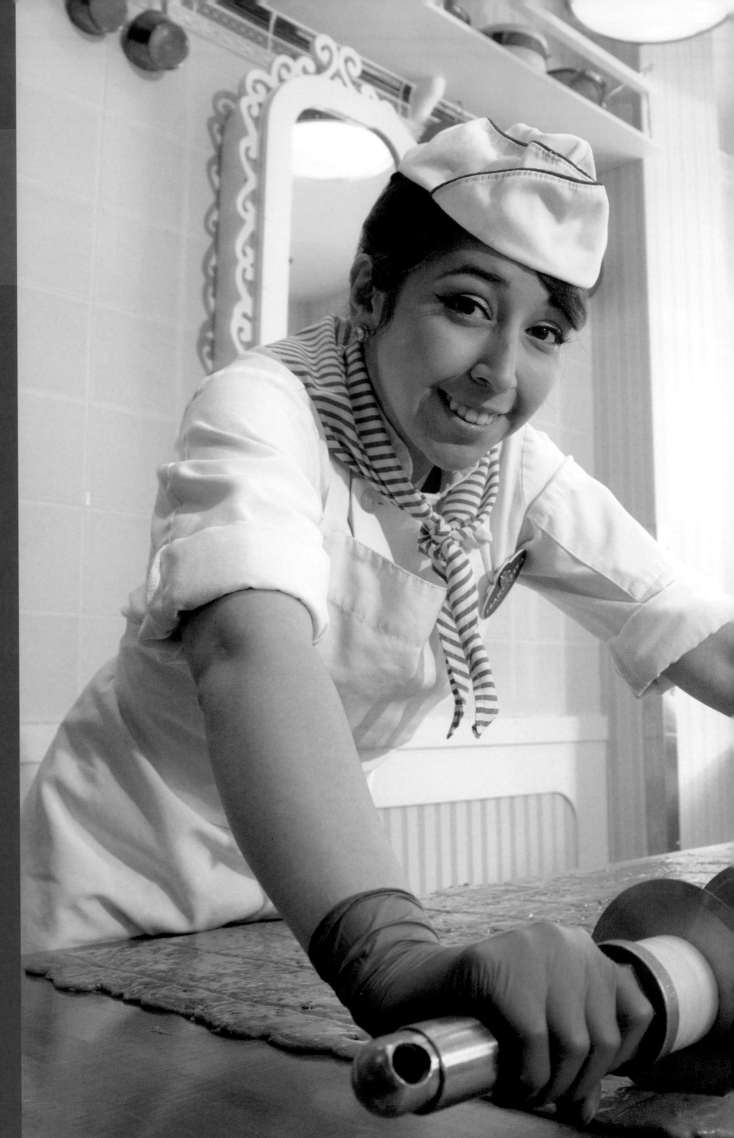

FRANCHESKA
ROMAN

Hometown
Las Vegas, Nevada, USA

Job
Candymaker, Disneyland

Favorite Disney movie
Hercules

Anyone who wonders whether the English toffee is fresh at the Candy Palace in Disneyland can simply look into the shop's window and see Francheska Roman making it with confidence and showmanship.

She's come a long way from the nervous transfer from Fantasyland retail she was seven years ago, less than two years out of high school in Las Vegas. "Making English toffee is very intimidating when you're new and you don't have any prior kitchen experience," she says. "You just overthink things."

On top of that, "it was a little scary to see people watching me, because I didn't want to mess up," she says. It took a while for her to realize, "even when you do mess up, the guests like it because then they laugh and you can laugh with them."

Francheska calls the Main Street, U.S.A., store one of the park's hidden gems, since most guests don't know Disneyland has its own candymakers.

Her own favorite creations are the ever-changing variety of candy apples, many of which Francheska had a hand in developing. "The ones I like the most are the Nemo and Dory, although I'm a little bit biased" since she helped invent them. "They're so cute. And they're apples!"

The artistic side of candy making taps into Francheska's lifelong passion for drawing, a talent she now puts to use creating artwork in chocolate displayed in the shop's front window. A recent favorite was a chocolate portrait of Lilo and Stitch, complete with record player.

For her work at the Candy Palace, Francheska was the recipient of The Walt Disney Legacy Award, the highest honor given to cast members and Imagineers who exemplify three Disney principles: "dream, create, and inspire."

Getting the award was "an amazing feeling," she said, on a level with the joy she felt as a little girl dancing in her jammies to "Hakuna Matata" with her grandmother, who lives near Anaheim. "Anytime I got to stay with my grandma, that's when I got to go to Disneyland," inspiring her dream of working there.

On every visit, "My grandma and I would get a pretzel and watch the parade and then the fireworks," she recalls. Even today, when her grandmother joins her in the park, "We always make it a tradition to get a pretzel before we leave."

And maybe a candy apple to go.

Francheska Roman uses a specially designed cutter to divide fresh English toffee into squares at the Candy Palace in Disneyland.

KRIS

Part of the Magic

KRIS BECKER

Hometown
Pierre, South Dakota, USA

Job
Animal Keeper,
Disney's Animal Kingdom

Favorite Disney movie
The Lion King (1994)

Watching Kris Becker with the lemurs she trains and cares for at Disney's Animal Kingdom is like seeing a revered schoolteacher with her charges: she's firm in her instruction but generous (with food rewards), and she clearly loves her pupils.

"They are incredibly cool," she says. The training is key to getting the animals to participate in their own care. As park guests look on, Kris is getting the animals used to being touched and teaching them simple commands that will facilitate future interactions, such as when it's time to see a veterinarian.

"Animals tend not to show illness until they're really ill," Kris notes, "so it's our job to be paying attention to individual behavior to know if somebody's acting off today."

Kris is also the Species Survival Plan coordinator through the Association of Zoos and Aquariums, and is responsible for the "studbook" for more than forty red-collared brown lemurs in North America. Its detailed family trees and genetic information allow facilities with fertile females to optimize breeding matches.

Kris has worked with countless animal species over the years, starting as a volunteer and then a staff keeper at the Great Plains Zoo in Sioux Falls, South Dakota, a three-hour drive from her hometown of Pierre. She was working at the El Paso Zoo when she heard early news about Disney's Animal Kingdom. "To me it sounded like they were doing some cutting-edge animal care," she recalls. She became a cast member in the park's first year.

Conservation has been part of Disney's Animal Kingdom mission since its founding; that's why, in addition to her daily duties, Kris gets time to work with the Association of Zoos and Aquariums Prosimian Taxon Advisory Group—a professional association that works to improve animal conservation and management—and with the Disney Conservation team that safeguards the sea turtles that nest near Disney's Vero Beach Resort in Florida.

Each spring, she relates, "we spend the night on the beach, and anytime nesting sea turtles come up on the beach, we assess their health through body measurements, blood samples, things like that."

All in all, the job is far from the "playing with the animals all day" that some people might imagine. It's a "pretty dirty job," Kris says. "We have the opportunity to show guests how important these animals are and ways we can save their counterpart in the wild."

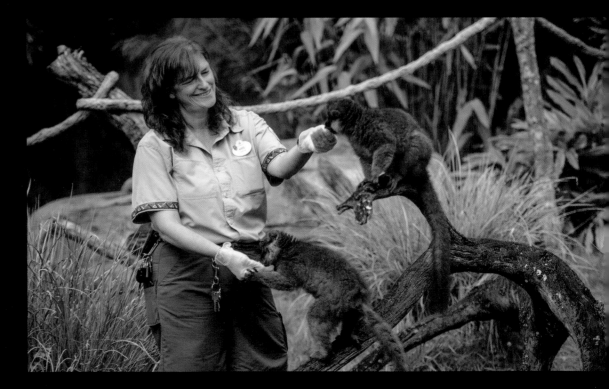

Kris Becker's two principal charges are the brown collared lemurs Thierry (above, top) and his son Pepe. She also works with ring-tailed lemurs (right).

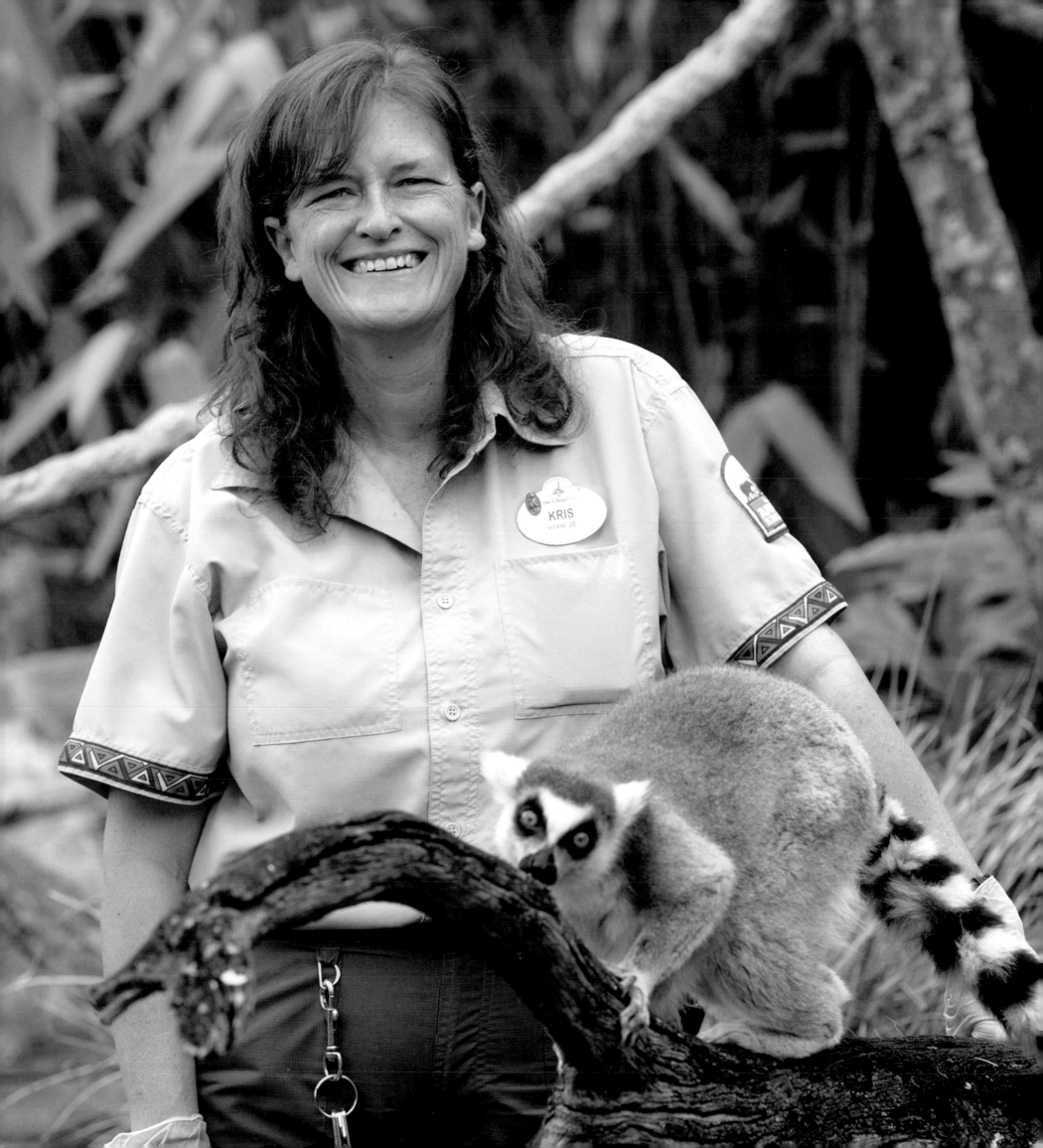

JOE

Part of the Magic

Joseph Hernandez

Hometown
Long Beach, California,
USA

Job
Mark Twain Riverboat
Attraction Working Lead

Favorite Disney movie
Pixar's *The Incredibles*

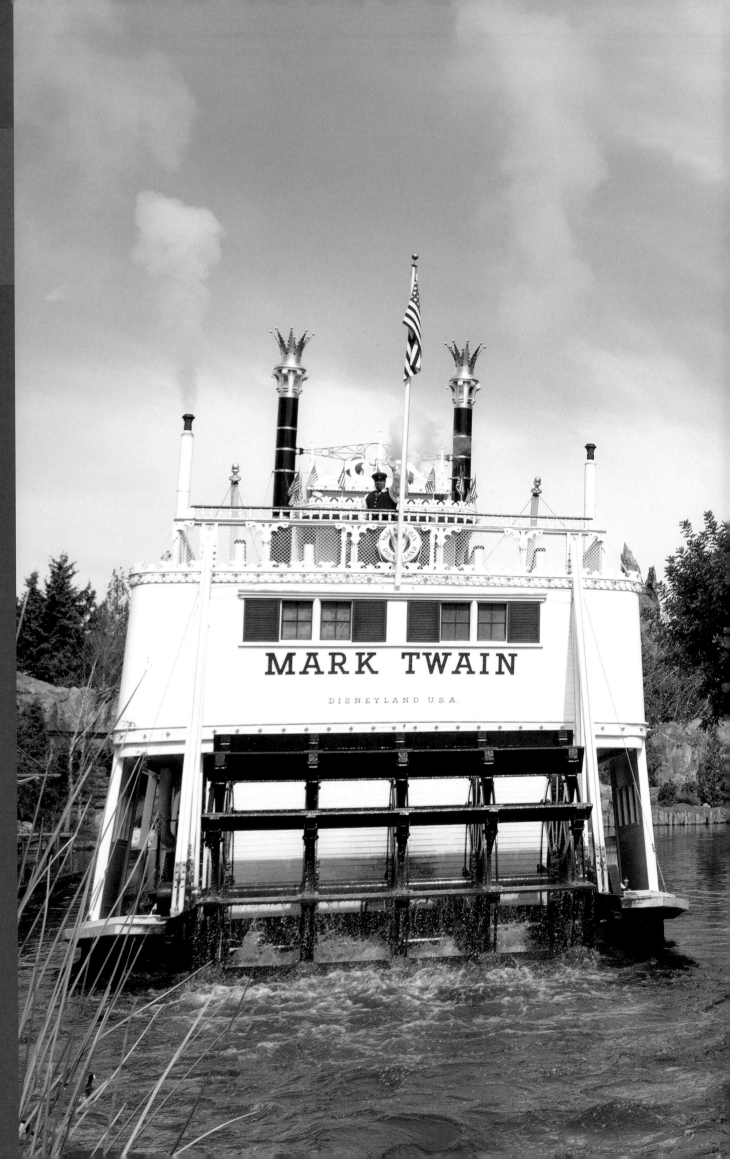

Joe Hernandez goes to work every day on a ship where Lillian Disney once swept the decks. That was in 1955, just before Disneyland opened to the public.

"The actual maiden voyage for the *Mark Twain* was a couple days prior to the park's opening, for Walt and Lillian Disney's anniversary that year," Joe explains, sharing a story he often tells guests as captain of the riverboat. Envisioned by Walt himself, the *Mark Twain* was an opening-day attraction, one of many park features overseen during construction by retired admiral Joe Fowler.

"Admiral Joe Fowler had come down to do an inspection of the *Mark Twain* prior to departure, and he found Lillian Disney on the main deck, making sure everything was neat and tidy," Joe says. "As soon as he stepped foot on the boat, she handed him a broom."

Nearly sixty-five years and a couple of refurbishments later, the *Mark Twain* is still making as many as sixteen voyages a day on the Rivers of America. It's piloted by an onboard engineer, while the captain is the eyes and ears of the boat, watching for other watercraft and interacting with the onboard engineer using signal bells.

The captain also mingles with guests. During most trips, Joe brings a group in to enjoy the trip from the wheelhouse, where they can ask him questions and pose for photos at the helm.

"The most common question I get asked is, 'What are the red buckets for?'" he says, referring to the many pails on the hurricane deck visible below the wheelhouse. "Being that this boat is modeled after an 1800 steamer"—on which steam was generated by burning wood—"those buckets are used to collect rainwater to put out any fire ignited by embers flying out of your smokestacks."

That's not a danger on the *Mark Twain*, but the details were important to Walt Disney. He had the upper decks of the riverboat constructed by Hollywood set wizards on a soundstage at his Burbank studios while the superstructure was built in a shipyard in San Pedro, California.

Joe has been her captain for twelve years, since he started at Disneyland after seeing a flyer advertising jobs on a community college campus. He also sometimes pitches in with the Davy Crockett's Explorer Canoes, helms the *Columbia*, where the captain is also the pilot, and serves as one of the ships' captains during performances of Fantasmic! "On rare occasions, you can find me at Pirates of the Caribbean," he adds. "But usually I'm out on the river."

Joe Hernandez has been captain of the *Mark Twain* Riverboat in Disneyland for more than twelve years. The vessel dates to the park's opening in 1955.

SCOT

Part of the Magic

Scot Drake

Hometown
Newhall, California, USA

Job
Creative Executive,
Marvel Global Portfolio,
Walt Disney Imagineering

Favorite Disney attraction
The Haunted Mansion

Appropriately for an Imagineer, Scot Drake's first job was at an amusement park. Still in high school, he recalls, "I taught myself how to use airbrushes just to go and apply for a job" making custom T-shirts. Scot grew up near a Santa Clarita, California, amusement park. "Everyone I knew started working there when they were fifteen," he notes.

Scot was the only one of those kids who grew up to be the person in charge of bringing Super Heroes to Disney Parks—worldwide. He calls the assignment "an amazing shift in opportunity" from his previous Walt Disney Imagineering duties. "Marvel is not just an amazing storytelling platform," he says, "it's thousands of characters and eighty years of stories. And all the stories are dynamic and relevant to what is happening now."

In addition to attractions already open in Anaheim and Hong Kong, WDI has teased plans for a Guardians of the Galaxy attraction in Epcot and full Super Hero lands in the Hong Kong, Paris, and Anaheim parks—although most details remain closely guarded. What all the encounters will share in common, Scot says, is that guests will finally have "an active role alongside these superheroes, and we can show that you're connected to this larger universe."

Scot hopes the opening of these superhero attractions will match his experience as executive creative director for the new Tomorrowland at Shanghai Disney Resort. "That project was handed to me with essentially a blank sheet of paper," he says. "We had the opportunity to create what a Tomorrowland could be in a city that's already the city of the future. We brought in every type of theorist and futurist to talk about it." That was followed by three memorable years living in China with his family in advance of the 2016 opening of Disney's latest park, time that included adopting a son there. "That park is a very special place for all of us now."

For inspiration, Scot looks to classic Disney attractions like his favorite, the original Haunted Mansion in Disneyland. "I know how it works; I've reviewed the effects and technologies. But I try to divorce my brain from that understanding when I experience it," he says. He cherishes "the emotional reminder of when I was a child going on that with my mom and my aunt and my cousin. Those are the things that I now share with my kids. I am so amazed that the storytelling holds up, that there is something there bigger than any one component."

Scot says something similar about Imagineering. WDI attracts "experts in robotics, in ride engineering, in architecture, in aerospace or the military"—to name a few— "and the culture that is created because of all these diverse backgrounds is what I think is the secret sauce that makes Imagineering so special."

Scot Drake's office is the hub for all his upcoming projects at Walt Disney Imagineering, which is developing Super Hero lands at Disney Parks throughout the world.

NONTRA
Part of the Magic

NONTRA NULL

Hometown
Silver Spring, Maryland, USA

Job
Design Manager, Softlines Product Development

Favorite Disney movie
Beauty and the Beast (1991)

Nontra Null ticked all the boxes on the "destined to work for Disney" checklist: liked to draw princesses as a girl? Yep. Wanted to be an animator? Check. Quoted Buzz Lightyear's "To infinity and beyond!" in her college entry essay? Of course. Cherished her childhood bottle of Disney pixie dust? "It was my favorite little toy," she says. "But I wasn't allowed to open it because it would make a mess."

She also loved sewing and started making her own clothes at age seven, mentored by her live-in grandmother, who had made all the clothes for her seven children back in Thailand. "She walked me through the process at an early age," Nontra recalls. "It was something I was good at, so I kept on doing it."

When college-bound Nontra saw that the future of Disney animation favored computers over drawing, she switched her focus to fashion. But after graduation and a couple entry-level jobs elsewhere, she ended up working for Disney after all, now as a design manager for Disney's softlines product development.

Softlines encompasses "anything wearable," she explains, including accessories from shoes and handbags to sunglasses and flip-flops. Her focus is girls ages two to fourteen. With her drawing skills, Nontra not only designs production-ready clothes, she creates graphics and artwork for the merchandise.

"Bringing the stories to life on our products is part of my job," she says. "It's not just making a square lunch box with a graphic on it. It's about making a lunch box that feels like a van Mickey Mouse would camp in. Or making a dress that has a little bit of a costume feel to it, so a little girl can feel like a princess even though she's in her everyday clothes."

Nontra's days are filled not only with designing but also with "a million different meetings" and trend research. One growing market? "Families buying matching items from baby all the way through Mom and Dad," according to Nontra. "It's exciting to see that the whole family is embracing the look together."

Now a mother herself, Nontra frequently encounters her creations in everyday life. "Swimwear is a big category for us, and we have our fun bags and coolers, so my son's swim school is a concentrated area of Disney products."

Nontra's little boy has already started his own Disney career, having served as an infant model online. Once he was six months old and passed his audition, "he ended up as Buzz Lightyear on our website." *To infinity and beyond,* indeed.

Children's clothing designer Nontra Null is a lifelong Disney fan, having visited Walt Disney World twelve times before she turned eighteen.

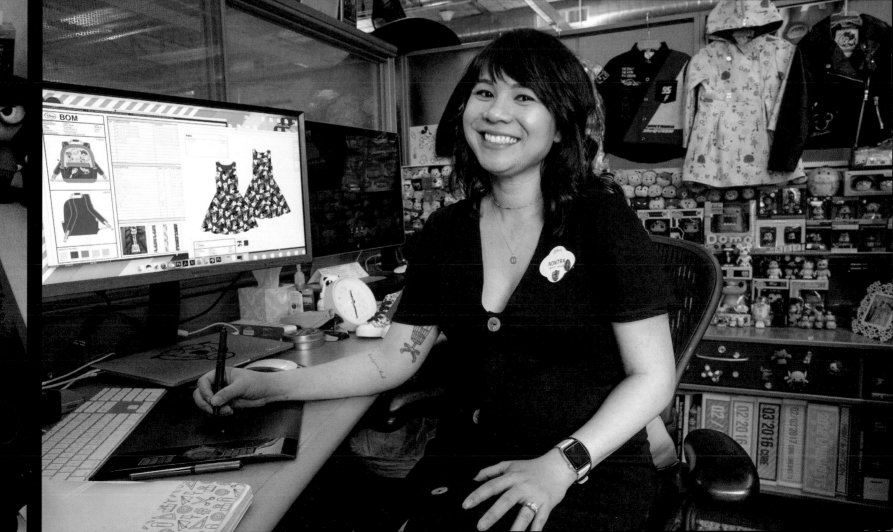

ED

Part of the Magic

EDWARD FRITZ

Hometown
Detroit, Michigan, USA

Job
Ride Engineering
Executive,
Walt Disney Imagineering

Favorite Disney attractions
Indiana Jones Adventure
and Avatar Flight of
Passage

Ed Fritz didn't even know how to turn on a computer when he applied for a summer job creating a spreadsheet program for a small automotive engineering company in Detroit, back around 1980. Ed recounts the advice a friend gave him before he headed to his interview with the owner of the company: "Whatever he asks, just tell him you can do it. You'll be able to figure it out."

He got the job, finished the program halfway through the summer, and has been living by the motto "You'll be able to figure it out" ever since. It's that belief that drove him for five years as he developed the enormously popular Avatar Flight of Passage attraction within Walt Disney Imagineering that's now drawing throngs at Disney's Animal Kingdom.

Early on, Ed proposed that the big ride in Pandora at Disney's Animal Kingdom should put guests on the back of a banshee—as depicted in the film *Avatar*—and fly them around the planet. The question he was asked by Imagineering executive designer and vice president Joe Rohde was, "Can you build a machine that's so smooth and fluid it feels like you're on an animal?"

Ed's answer: "Oh, yeah, for sure I can figure that out."

The Imagineering team then proceeded to do just that. They designed "the big machine that moves you around" and built a prototype at two-thirds scale to test it. They went through fourteen prototypes for the seats, starting with

a cafeteria chair attached to a robot arm—used to determine the ideal range of motion—and progressed through fiberglass models to the finished steel used in the ride. "We just take each problem and break it down into little pieces and attack each piece," Ed says, making it sound like a simple process.

His confidence is well grounded after thirty years with Imagineering, having begun as an automotive engineer who was called down to Walt Disney World to help perfect steering and suspension for The Great Movie Ride. A few years later he went to California to work out the "crazy off-road motion" for the Indiana Jones Adventure vehicles at Disneyland. He expected to be there two years, but never left.

Ed is hesitant to toot his own car horn but says, "I'm told what sets me apart here at Imagineering is that I'm able to take very complicated topics and explain them to people in simple terms. And I think part of getting these jobs moving forward is to be able to convince people that you have it under control."

Having worked on the recently opened Disney Skyliner gondola transportation system at Walt Disney World, Ed's next big attraction premiere will be Mickey & Minnie's Runaway Railway, on the former site of The Great Movie Ride at Disney's Hollywood Studios. "It's the first Mickey Mouse–themed ride we've ever done," he notes. And just one more challenge Ed's got figured out.

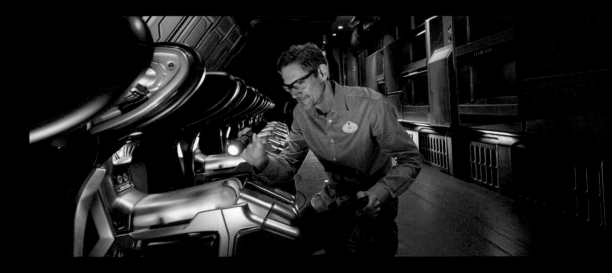

Ed Fritz inspects the Avatar Flight of Passage attraction at Disney's Animal Kingdom, the culmination of his thirty-plus years with Imagineering.

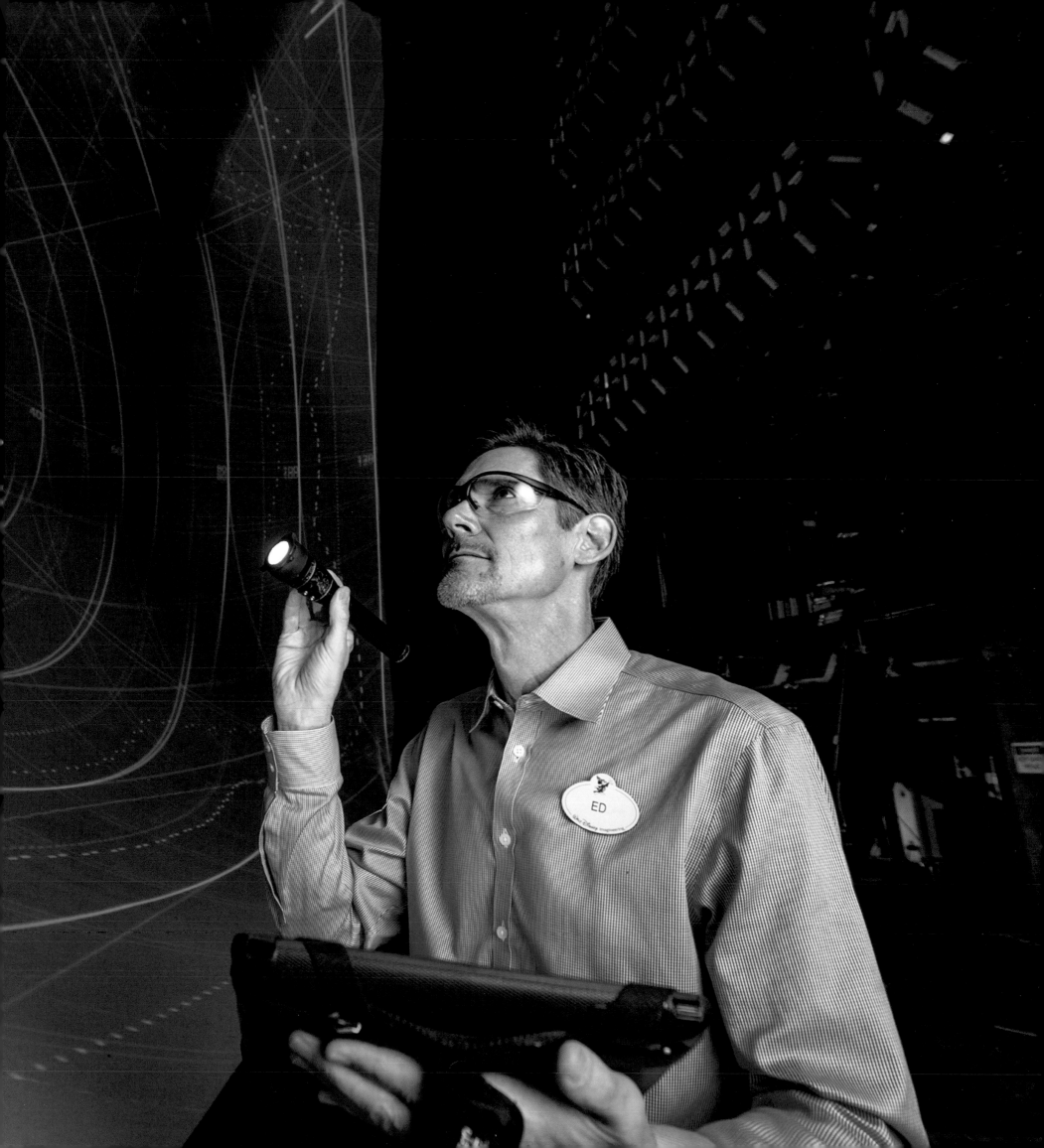

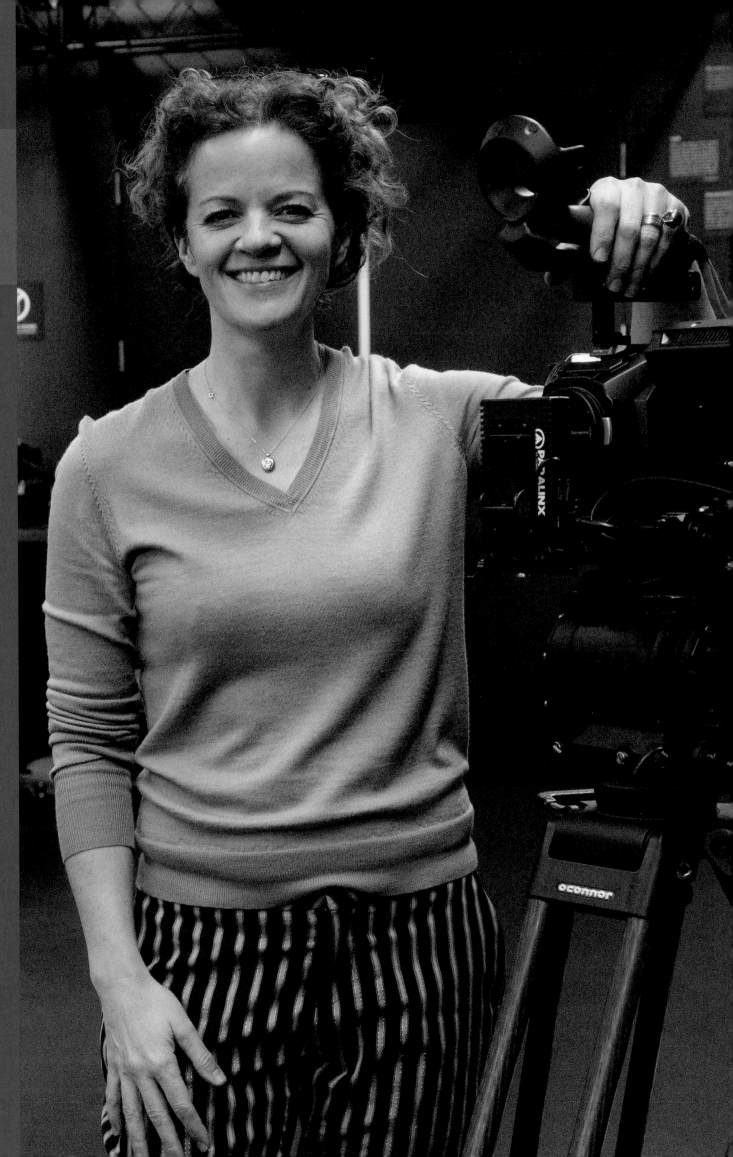

ALICE
Part of the Magic

Alice Taylor

Hometown
London, England

Job
Vice President, Content
Innovation and StudioLAB

Favorite Disney attraction
The Haunted Mansion

This past spring, Alice Taylor was working on seventy-one different projects in her role as vice president for Content Innovation and StudioLAB at The Walt Disney Studios. And she can't tell you about any of them.

Well, that's not entirely true. One thing her team is developing is an advanced drone system they've dubbed Scout in a Box, for movie-location scouting. The drone flies around a site—say, the strip mall where Vers crash-lands early in *Captain Marvel*—and through 4K video and a CG technology called photogrammetry, "within something like ten minutes we have a rough 3-D computer model to be sent back to HQ," she explains.

That's just one example of what Alice calls "advanced technology for storytelling"—her four-word job description. That may mean creating tools for filmmakers, like Scout in a Box, or immersive experiences for consumers, like virtual reality (VR), or some other breakthrough whose utility will emerge as it evolves. "It always comes back to the question, are there new ways to create stories with this technology?" Alice ponders.

The overriding mission is innovation, an impulse personified by Walt Disney himself. "He had a healthy obsession with both technology and with art—and what the combination of the two can create," Alice says.

Not every project succeeds. "The point about having an innovation group is that there should be a failure rate—like, 40 percent—because if you're not failing at something, you're probably not being courageous and inventive enough."

Team members have a lot of PhDs—in natural language processing and artificial intelligence, for example—and include pioneers in fields like VR, visual effects, and computer graphics. Alice herself built some of the first websites for the communications industry in Great Britain and spent many years in R & D and digital media for the BBC and in children's media development for Britain's Channel 4 in her native London.

Alice popped onto Disney's radar when she quit her job to create MakieLab, a start-up that allowed kids to create customized dolls that could then be printed out in 3-D plus turned into video avatars. "Disney was very interested in the idea of individualized toys," she says. MakieLab became a Disney Accelerator company, and Alice shifted over into her current job.

"People have always called me a creative technologist," she says, "and I thoroughly enjoy the challenge of bringing those two worlds together." That includes bringing people with diverse personalities and backgrounds together in order to be able to cover the breadth of where the challenges and opportunities lie. "I like it best when our team is laughing and full of delight at the thing that they just discovered," she says. "It's a feeling that Mr. Disney probably had daily, given that he was inventing things that folks had never really seen before."

At The Walt Disney Studios, Alice Taylor runs the gadget-filled StudioLAB, a project to create and test technologically innovative modes of storytelling, including VR and drones.

RYAN

Part of the Magic

Ryan Meinerding

Hometown
North Canton, Ohio, USA

Job
Head of Visual
Development,
Marvel Studios

Favorite Disney movie
Tarzan

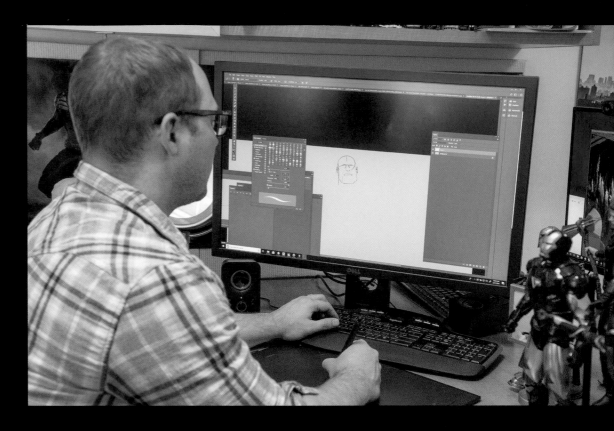

Ryan Meinerding's mom should be happy now. "She used to get angry at me for using too much paper for my drawings and drawings and drawings," he recalls. "She'd say, 'Why can't you turn the piece of paper over?' And I'd say 'It's a work of art. You can't just draw on the back.'"

As the head of Visual Development for Marvel Studios, Ryan now spends much of his day drawing, painting, and sculpting without using any paper at all. "These days, painting means digital paint—drawing and sculpting in the computer."

Ryan's team of artists designs all the heroes and villains for the Marvel Cinematic Universe, inspired but not limited by their comic book counterparts. They shepherd every helmet, hammer, and costume from dozens of early sketches to final fittings, or—in the case of CG characters—digital execution.

"I designed Thanos's face and costume for *Infinity War*, so that went off to the visual effects house, where they brought in Josh Brolin's performance," he explains.

Ryan's been a Marvel fan since he was a toddler running around in Spider-Man Underoos in North Canton, Ohio. "I owned a bunch of superhero merchandise before I actually got a comic book," Ryan remembers. It was hardly a fleeting thing. His final thesis for the industrial design program at the University of Notre Dame

was the three action figures he had sculpted and painted, and then presented in original, handcrafted packaging as if store-bought.

He moved to California after Notre Dame to attend the ArtCenter College of Design in Pasadena. His work there impressed one of his heroes: *Star Wars* concept artist Iain McCaig—designer of Darth Maul, among many other iconic figures. Iain introduced Ryan to Jon Favreau, who was then developing the first *Iron Man* movie; soon after, Ryan was charged with designing the hero's suit, "one of the very first 3-D–printed costumes."

The success of *Iron Man* triggered the explosive growth of Marvel Studios, and Ryan was soon supervising a squad of artists, creating and safeguarding the visual imagery for the company's many cinematic properties.

Every character in every movie goes through countless iterations, and every detail matters—a lesson Ryan learned early. Across the front of Iron Man's first helmet, crafted by Tony Stark from scraps in his prison cave, Ryan added a welding seam, "just so in close-ups you would still get that this was a cobbled-together suit," he explains. "That weld line became something that people were very angry about for a period of time. I didn't see that coming."

A small army of Marvel characters greets Ryan Meinerding at his office, where he supervises visual development for Marvel Studios, with a particular focus on character design.

MICHAEL

Part of the Magic

Michael Ilardi

Hometown
Dobbs Ferry, New York, USA

Job
Principal Research & Development Imagineer

Favorite Disney movie
The Lion King (1994)

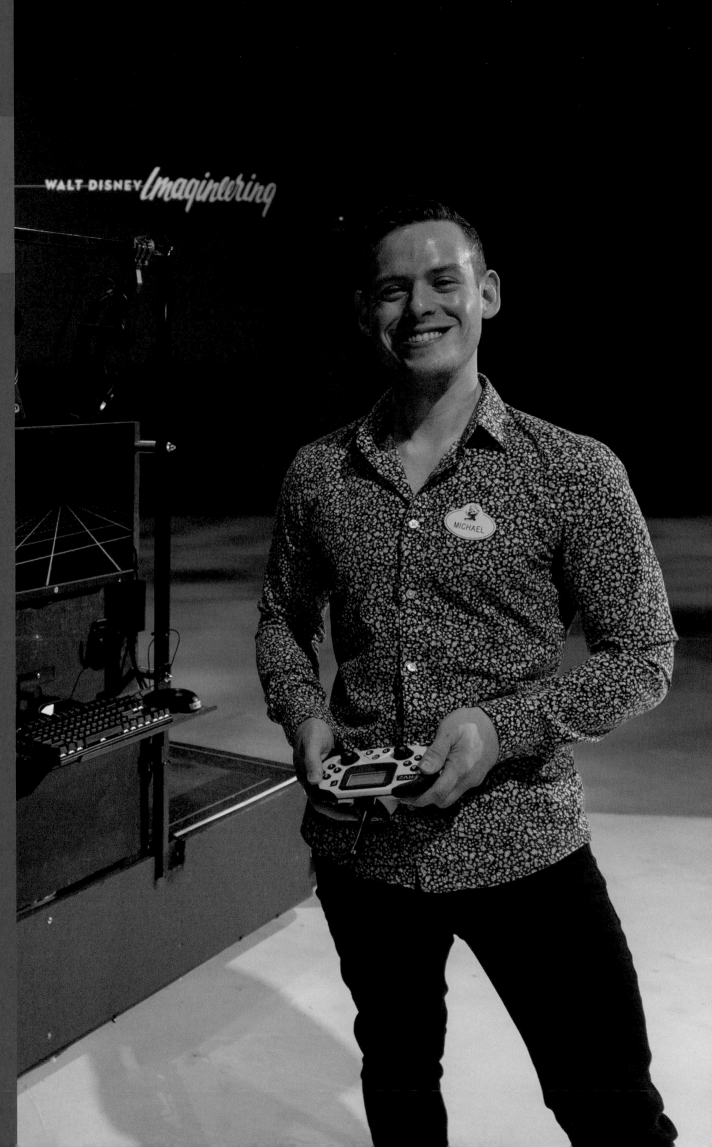

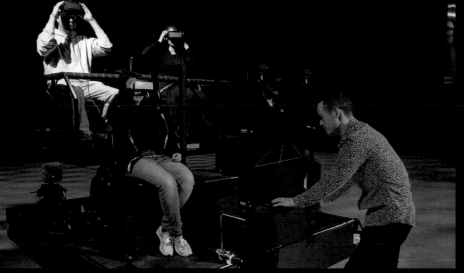

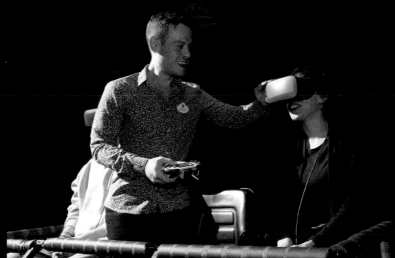

By the time he repurposed his family's humidifiers, Michael Ilardi's parents probably had a pretty good idea that their son would grow up to be an Imagineer. Then about ten years old, young Michael recruited his best friend from down the block in Dobbs Ferry, New York, to set up a basement preshow and living room special effects for a family viewing of *The Lion King* on VHS. (The humidifiers produced a nice fog effect for when Mufasa appeared out of the clouds.)

Between his early home theatrical endeavors and many Halloweens of elaborate yard displays, it wasn't surprising that Michael wanted to design theme park attractions from the moment he became aware that grown-ups could do that as an actual job.

Now he's a principal research and development Imagineer, having augmented his early showmanship with a degree in computer science and nearly a dozen years at Imagineering's Glendale, California, campus.

He and his team "prototype all kinds of ideas—anything you can imagine but with a focus on the future of dimensional entertainment." That encompasses everything from Audio-Animatronics technology and animation to virtual reality and technologies so cutting edge that they're still shrouded in secrecy.

In other words, if an Imagineer can dream it up, it's the the team's job to use their programming, mechanical, and other skills—plus, of course, their imaginations—to make it real.

A lot of the technology his team develops later appears in the parks with "a very different creative wrapper," he says. But not always. Anyone who has enjoyed having their shadow interact with the shadow butterflies and Tinker Bell in the queue at Peter Pan's Flight at Walt Disney World has seen Michael's blend of tech and whimsy in action.

Michael's career as an Imagineer almost didn't happen. It began with the offer of a three-month internship right after college that he considered turning down, since to take it meant he would have to quit a full-time job he loved in New York City and move to Los Angeles, where he didn't know anyone. Then he realized that "the twelve-year-old me would have been very disappointed if I hadn't taken it." He took the leap and, like Peter Pan, he has yet to land.

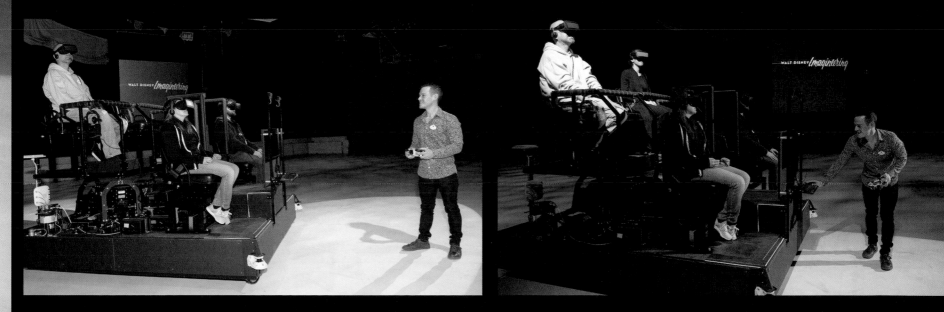

While the finished attraction won't use virtual reality, Michael Ilardi and Imagineers utilize VR headsets on trackless ride vehicles in a mock-up facility to simulate an attraction experience long before construction begins.

TIA WALLACE KRATTER

Hometown
Orinda, California, USA

Job
Manager,
Art & Film Education,
Pixar University

Favorite Disney movie
Dumbo (1941)

Growing up, Tia Wallace Kratter says, "I knew I wanted to be either an artist or a teacher." She got to be both: first as a background artist for Disney animated features, and then as a shading art director for Pixar movies . . . and now as manager for art and film education in Pixar University, Pixar Animation Studios' continuing education program.

Her determination to work in the arts was cemented during a visit to "it's a small world" at Disneyland back when she was in her tweens. "I saw that hippo in the front of the rain forest section, and I just thought, *Oh my God, that's what I want to do. I want to make these things for Disneyland.*"

As it turned out, "I'm not a very good three-dimensional sculptor," Tia says with a laugh. So she turned to painting and got a job right out of college working on Disney's animated films including The *Fox and the Hound, Aladdin,* and *Beauty and the Beast.*

A native of the Bay Area, she reconnected with former Disney animator John Lasseter when she returned to San Francisco in the early 1990s, just as Pixar was gearing up for its first feature, *Toy Story.* She taught herself digital painting, joined the crew, and never left.

As a "shading art director" on movies such as *Cars* and *Brave,* Tia says, her team "figured out the colors and textures of anything modeled in the film." Fo *Monsters, Inc.,* for example, that mean creating "about fifty paintings of differen hair patterns and different color ideas just for the character of Sulley. After al that, the final fur pattern was an inspiratior of cowriter Andrew Stanton, who told Tia "Listen, this is a monster in a kid's world. I should just be big round circles." Tia took that idea and shepherded the design through its final, memorable form.

Now, as one of Pixar's in-house educators, Tia's job is to inspire fresh creativity by exposing the studio's entire staff to "new looks, new visuals, and new approaches to the worlds we create," she says. "We cannot become complacent ir what we do."

Perfection, however, was not always the top priority on her agenda. Or *Toy Story,* Tia's job description was "Imperfectionist." It was her job to add believability and patina to the flawless environment created within a computer By adding scratches and splatters, and staining surfaces, Tia helped to create a more believable, lived-in world that didn' feel so stiff and rigid. "So, my job was to go in and put dirt and scuff marks on the floors and on the baseboards, fade the wallpaper, and scratch up desks."

After a moment, she adds, "I still am very good at being imperfect."

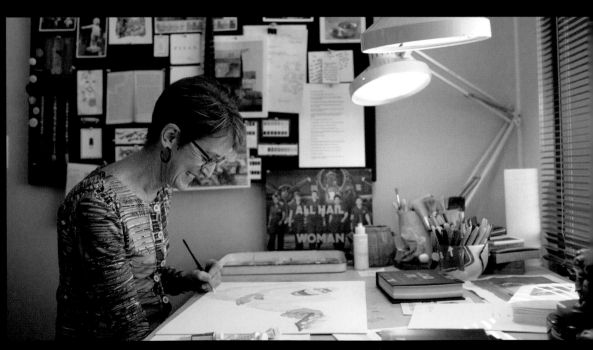

Tia Kratter utilizes her decades of experience as a Disney and Pixar artist to hone the skills of other cast members through hands-on creative projects at Pixar University.

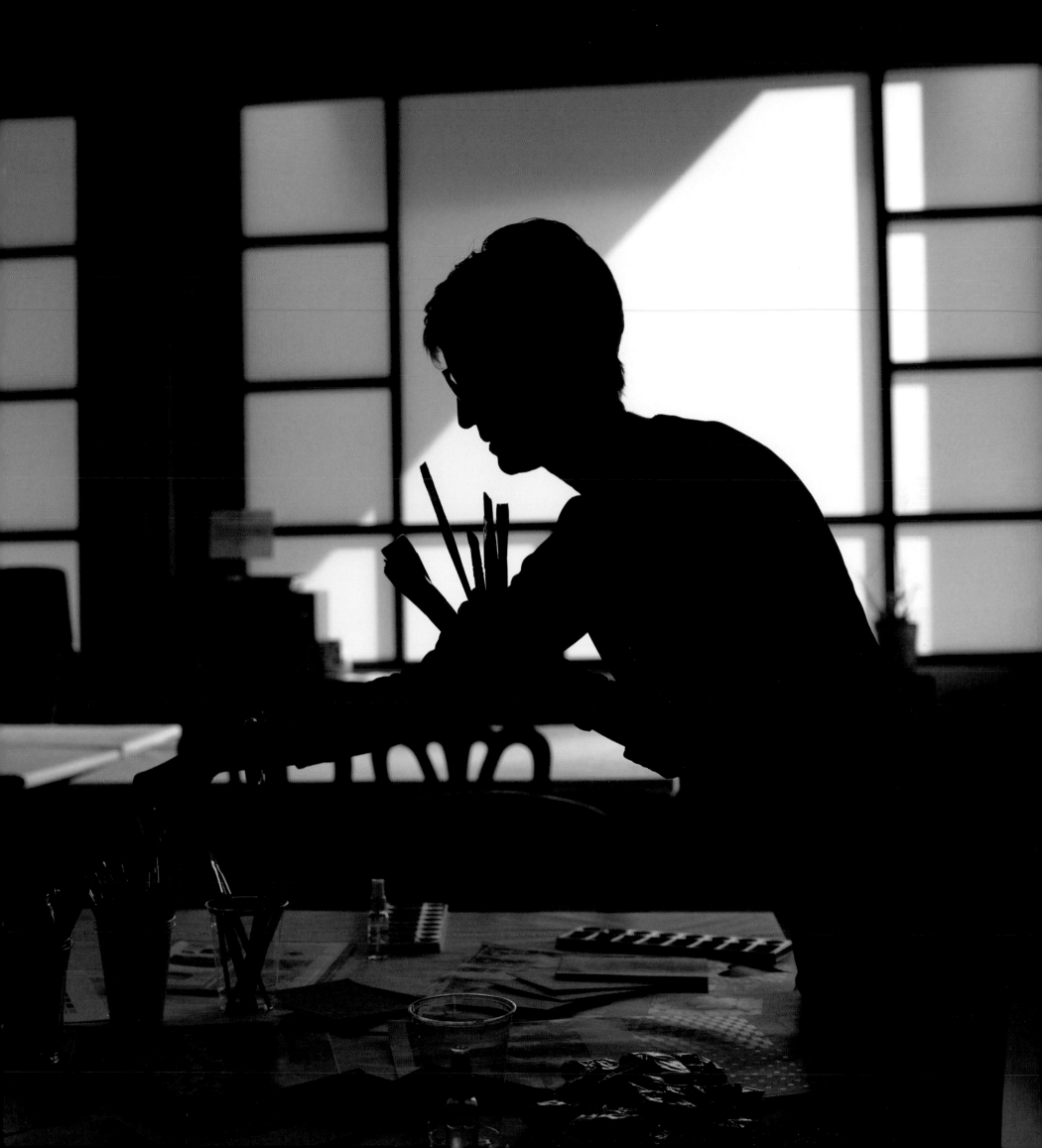

BOB

Part of the Magic

BOB
IGER

Hometown
Oceanside, New York, USA

Job
Chairman,
Chief Executive Officer,
The Walt Disney Company

Favorite Disney attraction
Pirates of the Caribbean

Bob Iger was four or five years old when he saw *Cinderella*, sitting with his grandparents during his first trip to a movie theater. "I must have connected with it," he recalls of seeing a mid-1950s rerelease of the Disney animated classic, "because every time I've seen that movie since, it evokes that memory."

Connecting audiences with beloved stories has been at the heart of The Walt Disney Company since the beginning, and it still defines Bob's work as Chairman and CEO. Storytelling, he says, "is how we're best known. All of our art is tied directly to the stories that we tell."

Bob's involvement with story development—whether fielding early pitches at Pixar as part of the SparksShorts animated-shorts program, as seen in these photographs, or seeing an early screening of the live-action *The Lion King* with its creative crew—is "probably the most important part of my job."

Bob emphasizes that this focus started with Walt Disney himself. "The whole notion of telling stories and setting as the primary goal touching people's hearts—that's definitely a lesson I've learned from learning as much as I can about Walt."

Another lesson? Walt Disney's "relentless pursuit of perfection," Bob says. "He called it 'plussing'—doing whatever you can to make something that is good great and make something that is great even greater."

Walt Disney made his first impact on Bob in childhood, through a small black-and-white TV set. "I remember Walt Disney talking about and showcasing his plans to build Disneyland on television," he says. "I remember very, very distinctly watching Disneyland get built and dreaming of one day being able to go there."

Bob's first visit to the park, in his twenties, had to wait until he'd finished high school in Oceanside, New York, and earned a Bachelor of Science degree in Television and Radio from Ithaca College. After a brief stint as a TV weatherman in Ithaca, Bob moved to New York City and joined ABC. He rose steadily at the network, and by the time Disney bought the company in 1996, he was president and COO. He became president and COO of Disney in 2000 and CEO in 2005.

Running such a large, international company takes teamwork, Bob notes. "I have a very talented team of people that work with me, and they manage these processes very effectively—including the process of determining what should rise to my level."

At every level, Bob has faith in cast members to fulfill the company's storytelling traditions. "It's very important for us to never lose sight of the value that every cast member brings to the whole of The Walt Disney Company," he says. "Walt gave our cast the name 'cast members' for a reason. He knew that our cast were basically performers—people responsible for creating and delivering magic to others, particularly at our parks."

Some of Bob's most satisfying moments on the job are witnessing the impact of that magic in person: seeing a Disney movie with a regular audience, for example, or spending time in the parks. "It's beyond thrilling when I get to see firsthand just how the stories that we tell excite people around the world," he says. "Nothing's better than walking down Main Street in one of our parks and watching guests immerse themselves in the greatness that is Disney theme parks. It never gets old."

SOFIA

Part of the Magic

SOFIA WYLIE

Hometown
Scottsdale, Arizona, USA

Job
Plays Gina in the Disney+ series
High School Musical: The Musical: The Series

Favorite Disney movie
High School Musical

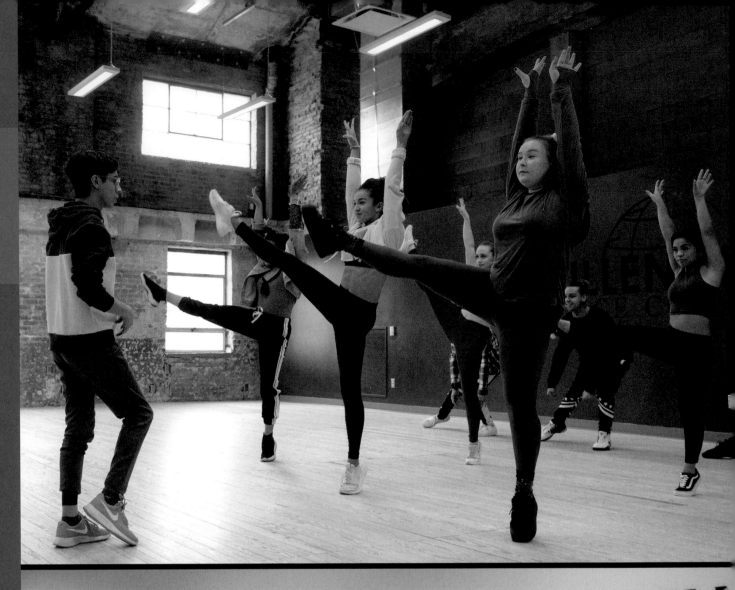

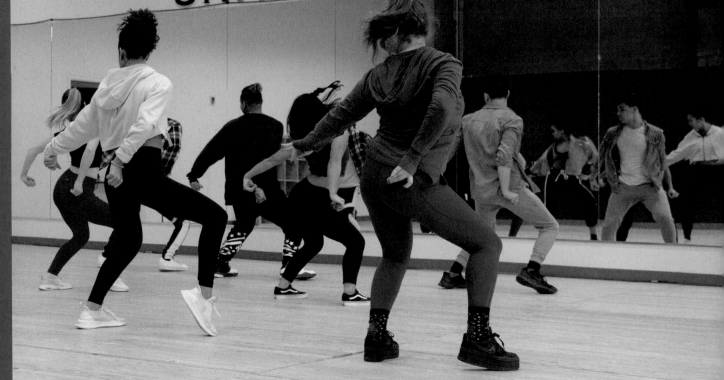

Sofia Wylie (in pink top) rehearses at the home of the Millennium Dance Company in Salt Lake City with fellow cast members from *High School Musical: The Musical: The Series*. They include series regulars Frankie A. Rodriguez (in yellow) and Julia Lester (in purple sweatshirt).

Few childhood dreams come true with quite the specificity Sofia Wylie has. Years ago, she and her sister would reenact songs from Disney's original *High School Musical*, "because that was our favorite movie growing up," Sofia recalls. Now she's in the cast of *High School Musical: The Musical: The Series* for Disney+, performing some of those same songs for the cameras to be seen by millions, not just her family.

Filming even took place at the same Salt Lake City, Utah, high school locale where the original movies were shot. "My first day on the set, my dad and I pulled up to East High, and I bawled my eyes out. Looking at the school and knowing I was about to go in there and film was so, so incredible. The rest of the day I just couldn't get a smile off my face."

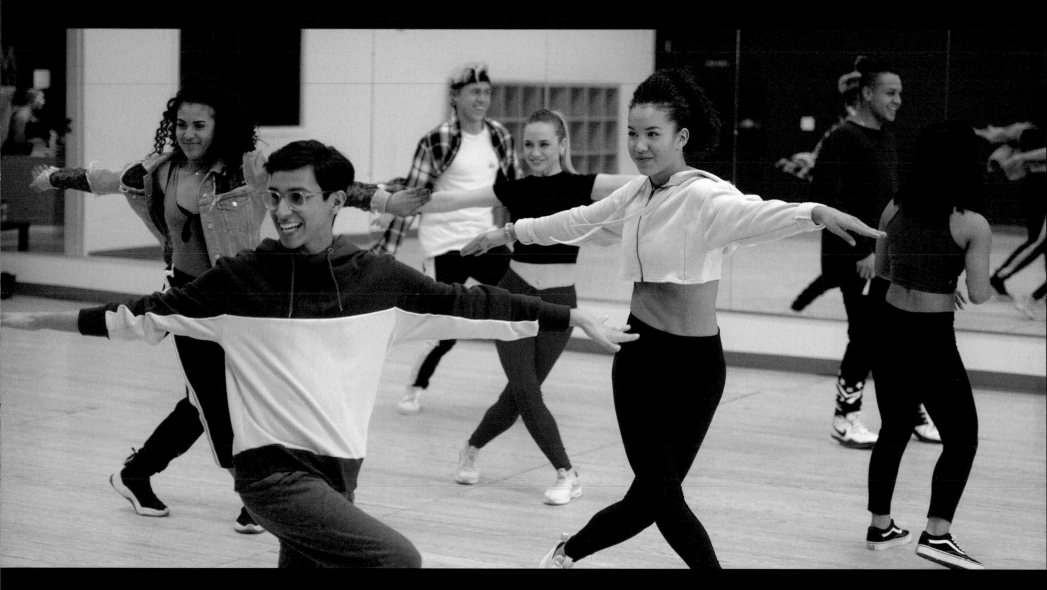

At fifteen, Sofia is a Disney Channel veteran, having won the role of Buffy on the series *Andi Mack* in 2016—after auditioning "a million times." But she's been performing since at least age seven, when she played Oompa-Loompa No. 6 in a youth musical production of *Willy Wonka* in her hometown of Scottsdale, Arizona.

When she turned ten, "I really got into dancing," Sofia remembers. "I was obsessed with it," she adds, "and eventually that love for dancing grew into a love for acting."

She's already got one starring role to her credit, in the soccer-themed Disney Channel movie *Back of the Net*; and she's the voice of main character Riri Williams in the Disney XD animated special *Marvel Rising: Heart of Iron*. All that and she just became a high school sophomore.

"I used to say how easy it was to act and do school on set. But that was when I was in middle school. High school is definitely much harder," she says.

With ten episodes in its first season, the *High School Musical* series expands the franchise in characters and subject matter. "There is so much diversity within the cast, and the story lines are just incredible." That's true of the music, too. "I cannot stop humming all of the new songs," Sofia says. "They are so incredible and catchy—and the messages are so uplifting."

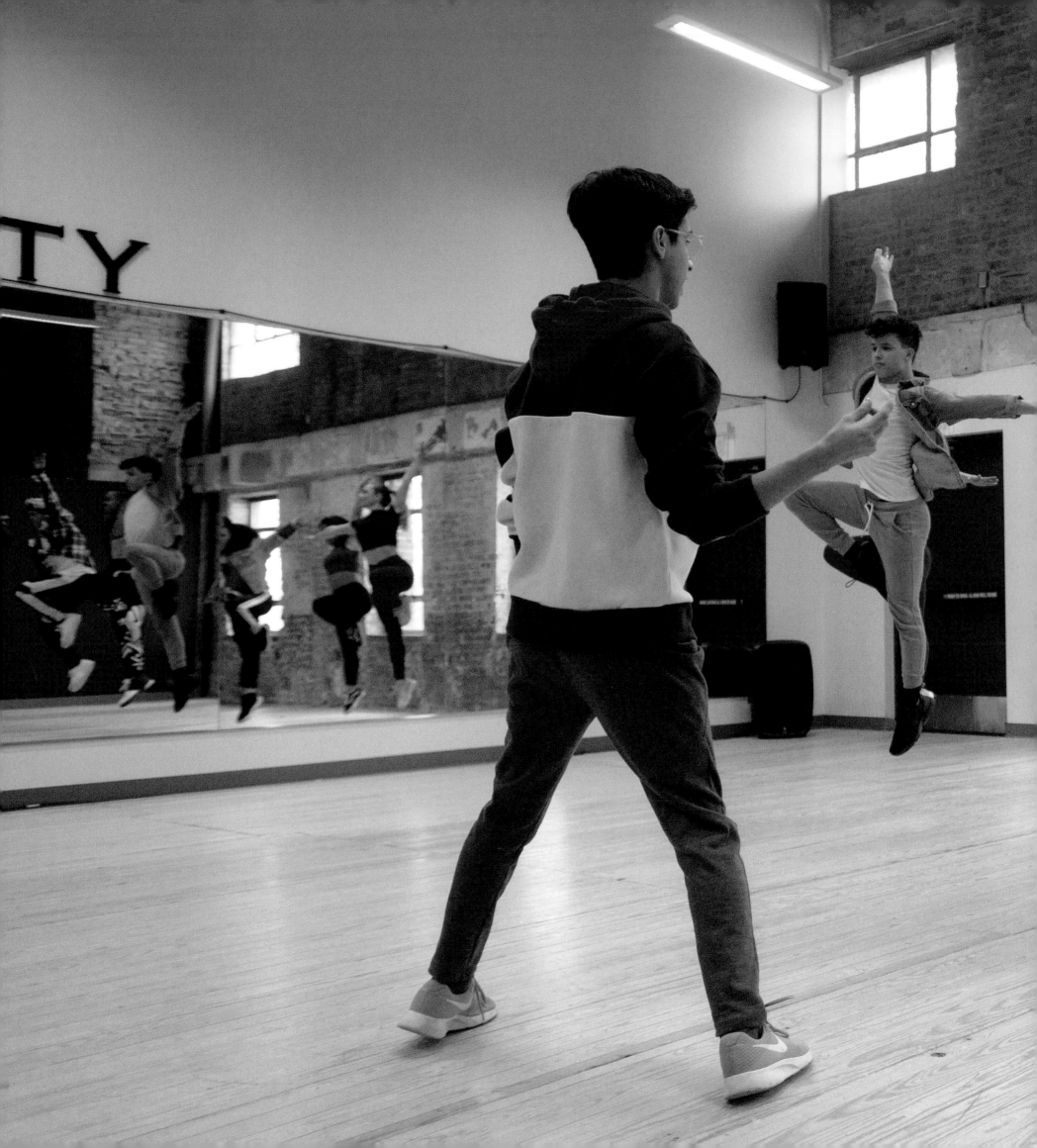

Chapter Five

Noon – 3 pm

As intense as the midday sun over California is the love of family in the hearts of Disney cast members. Whether it's actor-producer Ellen Pompeo's devotion to being present for her children, or *The Mandalorian* director Bryce Dallas Howard's acknowledgment of her debt to her father, director Ron Howard, family comes first and last.

For instance, Walt Disney Imagineering's Laura Cabo grew up in eighteen or nineteen different places, buoyed around the globe by her father's U.S. Navy career—never imagining her accomplishments in architecture would take her full circle . . . to a shipyard. Leslie Evans's mom taught her to sew so she could make her own stuffed animals—which in some ways Leslie is still doing at Imagineering.

And as family memories go, none burns brighter than *Finding Nemo—The Musical* actor Katie Whetsell's story of her mom's first and only visit to Walt Disney World. As long as the sun shines, cast members will remember where they came from.

JESSE
Part of the Magic

JESSE TYLER FERGUSON

Hometown
Albuquerque,
New Mexico, USA

Job
Plays Mitchell on ABC's
Modern Family

Favorite Disney movie
Peter Pan

The closest Eric Stonestreet gets to a TV viewer's experience of catching a fresh episode of ABC's *Modern Family* is at the weekly "table read." That's when the cast and creative staff gather to perform a script aloud for the first time.

"I prepare my part, but I don't read anyone else's parts [in advance]," says Eric, who plays Cameron on the show. "It's the first time we're seeing it and hearing it all come together, and it's very pleasing to be a part of that creative collision."

For fellow cast member Jesse Tyler Ferguson—who has played Mitchell, Cam's husband, since the pilot in 2009—the table read is like a mini reunion. Since most scenes in the sitcom are shot with just a few actors at a time, "It's the one time of the week that the whole cast is guaranteed to be in the same room," Jesse notes. "It's fun for us to come together before we go our separate ways for the week."

Jesse and Eric came to *Modern Family* eleven years ago by different paths: Jesse had done more New York theater; Eric had done more television. But both had to lobby and try out for the roles they eventually secured. Jesse first auditioned for Cam, when the role he wanted was Mitch, while Eric was told no twice after auditions before being invited back for a third try. That's when the two actors first met—since Jesse played Mitch during Eric's third audition for Cam.

"I was one of the first people that they actually offered a job to through casting calls," Jesse recounts.

"Jesse already had the part," Eric says. "He loves telling everybody that."

The third time was the charm for Eric. The audition led to a meeting at the network, and "within fifteen minutes of me leaving ABC, I had the part," he remembers. "It's proof that Hollywood is a town of the fastest 'Yes' and the slowest 'No.'"

For Jesse, it was the most important part he'd won since Chip—the character Frank Sinatra once played—in the 1998 Broadway revival of *On the Town*. Then a struggling New York actor, Jesse had been tending bar at the Winter Garden Theatre to help make ends meet. "*On the Town* allowed me to leave that job," he recalls. "Ironically, a lot of people in the production of *Cats* [at the Winter Garden] also auditioned for *On the Town*, and I think they were a little angry that the bartender got the job."

Not long after, in Los Angeles, Eric got what he considers his breakthrough role: a bit part as a hotel clerk in Cameron Crowe's 2000 movie, *Almost Famous*. "Having a few lines

ERIC

Part of the Magic

Eric Stonestreet

in a major motion picture with a really respected director—that was a big, big moment for a guy who'd been out here less than two years," he observes. "It gave casting directors a reason to see me. It helped me stumble forward and put me on the trajectory to be called in for Cam on *Modern Family*."

Shortly after Jesse and Eric both won their *Modern Family* roles came a table read of the pilot that would be crucial to the show's future. It was held in a cavernous room at The Walt Disney Studios and attended by about two hundred people—network and studio executives, marketing staff, casting directors, other important folk. "It went really well," Jesse says, "but I know Eric was terrified that he was going to get fired."

True, Eric says, but "if any actor after any [initial] table read of any network TV show says they're not scared they're going to be fired, they're lying to you."

It was after that crucible of a performance that someone grabbed Jesse and Eric so they could pose for a photo. That awkward image, captured when the two actors were freshly "whiplashed by this table read," as Jesse puts it, became the painted mural that would grace the set for Cam and Mitch's daughter's bedroom for years to come.

That was more than ten years ago now—and the wild ride *Modern Family* has taken its cast and viewers on is set to come to an end after season eleven. Both actors acknowledge the impact the show has had on viewers, particularly Cam and Mitch's enduring and endearing same-sex marriage.

"We've had hundreds of conversations in the last ten years," Eric says. "People saying and telling us, 'Mitch and Cam made a difference in my life. They made my parents more accepting. They made it easier for me to come out.' Those kinds of things mean a lot."

Jesse credits the show's writing team for gradually "pushing the envelope" over many seasons. "The writers have done a really great job of balancing humor and pathos over the past ten years."

The show's impact is likely to continue even after season eleven—and the series—draws to a close.

"Fans of the show keep getting younger and younger because of syndication," Eric says. "So, I have a nine-year-old kid come up to me and say, 'Hey! Are you Cam on *Modern Family*?' And I'm like, 'Yeah. And you weren't born when I started this job!' That's so cool. And it makes me realize that I'm going to be on TV probably for a really long time."

Hometown
Kansas City, Kansas, USA

Job
Plays Cameron on ABC's *Modern Family*

Favorite Disney attractions
Casey Jr. Circus Train and Peter Pan's Flight

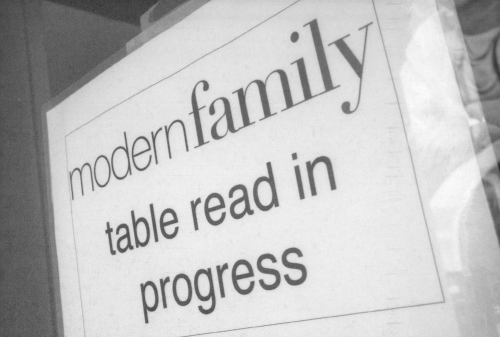

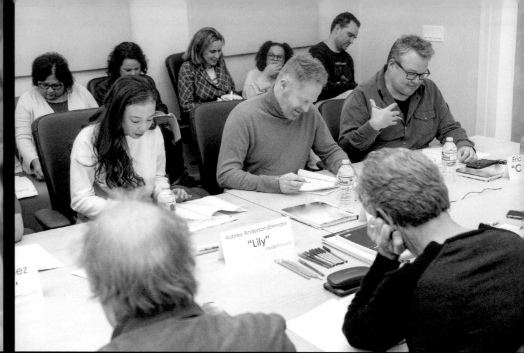

modern*family* table read in progress

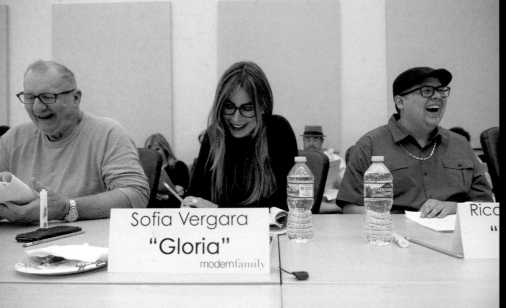

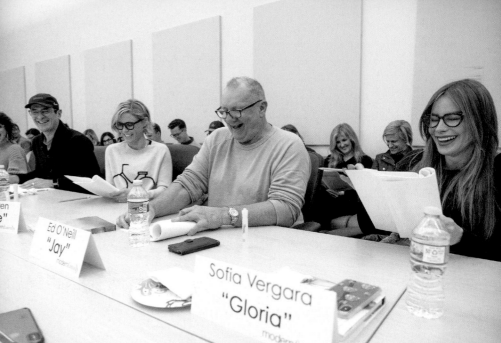

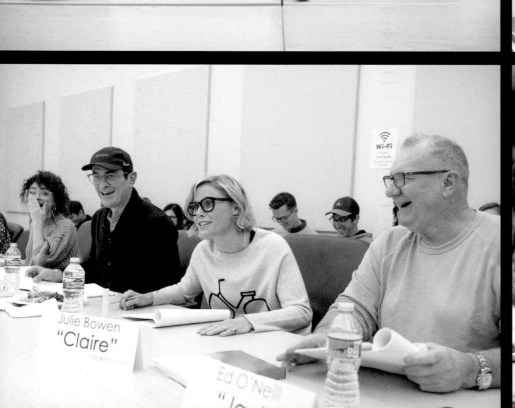

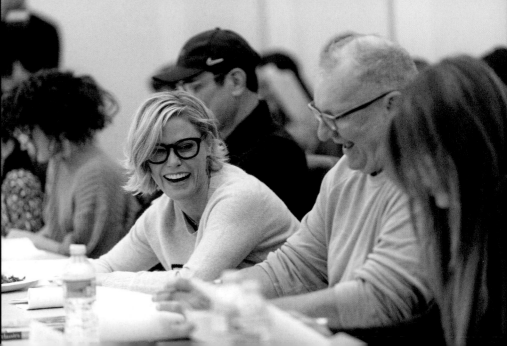

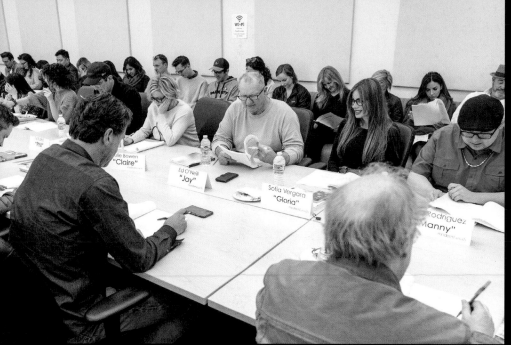

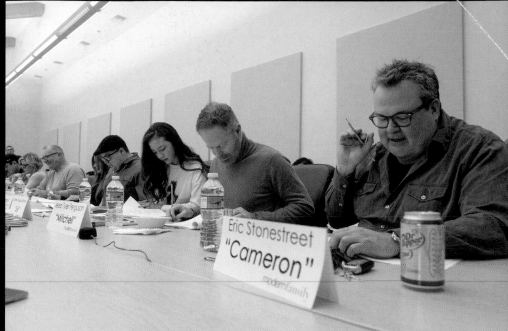

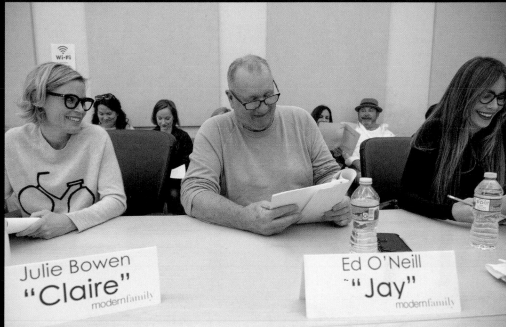

ELLEN

Part of the Magic

ELLEN POMPEO

Hometown
Everett, Massachusetts, USA

Job
Star and Producer of *Grey's Anatomy*

Favorite Disney movies
The Lion King (1994) and Marvel's *Black Panther*

Whatever may be piled on Ellen Pompeo's plate on any given morning at ABC's *Grey's Anatomy*—script meetings, directing, production duties, performing as the iconic Dr. Meredith Grey among the familiar sets that make up Grey Sloan Memorial Hospital—she knows what role she'll be playing that evening.

"I get to go home and be a mom again," says the mother of three children, ages three to ten. "I have an incredible work–life balance. I don't leave my children. I get to make them breakfast. I get to make them dinner. I spend as much time with my children as I do here."

That balance is courtesy of ABC and Disney, which have "recognized that I've given my all to the show," Ellen says. "I wake up every morning grateful that I get to come to this place."

Over the course of the show's record-breaking fifteen seasons, Ellen has evolved from "an actress who had very little voice in this process," as she puts it, to a director and producer on *Grey's* and the head of her own production company, Calamity Jane.

Working for Disney also resonates with Ellen's childhood. "I remember as a kid coming to California to visit Disneyland, and I remember going on 'it's a small world.' That was a really impactful moment for me. I had just lost my mother and I was five years old, and I think that was maybe the first moment I had smiled and felt a sense of wonder after that tragedy."

That memory came back to her decades later on her first ride on "it's a small world" with her older daughter. "It was pretty emotional for me," she says.

Working on TV's longest-running prime-time medical drama series is a different kind of joy, she notes. "We get to have fun and joke and be creative. If we're having a good time, the audience is going to have a good time."

In addition to starring on the ABC hit *Grey's Anatomy*, Ellen Pompeo is a producer, seen here with script supervisor Lindsay Cohen and director Geary McLeod monitoring preparations on set via the director monitors at video village.

LOIS
Part of the Magic

LOIS HAMMERSLEY

Hometown
Indianapolis, Indiana, USA

Job
Attractions Hostess,
Magic Kingdom,
Walt Disney World

Favorite Disney theme park
Magic Kingdom

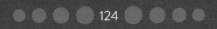

On Main Street, U.S.A., Lois Hammersley now and then encounters children she helped bring into the world—but whom she has never previously met.

A retired nurse, Lois worked for about thirty-four years in a reproductive endocrinology practice in Indiana. In her role there, she helped women who had difficulties getting pregnant. Fast-forward to family vacations years after her time at the practice, and there's "Miss Lois," as the parents she helped back then call her, now working to help guests safely enjoy the park's parades and fireworks.

"It's a fun surprise," Lois says of these spontaneous reunions. "We have lots of pictures and lots of hugs."

Putting up and taking down ropes and directing guests to walkways and viewing areas before and during such events has one important thing in common with nursing, Lois points out: "If you don't love people, you're in the wrong place."

Lois relishes engaging guests—speaking to them and answering their questions, taking their photos, even dancing with them during the Move It! Shake It! MousekeDance It! Street Party, an interactive parade that pauses in front of the castle so everyone can shake their booty with Disney characters and cast members.

She gives equal, focused attention to all guests, whether it's boogieing happily with a toddler or attending to older guests, such as the time she calmly assisted a middle-aged woman visiting the park who suddenly felt ill and had to sit down on the pavement outside the Main Street Emporium. (Lois quickly summoned the first aid team to help.)

With rare exceptions, guests are equally generous in return, offering her smiles and thank-yous, or, from the little ones, an unexpected embrace. A few folks sometimes need extra reminders to clear a walkway on the jam-packed street during the fireworks, but they generally comply with Lois's gentle urgings.

Lois spent about a year not working after she and her husband retired and moved to central Florida. But once their new home was renovated and landscaped, "I was like, 'What do I do now?'" Her husband reminded her that during their family's regular visits to Walt Disney World when their five children were small, she always thought she'd enjoy working there. So, she applied and was soon getting audience-management training.

And after four years on the job, she still looks forward to each shift. While guests watch the parade, she monitors the ropes and watches the children across Main Street, U.S.A. "I wish the parents were standing on my side of the street so they could see the looks on their kids' faces," she says with a smile. "It's truly magical."

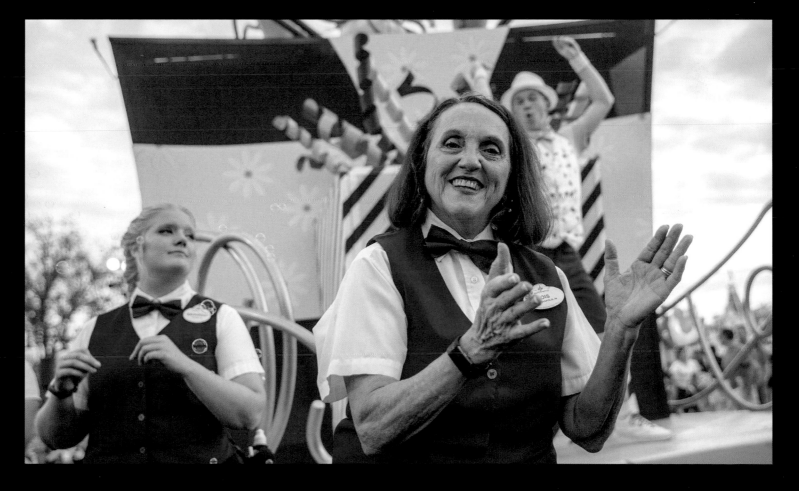

Lois Hammersley (above) dances with children enjoying the Move It! Shake it! MousekeDance It! Street Party at the Magic Kingdom in Walt Disney World.

PETE
Part of the Magic

PETER DUFOUR

Hometown
Madawaska, Maine, USA

Job
Security Host,
Magic Kingdom,
Walt Disney World

Favorite Disney movie
Pixar's *Toy Story*

Peter Dufour (at right, with the flag) and the Flag Retreat ceremony honor guard salute the service of Terrance McPherson, of Ionia, Michigan, the Veteran of the Day and a former engineman, 2nd class, in the U.S. Navy.

Peter Dufour stands at attention and in awe every day he's at work in the Magic Kingdom at Walt Disney World. He's at attention during the daily Flag Retreat ceremony in the square at the base of Main Street, U.S.A. He's in awe because he has just met the Veteran of the Day—a park guest selected at random to join the three-man color guard for the late afternoon ceremony to lower, fold, and retire the American flag for the day.

Typically involving members of the Main Street Philharmonic band and the Dapper Dans barbershop quartet—and sometimes a tiny Cub Scout—it's a tradition established at Disneyland by Walt Disney himself to honor those in military service.

"Every veteran I meet has a story to tell, and I am honored to meet them," Pete says. Terrance McPherson, pictured here, was an engineman second class in the U.S. Navy and part of Operation Deep Freeze in Antarctica in the 1950s. On another day, the ceremony included three veterans from one family: a husband, a wife, and a daughter. Pete remembers "so many that stand out," from the woman who served in World War II to the man who logged thirty years in the service without ever leaving the legal department.

As a young man, Pete spent six years in the U.S. Army. Two in the artillery—following in his father's footsteps—and four as a quartermaster, responsible for supplying troops with all the gear they needed. That was an especially busy post during his two years in Alaska, where shivering soldiers would disembark, dressed for Southern heat, from a plane they'd boarded in South Carolina.

After the army, Pete worked as a mechanical draftsman in New Hampshire, but a visit to his parents in Florida redirected his career path. "We went to Disney World and I said, 'Are you kidding me? This is where I need to work.' So I moved to Florida." He worked at the resort's hotels and in recreation—wearing flip-flops and shorts to his job renting out boats—before donning a security uniform about twelve years ago.

His job chiefly involves helping out the park's guests, whether they need immediate paramedic assistance, support finding lost parents, or a FastPass tutorial. Patrolling Adventureland most days, Pete says, "I've found my spot."

He adds, "People ask me, 'What do you like about your job?' And I'll point at the castle and say, 'Welcome to my office!'"

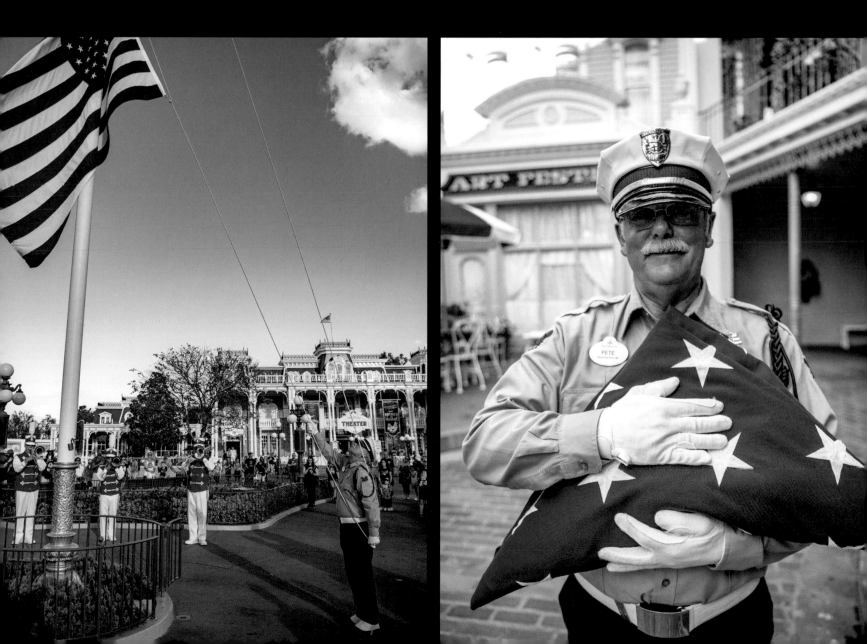

KATIE

Part of the Magic

KATIE WHETSELL

Hometown
Cleveland, Ohio, USA

Job
Principal Actor in
Finding Nemo—The Musical
at Disney's Animal Kingdom
Theme Park

Favorite Disney attraction
Soarin'

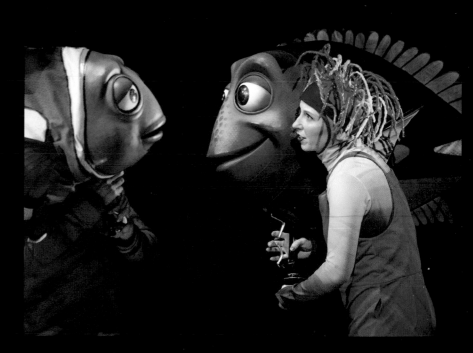

Everything is larger than life backstage at *Finding Nemo—The Musical* in Disney's Animal Kingdom Theme Park: the 750-pound Crush puppet that's the size of a Volkswagen Beetle, the nearly twenty-foot-tall aquarium set, the fly system of ropes and pulleys overhead that allows performers to fly through the air as they just keep swimming through the familiar story.

But the real magic takes place with the interaction between performers like Katie Whetsell and the big, colorful (but surprisingly simple) puppets they operate to bring the characters to life. Katie's Dory puppet is super low-tech, operated with just two mechanical levers on the handle: one for the mouth . . . and one for the eyelids. Katie says the puppets may be "simple in terms of operation, but the craftsmanship that went into them is far from low-tech. All of us are very passionate about how incredible these puppets are.

"There's so much that you have to accomplish at one time," Katie says. Besides "being present" with other cast members, checking her harness several times for flying scenes, and keeping to the show's exact pacing to match the recorded instrumental track, she must always be sure that her facial expression mirrors Dory's, "so the audience gets the same experience whether they're looking at the performer or the puppet."

It takes thirty-nine people to put on each thirty-seven-minute show, performed as many as seven times a day with rotating casts. Katie typically does thirteen shows a week, up to three a day at times. "It's definitely strenuous, wielding a seven-pound puppet, flying and running here, there, and everywhere—but that's what

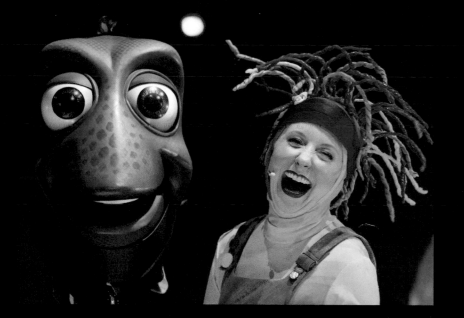

makes it fun!" Rehearsals incorporated learning special exercises to prevent muscle strain and other injuries.

Katie joined the show for a year or so starting in 2012, then returned full time in 2017. But she's not new to Disney stages. She also played Ariel in the Disney Cruise Line show *Disney Dreams*—a coming-full-circle moment for Katie, since she sang "Part of Your World" at show-and-tell in first grade. From then on, there were a lot of regional theater stints, five seasons at the Utah Shakespeare Festival, a national tour of *Wonderful Town*, and many other roles in New York City, her postcollege home, including the role of waitress during dry spells.

It was a butterfly that really made Katie set her sights on performing for Disney—during her first trip to Walt Disney World, accompanied by her mother, who was battling cancer and weak from chemotherapy. She was in a wheelchair, but it was still the dream vacation the family had long imagined. One evening, during the SpectroMagic parade in the Magic Kingdom, a performer in a butterfly costume "came out of nowhere and just put her hand on my mom's shoulder and smiled. It was so beautiful—and not one of those 'I'm so sorry' smiles. It was just pure joy. Mom started crying. I started crying."

Katie pauses to collect herself, then adds, "At that moment I was like, 'This place does something really special that you can't find anywhere else. Even a grown woman who has a terminal illness can still feel like a kid.' It was like she gave Mom the moment she never got to have in her childhood in that single instant."

Her mother passed away when Katie was a freshman in college, but she still feels her presence. Just hours after sharing the butterfly story for this book, Katie says, she was on an escalator at Disney Springs and heard the music from the SpectroMagic parade. "I was like, 'There she is. Yeah.'"

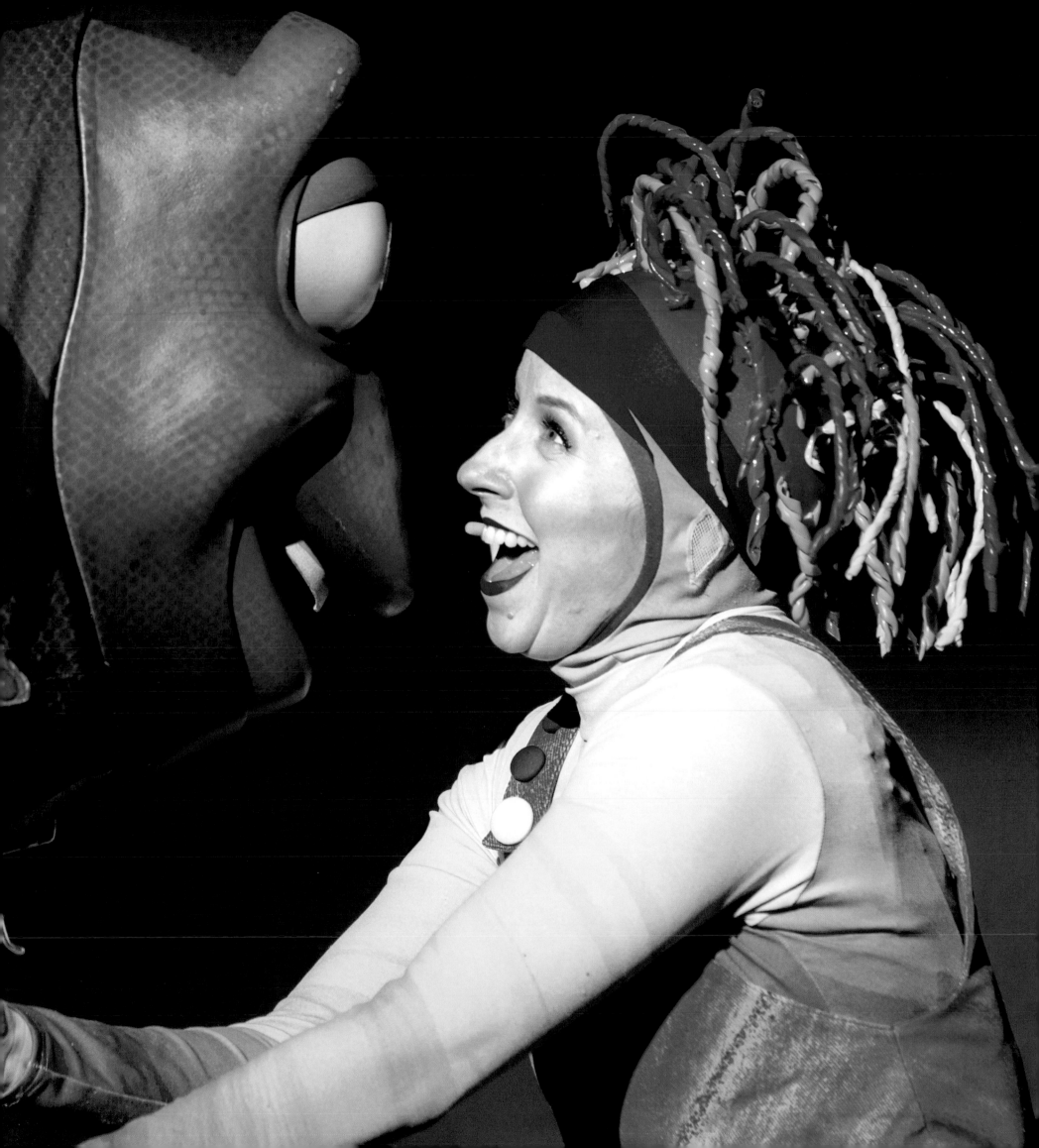

MARC
Part of the Magic

MARC SMITH

Hometown
Chatsworth, California, USA

Job
Director of Story for Walt Disney Animation Studios' *Frozen 2*

Favorite Disney movie
Dumbo (1941)

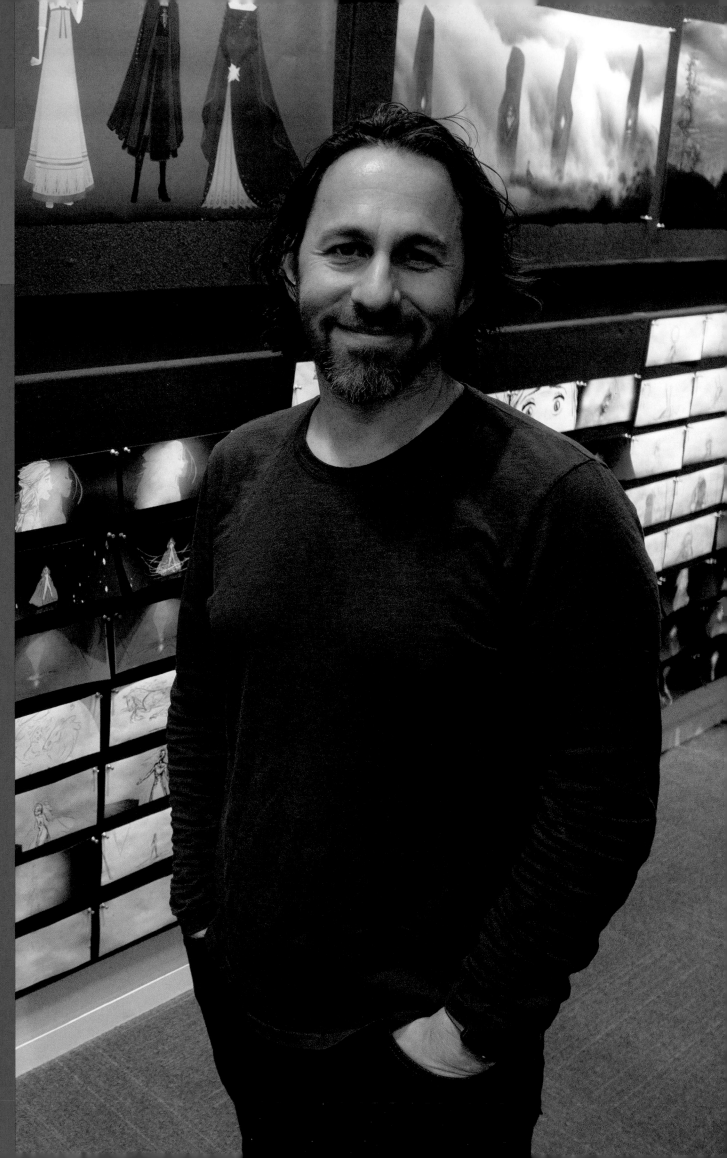

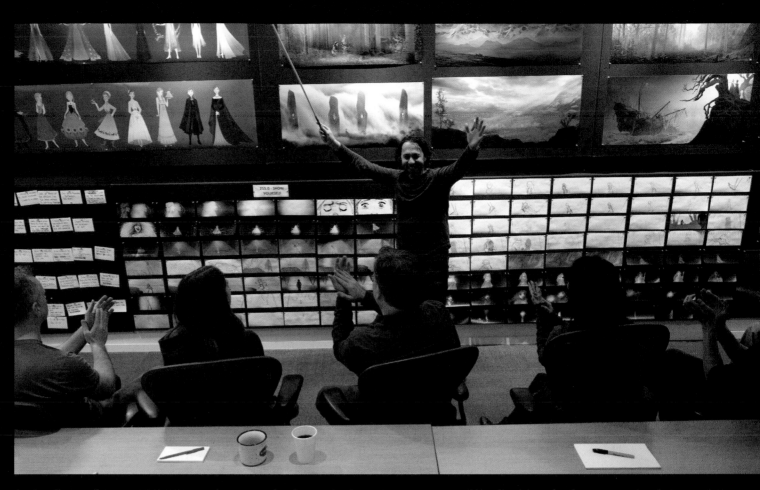

As the *Frozen 2* team at Walt Disney Animation Studios works through a sequence of the film, Marc Smith serves as lead story artist, performer, moderator, and cheerleader, all at once.

"This isn't at all what we're looking for." That could have been the end of Marc Smith's dream of becoming an animator. He'd just shown his drawings—imitations of cartoon characters from TV, or of pictures from magazines—to Bob Winquist, then the director of the character animation program at the California Institute of the Arts (CalArts).

"He said, 'Go draw from life. Go to the zoo. Go to the mall. Just observe people. Come back to me in two weeks.' So, I went home and stole a big ream of eleven-by-seventeen paper from my dad's office and I just drew for two weeks," Marc recalls. "I went to the airport, the zoo—I went everywhere."

The new drawings earned him admission to CalArts, which led to an internship at Disney and, after graduation, Marc's dream job as an animator. He worked a bit on *The Lion King* and then on *Pocahontas*, *The Hunchback of Notre Dame*, *Hercules*, *Tarzan*, and other modern Disney classics.

After twenty-five years, he's still drawing—sometimes on a Wacom Cintiq tablet, sometimes with a big, fat Sharpie—but now he's the head of story for Walt Disney Animation Studios' *Frozen 2*. That's the team that works

out each film, scene by scene, shot by shot, one drawing at a time. Huddling with the directors and the writers, story artists hone in on the narrative, the emotions, the gags—every little thing—until it all sparks and flows. Only then do the animators take over.

The story sketches, accompanied by dialogue, sound, and music, become rough edits of the movie—and during the years it takes to develop a feature, there might be as many as twelve versions. As fragments of animation are finished, they're edited in as well. "It's probably the fastest was to visually represent the ideas that you want to get up on-screen," Marc says.

Marc first shifted from animation to story on a temporary basis, but decided to stay put. "I never get exhausted by doing drawings," he says. "You're always working on new ideas, and there's always a challenge."

Finally comes the time when Marc and all the other artists get to see their work in finished form with a fresh audience for the first time.

"And all of the stress and the conflict that happened—it all just goes away and you're able to just watch a movie and be entertained by it. The movies really take on a life of their own at some point."

STEVE
Part of the Magic

STEVE SLIGH

Hometown
Anaheim, California, USA

Job
Senior Manager,
Golden Oak Ranch

Favorite Disney attraction
Space Mountain

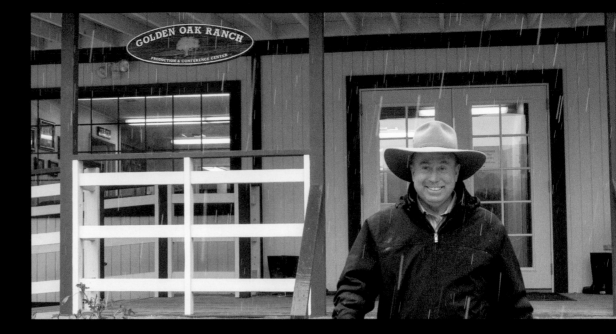

Rattlesnakes and movie stars are all in a day's work for Steve Sligh, and he's more familiar with the reptiles than the celebrities. As senior manager at Golden Oak Ranch, Steve once got a hug from Halle Berry without knowing who she was.

Golden Oak is Disney's film production ranch in the grassy hills and valleys thirty miles north of Burbank, California. "Walt Disney bought it in 1959 after filming [the TV series] *Spin and Marty* here for a couple of years," Steve explains. In the decades since, it has grown from 328 acres to 890 and hosted film and television production from Disney classics *Toby Tyler* and *Old Yeller* to recent TV hits *Mad Men* and *CSI*, as well as a couple of the Pirates of the Caribbean movies.

With a background in agriculture ("growing up, we always had horses") and law enforcement (ten years with the Orange County Sheriff's Department), Steve's first day at Golden Oak twenty-eight years ago was also his first day on a film production. He quickly learned the lingo, the routine, and how to manage Hollywood-sized attitudes with down-home calm and a former deputy's authority.

The ranch may have two permanent and highly adaptable back lots—a forty-two-storefront business district and a fourteen-home suburban street—but it's also an agricultural operation, generating hay for livestock and some produce for the local community as well as some of the dining rooms at The Walt Disney Studios lot. "We work from a premise of balancing the environment, the community, and operations," Steve says. That means knowing how to handle wildlife, whether snakes or deer, and hosting a helicopter base where firefighting choppers can pick up water to fight wildfires (a couple of which have encroached on the ranch).

It also means chasing away paparazzi gathered at the gates, an effort that earned him that hug from a grateful actress he only learned later was Halle Berry.

Steve doesn't see a lot of movies, in part because he and his wife Debbie lived on Golden Oak Ranch from 1992 until 2017. So when he had a long chat with a polite young man on his front porch during filming for *Pearl Harbor*, Debbie had to explain he'd been talking with Ben Affleck. "I get a lot of those 'you're kidding' moments," he says.

Steve's Disney connections stretch back to his early twenties, when he drove the streetcar horses on Main Street, U.S.A., in Disneyland. At twenty-two, he spent four months traveling the country with a team of horses and the calliope from *Toby Tyler* to celebrate Walt Disney World's tenth anniversary.

"It was great," he recalls of visiting rodeos and state fairs. "Everybody was happy to see us."

These days he meets with his operations team at six every morning to go over scheduling, typically laughing at the idea that any day will go as planned, as the weather or production snafus or who knows what will no doubt wrench up the agenda. And that's fine with Steve. When he says, "I have the best job in the company," you definitely believe him.

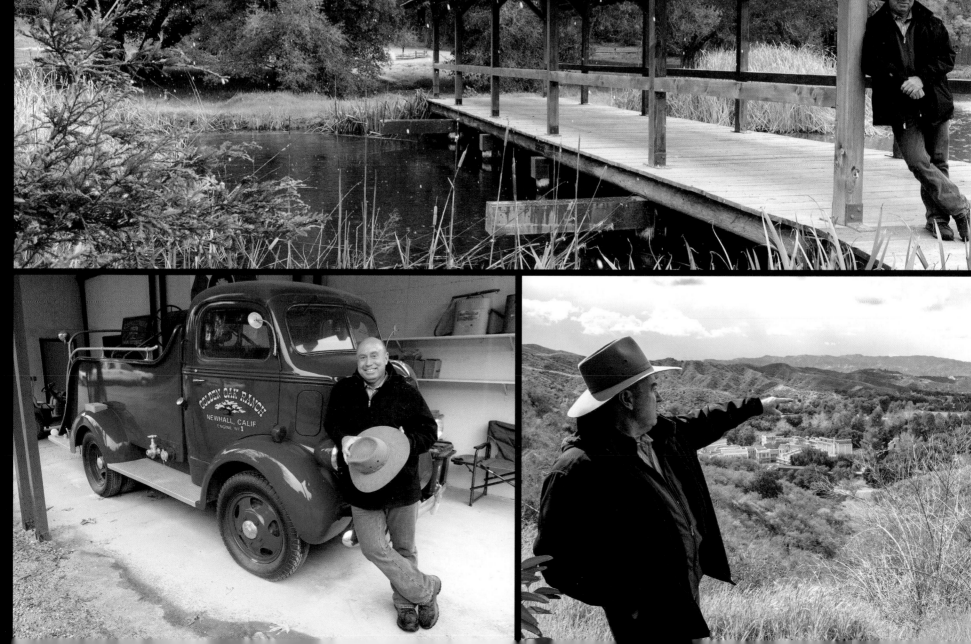

Steve Sligh looks after the many and varied filming locations that make up Disney's storied Golden Oak Ranch, including its iconic and timeless Business District.

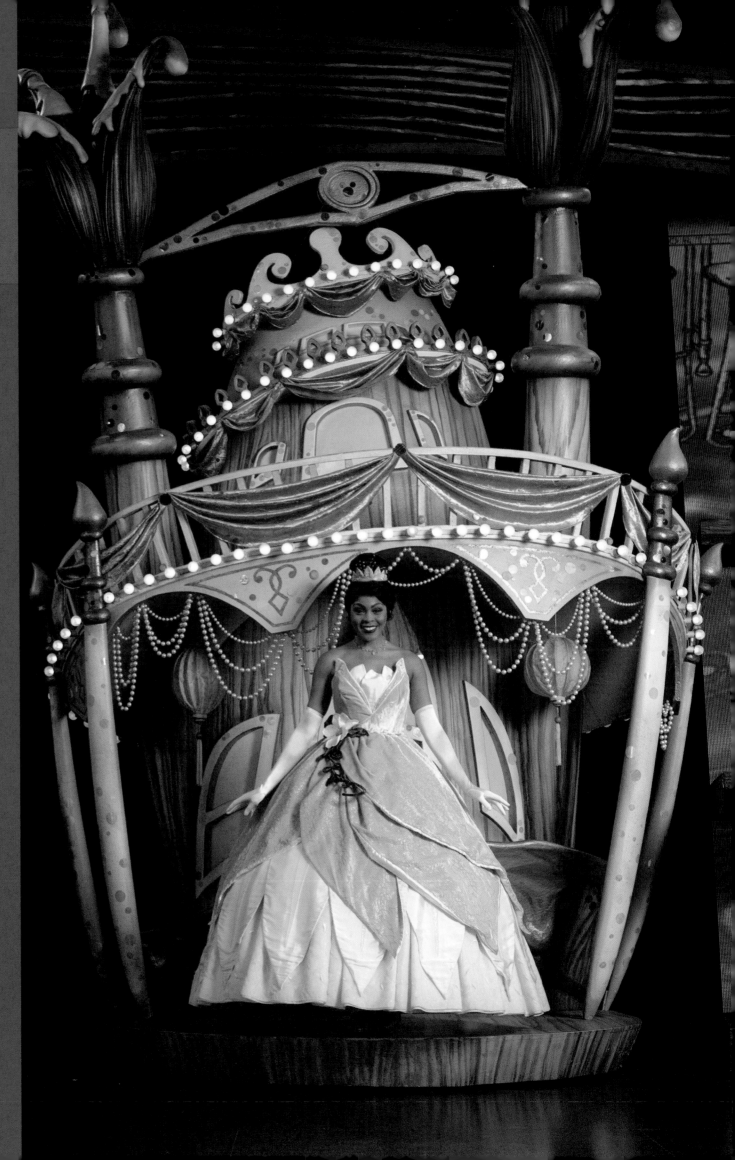

EBONY

Part of the Magic

EBONY WINSKI

Hometown
Hacienda Heights,
California, USA

Job
Princess Tiana in *Mickey
and the Magical Map*
at Disneyland

Favorite Disney movies
The Princess and the Frog
and *The Little Mermaid*

To portray a theatrical representation of Princess Tiana from *The Princess and the Frog* in *Mickey and the Magical Map* at Disneyland, Ebony Winski first had to graduate from princess school. "It's just a little course, learning about the character and her ways. I learned how she talks and her signature—just everything about Tiana," Ebony recalls. "Then I put a little bit of sparkle from myself into the character to make it my own. And there you go."

She first appeared in a show staged in the heart of New Orleans Square: "Princess Tiana's Mardi Gras Celebration," which included live musicians, songs from the movie, and the unpredictable pleasures of guest interactions.

"It was always fun to me, getting to meet the kids; and they're so excited to see you," she says.

Now she's one of the stars of *Mickey and the Magical Map* at the 1,800-seat Fantasyland Theatre. She makes a grand entrance on an eighteen-foot-tall, 1,200-pound riverboat and sings "Dig a Little Deeper," a song introduced by Mama Odie in *The Princess and the Frog*. Then she joins the rest of the cast of more than fifty for the finale.

Even six years after *Mickey and the Magical Map's* 2013 debut, "it's still an amazing experience to do the show," Ebony says. "It's just awesome to work with so many amazing people."

She typically does five shows a day, one to four days a week—a less demanding schedule than the all-day rehearsals during the month before the production opened. That first performance for park guests "took so much energy out of all of us, because we were giving a hundred and eighty percent . . . I pretty much relive that every single day I'm out there."

Ebony started singing in church when she was four. As a teenager, with her mother's support, she did a lot of "showcases and my own concerts and stage plays." She even booked some national TV commercials for McDonald's, Macy's, and Robinsons-May, and branched out into modeling.

Nowadays, she spends much of her time offstage running her own design and planning business for weddings and other events.

If they're lucky, the brides she works with might have a dress half as spectacular as Tiana's in *Mickey and the Magical Map*. It's an elaborate costume in four parts, two skirts and a two-part bustier, and "it looks amazing," Ebony says.

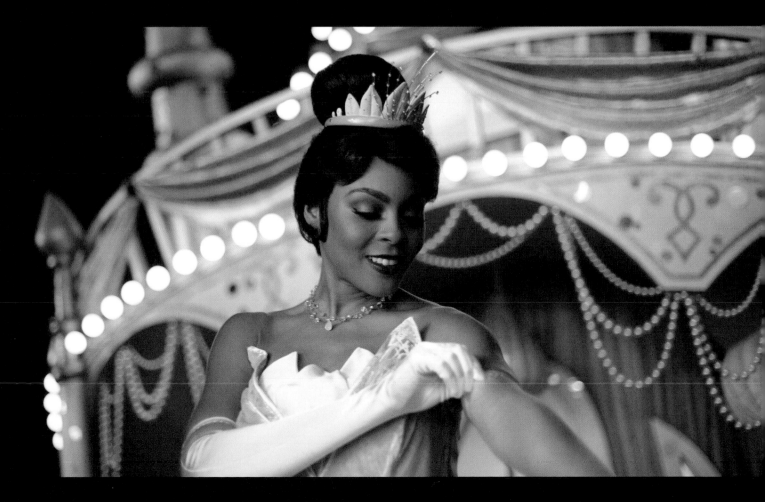

Ebony Winski makes a grand entrance on the bow of an eighteen-foot-tall riverboat for the finale of *Mickey and the Magical Map* at Disneyland's Fantasyland Theatre, wearing a four-piece gown with matching gloves and jewelry.

LAURA

Part of the Magic

LAURA CABO

Hometown
Boston, Massachusetts, USA

Job
Portfolio Creative Executive, Walt Disney Imagineering

Favorite Disney attractions
Pirates of the Caribbean and Peter Pan's Flight

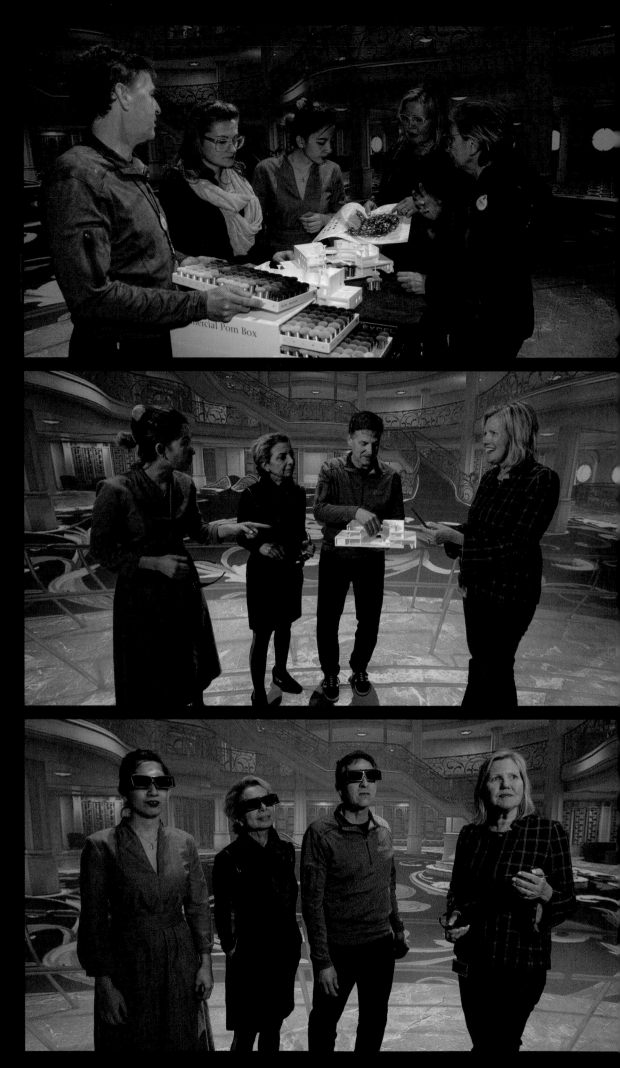

Top photo, from left: Dave Fisher, Lina Barr, Zohreh Sadeghi, Laura Cabo, and Ramesh Laridjani examine digital computer models of the new class of cruise ships that will debut in 2021.

Because of the pirates, Laura Cabo wound up jumping into the North Sea.

It's a long story.

It begins with Laura as a top architect at the Boston firm of Graham Gund, happily working (now and again) on commissions for The Walt Disney Company, starting with the Coronado Springs Resort at Walt Disney World. Then, after nearly two decades of being Disney adjacent, Laura is invited to interview with Walt Disney Imagineering to become their global leader for architecture. But she loves her job, and Boston, and the Celtics, and—really? On the other side of the country? Still, a visit couldn't hurt, right?

"So there I was, waiting for someone out in the Green Space (outdoor park) on the campus of WDI, and a bunch of employees came out dressed as pirates," Laura recounts. She never finds out *why* they are dressed as pirates, but she thinks, "Wow. This place is so unique. When am I ever going to get another opportunity like this to do something so different?"

So she takes the job, and she loves it.

Cut to 2018. Laura's new role is leading design for the new class for Disney Cruise Line: three big, fabulous new ships, set to launch beginning in 2021. She's in Oslo, Norway, consulting with a design firm working on the project. "Their office is a historic building on the end of a pier, and one of the designers, he jumps into the North Sea every day," Laura says. "And I said, 'Okay, we're going to do that as a team. After lunch, we're going to jump into the North Sea, holding hands, and be a team.' And we did."

The details of the new project remain top secret, but the ships have a lot in common with Laura's previous Disney architectural projects: "We design environments that take people deep into our stories and the fantastical worlds that we dream up," she says, noting that each space also has "such an emotional touch. I think that's what drew me here."

That, those pirates, and maybe fate. Laura grew up as a "navy brat," so to find herself now working on ship design seems a touch of kismet. It has also touched her heart, particularly on a visit to the Papenburg, Germany, shipyard where the new ships are being built.

"Standing on that dry dock, looking at the unadorned steel structure rising two hundred and twenty feet up in the air, I really felt like my dad—who passed away six years ago—was at my shoulder. I just thought, 'My father would just be out of his mind if he could see what I'm seeing.' It was really a great moment."

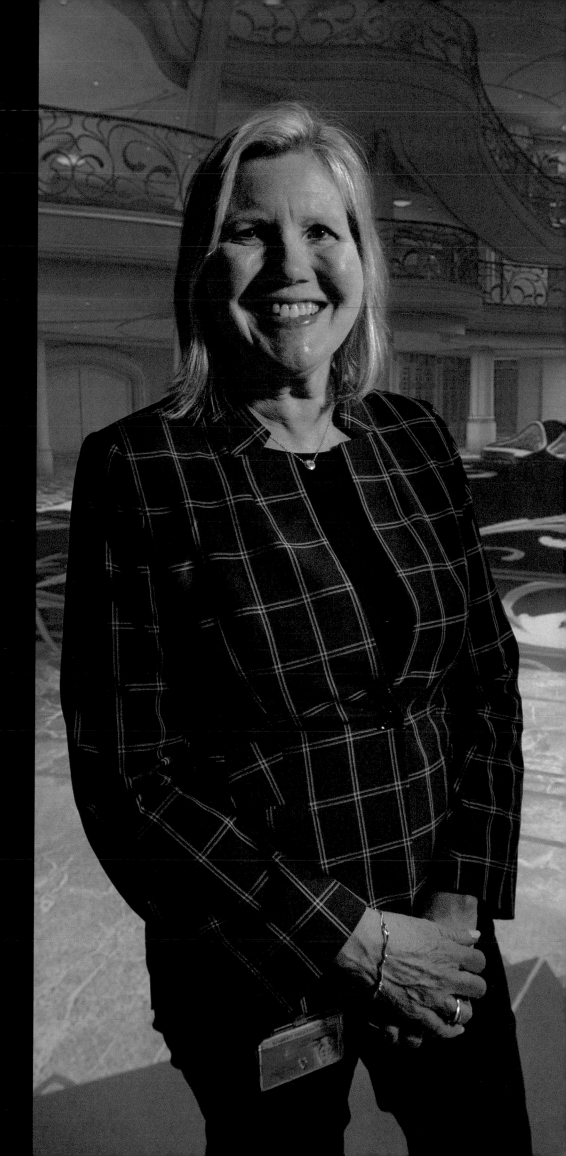

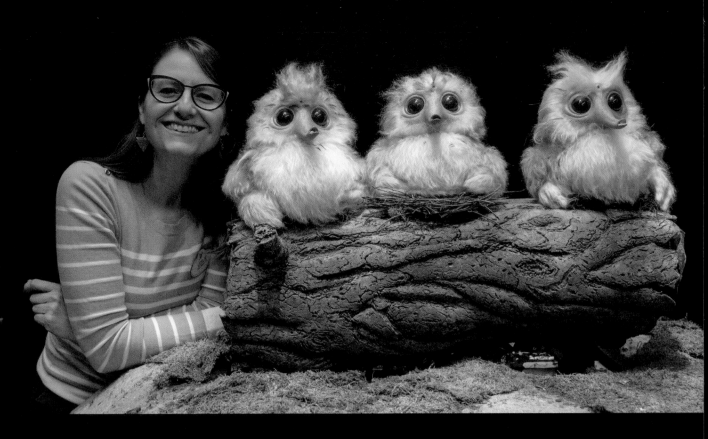

LESLIE
Part of the Magic

LESLIE EVANS

Hometown
Southbury, Connecticut, USA

Job
Manager, Research & Development, Walt Disney Imagineering

Favorite Disney attraction
Big Thunder Mountain Railroad

If you get the feeling that a little trio of beaked, fuzz-ball aliens are watching you in the ride queue at Guardians of the Galaxy—Mission: Breakout! in Disney California Adventure, you're right. The three Vyloo are autonomous interactive characters created by Leslie Evans and the rest of the R & D team at Walt Disney Imagineering. And their origins go back to *Snow White and the Seven Dwarfs*.

The project is informally called Tiny Life. Leslie says, "In the classic Disney films, you always had these woodland creatures that didn't speak but were clearly observant and smart. We wanted to re-create this in Audio-Animatronics characters—to build characters with personality who could make their own decisions all day, every day, and there's no human in the loop."

No human, that is, except the guests. "Watching people interact with the Vyloo is so gratifying. They have a moment when they realize that this thing's smart, like they know what's going on in the world."

The Vyloo are indicative of the team approach to attraction building at WDI, involving engineers, designers, and even the filmmakers of *Guardians of the Galaxy Vol. 2*, who liked the Imagineers' initial models so much that they gave the cute creatures a cameo in the movie.

Leslie and her team are working on other cutting-edge technologies for still-secret attractions.

Leslie joined WDI in 2013 with experience in the aerospace industry and what she calls her "triad" of training: bachelor's degrees in material science engineering and business, and a master's in industrial design.

"When I was a kid I was always designing and building things, making habitats for my toys and my own stuffed animals," she recalls, "complete with patterns and instructions for production." Her innate curiosity was especially piqued by her favorite Disney roller coaster, Big Thunder Mountain Railroad. It was there, even though she didn't realize it at the time, that she glimpsed her future career.

"Thunder Mountain was always my go-to, and the goat with the dynamite in its mouth is still my favorite thing at a Disney park," she says. "I was always thinking about how someone came up with a story and designed that. That just seemed like the most magical creative process."

Besides, she adds, "it just makes me giggle every time I go past it." Not unlike a Vyloo.

Leslie Evans works on interactive Vyloo creatures in the shop at Walt Disney Imagineering's Events Development department, part of an ongoing WDI initiative called Tiny Life.

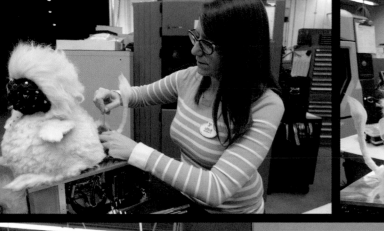
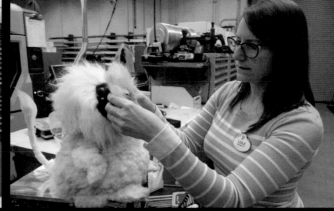
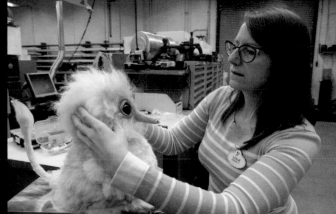
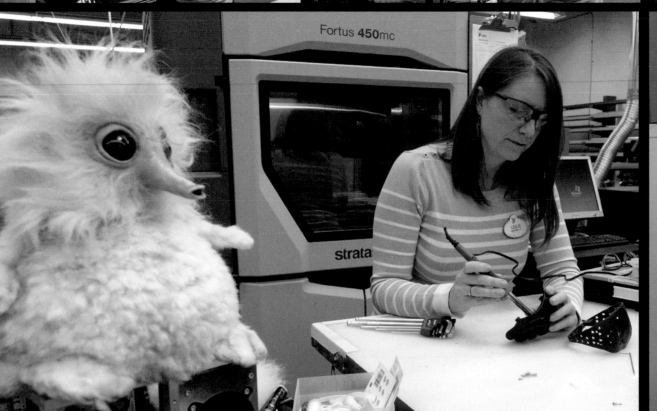
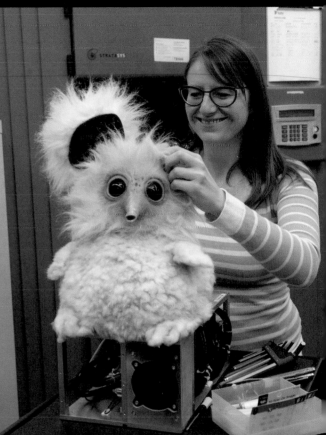
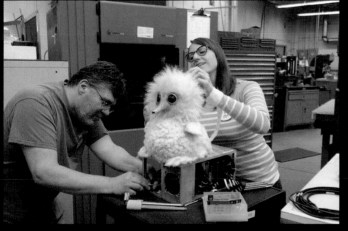
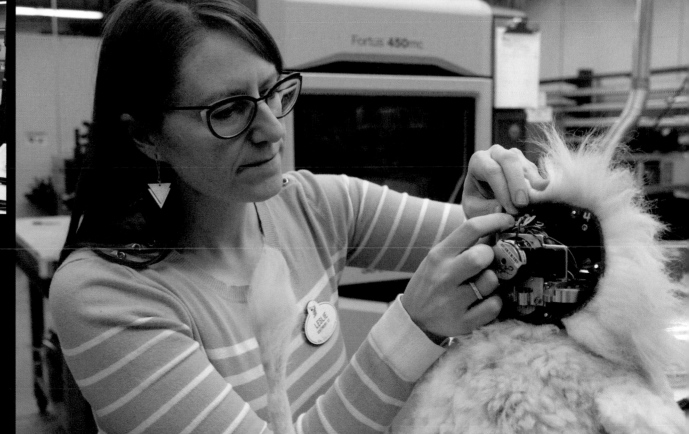
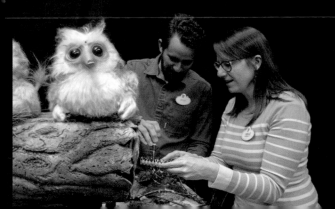

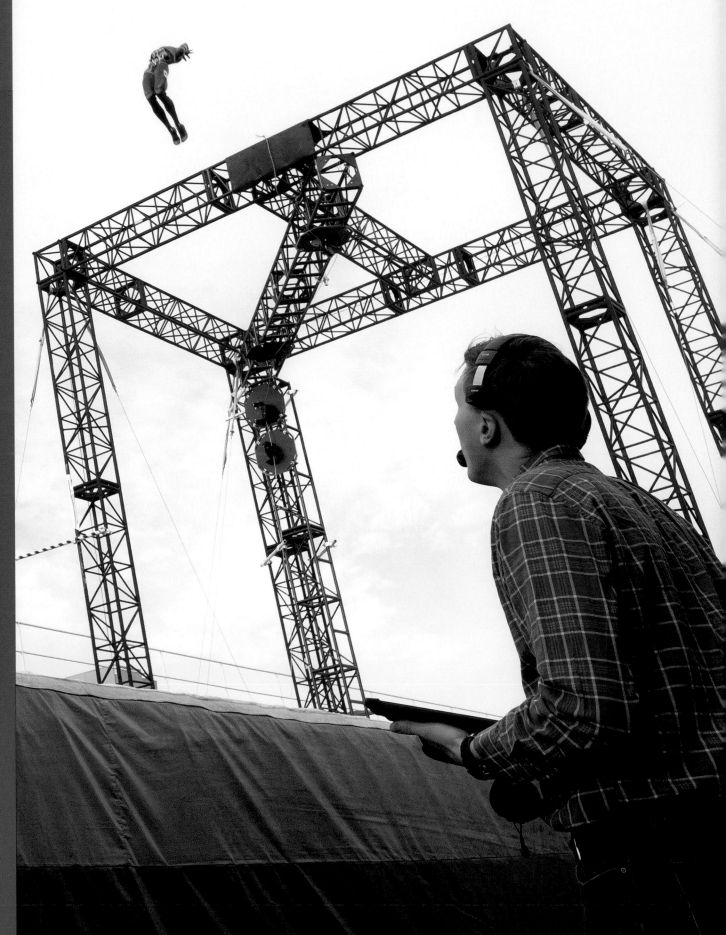

Morgan Pope puts a Stuntronics robot through its routine outside the Imagineering offices. The robots, still in development, can soar six stories high and land gracefully in a safety net.

MORGAN

Part of the Magic

MORGAN POPE

Hometown
Hyrum, Utah, USA

Job
Associate Research Scientist, Research & Development, Walt Disney Imagineering

Favorite Disney movie
Snow White and the Seven Dwarfs

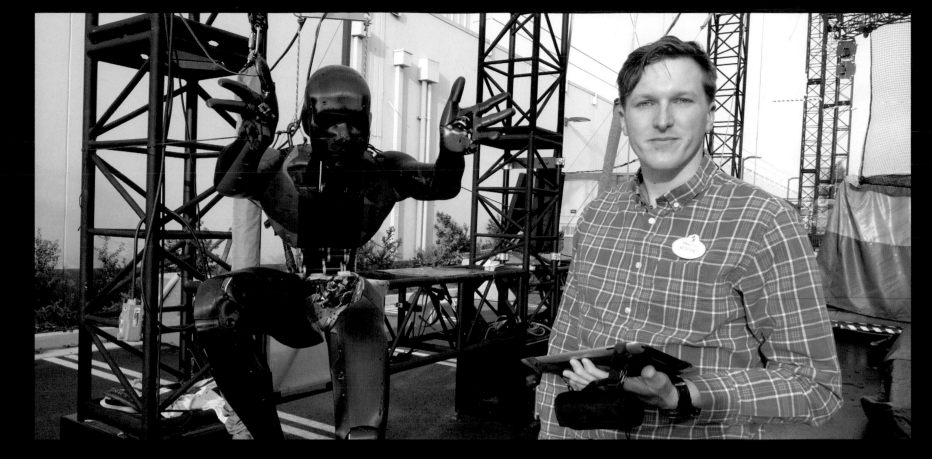

What would happen if you took one of the Audio-Animatronics figures from Pirates of the Caribbean, tossed him sixty-five feet in the air, and watched him gracefully somersault into a safety net? You'd have Stuntronics, the flying robot technology Morgan Pope has been working on during his three years as an associate research scientist in the R & D department at Imagineering.

The goal is "an acrobatic robot," says Morgan, who joined Disney after earning a PhD in engineering from Stanford University. The project began by hurling devices shaped like bricks and sticks. Now the Stuntronics figures look like skinless, carbon-colored cousins of C-3PO—and they can tuck and spin in flight like seasoned trapeze artists.

"Over the years, Disney has developed Audio-Animatronics figures that deliver really capable up close performances," Morgan says, citing as an example the "convincing and fluid" Shaman who presides over the Na'vi River Journey in Pandora at Disney's Animal Kingdom. "But you can't take her and throw her across the room because she weighs something like two tons and isn't designed for taking the impact."

Stuntronics are not intended to replace human stuntpeople or park performers but may well play the role of stunt doubles for Audio-Animatronics figures, performing awesome feats that no human could repeat "over and over and over and over again," Morgan says. "They're not as good-looking as the close-up guys, but they can take a hit and do something kind of amazing."

Morgan is also working on other advances in robotics that aren't yet ready to appear on YouTube but may shape the world of the future. "I'm amazed by the advancement in technology of the last couple hundred years and how measurably it has impacted people's lives," he says. "Even out in the sticks of Hyrum, Utah."

That's where Morgan grew up, reaching "peak nerdiness" in the eighth grade—complete with braces, glasses, and mountains of books—before overcoming his social awkwardness in high school and heading to Harvard University as an undergraduate.

Since then, his goal has always been "to build something that was cool and used design engineering to make a difference." He cites as one inspiration Walt Disney's Enchanted Tiki Room in Disneyland, which he visits when in the park with his young children.

The singing birds and totem poles are just "pneumatic actuators, hydraulic actuators, and servos and lights and stuff—all very dry mechanical things," Morgan says. "But then when they're put together in the right way, it becomes a transportive, emotional experience."

Even if you can't toss the parrots across the room. Yet.

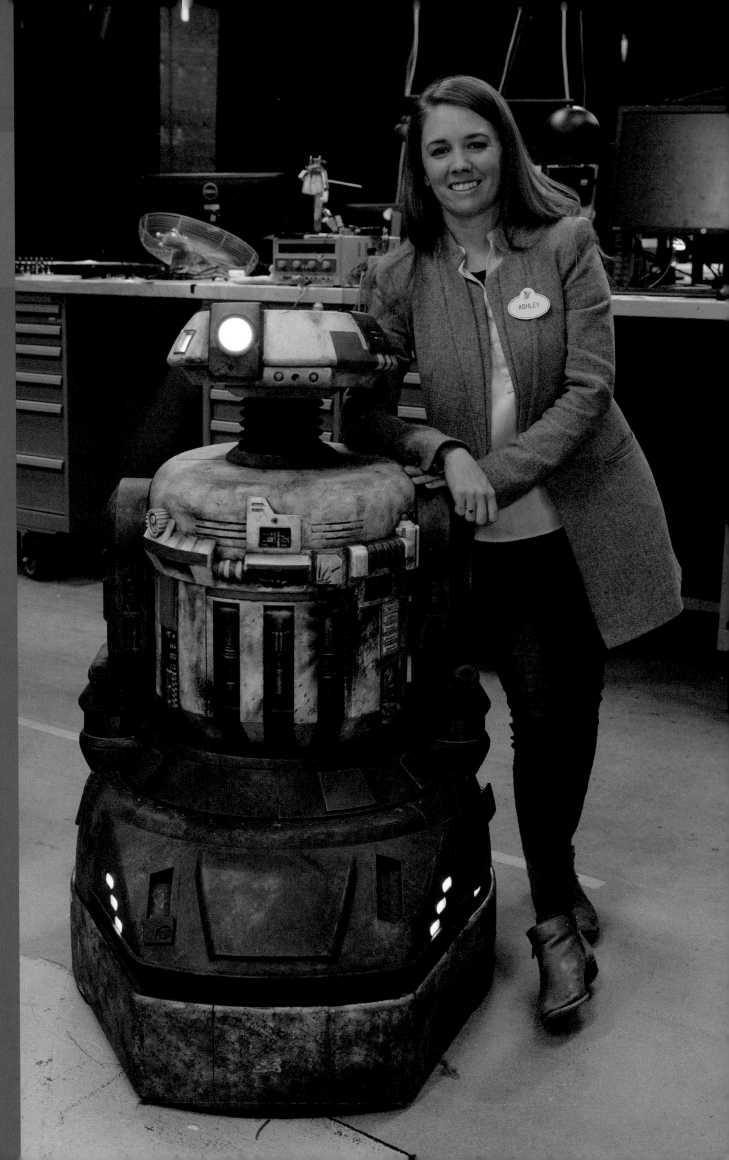

ASHLEY

Part of the Magic

Ashley
Girdich

Hometown
Orlando, Florida, USA

Job
Technical Program
Manager, Research
& Development, Walt
Disney Imagineering

Favorite Disney movie
Beauty and the Beast
(1991)

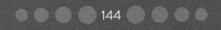

Meet Jake, "a fully autonomous character who can roll around the park, interact with the environment and the people, and make decisions on his own," says Ashley Girdich, the Research & Development project manager who has been working on robotics since she arrived at Imagineering three years ago.

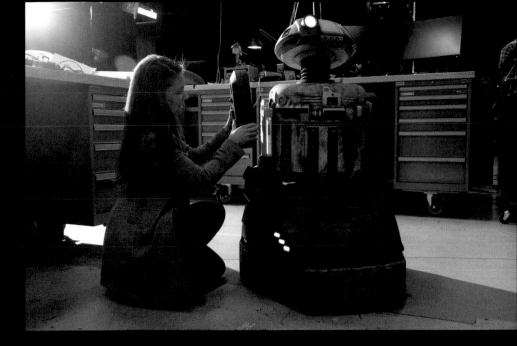

But Jake is not the polished wanderer who will eventually roam Tomorrowland, where he was "play-tested" among actual park guests. ("People loved playing with him," Ashley recalls.) Jake is what R & D calls a "minimally viable prototype," intended to "test out what we're doing and see if it's going to work," Ashley says. Once the R & D creation looks solid—as Jake does—other Imagineers will come aboard "to create real product versions that are durable and reliable."

Ashley explains, "What we do here at R & D is take the latest technology, take it apart, and put it back together in a different way that helps us create incredible guest experiences." What her team is now doing with robotics, she compares to what Pixar did with computer graphics: taking new tech and using it for cutting-edge storytelling. With robotics, the narrative and characters become interactive.

As project manager, Ashley helps her team set priorities and schedules and problem-solve, a role her diverse background in mechanical engineering is perfectly suited for. Before joining Imagineering, she worked on industrial-size gas turbines for the energy industry and, before that, on aircraft and Humvee training modules ("essentially a massive video game"). She also gained hands-on experience in design, contracts, sales, and marketing—"skills I feel really transferred here."

Ashley has been in engineering mode since she was ten, when she gummed up her pencil sharpener with a crayon. She carefully took it apart, fixed it, and put it back together. "I've also taken apart a few vacuums, much to my parents' chagrin," she adds with a laugh.

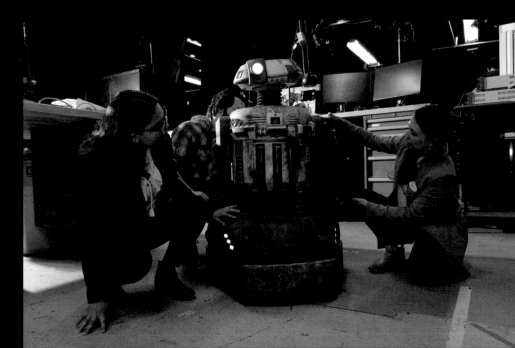

She offers encouraging words for aspiring tinkerers: "I never thought I could be an Imagineer," she says. "So people shouldn't restrict themselves just because maybe they haven't done something. We like to say we have over a hundred forty disciplines here, but we have hundreds of thousands of skill sets."

And when they're all working together, the result might be a robot who can run free all over Tomorrowland.

Ashley Girdich gives Jake a checkup. The robot, which can wander and interact with Disney Parks guests without human input, is a prototype for more elaborate autonomous figures still in development.

ERIC GOLDBERG

Hometown
Glendale, California, USA

Job
Animator and Director,
Walt Disney Animation
Studios

Favorite Disney movie
Dumbo (1941)

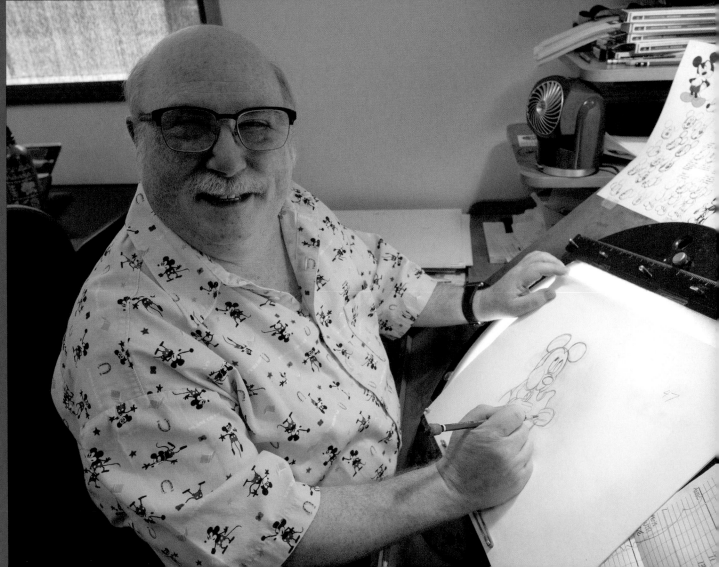

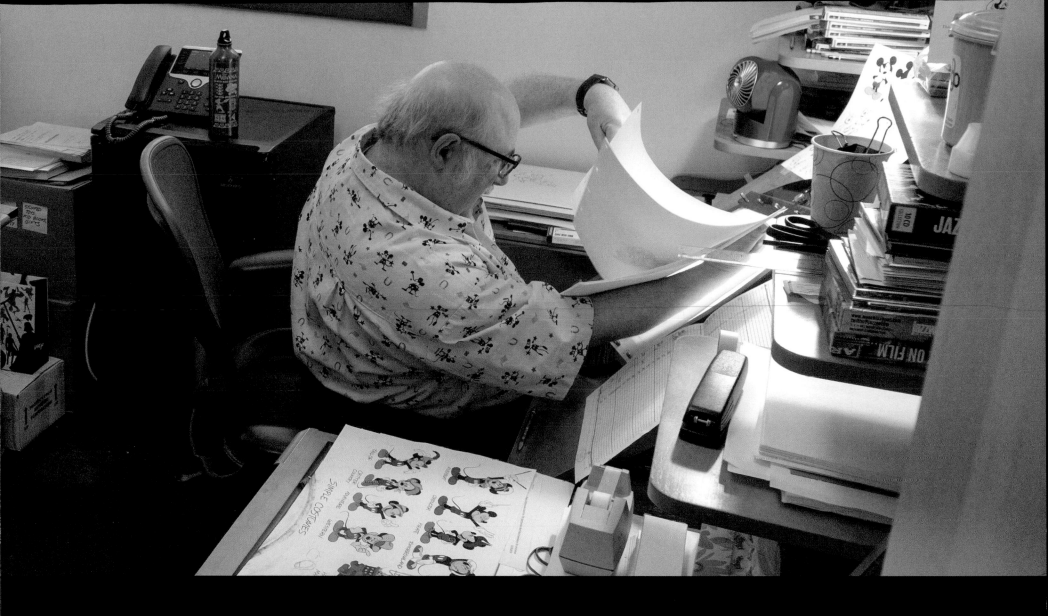

Even Mickey Mouse needs someone to look out for him, to make sure he always looks his best. These days, the man behind the mouse is often legendary animator and director Eric Goldberg.

The artist who animated Genie for *Aladdin* (1992) is a pillar of Disney's Creative Legacy department, which safeguards all the company's animated characters, both 2-D and 3-D. Whether they're going to be projected onto walls or water at one of the parks or appear in marketing clips or TV spots, "we make sure that the characters absolutely feel like the characters," Eric says. Not only must the designs match, "the movement and style need to be exactly the same as in the original film."

It's a job to which Eric is well suited. He grew up on the classic cartoons shown on the *Mickey Mouse Club* and other early children's television and started drawing animated characters in flip-books by the time he was six years old. "No memo pad in the house was safe," he says.

He studied illustration in college and was soon an assistant animator for the celebrated Richard Williams, who was later the animation director for *Who Framed Roger Rabbit*. After many years working on film, TV, and commercial animation, Eric got a call from a Disney recruiter, which he recalls this way: "Directors John Musker and Ron Clements are doing a movie of *Aladdin*

and they're getting Robin Williams for the genie. I don't know if you're interested."

He certainly was. Eric went on to work on *Hercules*, *The Princess and the Frog*, and other features, and he directed *Pocahontas* and two segments of *Fantasia/2000*. More recently he supervised the hand-drawn "mini Maui" animation in *Moana*, which was also directed by Musker and Clements. Eric is grateful to the directors. "They absolutely wanted hand-drawn in *Moana* and they thought, 'What better way than to have it on Maui's tattoos?'"

Eric still works with pencil and paper, even for his contributions to the complex blend of hand-drawn and CG animation in the Oscar-nominated Mickey Mouse short *Get a Horse!* He also draws many of the classic Disney characters' cameos in park attractions and elsewhere under the Creative Legacy program. But that doesn't mean he's blasé about following in the footsteps of the legendary Nine Old Men, the top character animators in Walt Disney's day.

"There's times I've had to animate Peter Pan and it's like, 'I better do a pretty good Milt Kahl or, you know, the lightning bolts will come down." Eric laughs (which he does a lot). "I give it my level best and make it as true to the characters as I can."

GABRIELA

Part of the Magic

GABRIELA CLARK

Hometown
Hacienda Heights,
California, USA

Job
Senior Manager,
Creative Print Services

Favorite Disney movie
The Lion King (1994)

As part of her job, Gabriela Clark got to organize the tenth anniversary "classroom photo" with Marvel movie cast members—from Iron Man to Captain Marvel—during the filming of *Avengers: Endgame*. As the stars arrived at the Pinewood Atlanta Studios soundstage, she told them where to sit on the bleachers.

Then she got to direct them. "I needed them all to look forward and smile," Gabriela recalls. "But to be in a room with all our superheroes at once—that was incredible."

As senior manager for Creative Print Services, Gabriela is guardian of the marketing images for Disney's movies—all the posters, online ads, and other artwork that her team simply calls the "creative."

She travels the world to movie sets—in England, New Zealand, wherever—to produce the photo shoots on which all the creative is based. In 2013, she worked with legendary photographer Annie Leibovitz on *Cinderella*. She got a bird's-eye view of the proceedings when a crew member escorted her into the movie studio's rafters above the palace ballroom set.

"It was amazing," she says, "looking down at Annie Leibovitz setting up her lights—and those sets were just so gorgeous. I started to tear up, because who would have ever told me that I would have been at this moment in my life?"

It's certainly not anything Gabriela envisioned as a teenager at her part-time job selling corn dogs from the Little Red Wagon on Main Street, U.S.A., in Disneyland. Her full-time Disney career began at a Disney Store in Cambridge, England, where she was going to school. She then moved into the head office for visual merchandising, "doing the window displays and signage for all the European stores."

Other positions in creative services followed, taking her back to her native California, where she is part of the team responsible for the images seen on billboards, at movie concession counters, in Disney Stores and parks, and on toys and T-shirts and notebooks and websites—essentially everywhere, worldwide.

"I'm very organized," she says, and also very hands-on, checking revisions of each image, "making sure all the finishing notes are translating correctly and making sure our creative looks really good."

As the nexus among photographers, actors, designers, vendors, and countless others, each with their own priorities, Gabriela has become a master problem-solver—thanks in part to advice from her father.

"My dad was a mechanic, and he was always teaching me that if you can't fix it this way, then come at it in a different way. I think of him all the time, because he always said nothing's ever impossible—it's just a challenge. And finding out how to solve that challenge is key."

Gabriela Clark proofs a billboard for *Captain Marvel*, checking that the artwork looks perfect and the colors true. The proof is just 25 percent the size of the final billboard.

JON

Part of the Magic

JON FAVREAU

Hometown
Queens, New York, USA

Job
Executive Producer,
The Mandalorian for
Disney+

Favorite Disney attraction
Space Mountain

As many great movies as Jon Favreau has served up as a director over the years—from the original *Iron Man* to the live-action *The Lion King*—he knows where the flavors really come together: "Filming is buying the groceries," he says. "Editing is preparing the meal."

Jon is both writer and executive producer on the Lucasfilm and Disney+ series *The Mandalorian*, which is about a lone gunfighter traveling remote realms of the *Star Wars* galaxy a few years after the events that unfolded in *Return of the Jedi*. But this time Jon is leaving the directing to others, including Bryce Dallas Howard, who helmed episode four of the series.

Bryce's long résumé as an actor and her storied family have uniquely prepared her for this work. "I've been fortunate enough to meet and glean from some of the wisest and most celebrated creatives," she says. That includes her father, director Ron Howard, and—through him—*Star Wars* creator George Lucas, who directed the then seventeen-year-old actor in *American Graffiti*, which was released in 1973.

"My dad told me that George always said that 'the writing and the filming of a project are when you're gathering all the materials. When you're editing, that's when you build the house.' That has always stuck with me."

The tools of editing have changed considerably in the nearly half century since *American Graffiti* was initially in theaters—leaps of technology that excited Bryce during

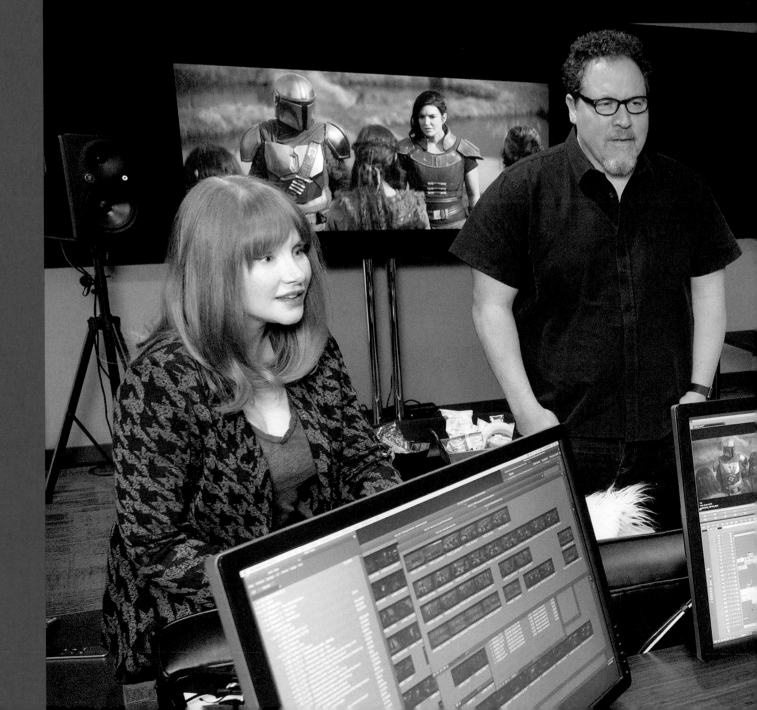

the many sessions spent with editor Dana E. Glauberman crafting the episode. "This team is on the forefront of pushing the medium of cinema forward," she says, "and I am over the moon to be a participating member of the first season of the show." Bryce remains steadfast about this feeling even though she woke up every morning while working on the episode with "my brain exploding from the day before."

It was something of a race to the finish as the show's many visual effects were still being tinkered with during the editing, Bryce reveals, making it necessary to edit "somewhat out of sequence." Another challenge, she adds, "was the secrecy about everything!" The cloak of silence limited Bryce's usual tendency to invite "the entire neighborhood over, to hear what they think."

Nevertheless, she had the feedback she needed thanks to support from Jon and fellow *Mandalorian* executive producer Dave Filoni and everyone at Lucasfilm and Disney. She singles out Jon as "exceptionally generous" and "a passionately inspired creator."

For his part, Jon cherishes his collaborations with Disney. "I love being a professional storyteller," he says, adding that it's exciting to be "collaborating with other *Star Wars* fans and creating stories that we would want to see."

Asked what she loves about her job, Bryce answers simply that it's "the people and the laughter! This is the best job in the world because I get to collaborate with brilliant, hilarious, and creative individuals on a daily basis."

Episode director Bryce Dallas Howard and series executive producer Jon Favreau work on editing a scene from the *Star Wars* series *The Mandalorian* with editor Dana E. Glauberman, ACE.

BRYCE

Part of the Magic

BRYCE
DALLAS
HOWARD

Hometowns
Greenwich, Connecticut, and Los Angeles, California, USA

Job
Director, Episode 4 of *The Mandalorian* for Disney+

Favorite Disney movie
Pixar's *Inside Out*

Every afternoon at Disney is a new adventure, but one grounded in thousands of afternoons that have come before.

As Dana Amendola prepares for another performance of the stage musical *Aladdin*, he's also honoring the century of Broadway tradition embodied by the New Amsterdam Theatre. On the set of *black•ish*, actor-producer-director Anthony Anderson channels classic Norman Lear sitcoms from the 1970s that were among the first to feature African American families . . . while simultaneously breaking new ground.

The story of Disney also now encompasses Marvel's nearly sixty years of storytelling—a narrative that film development executive Nate Moore knows well—plus Lucasfilm's nearly fifty, honored by every fan event Este Meza supervises.

Some cast members themselves embody this rich record—no one more so than Disneyland plasterer George Montano, who visited the park when it was new . . . and still works there! At Disney, history comes alive in more ways than one.

Chapter Six

3 pm – 6 pm

SAGE

Part of the Magic

SAGE STEELE

Hometown
None—"I'm an army brat!"

Job
Anchor, ESPN *SportsCenter*

Favorite Disney movie
Beauty and the Beast
(1991)

The forty-year-old institution known as ESPN's *SportsCenter* is a well-oiled machine. Before each live broadcast, host Sage Steele and the rest of the *SportsCenter* team gather in what they call the "screening area," just off the set in the network's Bristol, Connecticut, studios. "It's pretty chaotic every day," Sage says, with a tone that suggests that's a good thing. "It's show prep and writing scripts and clipping highlights and debating over what should be ahead of what. It's the hub for everyone who's putting the show together."

Whether in the midst of screening highlights, interviewing athletes on the air, or covering a heated NBA game, Sage says she relies on her people skills to keep her focused. Her calm composure in high-stress situations was forged in her family-focused childhood as a self-described "army brat," who was changing towns, schools, and even countries every few years. "I know what it's like to feel uncomfortable—to walk into a room alone for the first time because you're the new kid, or you have neighbors who don't even speak your language."

It was during one such move in 1984 that Sage decided to become a sports broadcaster. She was eleven. "We had just moved into our house in Colorado Springs, Colorado. There was no furniture, but there was one tiny TV." Sage sat on the floor, watching the Summer Olympics, in awe of Carl Lewis and Mary Lou Retton. "I wanted to learn what made them tick and to tell their stories. So, that night at dinner, with us on the floor, I said, 'Mom and Dad, I want to talk about sports on TV when I grow up.' And they're like, 'Well, that's cute.'"

Sage made it happen. She graduated from Indiana University with a degree in sports communications and worked as a sports reporter and anchor in Indiana, Florida, and Maryland before joining ESPN in 2007.

The distance she has traveled hit her one evening in 2014, just before the start of Game 3 of that year's NBA Finals. "I got emotional because I thought back on this eleven-year-old girl sitting on the floor, and all those times when this was the dream—and to think I was now sitting there in that chair among twenty thousand screaming fans and LeBron James and Stephen Curry and a million people watching . . . and I'm hosting?" reflects Sage. "I'm like, I'm gonna cry on national TV. I had to compose myself quickly."

She pulled it together and then thought to herself, *Take a visual picture and smell the roses, but don't ever forget what it took to get here.*

Sage Steele hosts ESPN's *SportsCenter* from the network's Digital Center in Bristol, Connecticut, when she's not covering sports events in person.

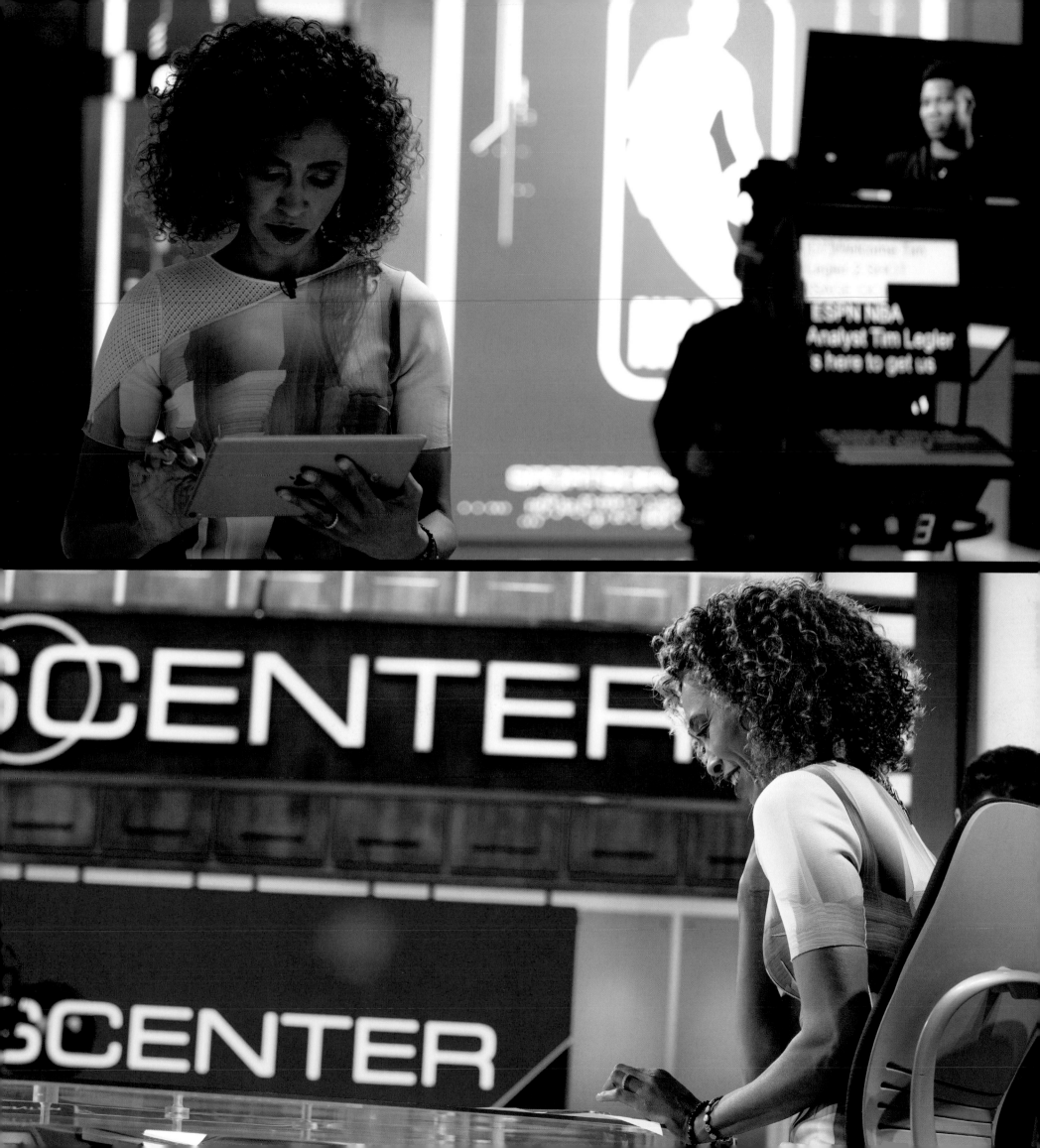

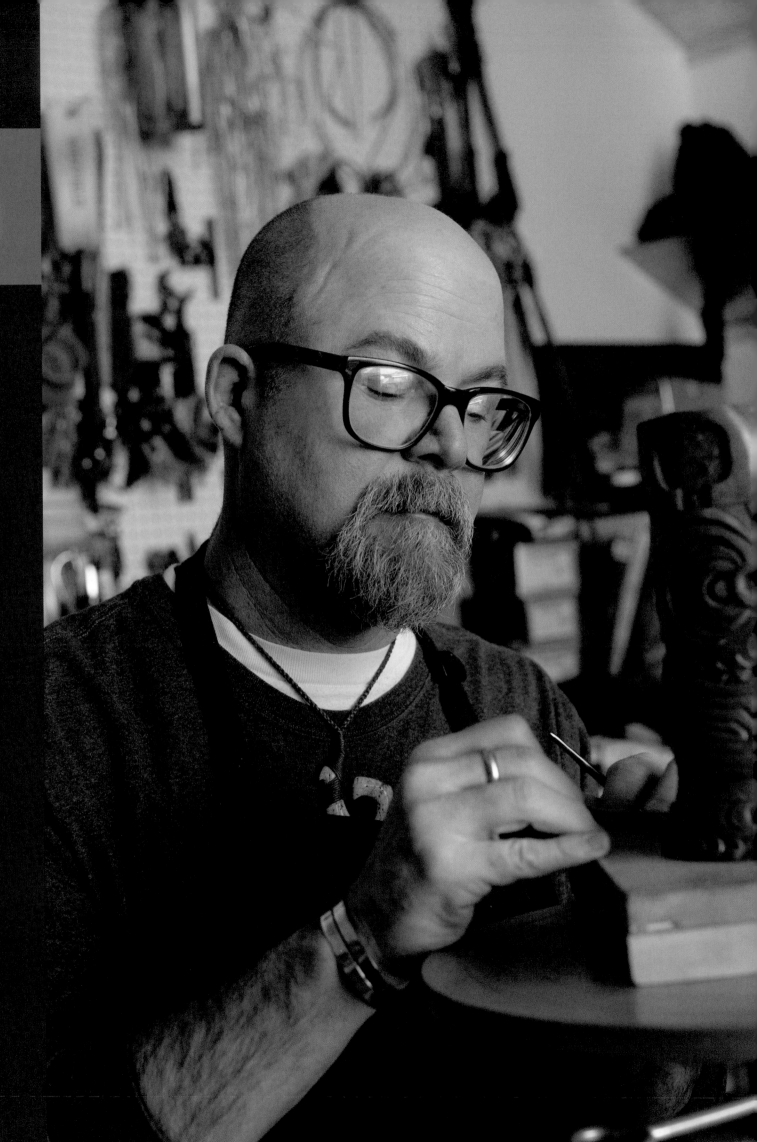

JEROME
Part of the Magic

JEROME RANFT

Hometown
Whittier, California, USA

Job
Sculptor at Pixar
Animation Studios

Favorite Disney movie
Pixar's *The Incredibles*

Jerome Ranft expresses his life's calling simply this way: "I make stuff." At Pixar, he's been sculpting many of the maquettes that have defined the studio's iconic characters for more than twenty years. Here's a partial list of what else he makes: Bronze casts. Carved wood. Chiseled marble. Photographs. Jewelry. His own fishing rod—from scratch! "I'm making some furniture for my wife right now at home," he adds. "To me it's all related. I don't try to compartmentalize all those different disciplines. To me it's all one thing. It's just making stuff."

Pixar characters evolve through as many as a couple dozen design iterations, hand modeled in clay or Plasticine, as a project develops. "It's a way to pre-visualize 3-D design before we spend the time and money to do it in the computer," Jerome explains.

Having worked on Pixar films from 1998's *A Bug's Life* through 2019's *Toy Story 4*, Jerome is hard-pressed to pick a favorite character he has sculpted, though a leading contender is Henry J. Waternoose III, the five-eyed, crab-legged power plant chairman in *Monsters, Inc.*—"I think because he was technically very challenging."

Jerome started his education in art on the ground level. "We had a big pile of dirt on the side of the house, and my mom used to just give me a spoon and I'd go dig around. I used to take her emergency candles and melt them down and make stuff out of them. So, I was always attracted to manipulating materials."

He earned a BFA in sculpture then landed a job as a model builder on *Tim Burton's The Nightmare Before Christmas*. After also working on *James and the Giant Peach*, he got a job as a freelancer at Pixar for *A Bug's Life*. He never left.

In addition to his sculpting, Jerome works with Imagineering on projects that utilize Pixar figures and even voices some characters on the "scratch" recordings used before the final voices are locked in. A few, however, have even been retained—and are heard in the final versions of released films: he's Gamma the bulldog in *Up* and Jacques, the French-inflected shrimp, in *Finding Dory*.

Still, he identifies primarily as a "maker." "I define myself as a sculptor first and a guy who works at Pixar second." He aspires to having his own gallery show and is "constantly trying to find a balance in life." In the meantime, he says, "it's really nice to work with people you respect, who have never asked me to compromise my intentions or my values in any way."

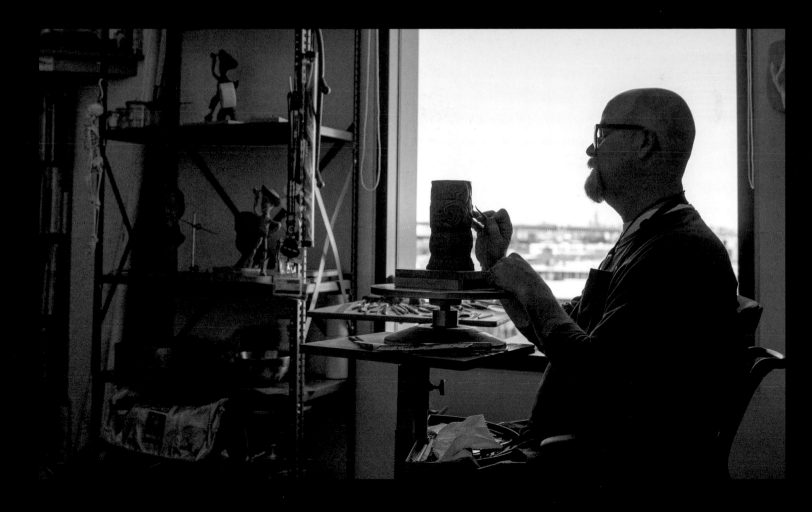

Jerome Ranft sculpts the prototype for a Tiki mug to be used at the D23 Expo in Anaheim. As an artist for Pixar, Jerome has hand-sculpted many of the studio's most iconic characters before they were animated.

DANA

Part of the Magic

DANA AMENDOLA

Hometown
Orr's Island, Maine, USA

Job
Vice President,
Operations,
Disney Theatrical Group

Favorite Disney attraction
Disneyland Railroad

Dana Amendola supervises operations for Disney Theatrical Group from the historic New Amsterdam Theatre, which houses the group's headquarters in its recently renovated top floor (right).

On the eve of the opening of *The Lion King* at New York's New Amsterdam Theatre in 1997, Dana Amendola recalls, "We were scared to death."

Disney had spent millions to restore the former home of the Ziegfeld Follies, built in 1903, and develop a show that would bring families back to a revitalized Forty-Second Street. "We felt the way Walt and the animators must have felt right around *Snow White*," says Dana, vice president of operations for Disney Theatrical Group. "We all had a sense that we were about to make history."

That they did.

The Lion King was a popular and critical smash when it premiered, and it's still playing—now at the Minskoff Theatre, a few blocks away (while the New Amsterdam hosts *Aladdin*). Dana credits that success in part to the show's original home—renovated with loving attention to period detail, from carpet to frescoed ceiling, sconces to balustrades, and on and on. "It was my job to make sure the show starts the minute the audience walks through those front doors, not just when the curtain goes up," says Dana.

Before Disney, Dana spent many years

managing three-thousand-seat venues around the country. But now he oversees the operation of theaters worldwide that are home to Disney Theatrical Group stage shows. Yet Dana still watches the patrons pour into the New Amsterdam "every chance I get," he says. "I can look at an audience and tell you what day of the week it is."

Guests seeking the full story on the New Amsterdam—and its incredible restoration—can take a guided tour through its ornate spaces and eye displays from its past Ziegfeld days and other theater memorabilia. Many photos of Follies star Olive Thomas, Florenz Ziegfeld's onetime mistress, are included in the tour. She died in 1920 but is said to still haunt the building, bringing good luck rather than frights.

"I've never seen her, but I've met people who have," Dana says. That includes some Disney Theatrical Group cast members who have their offices in a remodeled space that was once Ziegfeld's rooftop nightclub. "Everyone that works here knows about Olive. At every exit of this building is a picture of her. When people go home, they blow her a kiss good night."

JACKIE
Part of the Magic

JACKIE MA

Hometown
Hong Kong, China

Job
Senior Arborist,
Hong Kong Disneyland
Resort

Favorite Disney attraction
The trees and
landscaping of Hong
Kong Disneyland

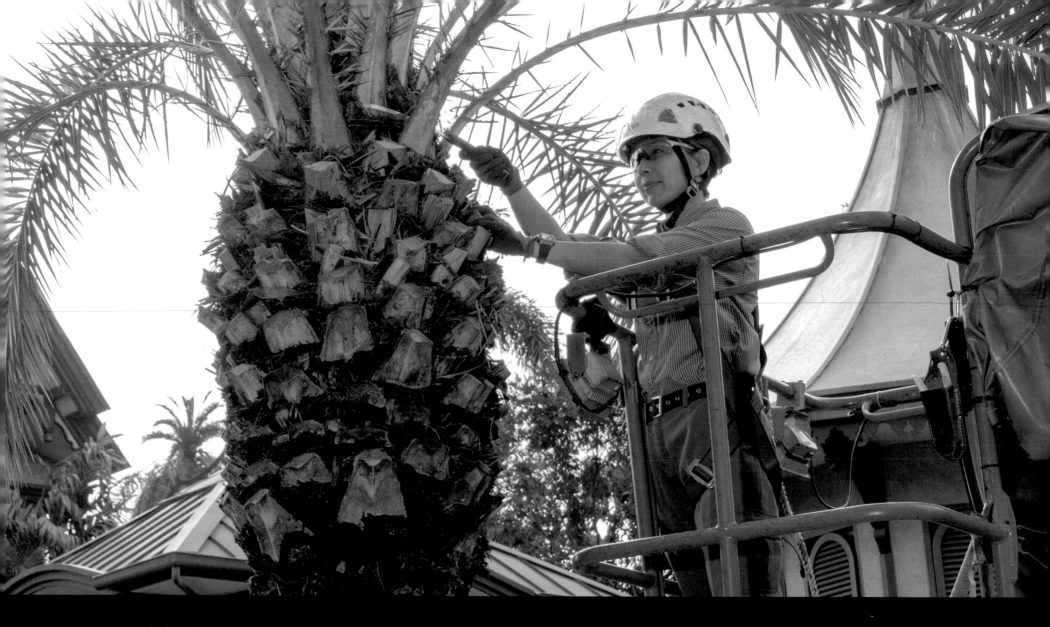

Jackie Ma works on trimming the palm trees outside the Mystic Manor attraction at Hong Kong Disneyland. She is the park's first woman arborist.

Senior arborist Jackie Ma may be twenty feet in the air when she's grooming trees at Hong Kong Disneyland Resort, but she's also a groundbreaker. Jackie is the first and still only female tree specialist on the park's eighty-person horticulture team, which she joined in 2015.

With some two hundred species of trees and four hundred species of shrubs in Hong Kong Disneyland Resort, there's a lot to keep the team busy. The resort is known for its gorgeous gardens and landscaping, vibrant with topiary and seasonal blossoms. The resort area has five nature trails with their own dedicated guidebook, which describes the plant life as well as the many varieties of butterflies and birds.

"The first two years I worked here, I would visit the resort after work maybe twice a week to take photos of the different plants, the trees, the flowers," Jackie recalls. "There are a lot of flowering trees in Hong Kong Disneyland Resort."

Jackie cared for trees in her previous job, but the opportunity to join Disney was too appealing to pass up. "For me this is a happy place, a fantastic place. I wanted to try working here."

Her Disney experience has led to professional recognition after she received her arborist certification from the International Society of Arboriculture in 2012. It has also expanded her circle of friends, as she joined the resort's hobby groups that introduced her to fellow runners and dragon boat enthusiasts.

The work is hard, she says—"We have to trim or shape the trees to make them look beautiful"—and it takes practice and concentration to ensure it's done safely at all times. That's a particular challenge when the aerial work platform is inaccessible. "Then we have to climb the tree. That's the difficult part." (Jackie got her certification as a tree worker-climber in 2014.)

For young girls aspiring to follow in her booted footsteps, Jackie advises, "You have to love trees and love nature. Be brave and don't give up easily. Keep learning. And I think the most important thing is, when opportunity comes, grab it."

MAXINE

Part of the Magic

MAXINE SHEPARD

Hometown
Los Angeles, California, USA

Job
Production Designer, ABC's *black•ish*

Favorite Disney movie
Pixar's *WALL•E*

Maxine Shepard knew she'd hit her mark as production designer for ABC's *black•ish* when two of the actors in the ensemble wanted to sit down and play on her set. Of course, Miles Brown and Marsai Martin were just nine years old at the time, but "just seeing the delight when they first walked into their [characters'] bedroom told me that I was successful," Maxine recalls.

She's been in her role since the show's 2014 launch, a change of pace after long stints designing gritty dramas such as *CSI: Miami* and *Southland.* "I was always in there with the detectives and car chases and murder scenes, so to step back and do a funny show about a family was just very different for me."

She won the job after pitching her design ideas to creator Kenya Barris, relying on her well-honed instincts with just the pilot script to go on. Her sketches for the look of the Johnsons' home were "on the money with what Kenya wanted, and we just took off running," Maxine remembers.

The show has kept her on her toes for five seasons, not just revamping the children's bedrooms as they've grown—and making sure Dre's sneaker collection is up to date—but also creating unique sets for individual episodes.

Among the most challenging was a slave cabin set for season four's musical opener, "Juneteenth." As Maxine was asking herself how realistic to make slave quarters for a comedy, "Kenya Barris just said one word to me, and all of a sudden it all made sense. All he said was '*Hamilton.*'" Creating a set for a song about slavery "is just not something that you get to do every day. It was a special design moment where you're like, 'Wow, I really get to stretch myself here.'"

She also gets to highlight the work of contemporary artists. Fans of the show are always asking where they can buy certain décor elements, and the painting over the Johnsons' mantelpiece tops social media mentions. Maxine is happy to direct the curious to the works of artist Noah Davis, for example, an African American painter from Los Angeles who died in 2015. "There's also a piece next to the front door by Fahamu Pecou," a Brooklyn-born artist, that people ask about.

"It's great that we can share especially African American artists' work on the show, and it's a great way to decorate the set," Maxine says. "It's a win-win for everybody."

Maxine Shepard holds one of many pairs of sneakers from Dre Johnson's closet on the set of *black•ish*. The shoe collection is updated every season and includes some custom-made pairs.

ALFREDO
Part of the Magic

ALFREDO AYALA

Hometown
Los Angeles, California, USA

Job
Executive, Research & Development, Walt Disney Imagineering

Favorite Disney movie
Pixar's Coco

Alfredo Ayala was four years old when Disneyland's Pirates of the Caribbean attraction "scared the weejeebies out of me," as he puts it. A couple decades later, he was working at Walt Disney Imagineering as part of the team giving those scary pirates a makeover.

The goal was to replace all the Audio-Animatronics figures' skins with a more up-to-date synthetic, and Alfredo came on board as an intern. His background was as a scientist researching organic synthesis—specifically, the kinds of polymers that could be molded onto robots to make them look lifelike. His work helped WDI create a new synthetic skin that's still being used in the parks today. Twenty-five years later, the polymer formula remains a closely guarded trade secret—"like Coke," he quips.

Alfredo's internship led to a full-time position and a series of assignments on the WDI Research and Development team utilizing his dual degrees in chemistry and electrical engineering, working on everything from optics (on Soarin' and the Finding Nemo Submarine Voyage) to Audio-Animatronics figures (for an update to the Abraham Lincoln figure in Great Moments with Mr. Lincoln at Disneyland). A career at Imagineering is "an evolutionary thing," he says. "There are no limits, and you get to wear many caps."

A recent venture was the use of performance capture technology to animate the stunning, many-armed shaman figure in the Na'vi River Journey attraction in Pandora at Disney's Animal Kingdom. His summary of Imagineering's mission is simple: "We bring life into everything we touch."

Alfredo sees science and art as twin endeavors. "My father was an artist, a custom saddlemaker, designing and stenciling the leather," he relates. "Working in my dad's shop was my introduction to art. He said, 'Great artists have great observational skills.' And what my professors taught me is that scientists have great observational skills. To me, there is no difference."

The imperative to observe takes Alfredo out into the parks at least once a month "to see how guests are enjoying the things that we make." His field trips always inspire him to ask, "What if . . . ?" Then it's the R & D team's objective to answer the next question: "How do you make that 'what if' come true?"

One of Alfredo's favorite "what if" questions to consider is this: If robots could sleep, what would they dream? His answer sounds like the aspirations of any Imagineer: "They dream of a place where they're happy and making a positive difference, that they're making people laugh and cry, that they're making people smile."

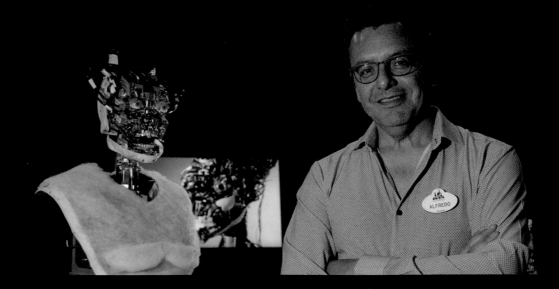

Alfredo Ayala examines the inner workings of the head for the Audio-Animatronics figure of the shaman seen in the Na'vi River Journey attraction in Disney's Animal Kingdom, one of Imagineering's most advanced robot performers.

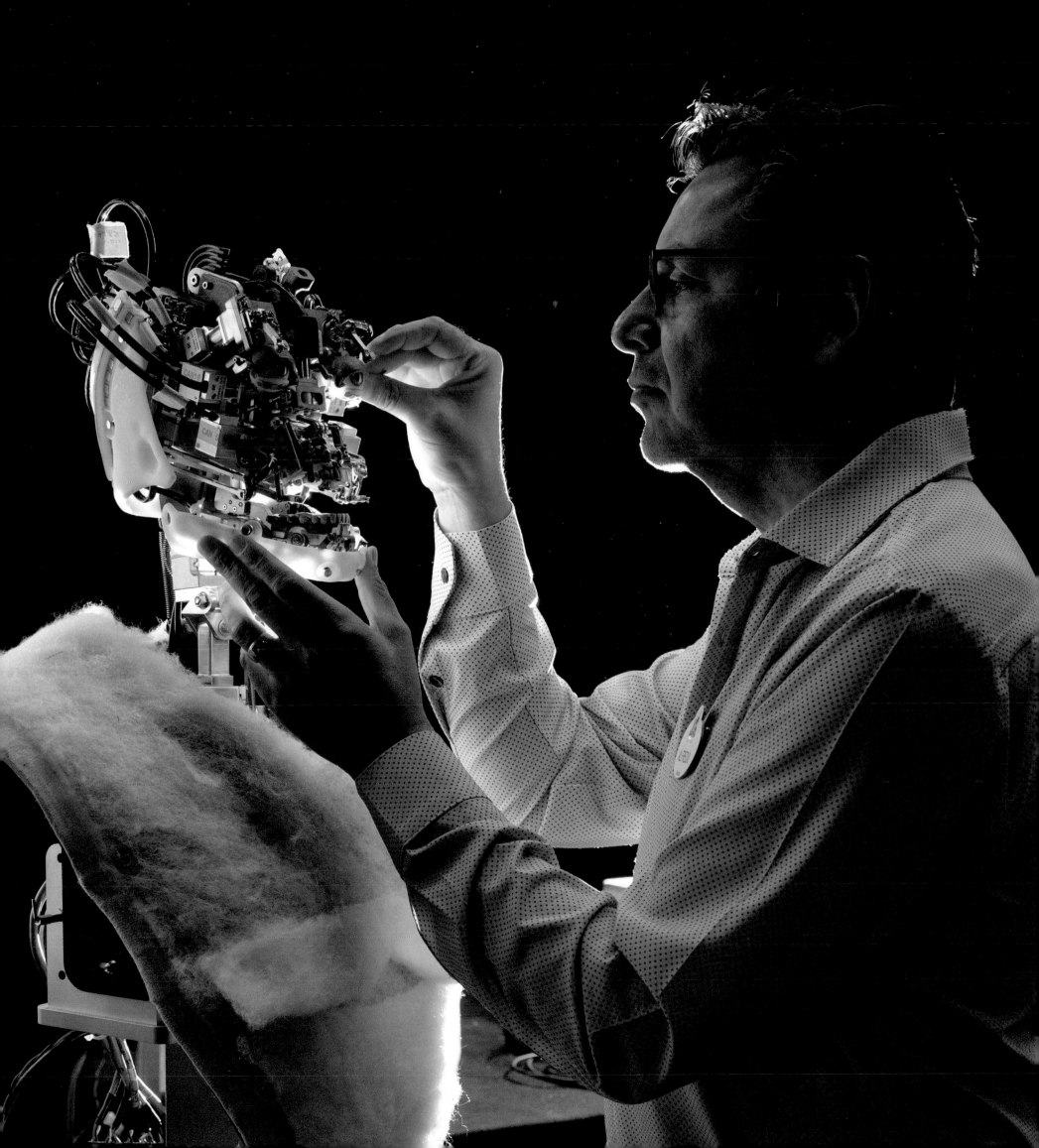

DAVID
Part of the Magic

DAVID
MUIR

Hometown
Syracuse, New York, USA

Job
Anchor and Managing Editor for *ABC World News Tonight with David Muir*

Favorite Disney movie
Marvel's *Black Panther*

David Muir, seen here in the *ABC World News Tonight* studio, says, "The newscast we envision early in the morning more often than not does not exist by the end of the day."

BILLY RAY CHUBBS

Hometown
McComb, Mississippi, USA

Job
Motion Capture Performer and Receptionist for Lucasfilm

Favorite Disney attraction
Main Street, U.S.A., Disneyland

Samuel L. Jackson (aka Mace Windu from the *Star Wars* universe) called Lucasfilm one day, and the Hulk answered the phone. Or maybe it was Megatron from the Transformer films, or the T. rex from *Jurassic World*, or King Kong from *Kong: Skull Island*. Billy Ray Chubbs has played all those and more as an Industrial Light & Magic (ILM) motion capture performer. And when he's not acting out the storming of Wakanda by thousands of multiarmed Outriders for *Avengers: Infinity War*, he answers the telephone as Lucasfilm's receptionist.

It all began with figure skating. Billy Ray attended a private-study high school in which he trained for years as an ice-skater—and also took a lot of teasing for it from the athletes at San Mateo College, located across the street.

"I couldn't wait to graduate so I could stop skating and jump on the football team," he recalls. That's exactly what he did. Then he took another athletic left turn: training with the team, "I discovered that I liked lifting weights more than I liked playing football."

Ever after, whatever full-time job Billy Ray had—ticket agent at the San Francisco airport, undercover security at Whole Foods—he made sure he also had a part-time gig at a gym, to get a free membership. So he was quite the buff guy in 2003 when a Whole Foods customer gave him a tip that a security slot was opening up at Industrial Light & Magic, the

visual effects division of Lucasfilm. He go the job, and three years later happily hung up his security uniform for the receptior desk.

"So I'm sitting at my desk one day and they asked me if I'd come down and pu on the [motion capture] suit and pretend I was the Hulk," he recalls. ILM was doing a demo for Marvel's *The Incredible Hulk* movie, and "they had me roaring and screaming and jumping around—basically saying, 'The more you come unglued, the better it's going to come across.'"

Billy Ray has been ungluing himsel regularly ever since. The movement o the tracking points on the "mo-cap" sui he wears are captured by a camerc that transfers his every gesture onto a computer model of the creature or character, which visual effects techs anc animators use to create the performance: seen by movie audiences.

Those audiences include Billy Ray anc his three children, ages ten to twenty-four "I still get kind of teary-eyed when I watch these films and see the stuff I've done," he says. "It's really cool to tell your kid you're the Hulk or the T. rex."

He did not, however, tell Samuel L Jackson that. "He said, 'Hey, this is Sam Jackson. Let me speak to so-and-so,' anc I was kind of floored for like two seconds I just had to pretend like I wasn't starstruck and transfer him."

Some people are even cooler thar the Hulk.

When he's not in his motion capture suit (right), performing as the Hulk or a multiarmed Outrider, Billy Ray Chubbs is the receptionist for Lucasfilm.

GRACE

Part of the Magic

GRACE LEE

Hometown
Kaohsiung, Taiwan

Job
Senior Illustration
Manager,
Disney Publishing
Worldwide

Favorite Disney movie
Beauty and the Beast
(1991)

170

Princesses with puffy sleeves were fundamental to Grace Lee's journey as an artist. At least when she was seven years old. "I remember really liking the ball gowns," she says. "The sleeves were really easy to draw because it's like a circle shape that came naturally to me."

Disney Junior princess Sofia the First still rocks the puffy sleeve look now and again in the children's books Grace illustrates—including *Sofia the First: The Floating Palace*, which won her Illustrator of the Year in 2014 at the Children's Choice Book Awards sponsored by the Children's Book Council.

Grace's favorite book project during her seven years as an artist with Disney Publishing Worldwide was for *Frozen*, since she got to work with one of her idols: art director Michael Giaimo, whose career at Disney stretches back to *Pocahontas*.

"It's really cool to see the work in progress as the films are being made," Grace notes. Her early involvement is imperative, since the books have to be finished before the movie is done so they can be printed and shipped to stores in time for the film's debut.

So as *Moana* and *Zootopia* took shape, Grace—who supervised the painting work done for those films' picture books—was in touch with the movie's production team. For each project "there's a pool of artwork that needs to be created," she explains. "It's a critical part of the book development process."

She also illustrates a few books solo start to finish, such as the latest Fancy Nancy title, *My Fanciest Things*.

Grace credits her success to "discipline and determination," as well as kindness. " may not have been the best artist in the class, but I worked really hard and I tried to be respectful, and I feel that's really helped me."

And she's very grateful to her immigrant parents, who always encouraged her to pursue her dreams. Her first art class was at age seven. "I have my brother to thank for that because my mother saw talent in him and she decided to enroll both of us." Her brother ended up moving on quickly but those early classes set Grace on her path. "It's incredible to me to say I've achieved my dream of being part of the Disney magic that filled my childhood."

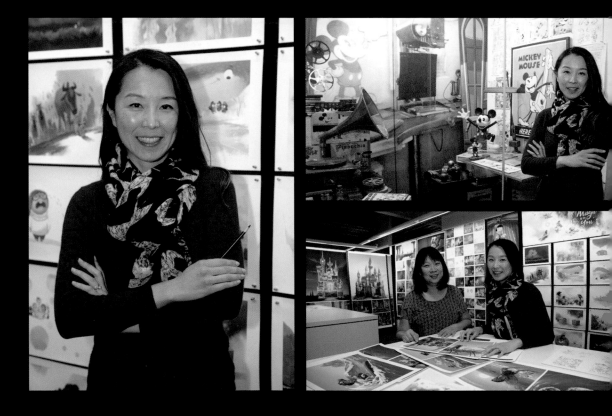

Artist Grace Lee has won awards for her illustrations of little girls in frilly dresses like Grace's own Cinderella dress, made for her by her mother for Halloween in the fifth grade. Grace is seen here with design manager Winnie Ho, collaborating on one of their many projects together.

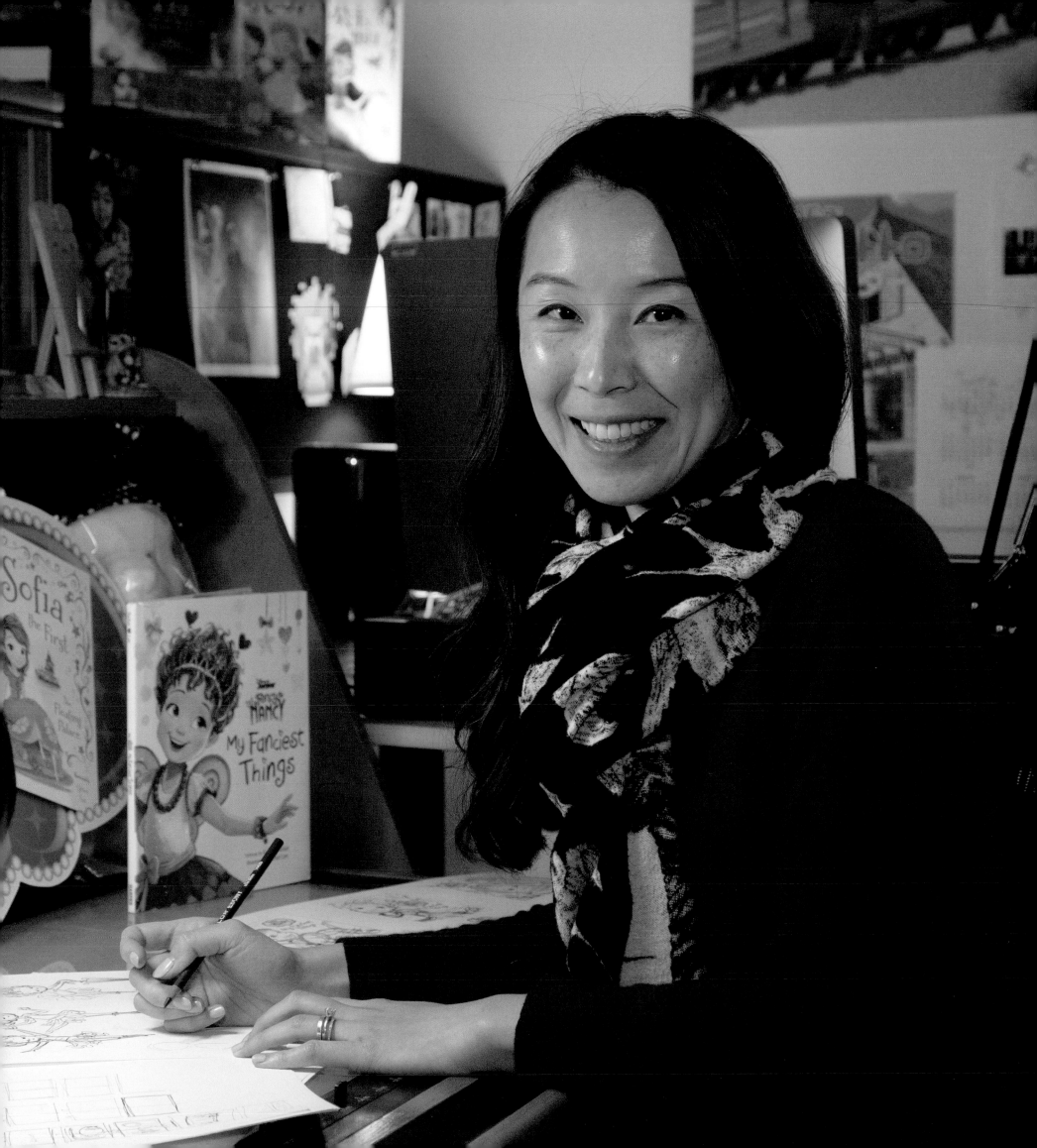

GEORGE

Part of the Magic

GEORGE MONTANO

Hometown
Santa Ana, California,
USA

Job
Staff Shop,
General Lead

Favorite Disney movie
*Davy Crockett,
King of the Wild Frontier*

When George Montano pitched in on renovations to the best-known structure at Disneyland last spring, it brought back memories of when he'd first laid his eyes on Sleeping Beauty Castle. He was ten years old, and the castle was brand-new. The park had been open just over a week, and he was there with his parents and brother.

"What I remember most from that visit is the castle," he says. "Going over the drawbridge and walking through it. I thought it was great."

Thirteen years after that 1955 visit, a contractor offered George a temporary position as a plasterer at Disneyland. "He said it could be three months, but not more than six." Fifty-one years later, George is still on the job.

By the time he joined the Staff Shop in 1968, his dad was already there, having worked on the construction of the Matterhorn Bobsleds as a contract worker in 1958 and going full-time to build "it's a small world" in 1965. For a while, George's brother was there as well, and in the late 1970s the three men worked together on the refurbishment of the Matterhorn attraction and on the creation of Big Thunder Mountain Railroad.

Although he would never say so himself, George is something of a superstar within Disney. Wherever Walt Disney Imagineering has been in recent decades, they've wanted George there. His plastering and rock-carving skills helped build Fantasyland in Disneyland Paris and Mickey's Toontown in Tokyo Disneyland. WDI asked him to pitch in at Hong Kong Disneyland as well, but George was too busy sprucing up Disneyland for its fiftieth birthday to leave his home base.

George learned to carve rocks out of cement plaster from some of the craftsmen who built Disneyland. He's also a master at architectural ornamentation, often created from his own handmade plaster molds. He may be most proud of the chimneys he crafted for the facade of Mr. Toad's Wild Ride, inspired by the smokestacks of London's Hampton Court. For Disneyland's complete overhaul of Fantasyland, WDI trusted George to fill in a lot of the details. "They said, 'It's yours. Get it done,'" he recalls.

Disneyland's original Staff Shop, where George first worked, is long gone, its former site now occupied by *Star Wars: Galaxy's Edge*. But his tools have changed little, and in fifty-plus years he has never doubted that every project could be completed to perfection, no matter how fantastic and impossible it looked on paper. "I've always been very optimistic," he says. "If you have this desire to make something work, it's going to work."

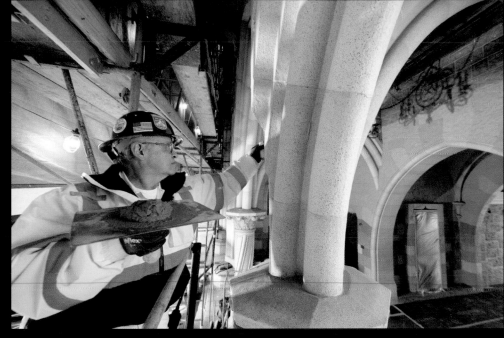

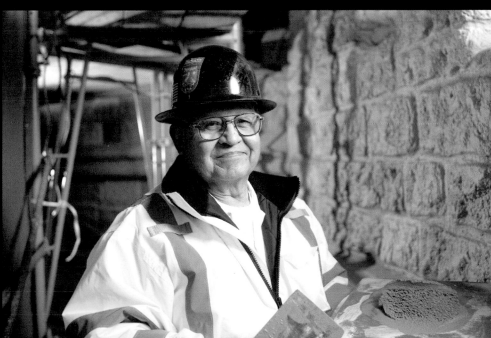

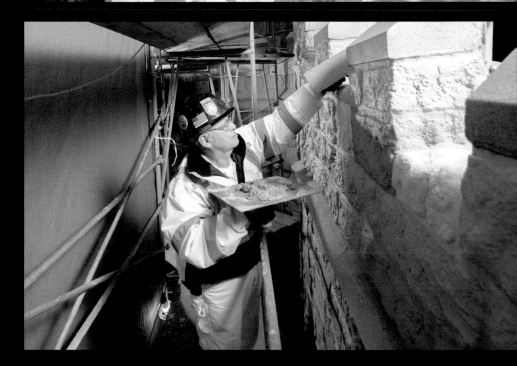

Plasterer George Montano works on the renovation of Sleeping Beauty Castle at Disneyland, which he first saw as a boy just a week after it opened.

LEAH
Part of the Magic

LEAH BUONO

Hometown
Rochester, Michigan, USA

Job
Executive Director,
Casting, Disney Channel

Favorite Disney movie
Cinderella (1950)

Leah Buono is well aware of how nerve-racking the audition process is for actors. "It's really my job to be their number one fan," says the executive director, casting, for Disney Channel. "As a casting director, you need to truly love actors."

Résumés and agents may get some actors in the door, Leah says, but "experience is secondary. You look for any individual that has a certain spark." The ideal audition, in Leah's opinion, is when everyone on her side of the table—creators, directors, producers—feels that same "undeniable 'This is it. This is the person.'"

The casting process for *High School Musical: The Musical: The Series*, premiering on Disney+, resulted in that kind of consensus. "Just being at the table read and seeing all the cast together for the first time was pretty magical—and I try not to throw that word around too often," Leah says.

Leah had acted some as a child while growing up in the Detroit area, and she even hosted an entertainment news program on local TV as a teenager. But Leah found that she enjoyed her siblings' auditions more than her own. Then came a revelation: "I was at the little art house movie theater and the credits rolled and it said, 'Casting by,' and I was like, 'That's something people do for a living, isn't

it?'" Leah was soon driving herself to Los Angeles for an unpaid summer internship in a casting office.

She had another epiphany some years later, after her career took her into the then-niche world of children's television: "I remember when *High School Musical* and *Hannah Montana* came out. And I was like, 'Things are about to change.' And boy, did they." Following her instincts, Leah joined Disney Channel about ten years ago.

During Leah's tenure at Disney Channel, she has played a pivotal role in casting a who's who of Young Hollywood, including Zendaya in her first series, *Shake It Up*, in 2010, and continuing through Sofia Carson (*Disney Descendants*), Ross Lynch (*Austin & Ally*), Maia Mitchell (*Teen Beach Movie*), the new *High School Musical* series gang, and too many others to list here.

Leah never knows when lightning will strike. "A kid can have me laughing on the floor just from having a regular old chitchat, without even reading any material."

Leah takes seriously the responsibility she shoulders while "working with people who are putting themselves out there in such a raw, free way. They're looking for me to help. You're affecting people's lives in the broadest aspect and not just their day."

Nothing says an audition is going well quite like joyful laughter all around, says casting executive director Leah Buono. Here Leah works with Scarlett Estevez, a lead on the Disney Channel series *Bunk'd*, and, behind the camera, Andrew B. Hinshaw, Director, Talent Relations and Casting for Disney Channel.

BRIE
Part of the Magic

BRIE
LARSON

Hometown
Los Angeles, California, USA

Job
Actor

Favorite Disney movie
Pixar's *Coco*

Hour after hour, Brie Larson graciously responded to hundreds of questions from dozens of journalists during the *Captain Marvel* press junket—essentially a daylong series of interviews in Los Angeles just weeks before the movie opened. But the questions that mattered most to her that day were the ones she was asking.

"It's my opportunity to ask people about what they're seeing and hearing about the movie," she says. *Captain Marvel* might have attracted record-setting crowds and glowing reviews, but Brie says that before opening day, she felt "kind of in the dark" about how Marvel fans and other moviegoers would respond.

Of course, that's always the case in the movie business. The difference this time for the Academy Award–winning actor was the size and nature of the team that was in the dark with her.

"I've never stepped into a family like this," she says of Marvel Studios. "I've never been part of a legacy like this."

A vocal feminist, Brie applauds Marvel and Disney for supporting her work for inclusivity and gender parity on-screen and off. "I wouldn't be able to do this without them," she says, then adds that Disney understands that "inclusion isn't about eliminating anybody; it's just about adding more.

"This is the first time I've worked at a company that dreams as big as me," she says.

Those dreams began around age seven, when Brie told her mom she wanted to be an actor. Five years later, she was already working for Disney, in the TV movie *Right on Track* for Disney Channel. "I was excited to drive race cars," she recalls of the fact-based movie about junior drag racers. "As with *Captain Marvel*, I wanted to do as much of my own stunt work as possibly could."

The self-described "super-shy" little girl might have blossomed into a self-assured actor and filmmaker, but she says, "It's nice to know at twenty-nine years old that it's the seven-year-old girl who got me here."

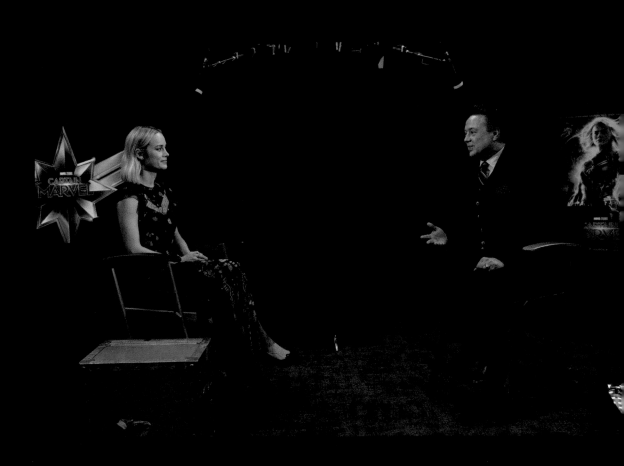

Captain Marvel star Brie Larson is interviewed by KABC-TV's George Pennacchio during the Los Angeles press junket for the film.

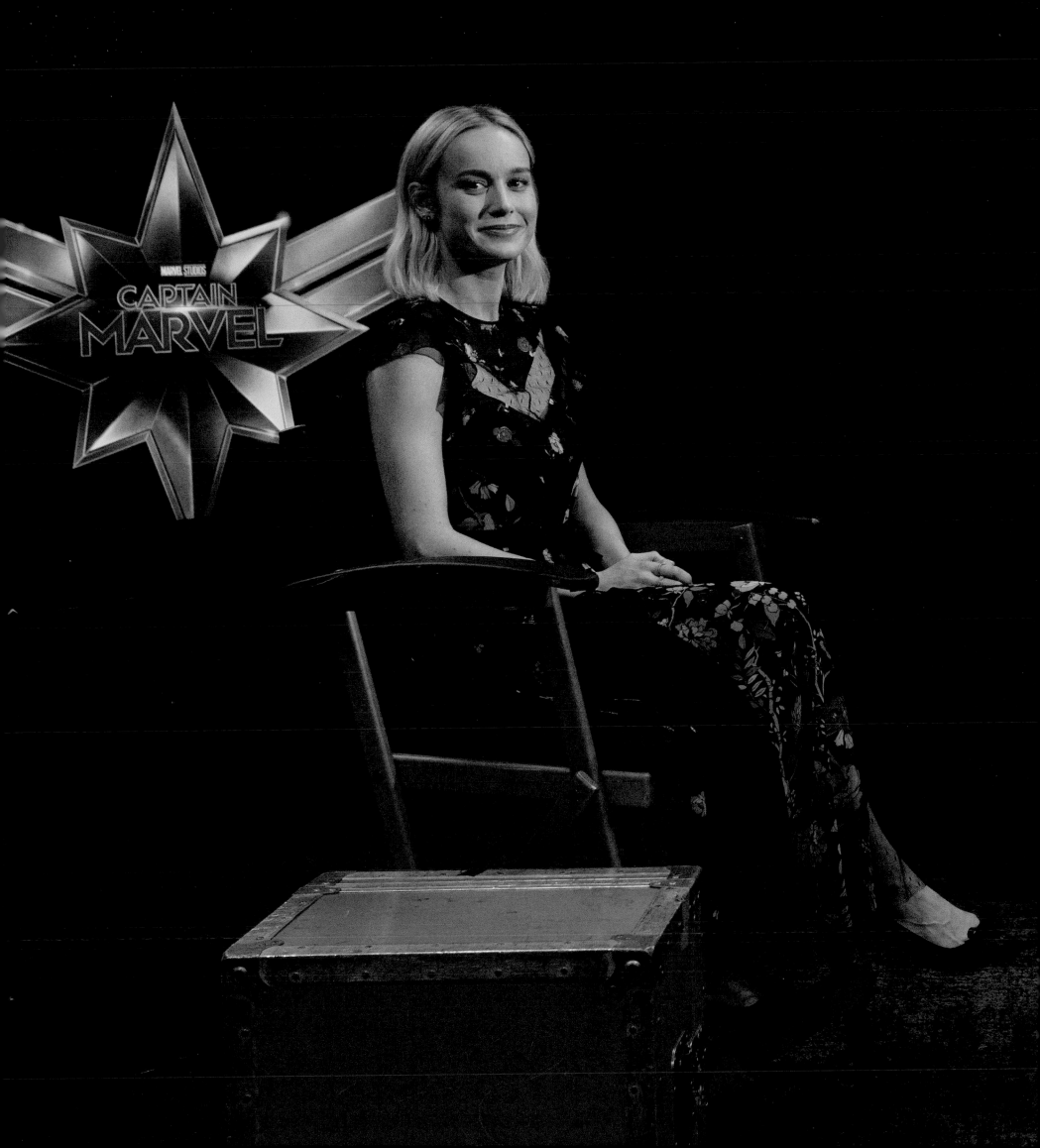

GEORGE PENNACCHIO

Hometown
Los Angeles, California, USA

Job
Entertainment Reporter, KABC-TV, Los Angeles

Favorite Disney movie
Pinocchio

Whether he's talking to twenty-nine-year-old Brie Larson or ninety-three-year-old Angela Lansbury, KABC-TV entertainment reporter George Pennacchio knows his subjects' work backward and forward. With Lansbury, he could talk as comfortably about *Gaslight* from 1944 as about *Murder, She Wrote* or *Mary Poppins Returns*.

"I love vintage Hollywood," he says, "people who helped make this town what it is today and are still here to talk about it." As for Larson, whom he interviewed at the press junket for *Captain Marvel*, "I remember her as a child star. She's someone who went from being a young working actress to an Oscar winner to a superhero."

Having a far-reaching knowledge of entertainment past and present is essential for anyone covering the industry, as George has been doing for twenty-three years in Los Angeles, after creating a similar job for himself at a Monterey, California, TV station. On interviewing prospective interns in 2019, he says, "I am stunned at people who tell me they want to be an entertainment reporter and I show them a picture of Frank Sinatra and they don't know who that is. Then you're in the wrong business."

George kicked off his Hollywood education as a kindergartener at his mother's side, watching the TV shows she loved. By seventh grade, he was at the movies almost every Saturday afternoon, and in high school he read all the celebrity magazines at the convenience store where he worked. Some of those publications were the work of legendary gossip columnist Rona Barrett—"the first person at KABC-TV who did my job."

When Barrett left the station, Regis Philbin took her place, so "I followed in some pretty big footsteps," George says. He works hard to fill those shoes, whether reporting live from the studio on breaking entertainment news or from the Academy Awards, where KABC-TV has the first live interview spot on the red carpet every year. When he's not on duty, he's still working, taking in all the latest TV shows, movies, books, and music.

"You can't be lazy and do this job," he says. "It's like being a Boy Scout—you have to be prepared. Because if you're not, you can look foolish and the star you're interviewing can be bored. You want to be in their memory as a good interview so when you walk into the room the next time, they'll say, 'Oh, look, it's George. This is going to be fun.'"

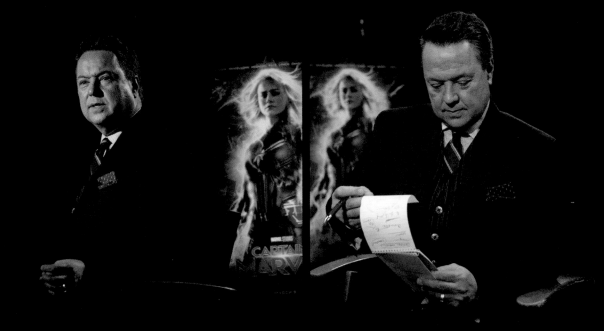

KABC-TV entertainment reporter George Pennacchio is known for his beautiful vests. He has hundreds of them, all custom-made for him by his wife, Erin.

ESTE
Part of the Magic

ESTE
MEZA

Hometown
Cupertino, California,
USA

Job
Senior Events Manager,
Lucasfilm

Favorite Disney movie
*Star Wars: The Empire
Strikes Back*

Here's what Este Meza doesn't tell strangers who ask him what he does for a living: He's been on a helipad with *Star Wars: The Rise of Skywalker* director J. J. Abrams. He's been in Japan with Chewbacca and in Uruguay with C-3PO. He recruited and organized thirty stormtroopers to march onto Soldier Field at halftime during a Chicago Bears football game. He's remotely operated R2-D2 and BB-8 at more places than he can remember.

When he can, Lucasfilm's senior events manager prefers to answer the "what do *you* do?" query with "just 'events'—because as soon as someone knows it's Lucasfilm, they want to ask all of the questions I'm not allowed to answer about *Star Wars*," he says.

Este's biggest ongoing responsibility is *Star Wars Celebration*, a huge multiday fan gathering begun in 1999 and now held every year or two in a different world-class city. Each takes about two years to plan, with the most recent, in Chicago in 2019, attracting some 150,000 people across five days. In between are innumerable smaller events ranging across the world where Este and his team manage displays and arrange for actors, filmmakers, and costumed characters to appear.

At any one of them, Este might be found with "one phone shoved to my ear with my shoulder and two phones in my hands, typing out e-mails or texts," he says. "It's always my plan to remain calm, and we work through the problems as they come in as a collective team."

At other times, he might be found living on an orange farm in Southern California for five weeks, working with Belgian prop builders to create the *Millennium Falcon* Experience. Constructed within a number of shipping containers, the painstakingly accurate reproduction of the interior of Han Solo's ship toured five cities in 2018.

Or Este might be at a hospital, squeezed into a corner, part of a two-man team trying to stay out of sight as they remotely operate BB-8, creating joy in a room full of children with life-threatening illnesses. "That was such a powerful experience," he says, after taking a moment to compose himself.

It may not be what Este envisioned when he decided in high school that he wanted to work in the film industry, but it beats the heck out of running audio-visual equipment at hotels or doing freelance video production, as he did for years before joining Lucasfilm in 2011.

Here's what Este feels about his job: "I have an opportunity to build out these amazing experiences that allow other really passionate people to enjoy and connect with one another," he says. "That's what drives me."

Este Meza is one of the few people trusted with the remote operation of both R2-D2 and BB-8, robots from the *Star Wars* movies that occasionally make live public appearances.

NATE

Part of the Magic

NATE MOORE

Hometown
Clovis, California, USA

Job
Vice President, Development & Production, Marvel Studios

Favorite Disney movie
The Rescuers

Nate Moore's Hollywood journey began with a college internship and an entry-level position in development for Columbia Pictures. Then, after taking a half-year break to hike the world, he reentered the business as a low-level production assistant on Sam Raimi's *Spider-Man 2*.

Years later, with solid work experience as a producer and an executive developing movies for independent production companies, Nate still included that minor role at the bottom of the résumé he sent over to Marvel Studios in late 2009. Kevin Feige, Marvel's president, had been an executive producer on *Spider-Man 2*. "I remember him on set," Nate says, "and I think he saw that credit and was like, 'Bring this guy in. I wonder if I remember him.'"

What got Nate the job, though, was his production experience, combined with his passion for comic books. "I was turned on to comics by my older brothers," he recalls, citing the Avengers among his favorite boyhood heroes. Growing up in a small town, "reading comics was how I learned about the world. The X-Men especially tended to travel to all these great places."

His youthful attempts to learn to draw failed, and he settled on films as a career goal. "Movies to me were very similar to comic books: It was escapism. It was learning about the world. I think I've seen *Who Framed Roger Rabbit* like forty or fifty times, to the point where my mom took it away from me."

As vice president for development and production, Nate is involved in a Marvel movie from concept through filming ("We are on set every day") to marketing and merchandise. From a producer's perspective, he says, "making a movie is matchmaking—finding the right filmmakers, the right writers, the right crew to bring these things to life."

That's true not only for movies, from the twenty-one Marvel Cinematic Universe blockbusters that led up to *Avengers: Endgame* to the upcoming debut of *The Eternals*, but also for the Marvel Studios limited series *The Falcon & Winter Soldier* for the Disney+ streaming service.

Nate never loses touch with the fact that "we're standing on the shoulders of greatness" as Marvel takes its characters into their seventh decade. He's also well aware that fans keep a close watch on how the comics are transformed into movies. "They want to see that you care for the material, but also that you're willing to make the hard choices that can make the property better."

Nate Moore stands at the comic library wall at Marvel Studios, where cast members can research the narrative history of Marvel characters within the comics.

VINCE
Part of the Magic

VINCE CARO

Hometown
New York, New York, USA

Job
Senior Recording/Mixing Engineer, Pixar Animation Studios

Favorite Disney movie
Dumbo (1941)

Vince Caro's life-changing moment came in the early 2000s in a New York City recording studio. And it wasn't because Vince, by then a well-known recording engineer, was working with Paul Simon and Stevie Wonder that day. It was because Pixar called with a possible job offer: move to California and work full-time in the recording studio they were building at their new Emeryville campus.

Vince had been working with Disney and Pixar for twenty years by then, ever since his experience recording dialogue and music both for animation and for Broadway cast albums got him an engineering job on the original *Beauty and the Beast*. He'd worked on *The Lion King*, *Pocahontas*, *Toy Story*, and countless other features for the two studios.

So he could afford to be "a little bold" when Pixar called that day. "Make me an offer I can't refuse," he joked, not really believing, as a lifelong New Yorker, that he would uproot his family and head west.

But his wife convinced him. "You only want to do things that are great," he recalls her telling him that night. "You don't really have patience for people who do schlock work. I know, because I've seen you come home from those jobs, and you're not a nice person. But anytime you come home from a Pixar or Disney session, you're

always the person I like—because you're working with people who want to do good work."

Vince took the job. Since then he has recorded dialogue for Pixar features and shorts—both the temporary "scratch" performances used during early production, and the voices of innumerable star actors—as well as a lot of music: guitars and cowbells for *Coco*, drums for *Brave*, o ukulele for the short *Lava*.

The marvels of manipulated sound have fascinated Vince since he was a boy listening to his father's LPs and wondering, "How does Elvis Presley sound like he's in the schoolyard, with that slap-back echo?" By high school he was building guitar amps and a PA system for the garage band he had formed with his pals.

He studied recording at Berklee College of Music and learned from the best in the business during his years at RCA. Vince worked on TV commercials with Bobby McFerrin and helped Harry Connick Jr. build a recording studio.

Does he miss those itinerant days when the next job might be, say, a chance to chase Eddie Murphy around the country to record dialogue for *Mulan*? Not a bit. Saying yes to that call from Pixar, he says, "has been the best decision I've ever made in my life."

At Pixar's in-house recording studio, Vince Caro works with Bob Peterson, an animator, director, and story artist who has voiced characters in *Up*, *Finding Nemo*, and other films.

ANTHONY

Part of the Magic

ANTHONY ANDERSON

Hometown
Compton, California, USA

Job
Star and Executive Producer of ABC's *black•ish*

Favorite Disney movie
Pixar's *Coco*

"There's a little more action at night, I like to say." That's why ABC7 helicopter reporter Chris Cristi says he prefers to take to the Los Angeles skies in the late afternoon. Often, he stays aloft until well past bedtime for most of those who reside in the continental United States.

He shares the sentiment of most Disney cast members when he further notes, "It's a very unpredictable job from one moment to the next."

Certainly, ESPN sports commentator Jason Benetti would agree. He cites the "emotion and vigor and pain" he sees at every game—and he's just talking about the fans.

Chapter Seven

6 pm – 9 pm

Even Patti Murin, who goes onstage as Princess Anna in *Frozen* eight times a week at New York's St. James Theatre, never knows what an overexcited young theatergoer might shout out at a crucial moment on any given evening.

As they sing in *Aladdin* at a theater a few blocks away from where Princess Anna is holding court, the nights "more often than not are hotter than hot—in a lot of good ways."

CHRIS
Part of the Magic

CHRIS CRISTI

Hometown
Pembroke Pines, Florida,
USA

Job
ABC7 Helicopter
Reporter, Los Angeles

Favorite Disney attraction
Carousel of Progress,
Magic Kingdom,
Walt Disney World

Helicopter reporter Chris Cristi covers the news with a bird's-eye view from his aerial office in the ABC7 news chopper. High above Los Angeles, from mountain to sea and everywhere in between, Chris and his fellow crew members—a pilot and a cameraman—capture unlikely shots, chase the action, and bring a unique perspective to breaking news for the local ABC TV station. It's an eighteen-year career fueled by a love for adventure and storytelling.

Chris was first inspired to pursue his lofty path back in 1994, when on a late June afternoon more than a dozen aircraft tracked that notorious low-speed chase between police and one-time NFL great—and prime murder suspect—O. J. Simpson in a white Ford Bronco along Los Angeles' sprawling freeways. Back then, Chris says, "there was literally a photographer hanging out of the helicopter with a camera on his shoulder."

Growing up in South Florida at the time, he says, "I remember watching the chase, thinking, *How cool would it be to cover this thing from a helicopter?*"

Nine years later, another huge story gave Chris his big break. By now he was in the industry and on the air as a morning radio traffic reporter in Orlando, where he was simultaneously studying broadcast journalism at the University of Central Florida. On the morning of February 1, 2003, Chris got a call from the station telling him to head to the airport to take a helicopter to Cape Canaveral on Florida's eastern coastline. The space shuttle *Columbia* had just been lost over Texas, and as awaiting crowds and astronauts' families gathered at NASA's Kennedy Space Center, "they needed a reporter in the air to talk about what was going on," Chris recalls.

In the years following the space shuttle tragedy, he subsequently reported from the sky for Fox and NBC stations in Orlando, Miami, New York, and Los Angeles. In 2018 he joined ABC7, for whom he reports during the evening newscasts. "I like the constant action of the job. We could be over a police chase one minute and then over a raging fire the next."

Southern California's devastating wildfires have been among his most impactful assignments. "These are such huge catastrophes that play out literally right before our eyes on live television." With his reports from overhead, Chris notes, he's "able to deliver really crucial information to our viewers."

For Chris, no workday is like any other and his reporting is all spontaneous, in-the-moment efforts to "strike the right balance" in providing both the facts and a sense of empathy. "I never have the luxury of a teleprompter or a script or anything like that. Every single report I do is right off the top of my head." Then he adds, without missing a beat, "It's all on the fly."

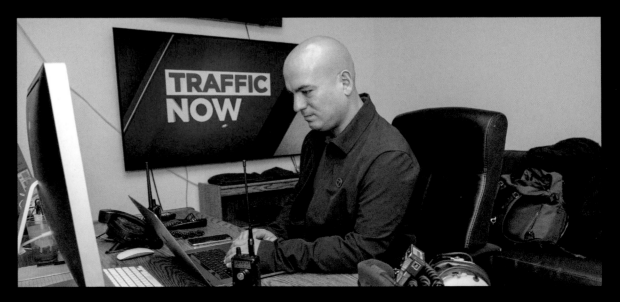

ABC7 helicopter reporter Chris Cristi, who got his start as a traffic reporter in Florida, says, "I truly feel like I have the best job in the world. I can't wait to get to work every day."

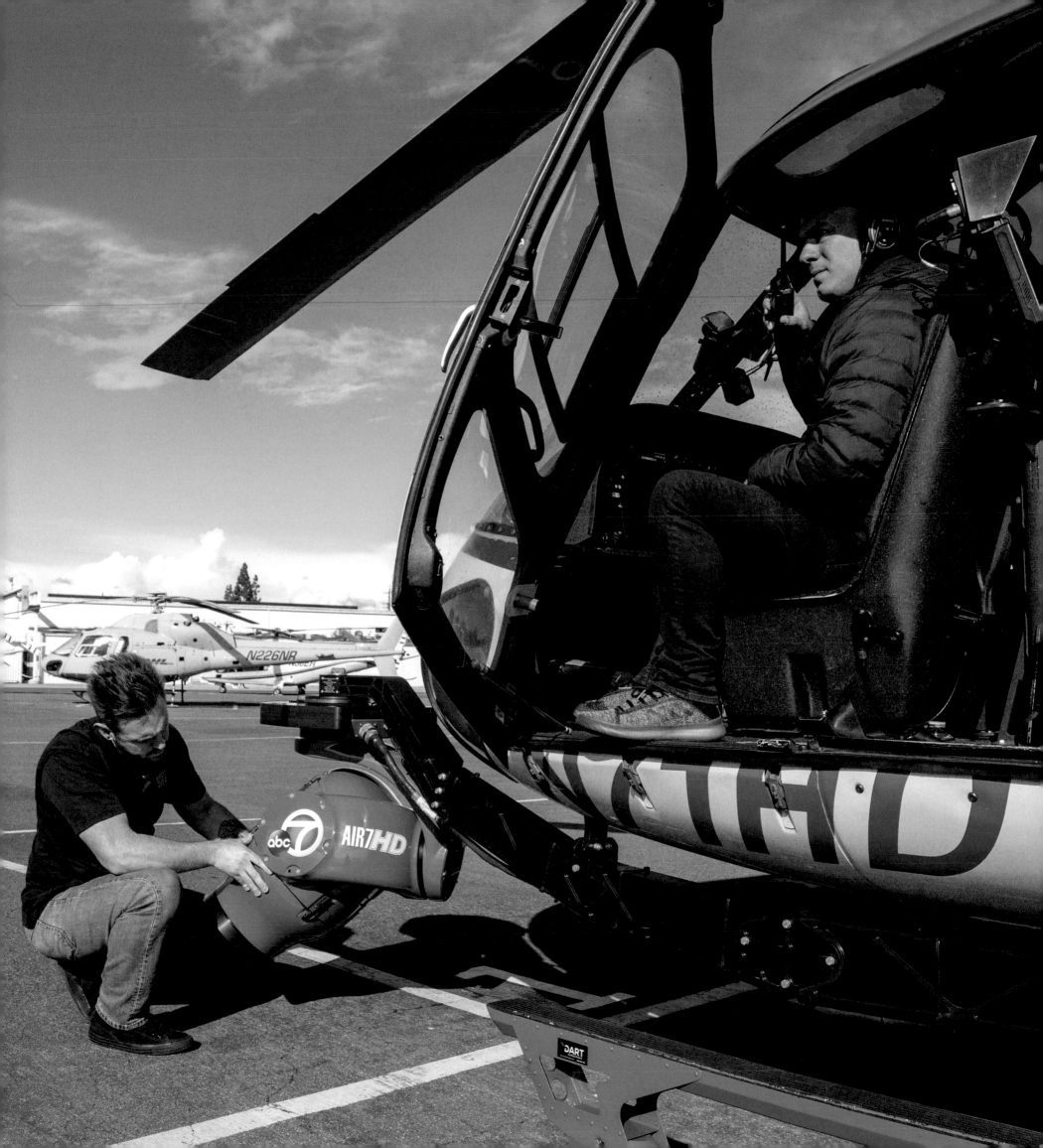

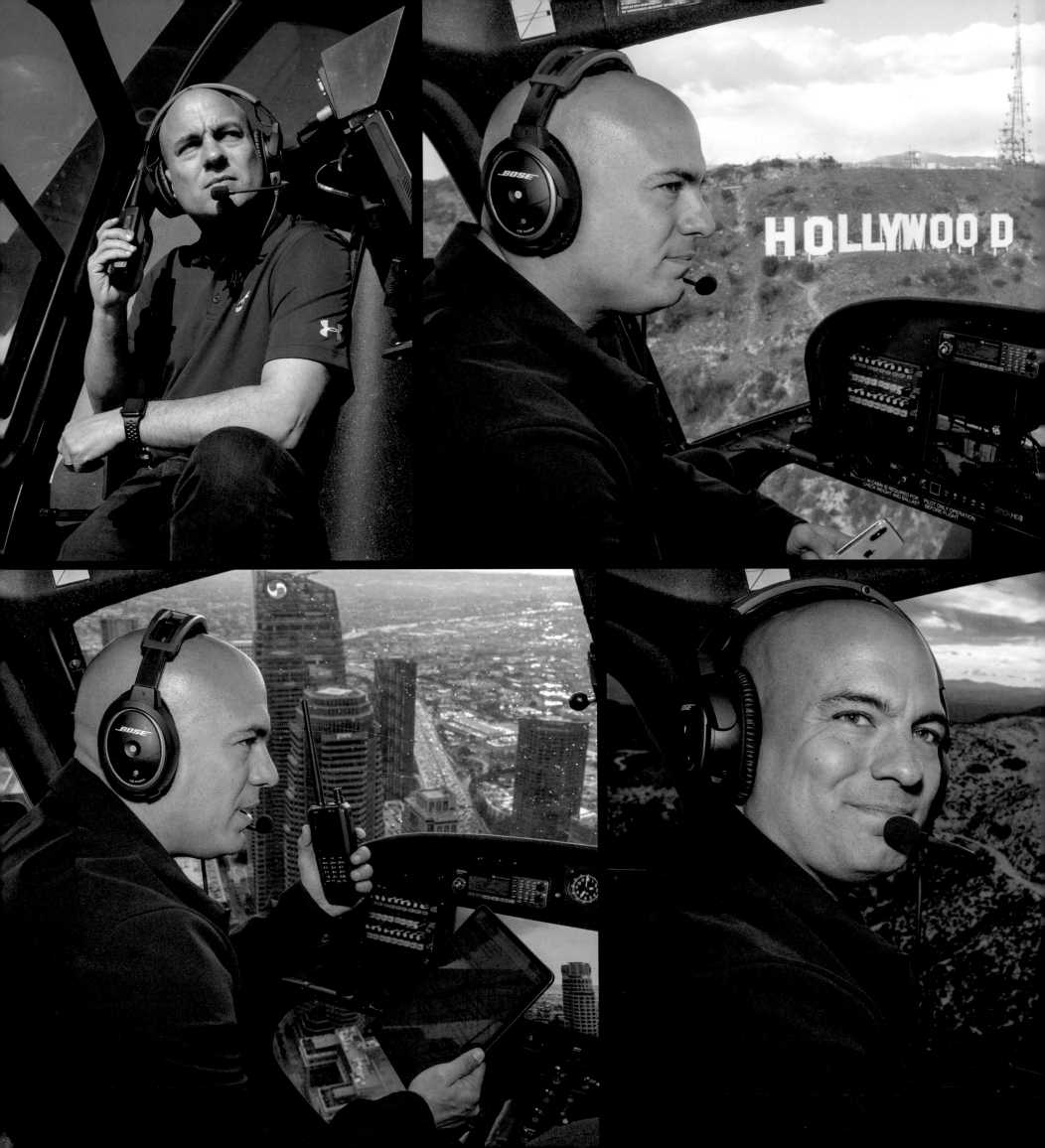

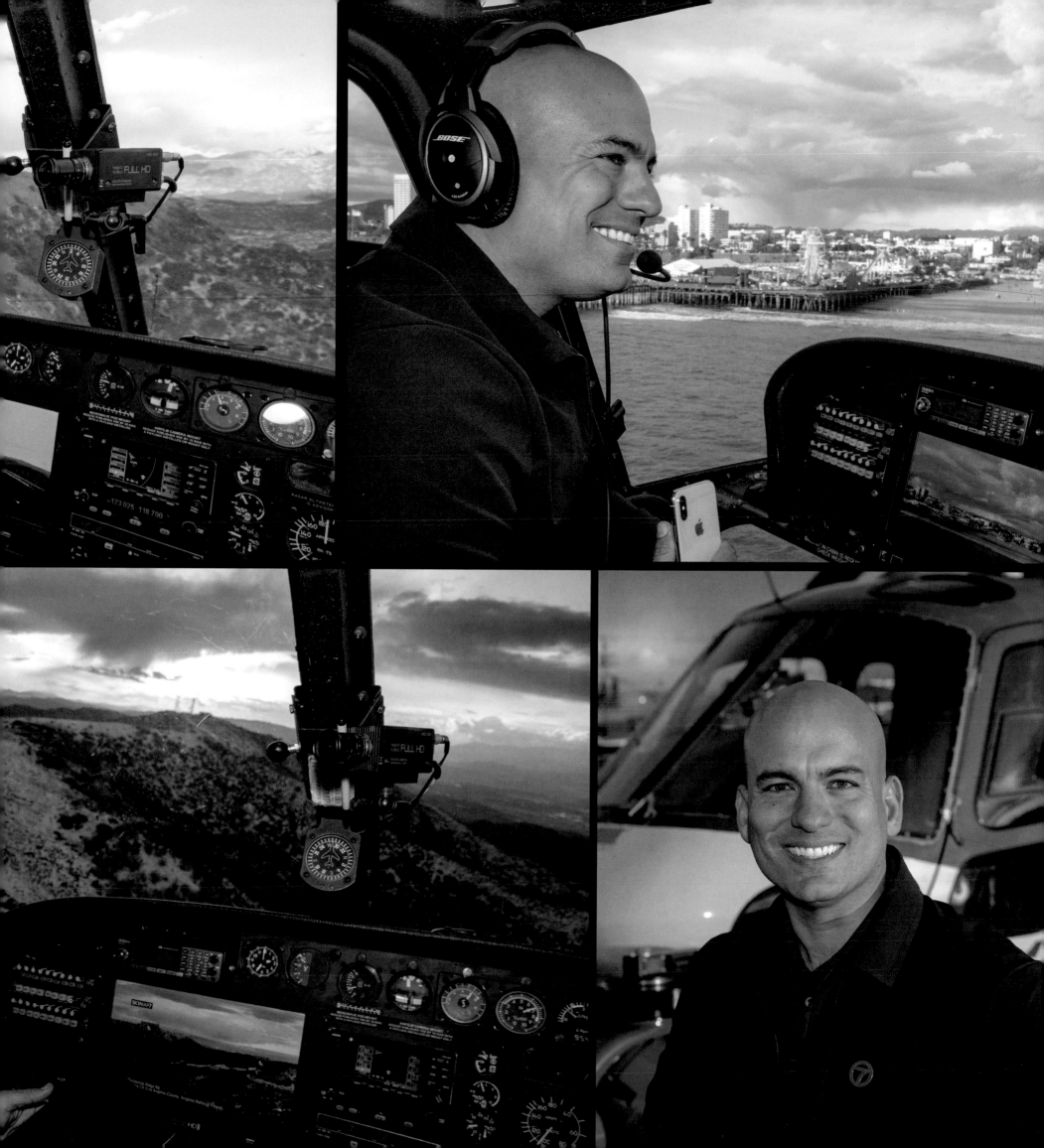

Not long after joining Hong Kong Disneyland Resort's custodial team in 2006, Kenneth Ko saw some remarkable photos from their sister park in Tokyo. Within two years, he was surprising Hong Kong guests with his discovery: A cast member with a broom and a bucket can also be an artist, sketching familiar Disney characters on the pavement with confident swooshes that turn water into paint, cement into canvas.

"The guest response was quite amazing, actually, even though I wasn't really good when I started," Kenneth says of his early efforts. "But they hadn't seen it before."

Now the water art team numbers about twenty custodial cast members, trained by Kenneth. They still attend to keeping the park spotlessly clean, but they get about an hour a day to perform their liquid craft. For special guest celebrations, Kenneth designs drawings that add a birthday cake or other element appropriate to the occasion.

Not content with just one way to dazzle guests, Kenneth taught himself how to twist balloon animals about ten years ago. "The kids love it," he says, and his repertoire of figures includes not just Disney figures like Mickey Mouse but also dogs, bears—"too many to count."

On one memorable occasion, he combined his talents for a guest's marriage proposal, recruiting a colleague to create a unique water drawing while he shaped balloons into flowers, surprising even the aspiring groom who had arranged the event. Kenneth has helped many gentlemen pop the question over the years, "and we haven't seen a lady say no yet."

Kenneth doesn't get a chance to perform every day anymore, having taken on additional responsibilities such as consulting on the custodial requirements for the ongoing park expansion.

He was also instrumental in the cleanup after Super Typhoon Mangkhut in September 2018, which left downed trees, patches of flooding, and debris—mostly leaves, branches, and palm fronds—throughout the park. The park was closed on the day the storm hit and again the next day, as the custodial team "had to be everywhere immediately," Kenneth says.

Cast members' brooms managed a wizardry quite different from water art that day, and the park welcomed guests back the day after, a welcome sight for the park's pavement artists. "I like to work with people," Kenneth quips.

Kenneth Ko says it takes about thirty minutes for a custodial cast member with a broom and a bucket to create a water art portrait of a Disney character.

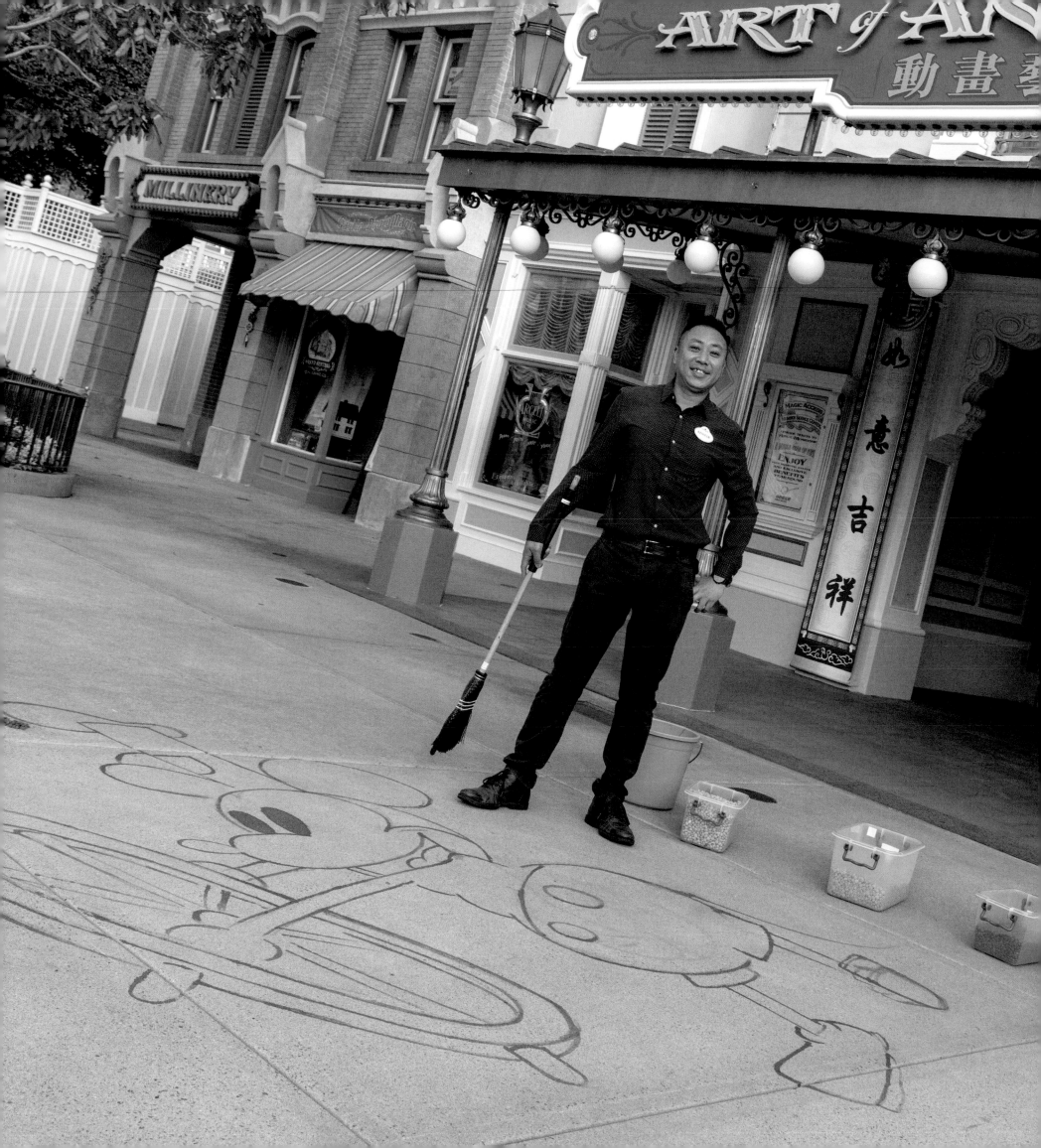

ROB

Part of the Magic

ROB
RICHARDS

Hometown
Aberdeen, South Dakota,
USA

Job
House Organist,
El Capitan Theatre,
Hollywood

Favorite Disney movie
*Snow White and the
Seven Dwarfs*

Rob Richards has put the Mighty Wurlitzer organ at Hollywood's El Capitan movie palace through "twenty years of hard labor," he says. The instrument was recently renovated.

In jeweled shoes and eye-popping jackets, Rob Richards has performed as the House Organist for audiences at the El Capitan movie palace in Hollywood for more than twenty years, his fingers flying around the grand, golden console and his feet dancing across the organ pedals.

"Sparkles are just my version of musical pixie dust," he says. "And since a T-shirt and blazer is a classic L.A. look, I've amassed a staggering collection of nearly two hundred Disney movie-themed tees" as well as dozens of dazzling jackets including velvet, rhinestones, and sequins.

Not many movie theaters with functioning pipe organs remain in the world, and there are even fewer with full-time organists. With forty-five years as a professional musician (and more than eight thousand performances just for Disney)—plus over a dozen international tours—it's unlikely there's another theater organist on the planet with Rob's experience and reach.

The organ, nicknamed "The Mighty Wurlitzer," was custom-made in 1929 for the ornate Fox Theatre in San Francisco, which was demolished in 1963. It's one of the top three theater organs left in the country, by Rob's estimation. But after having played all three (including the one at Radio City Music Hall in New York), Rob feels the El Capitan's is his favorite, with a sound he characterizes as "eloquent and extremely lyrical."

Rob's path to Hollywood from South Dakota took him through a music degree from Northern State University in his hometown of Aberdeen, South Dakota, and a long stint performing at restaurants with theater organs. After twelve years at Organ Stop Pizza's giant Wurlitzer in Mesa, Arizona, Rob decided it was time to "start my music career over from scratch." So, he picked up and moved to Los Angeles.

There he heard whispers of Disney's plans for the El Capitan and talked his way into an interview. "My whole life journey, actually, was preparation for this job," he says.

His set list any given night is tailored to the movie feature and drawn from two collections he assembled. The "action adventure book" is a salute to great Hollywood scores. The "classic Disney book" showcases the incredible melodic legacy from 1929's "Minnie's Yoo Hoo" to contemporary hits like "Let It Go."

Rob is often asked if he gets tired of playing Disney music. His response? "Never ever! How could anyone tire of nearly a century of film's most beautifully crafted songs that encompass every era and every style? This is the songbook of everyone's childhood. Pure magic!"

So it's likely many more pairs of sparkly footwear will be retired before maestro Rob Richards leaves his golden bench.

PATTI

Part of the Magic

PATTI MURIN

Hometown
Hopewell Junction,
New York, USA

Job
Plays Anna in Disney's
Frozen on Broadway

Favorite Disney movie
Beauty and the Beast
(1991)

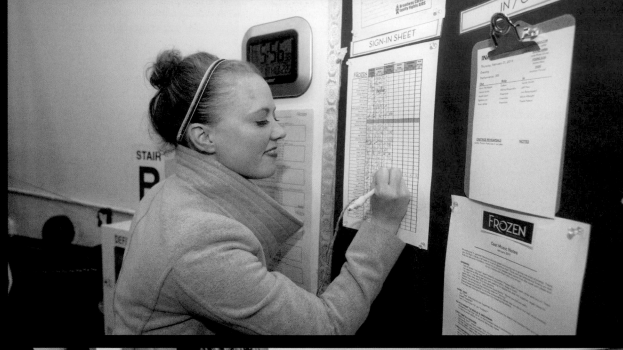

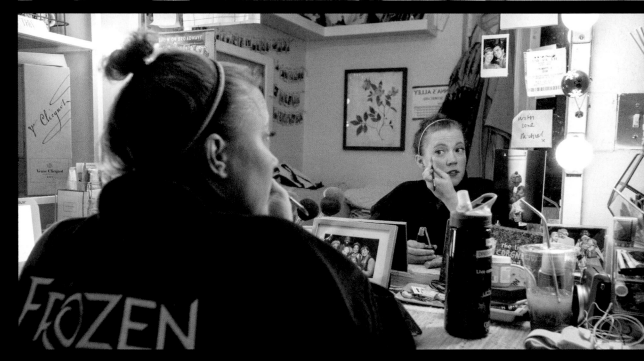

Before each performance of *Frozen* on Broadway, Patti Murin meets with the girls who play young Anna and Elsa (middle left). After the show, she often signs programs for fans outside the stage door.

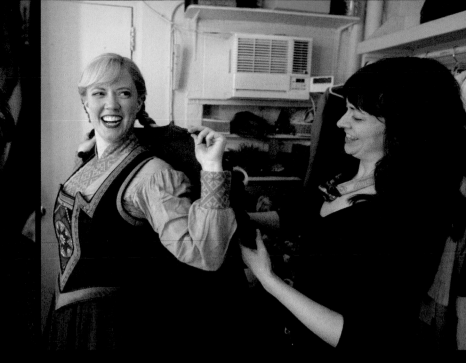

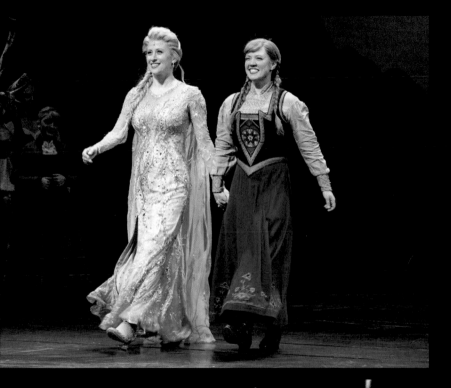

One of Patti Murin's last stops before she takes the stage as Princess Anna of Arendelle in Disney's *Frozen* on Broadway is the wig room.

"They call it Hairendelle," she says with a laugh. "They have an Instagram account and everything. It's the most fun room in the entire theater."

Patti has been having fun in Arendelle for three years now, having played Anna since the musical's earliest workshops, including in the 2017 pre-Broadway run in Denver. "Everyone asks, 'Doesn't it get boring?' Absolutely not. It's been three years and I'm still discovering things onstage every night."

Patti's dressing room at New York's St. James Theatre is not far from the stage, and it's there that the girls who play young Anna and young Elsa drop by before each show for some "Patti time." The girls have three songs—among the more than a dozen new numbers composed for the stage show—before grown-up Anna and Elsa appear onstage. That gives Patti a few minutes "to catch up and chill out" with costar Caissie Levy, who plays Elsa, before they make their entrance during "Do You Want to Build a Snowman?"

"Once I get onstage, it just doesn't stop: constant wig changes, costume changes—it's a minor miracle every time we get through the show."

"It just doesn't stop" might also describe Patti's career, beginning when she played a mouse in Rodgers and Hammerstein's *Cinderella* in the sixth grade. Once she found out she could study musical theater in college, "There was never a backup plan or anything. I don't think I was qualified to do anything else."

At twenty-six she was cast in *Xanadu*, her first Broadway show. Among many other roles, she has played Belle in *Beauty and the Beast* in a U.S. tour, Ariel in *The Little Mermaid* in St. Louis, and the title role in the Broadway musical *Lysistrata Jones*.

Of course, nothing can quite compare to *Frozen*, with its irrepressible young fans whose passions sometimes bubble over. Patti recalls the moment in a recent matinee when Anna's fiancé, Hans, is revealed to be the bad guy and leaves the stage. Patti was about to launch into "True Love," one of her solo numbers, when "in the one bit of silence after the door closes, this little voice came from the back of the auditorium, saying, 'I'll *kill* that Hans.'"

Neither audience nor Patti could ignore the youngster's outburst. "I just had to smile and blow him a kiss," Patti says. "And then I just continued with the song."

Jason Benetti

Hometown
Homewood, Illinois, USA

Job
Play-by-Play Announcer,
ESPN

Favorite Disney attraction
"it's a small world"

ESPN broadcaster Jason Benetti's first play-by-play patter had an audience of one—maybe two—back when he was a kid. "You know, you're sitting in your room and you're playing a video game alone or—even worse—with a friend, and you just start being like, 'Here's the pitch. And ground ball to shortstop!' And my friends are like, 'What are you doing?'" he recalls. "It was hyper-lame, but also vocationally positive."

Jason started calling real games back at Homewood-Flossmoor High School in Chicago. "My first love was radio. If you can vividly paint the picture" for fans, he says, "the imagery of radio is the absolute beauty of the medium."

Television play-by-play, in contrast, "is still about finding the right thing to say for the moment, but a great TV announcer to me is a listener." That means paying attention to his fellow announcers, to coaches, to producers, to fans—basically, "being in sync with everyone." It also means asking the right questions both during the game and before it starts, discovering players' untold stories, and finding the answers to questions long before they're asked.

Jason has been channeling listeners' curiosity for many years over a career that's had him careening around the country. He called games at Syracuse University (he's an alum); at High Point University (covering basketball); in Salem, Virginia (minor-league baseball); and in many other places before ESPN put him under contract, beginning with the 2015 football season. (He'd been working part-time for ESPN since 2011.)

Then the Chicago White Sox called—a big deal for a Chicago native. Jason was signed to cover the team's road games in 2016, and the next year was named the team's full-time announcer, taking over for the legendary Ken Harrelson. "ESPN is awesome about letting me do it," he says. "They said, 'We're happy for you and we'll work around it.' So it's been fantastic."

When Jason's not broadcasting—or standing in security lines at airports—he's working with the Cerebral Palsy Foundation (CPF) to raise awareness of the disability he has dealt with his entire life. He narrates and stars in CPF's "Awkward Moments" animated shorts, which educate by making light of the inappropriate reactions strangers often have to the "weirdness" of Jason's gait. "Rather than get frustrated, you just have to smile about it and say, 'Look, this keeps happening, and it's just like brain-turned-off insane.'"

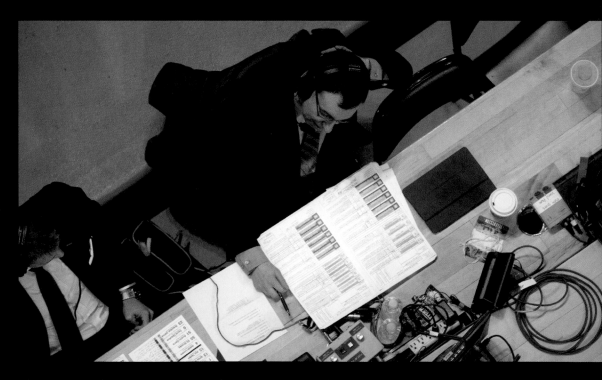

ESPN play-by-play announcer Jason Benetti covers a college basketball game between Minnesota and Michigan with broadcast partner Robbie Hummel (near right).

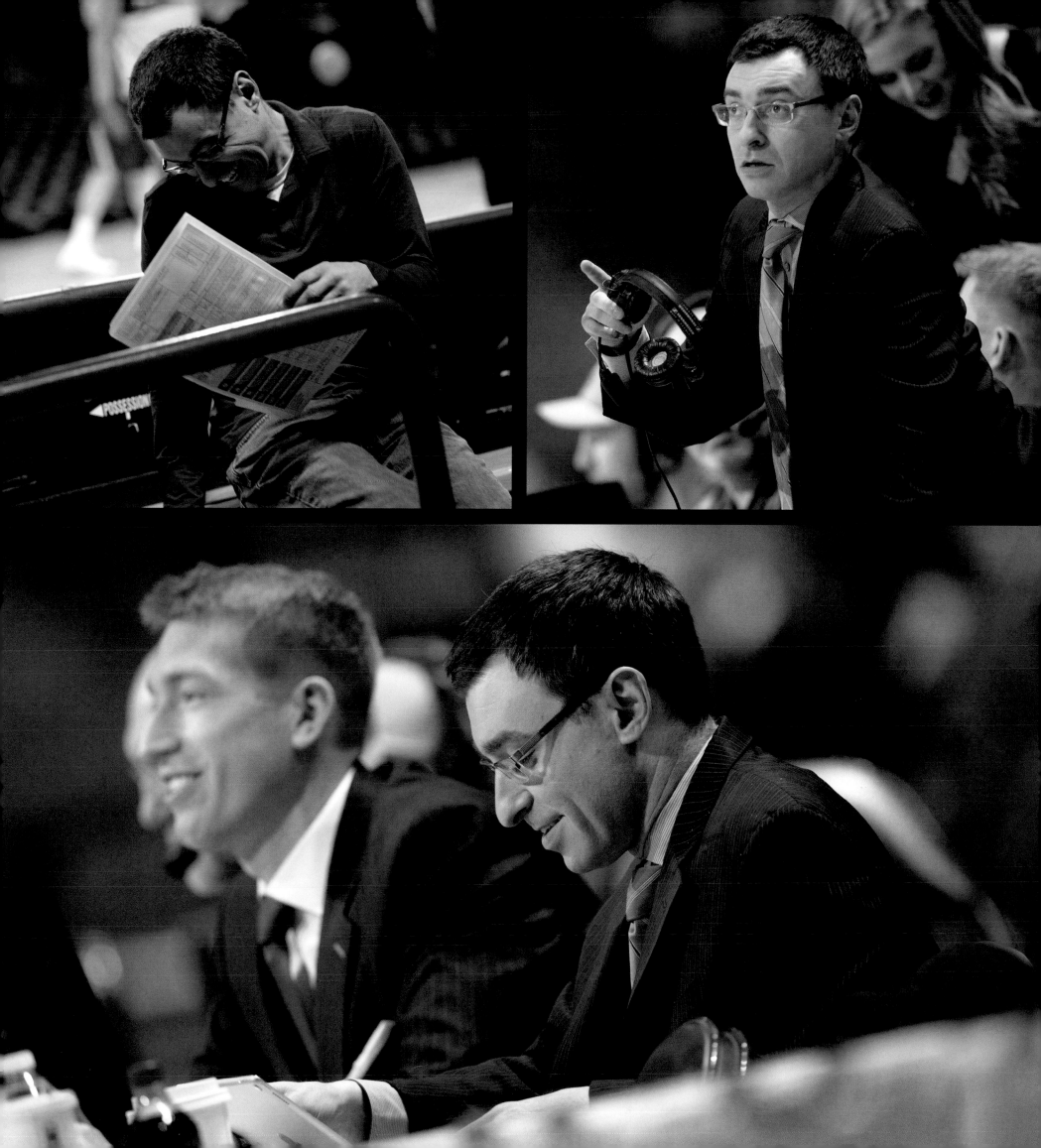

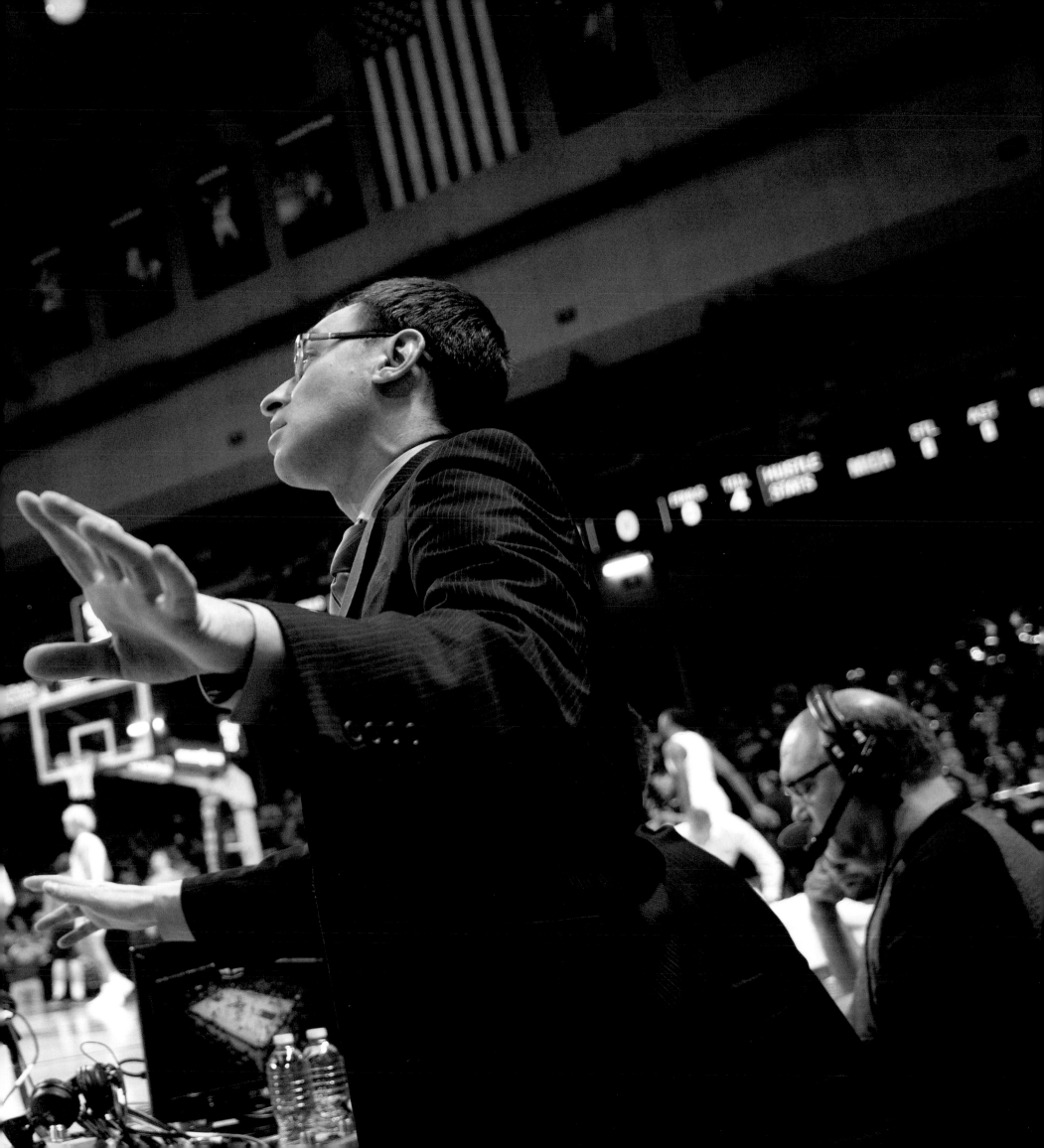

Chapter Eight

9 pm – Midnight

What's the end of a workday at Disney like? We've already met folks who close their evenings on an island in the Bahamas, at major sporting events, in a Tokyo parade, and inside palatial theaters in Shanghai, Madrid, New York, Orlando, and Los Angeles.

For others, the day continues into the night. As dusk spreads across the Pacific toward Hawai'i, Angela Morales is still bringing her native culture and traditions to guests at the Aulani resort on O'ahu. On the other side of the United States, Pablo Tufino has started his night shift at Disney's Animal Kingdom in Florida.

Pablo's journey to Disney took him thousands of miles over many years (and actually began in Ecuador). In contrast, Disneyland window designer Tony Salvaggio has worked for decades in the park that was essentially his childhood playground.

Cast members' journeys to Disney may be long or short when it comes to physical distance, but their transformations are never overnight.

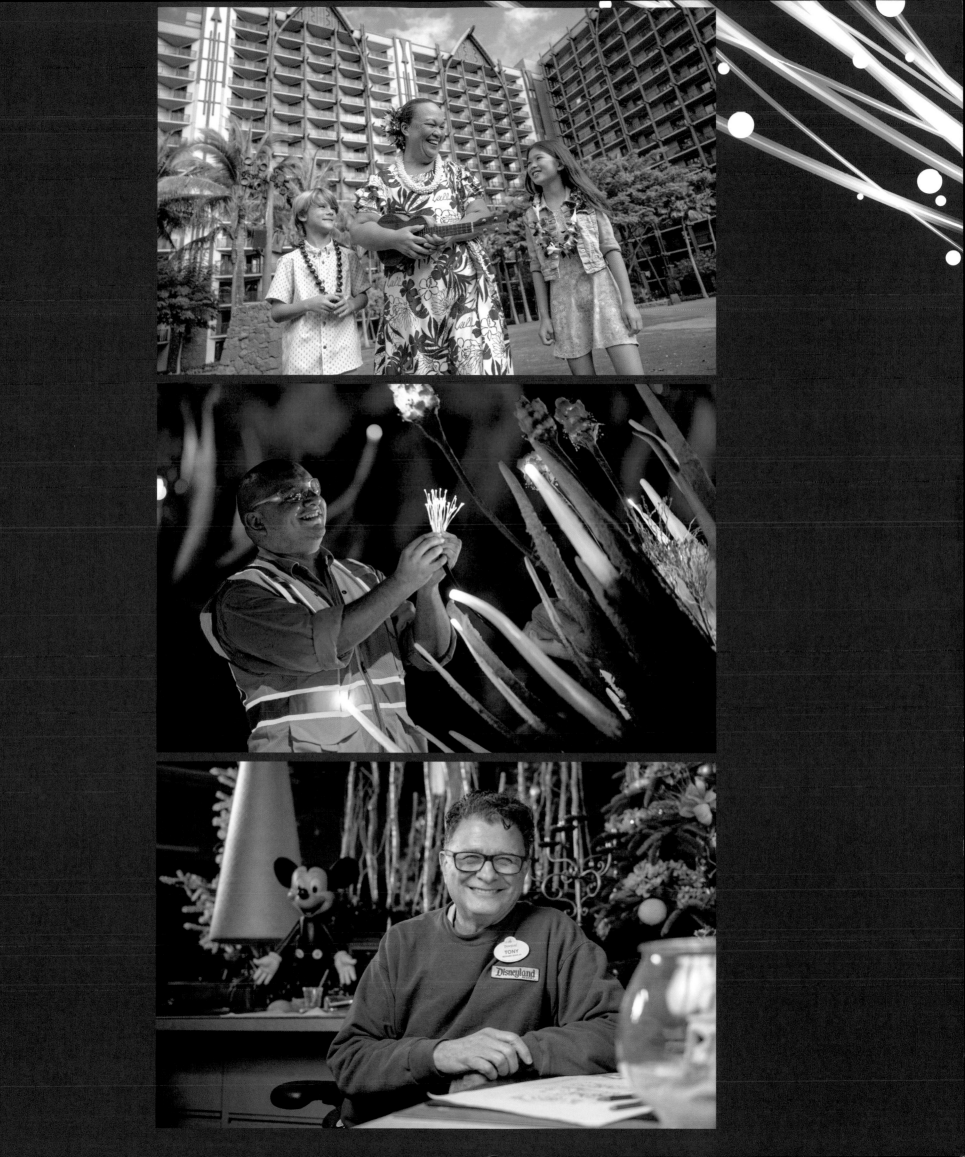

ANGELA

Part of the Magic

ANGELA MORALES

Hometown
Waiʻanae, Hawaiʻi, USA

Job
Resort Performer
("Aunty") and Live Music
Coordinator,
Aulani, A Disney Resort &
Spa, Ko Olina, Hawaiʻi

Favorite Disney movie
Pixar's *Ratatouille*

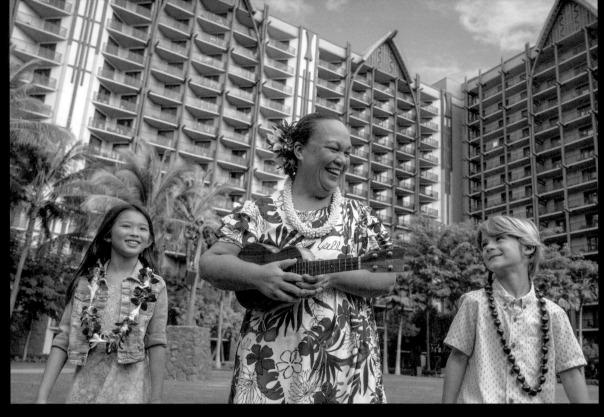

In portraying "Aunty" at Aulani Resort on Oʻahu, Angela Morales's mission is for the children she entertains to take home a better sense of Hawaiian culture.

Most guests arriving at Aulani, A Disney Resort & Spa, Ko Olina, Hawaiʻi know that *aloha* is Hawaiian for "hello" and "goodbye." But at the resort, Aunty Angela Morales makes sure the children who visit also learn what the word really means.

"It expresses love," she says, "and if you break down the word, the *ha* at the end means 'breath.' So when we say the word *aloha*, we are truly sharing an essence of who we are."

Aunty's Beach House at Aulani is a busy kids' club for children from ages three to twelve, with a computer room, a movie room, a backyard, and planned activities all day long. It's inspired by Hawaiian family customs, in which "aunties and uncles are the caretakers of the families," a role separate from that of the parents, the *kūpuna* (elders), and the *keiki* (children).

"Being able to portray Aunty at the resort gave me a love of sharing Hawaiian culture with our guests," Angela says. "That's always been my goal here—merging Hawaiian culture, Hawaiian values, and Disney values together."

Before Aulani opened, Angela had been doing well as a singer for nearly thirty years on her own and with her well-known vocal trio, Na Leo Pilimehana, having grown up in Hawaiʻi with parents who were both entertainers.

With a well-established career, she ignored the first invitation from Disney to audition for the role of Aunty, who sings throughout the resort as well as hosting at Aunty's Beach House. But Disney called again, and by opening day she was Aunty. "It's part of who I am now, and it's what I love," she says.

Angela's duties have expanded over the years. She assists with the entertainment at Aulani's KA WAʻA Lūʻau and other events and schedules Hawaiian entertainers to play music throughout the resort.

She sees the impact of her work every single day: "From children all the way to grandparents, guests just light up when they come here."

And when they leave, she hopes they take along some sense of Hawaiian culture, "even if they just go home and tell people 'aloha' somewhere in Texas or Tennessee. That would be wonderful," she says. "The aloha spirit means sharing your heart, being compassionate, being kind. You don't have to be Hawaiian to have that."

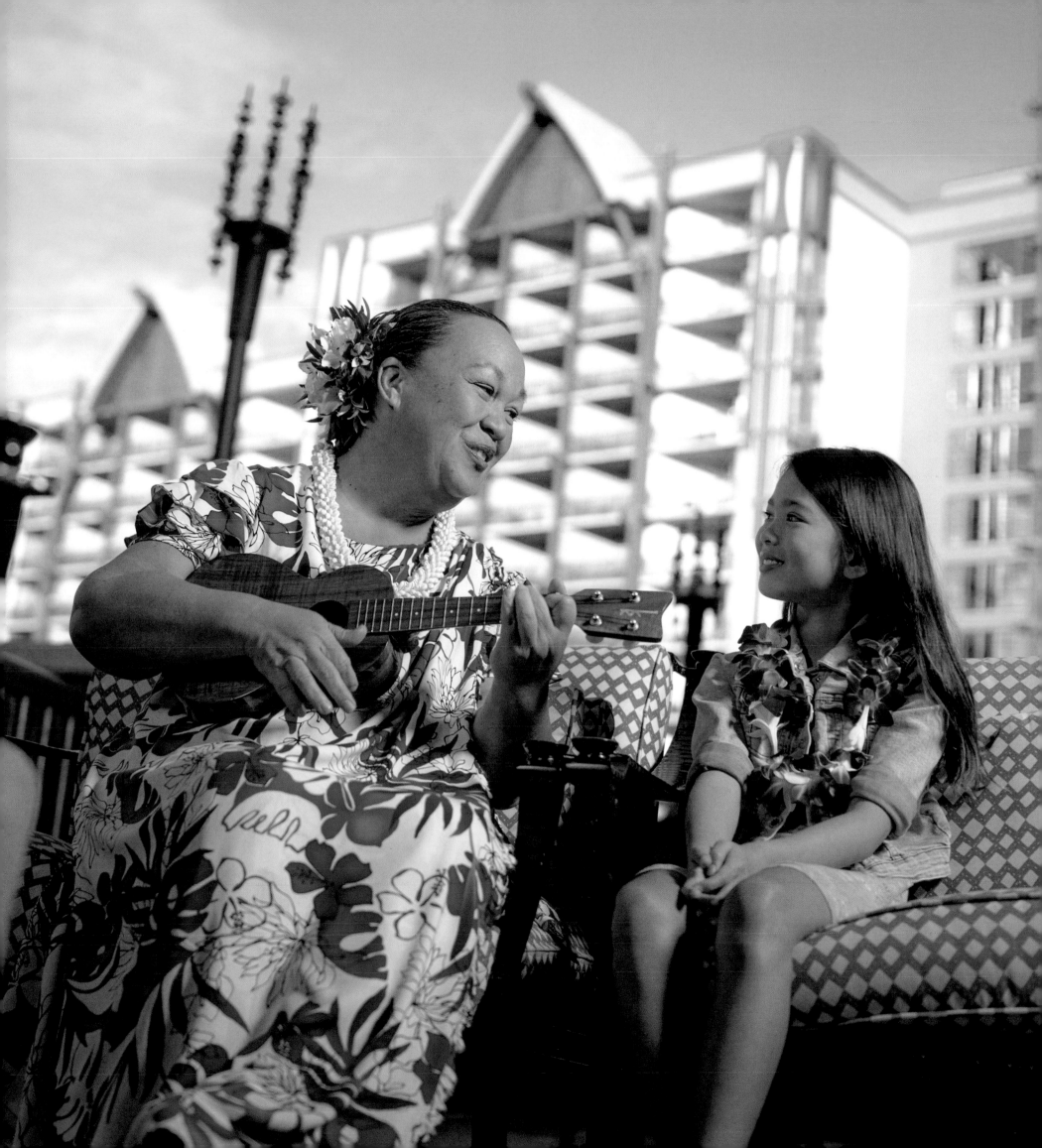

PABLO
Part of the Magic

PABLO
TUFINO

Hometown
Quito, Ecuador

Job
Foreman, Computer Ride
Show Tech, Disney's Animal
Kingdom Theme Park
Lighting Department

Favorite Disney movie
*Tim Burton's The Nightmare
Before Christmas*

Changing light bulbs is not a big part of Pablo Tufino's job in the lighting department at Disney's Animal Kingdom Theme Park. Particularly in Pandora—The World of Avatar, the park's newest land, illumination is everywhere, ever-evolving, and intricately programmed. When Pablo talks about his job, the conversation is peppered with words like "bioluminescence" (roughly, glowing life-forms) and "color kinetics" (dramatically changing hues and intensity) and acronyms like LED, UV, and DMX.

Working from about 8:00 p.m. until dawn, members of a team of about twenty techs, plus apprentices, sweep through the park—checking, testing, and making fixes as needed. Pablo spends most of his time in Pandora, perfecting what Walt Disney Imagineering terms "area development." That's the storytelling environment outside of the attractions, restaurants, and shops: that's everything from plants and waterfalls to ornamentation and, of course, lighting. Whatever guests see, Pablo explains, "There's a show behind it."

It's area development that makes guests feel like they're in Africa in one part of the park, Pablo points out. "But then they take a few steps down the path and it's turned into Asia, with a whole different atmosphere."

Just as the ambience has been meticulously imagined, it needs to be meticulously maintained by experienced technicians. Many of them, like Pablo, start off in the four-year apprentice program.

His own hands-on schooling as a Disney-specific electrician and computer tech started with changing fixtures and repairing TVs at Walt Disney World's Coronado Springs Resort. It then took him through parade-float programming at the Magic Kingdom, security gate repair backstage, and Audio-Animatronics at Disney's Hollywood Studios before he reached Pandora.

It's been quite an odyssey from Ecuador, where Pablo was born, through New York's borough of Brooklyn and then Pennsylvania (where he grew up), to South Carolina on his way to Florida. He worked in fast food before starting on his current career path with a job fixing arcade games at a skating rink and another doing tech support for a bookstore chain. When he heard about the Disney apprenticeship, he jumped at the opportunity. He graduated from the program and became a full "journeyman" in 2016. Pablo was part of the crew that prepared Pandora for its opening the next year.

The most precious days to Pablo now are when he gets to take his family through the park where he works. "I love taking my kids into Animal Kingdom, showing them the stuff that I work with," he says. "But I don't go into detail on how stuff works. I just want to see their reaction, like, 'Oh, wow! That's so amazing. How did they come up with stuff like that?'"

Working every night on the lighting in Pandora at Disney's Animal Kingdom, technician Pablo Tufino says, "it's like the forest is actually alive."

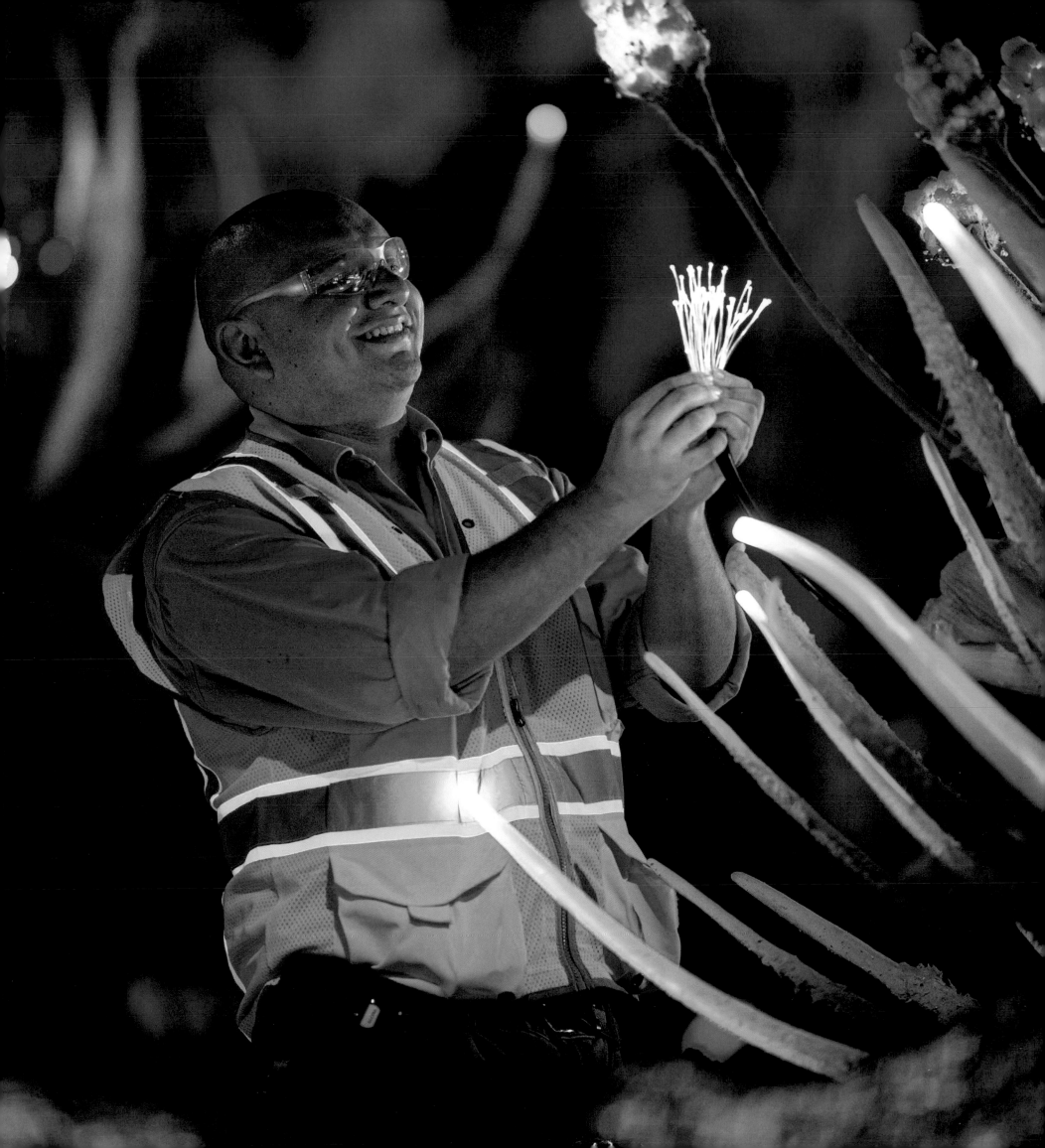

TONY
Part of the Magic

Anthony Salvaggio

Hometown
Anaheim, California, USA

Job
Park Decorator,
Window Display Team,
Disneyland

Favorite Disney movie
*20,000 Leagues Under
the Sea*

Every day is a holiday at Tony Salvaggio's
office backstage at Disneyland, where he
designs many of the ever-changing seasonal
window displays along Main Street, U.S.A.

Who better to work on decorating the shop windows of Disneyland than someone who grew up there? Tony Salvaggio's mom worked in the restaurants at Disneyland Hotel when he was a kid and took him to private Disney movie screenings for cast members' families when the park was closed. Little Tony would walk in awe with his mom down Main Street, U.S.A., to the Fantasyland Theatre, passing all those windows that would one day be his dominion.

"My mom was one to punch up every holiday," Tony says. "That's how I got the decorating bug and learned to go all out for all the holidays."

Now Tony designs and decorates the windows on the east side of Main Street and Town Square, though he has also plied his skills in the Downtown Disney District and Disney California Adventure. After all, the full resort has some two hundred windows that get changed out at least five times a year—for winter and Valentine's Day, Easter and spring, summer, Halloween, and, of course, Christmas.

In advance of both Halloween and Christmas, Tony works "about a month of midnights," updating windows and store interiors through the night and slipping out early in the morning, just before the parks open. "The span from Halloween to Christmas is busy," he says. "We're working on windows while our holiday team is working on lifts above our heads," putting up lights and garland, plus other exterior décor.

Tony joined the Window Display team in 2012. It's been his favorite job at the park so far—and he has had many. At age sixteen, he was a performer in the Christmas parade and he's been working his way up through the Disneyland ranks ever since, including stints with the Character Department while in college (studying theater arts) and for decades thereafter, including stage managing, scheduling, and touring—plus trips to Disney Stores throughout the Western United States and Hawai'i. His college degree ultimately was in interior design, which eventually took him to the scenic fabrication team, and then to windows.

"We constantly change things up," he says, utilizing a backstage warehouse brimming with seasonal baubles. "I'm always adding this or that as I see something in stock that I didn't know we had." The goal with every display is to "arrange things so it looks like it just happened, like it just fell together."

That goal held sway even as he worked to help add the final dressing touches to *Star Wars*: Galaxy's Edge before it opened at Disneyland. "The level of detail is so amazing," he says. "Guests feel like they've been transported." The new land is fourteen acres, he notes, but with fans pouring in, "I don't think it's going to be big enough."

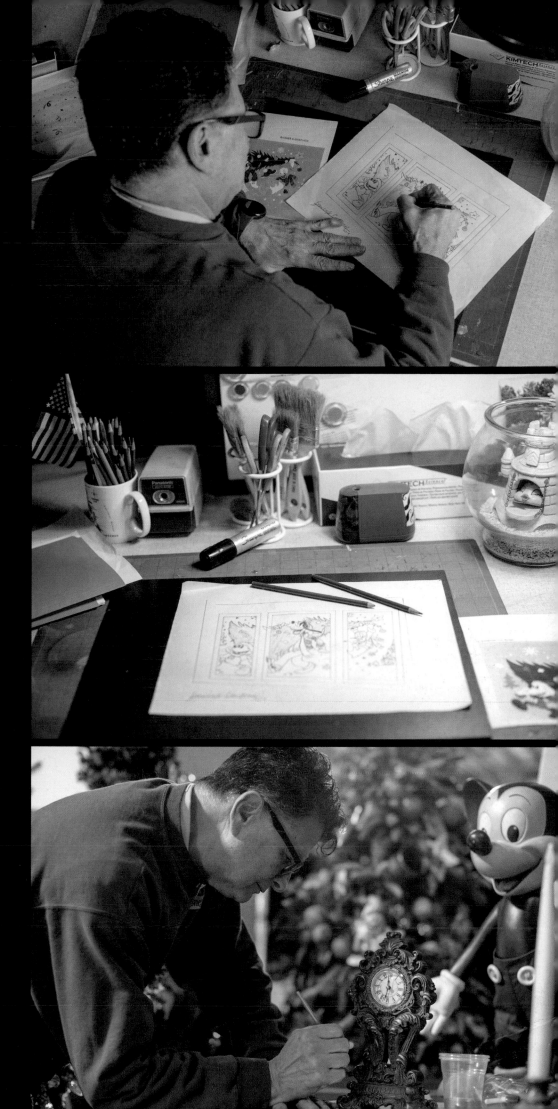

Whether creating

holiday magic

at Disneyland . . .

Or taking care of **guests** during a Walt Disney World parade . . .

It takes teamwork

to create magic

for families to treasure together!

WDW PUBLIC AFFAIRS AND GLOBAL PARKS AND RESORTS SITE SUPPORT TEAM

Lisa Arney
Wincy Au
Maureen Berendes
Amanda Cease
Wilma Colòn-Rivera
Mark Drennen
Jed Dunstan
Gabriel Gibaldi
Donny Hall
Stephanie Hall
Jenkin Ho

Carole Jublot
Luis Lugo
Billy Meeks
Rachel Monnier
Nikki Moreno
Vincent Pang
Diego Parras (WDI-FL)
Mary Precourt
Kathleen Prihoda
Nathalie Raverat
Frank Reifsnyder (WDI-CA)

Laura Schaffell
Jenny Shen
Lindsay Swantek
Miho Tomotsuka
Mary Townsend
Damien Vayne
Marlana Villena
Caroline Wilcox
Ana Williams
Craig Yoshinaga

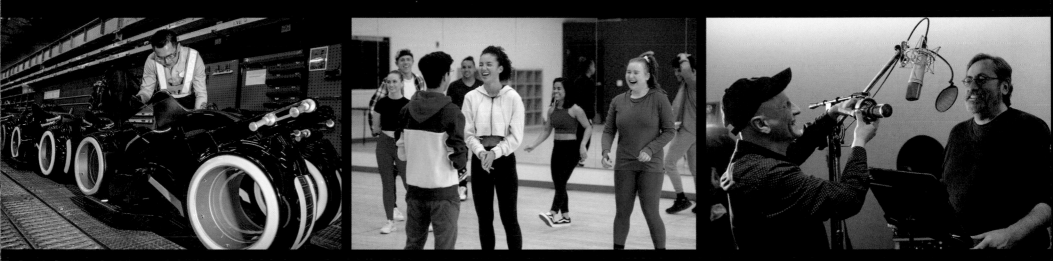

PHOTOGRAPHERS, ABC PHOTOGRAPHY AND VISUAL COMMUNICATIONS

Lorenzo Bevilaqua
Jessica Brooks
Richard Cartwright
Byron Cohen
Deborah Coleman
Scott Everett White
John Fleenor
Heidi Gutman
Mitch Haaseth
Jose Haro

Fred Hayes
Ed Herrera
Randy Holmes
Hana Keiningham (photo asst)
Eric McCandless
Kelsey McNeal
Gilles Mingasson
David Moir
Jeff Neira
Isolda Patròn-Costas (Jose's

photo asst)
Allyson Riggs
Tony Rivetti
Rick Rowell
Giovanni Rufino
Joshua Simpson (photo asst)
Craig Sjodin
Ron Tom
Chris Willard

A project like this is a tremendous undertaking. I would like to say thank you to a team that can only be described as amazing.

A special thank-you to Jack Anastasia, Jeffrey Epstein, Winnie Ho, Dan Richards, David Roark, Bruce C. Steele, and all the communications professionals throughout the company—none of this would have been possible without you.

To Zenia Mucha, for getting the project off and running and working hand in hand with the team from beginning to end.

And most importantly, to Bob Iger for his vision, support, and appreciation for the remarkable work being done every day by employees and cast members around the world.

—Wendy Lefkon
Editorial Director

Carla Anderson	Jennifer Black	Matt Derba
Jori Arancio	Jim Bowden	Monique Diman
Sarah Armstrong	Gregg Brilliant	Morgan DiStefano
Lisa Arney	Amber Brockman	Jed Dunstan
Katina Arnold	Brooke Butner	Joe Earley
Amy Astley	Jessica Casano	Alex Eiserloh
Wincy Au	David Chamberlain	Jackie Ferzacca
Dana Baccino	Victoria Chamlee	Caragh Fisher
Seale Ballenger	Agnes Chu	Alison Fisker
Steven Baron	Michael Cohen	Daisy Flores
Erin Barrier	Wilma Colon-Rivera	Bill Fortney
Shana Bawek	Laura Cullen	Ken Furer
Maureen Berendes	Sam Delpilar	Robert Gallo